15TH AND 16TH CENTURY ITALIAN DRAWINGS

IN THE METROPOLITAN MUSEUM OF ART

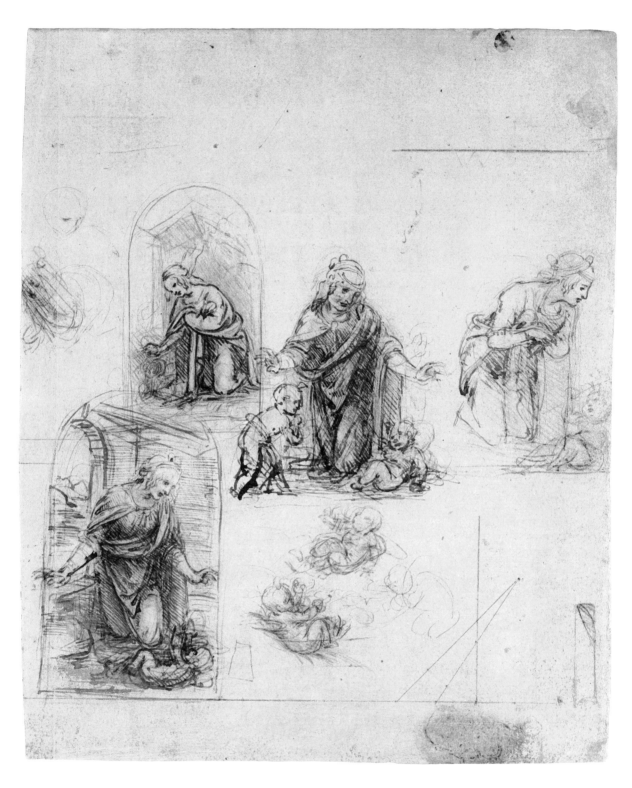

Leonardo da Vinci, No. 107
Photography by Malcolm Varon, New York

15TH AND 16TH CENTURY ITALIAN DRAWINGS

IN THE METROPOLITAN MUSEUM OF ART

JACOB BEAN

with the assistance of LAWRENCE TURČIĆ

The Metropolitan Museum of Art
New York 1982

Copyright © 1982 by The Metropolitan Museum of Art

LIBRARY OF CONGRESS CATALOGING IN PUBLICATION DATA

Metropolitan Museum of Art (New York, N.Y.)
 15th & 16th century Italian drawings in the
Metropolitan Museum of Art.

 Bibliography: p.
 Includes indexes.
 1. Drawing, Italian—Catalogs. 2. Drawing—15th century—
Italy—Catalogs. 3. Drawing—16th century—Italy—Catalogs.
4. Drawing—New York (N.Y.)—Catalogs. 5. Metropolitan Museum
of Art (New York, N.Y.)—Catalogs. I. Bean, Jacob. II. Turčić,
Lawrence. III. Title. IV. Title: Fifteenth and sixteenth century
Italian drawings in the Metropolitan Museum of Art.

NC225.M4 1982 741.945'074'01471 82-12432

ISBN 0-87099-314-3

ISBN 0-87099-315-1 (pbk.)

Contents

Preface

The collection of fifteenth- and sixteenth-century Italian drawings in the Metropolitan Museum is extensive, and a good many of the best draughtsmen of the time are represented therein. The Museum was opened in 1870, and the first drawings of the period that concerns us here entered the collection in the 1880s as gifts of Cornelius Vanderbilt and Cephas G. Thompson. Purchasing began at the end of the first decade of the twentieth century. The *Group of Trees* generally attributed to Titian was bought in 1908 and our first drawing by Leonardo da Vinci in 1910. Two more drawings by Leonardo were purchased in 1917, and in the same year nineteen drawings, including two by Correggio, were acquired at the Pembroke sale in London. Michelangelo's study for the *Libyan Sibyl* was purchased in Spain in 1924, the drawing having been called to the attention of the Trustees by John Singer Sargent. The sheet of figure studies by Filippino Lippi was bought at the Henry Oppenheimer sale in 1936. Of purchases made in the 1940s and 1950s, the *Design for the Fonte Gaia* in Siena and figure studies by Federico Barocci and Vittore Carpaccio should be singled out.

In all, one hundred of the drawings of this period were acquired by purchase, gift, or bequest before the establishment of the Department of Drawings as a separate curatorial division of the Museum in December 1960. Thus the remaining 193 drawings—nearly two-thirds of the fifteenth- and sixteenth-century material reproduced in this book—have been acquired since that time. The first sheet bought by the Department was the Pordenone *St. Christopher,* while no doubt the most important purchase in our twenty-two-year history was the Raphael study for the *Madonna of the Meadow.* In these years the collection has been enriched by gift and bequest; particular mention should be made of the twenty-two drawings of this period left to us by Walter C. Baker at his death in 1971, a bequest that includes the celebrated *Adoration of the Magi* by Fra Bartolomeo.

All drawings in our collection that I feel can be plausibly attributed to known artists of the period are described and reproduced. Old copies and sheets of (for me) dubious authenticity have been excluded, except where they may record an interesting lost original. The presence of a question mark after the artist's name in a catalogue heading is meant to indicate that there seems to be legitimate doubt concerning the attribution, in some cases because of the poor condition of the sheet. Ten still anonymous drawings of considerable interest are included at the end of the main section of the catalogue in the hope that their appearance will elicit new attributions. Descriptive notices are intentionally brief to allow maximum space for reproduction. The entries offer essential bibliographical references and a record of provenance. Since the Italian drawings of the fifteenth and sixteenth centuries in the Robert Lehman

Collection at The Metropolitan Museum of Art have been reproduced and described by George Szabo in very useful publications (1978, 1979), they are not illustrated here.

This volume includes an Appendix illustrating Italian seventeenth-century drawings acquired (by purchase, gift, or re-attribution) since the publication in 1979 of *17th Century Italian Drawings in The Metropolitan Museum of Art*.

I owe Lawrence Turčić a great debt of gratitude for his assistance in the preparation of this volume, of which he is in a good many ways co-author. I also wish to thank Helen B. Mules, Calvin Brown, and Judith Cohen, of the staff of the Department of Drawings, for their constant and efficacious assistance. Merritt Safford, Conservator for Prints and Drawings, has supplied valuable technical information.

I am grateful to the many scholars whose suggestions and attributions are recorded in the entries that follow. That the name of Philip Pouncey appears very often in this catalogue will not come as a surprise to those familiar with recent progress in the study of Italian draughtsmanship of the *Quattrocento* and *Cinquecento*. On his first visit to the collection in 1958, two years before the establishment of the Department of Drawings, he made many interesting discoveries. Indeed, this visit and Mr. Pouncey's subsequent recommendations were influential in the Trustees' decision to set up a separate department of drawings, with the intention of significantly augmenting the collection.

Lawrence Turčić and I should like to thank the following friends for their help: Roseline Bacou, James Byam Shaw, Bernice Davidson, James Draper, Everett Fahy, J. A. Gere, Richard Harprath, Carlos van Hasselt, Michel Laclotte, Jennifer Montagu, Nancy Ward Neilson, Konrad Oberhuber, Boniface Ramsey, O.P., and Felice Stampfle.

JACOB BEAN
Curator of Drawings

8

Works Cited in Abbreviated Form

Adelson, 1980
Candace Adelson in *Committenza e collezionismo medicei*, exhibition catalogue, Palazzo Vecchio, Florence, 1980.

Age of Vasari, 1970
The Age of Vasari, exhibition catalogue by Michael Milkovich, Dean A. Porter, and others, University of Notre Dame, Notre Dame, Indiana, and State University of New York at Binghamton, 1970.

Aglio, 1794
Giuseppe Aglio, *Le pitture e le sculture della città di Cremona*, Cremona, 1794.

Ames, 1962
Winslow Ames, *Great Drawings of All Time. Volume I. Italian, Thirteenth through Nineteenth Century*, New York, 1962.

Andrews, 1968
Keith Andrews, *National Gallery of Scotland. Catalogue of Italian Drawings*, 2 vols., Cambridge, 1968.

Baccheschi, 1977
Edi Baccheschi, *L'opera completa del Beccafumi*, with an introduction by Giuliano Briganti, Milan, 1977.

Bacou, 1981
Roseline Bacou, *The Famous Italian Drawings from the Mariette Collection at the Louvre in Paris*, Milan, 1981.

Baglione, 1642
Giovanni Baglione, *Le vite de' pittori, scultori et architetti, dal pontificato di Gregorio XIII del 1572, in fino a' tempi di Papa Urbano Ottavo nel 1642*, Rome, 1642.

Bartsch
Adam Bartsch, *Le Peintre graveur*, 21 vols., Vienna, 1803-1821.

Bean, 1962
Jacob Bean, "The Drawings Collection," *Metropolitan Museum of Art Bulletin*, January 1962, pp. 157-175.

Bean, 1963
Jacob Bean, "Form and Function in Italian Drawings: Observations on Several New Acquisitions," *Metropolitan Museum of Art Bulletin*, March 1963, pp. 225-239.

Bean, 1964
Jacob Bean, *100 European Drawings in the Metropolitan Museum of Art*, New York, 1964.

Bean, 1972
Drawings Recently Acquired, 1969-1971, exhibition catalogue by Jacob Bean, The Metropolitan Museum of Art, New York, 1972.

Bean, 1975
European Drawings Recently Acquired, 1972-1975, exhibition catalogue by Jacob Bean, The Metropolitan Museum of Art, New York, 1975.

Bean and Stampfle, 1965
Drawings from New York Collections, I, The Italian Renaissance, exhibition catalogue by Jacob Bean and Felice Stampfle, The Metropolitan Museum of Art, New York, 1965.

Béguin, 1972
Sylvie Béguin in *L'Ecole de Fontainebleau*, exhibition catalogue, Grand Palais, Paris, 1972.

Bellosi, 1978
I disegni antichi degli Uffizi, i tempi del Ghiberti, exhibition catalogue, introduction by Luciano Bellosi, Gabinetto Disegni e Stampe degli Uffizi, Florence, 1978.

Beltrame Quattrocchi, 1979
Disegni toscani e umbri del primo rinascimento dalle collezione del Gabinetto Nazionale delle Stampe, exhibition catalogue by Enrichetta Beltrame Quattrocchi, Farnesina, Rome, 1979.

Berenson, 1903
Bernhard Berenson, *The Drawings of the Florentine Painters*, 2 vols., New York, 1903.

Berenson, 1938
Bernard Berenson, *The Drawings of the Florentine Painters*, amplified edition, 3 vols., Chicago, 1938.

Berenson, 1961
Bernard Berenson, *I disegni dei pittori fiorentini*, 3 vols., Milan, 1961.

Bertini, 1958
Aldo Bertini, *I disegni italiani della Biblioteca Reale di Torino*, Rome, 1958.

Blunt and Cooke, 1960
Anthony Blunt and Hereward Lester Cooke, *The Roman Drawings of the XVII and XVIII Centuries . . . at Windsor Castle*, London, 1960.

Bodmer, 1931
Heinrich Bodmer, *Leonardo. Des Meisters Gemälde und Zeichnungen*, Stuttgart, 1931.

Bora, 1976
Giulio Bora, *I disegni del Codice Resta*, Milan, 1976.

Burroughs, 1918
Bryson Burroughs, "Drawings by Leonardo da Vinci on Exhibition," *Metropolitan Museum of Art Bulletin,* October 1918, pp. 214-217.

Burroughs, 1919
Bryson Burroughs, "Drawings from the Pembroke Collection," *Metropolitan Museum of Art Bulletin,* June 1919, pp. 136-140.

Byam Shaw, 1976
James Byam Shaw, *Drawings by Old Masters at Christ Church, Oxford,* 2 vols., Oxford, 1976.

Byam Shaw, 1981
Disegni veneti della collezione Lugt, exhibition catalogue by James Byam Shaw, Fondazione Giorgio Cini, Venice, 1981.

Cohen, 1973
Charles E. Cohen, "Drawings by Pomponio Amalteo," *Master Drawings,* XI, 3, 1973, pp. 239-267.

Cohen, 1975
Charles E. Cohen, *I disegni di Pomponio Amalteo,* Pordenone, 1975.

Cohen, 1980
Charles E. Cohen, *The Drawings of Giovanni Antonio da Pordenone,* Florence, 1980.

Commissione Vinciana
I manoscritti e i disegni di Leonardo da Vinci pubblicati dalla Reale Commissione Vinciana, Adolfo Venturi, ed., 4 vols., Rome, 1928-1936.

Dacos, 1977
Nicole Dacos, *Le logge di Raffaello,* Rome, 1977.

Dacos, 1980
Nicole Dacos, "Tommaso Vincidor, un élève de Raphaël aux Pays-Bas," *Relations artistiques entre les Pays-Bas et l'Italie à la Renaissance: études dédiées à Suzanne Sulzberger. Etudes d'histoire de l'art, publiées par l'Institut Historique Belge de Rome,* IV, Brussels and Rome, 1980, pp. 61-99.

Davidson, 1966
Mostra di disegni di Perino del Vaga e la sua cerchia, exhibition catalogue by Bernice F. Davidson, Gabinetto Disegni e Stampe degli Uffizi, Florence, 1966.

Degenhart, 1941-1942
Bernhard Degenhart, review of *Paolo Uccello* by W. Boeck, *Zeitschrift für Kunstgeschichte,* X, 1941-1942, pp. 79-85.

Degenhart, 1959
Bernhard Degenhart, "Domenico Veneziano als Zeichner," *Festschrift Friedrich Winkler,* Berlin, 1959.

Degenhart and Schmitt, 1968
Bernhard Degenhart and Annegrit Schmitt, *Corpus der italienischen Zeichnungen 1300-1450,* part I, *Süd- und Mittelitalien,* 4 vols., Berlin, 1968.

Edinburgh, 1969
Italian 16th-Century Drawings from British Private Collections, exhibition catalogue, The Merchants' Hall, Edinburgh, 1969.

Emiliani, 1975
Mostra di Federico Barocci, exhibition catalogue by Andrea Emiliani and Giovanna Gaeta Bertelà, Museo Civico, Bologna, 1975.

Fischel
Oskar Fischel, *Raphaels Zeichnungen,* 8 portfolios with text, Berlin, 1913-1941.

Freedberg, 1950
Sydney J. Freedberg, *Parmigianino. His Works in Painting,* Cambridge, Massachusetts, 1950.

Frerichs, 1981
Italiaanse Tekeningen II, de 15de en 16de Eeuw, exhibition catalogue by L. C. J. Frerichs, Rijksmuseum, Amsterdam, 1981.

Fry, 1908
Roger Fry, "Recent Acquisitions of Drawings," *Metropolitan Museum of Art Bulletin,* December 1908, pp. 223-224.

Fry, 1909
Roger Fry, "Recent Acquisitions of Drawings," *Metropolitan Museum of Art Bulletin,* January 1909, pp. 7-9.

Gere, 1966
Mostra di disegni degli Zuccari, exhibition catalogue by John Gere, Gabinetto Disegni e Stampe degli Uffizi, Florence, 1966.

Gere, 1969
J. A. Gere, *Taddeo Zuccaro. His Development Studied in his Drawings,* Chicago, 1969.

Gere, Paris, 1969
Dessins de Taddeo et Federico Zuccaro, exhibition catalogue by John Gere, Cabinet des Dessins, Musée du Louvre, Paris, 1969.

Gere, 1971
John Gere, *I disegni dei maestri. Il manierismo a Roma,* Milan, 1971.

Hamilton, 1980
Disegni di Bernardino Poccetti, exhibition catalogue by Paul C. Hamilton, Gabinetto Disegni e Stampe degli Uffizi, Florence, 1980.

Harprath, 1977
Italienische Zeichnungen des 16. Jahrhunderts aus eigenem Besitz, exhibition catalogue by Richard Harprath, Staatliche Graphische Sammlung, Munich, 1977.

Hartt, 1958
Frederick Hartt, *Giulio Romano,* 2 vols., New Haven, Connecticut, 1958.

Haverkamp-Begemann, 1964
Egbert Haverkamp-Begemann, Standish D. Lawder, and Charles W. Talbot, Jr., *Drawings from the Clark Art Institute,* 2 vols., New Haven, Connecticut, and London, 1964.

Heaton-Sessions, 1954
Charlotte Heaton-Sessions, "Drawings Attributed to Correggio at the Metropolitan Museum of Art," *Art Bulletin,* XXXVI, 1954, no. 3, pp. 224-228.

Hellman, 1916
George S. Hellman, "Drawings by Italian Artists in the Metropolitan Museum of Art," *Print Collector's Quarterly,* VI, 1916, pp. 157-184.

Heseltine Collection, 1913
Original Drawings by Old Masters of the Italian School Forming Part of the Collection of J. P. H[eseltine], London, 1913.

Heydenreich, 1954
Ludwig H. Heydenreich, *Leonardo da Vinci,* 2 vols., New York, 1954.

Kirwin, 1972
William Chandler Kirwin, "Cristofano Roncalli (1551/2-1626), an Exponent of the Proto-Baroque: His Activity through 1605," doctoral dissertation, Stanford University, Stanford, California, 1972 [University Microfilms, Ann Arbor, Michigan].

Kliemann, 1981
Julian Kliemann in *Giorgio Vasari. Principi, letterati e artisti nelle carte di Giorgio Vasari,* exhibition catalogue, Casa Vasari, Arezzo, 1981.

Lawrence Gallery. Fourth Exhibition
The Lawrence Gallery. Fourth Exhibition. A Catalogue of One Hundred Original Drawings by Il Parmigianino and Ant. da Correggio, Collected by Sir Thomas Lawrence, London, 1836.

Lawrence Gallery. Fifth Exhibition
The Lawrence Gallery. Fifth Exhibition. A Catalogue of One Hundred Original Drawings by J. Romano, F. Primaticcio, L. da Vinci, and Pierino del Vaga, Collected by Sir Thomas Lawrence, London, 1836.

Lugt
Frits Lugt, *Les Marques de collections de dessins et d'estampes . . . ,* Amsterdam, 1921.

Lugt Supp.
Frits Lugt, *Les Marques de collections de dessins et d'estampes . . . Supplément,* The Hague, 1956.

Macandrew, 1980
Hugh Macandrew, *Ashmolean Museum. Oxford. Catalogue of the Collection of Drawings. Volume III. Italian Schools: Supplement,* Oxford, 1980.

Malvasia, 1686
Carlo Cesare Malvasia, *Le pitture di Bologna, 1686,* edited by Andrea Emiliani, Bologna, 1969.

Meijer, Florence, 1976
Omaggio a Tiziano, exhibition catalogue by Bert W. Meijer, Istituto Universitario Olandese, Florence, 1976.

Meijer, Paris, 1976
Hommage à Titien, exhibition catalogue by Bert W. Meijer, Institut Néerlandais, Paris, 1976.

Metropolitan Museum, European Drawings, 1944
European Drawings from the Collections of The Metropolitan Museum of Art, Italian, Flemish, Dutch, German, Spanish, French, and British Drawings, new series, New York, 1944. (A portfolio of forty-eight collotype reproductions.)

Metropolitan Museum Hand-book, 1895
The Metropolitan Museum of Art, Hand-book No. 8. Drawings, Water-Color Paintings, Photographs and Etchings, Tapestries etc., New York, 1895. (An unillustrated, summary checklist of the 882 European drawings then in the Museum's collection; they were all apparently at that time on exhibition. The introductory note warns that "the attributions of authorship are by former owners.")

Metropolitan Museum, Italian Drawings, 1942
European Drawings from the Collections of The Metropolitan Museum of Art, I, *Italian Drawings,* New York, 1942. (A portfolio of sixty collotype reproductions.)

Metz, 1798
C. M. Metz, *Imitations of Ancient and Modern Drawings, from the Restoration of the Arts in Italy, to the Present Time,* London, 1798.

Monbeig-Goguel, 1972
Catherine Monbeig-Goguel, *Musée du Louvre, Cabinet des Dessins. Inventaire général des dessins italiens. I. Maîtres toscans nés après 1500, morts avant 1600. Vasari et son temps,* Paris, 1972.

Müntz, 1897
Eugène Müntz, *Les Tapisseries de Raphael au Vatican . . . ,* Paris, 1897.

Neilson, 1979
Nancy Ward Neilson, *Camillo Procaccini. Paintings and Drawings,* New York and London, 1979.

Notable Acquisitions, 1975
The Metropolitan Museum of Art, Notable Acquisitions, 1965-1975, New York, 1975.

Notable Acquisitions, 1979
The Metropolitan Museum of Art, Notable Acquisitions, 1975-1979, New York, 1979.

Notable Acquisitions, 1980
The Metropolitan Museum of Art, Notable Acquisitions, 1979-1980, New York, 1980.

Ottawa, 1982
Bolognese Drawings in North American Collections, 1500-1800, exhibition catalogue by Mimi Cazort and Catherine Johnston, The National Gallery of Canada, Ottawa, 1982.

Parker II
K. T. Parker, *Catalogue of the Collection of Drawings in the Ashmolean Museum. Volume II. Italian Schools,* Oxford, 1956.

Pedretti, 1973
Leonardo da Vinci . . . Exhibitions in Honour of Elmer Belt, M.D. on the Occasion of His Eightieth Birthday, catalogue by Carlo Pedretti, University of California, Los Angeles, 1973.

Pignatti, 1979
Terisio Pignatti, *Tiziano, disegni,* Florence, 1979.

Pillsbury, 1976
Edmund P. Pillsbury, "Barocci at Bologna and Florence," *Master Drawings,* XIV, 1, 1976, pp. 56-64.

Pillsbury, 1978
 The Graphic Art of Federico Barocci, exhibition catalogue by Edmund P. Pillsbury and Louise S. Richards, The Cleveland Museum of Art and Yale University Art Gallery, New Haven, Connecticut, 1978.

Popham, 1931
 Italian Drawings Exhibited at the Royal Academy, Burlington House, 1930, commemorative catalogue by A. E. Popham, London, 1931.

Popham, 1949
 A. E. Popham, *The Drawings of Leonardo da Vinci,* 2nd ed., London, 1949.

Popham, 1953
 A. E. Popham, *The Drawings of Parmigianino,* London, 1953.

Popham, 1957
 A. E. Popham, *Correggio's Drawings,* London, 1957.

Popham, 1967
 A. E. Popham, *Italian Drawings in the Department of Prints and Drawings in the British Museum. Artists Working in Parma in the Sixteenth Century,* 2 vols., London, 1967.

Popham, 1971
 A. E. Popham, *Catalogue of the Drawings of Parmigianino,* 3 vols., New Haven, Connecticut, and London, 1971.

Popham and Pouncey, 1950
 A. E. Popham and Philip Pouncey, *Italian Drawings in the Department of Prints and Drawings in the British Museum. The Fourteenth and Fifteenth Centuries,* 2 vols., London, 1950.

Popham and Wilde, 1949
 A. E. Popham and Johannes Wilde, *The Italian Drawings of the XV and XVI Centuries . . . at Windsor Castle,* London, 1949.

Popp, 1928
 Anny E. Popp, *Leonardo da Vinci. Zeichnungen,* Munich, 1928.

Pouncey and Gere, 1962
 Philip Pouncey and J. A. Gere, *Italian Drawings in the Department of Prints and Drawings in the British Museum. Raphael and His Circle,* 2 vols., London, 1962.

Ragghianti Collobi, 1974
 Licia Ragghianti Collobi, *Il Libro de' Disegni del Vasari,* 2 vols., Florence, 1974.

Rearick, 1980
 W. R. Rearick, *Maestri veneti del Cinquecento,* Florence, 1980.

Reveley, 1820
 Henry Reveley, *Notices Illustrative of the Drawings and Sketches by Some of the Most Distinguished Masters in All the Principal Schools of Design,* London, 1820.

Ricci, 1930
 Corrado Ricci, *Correggio,* London and New York, 1930.

Riedl, 1976
 Disegni dei Barocceschi senesi, exhibition catalogue by Peter Anselm Riedl, Gabinetto Disegni e Stampe degli Uffizi, Florence, 1976.

Robert-Dumesnil
 A. P. F. Robert-Dumesnil, *Le Peintre-graveur français,* 11 vols., Paris, 1835-1871.

Rossi, 1980
 Paola Rossi, *L'opera completa del Parmigianino,* Milan, 1980.

Rudolf Collection, 1962
 Old Master Drawings from the Collection of Mr. C. R. Rudolf, exhibition catalogue, The Arts Council, London, Birmingham, Leeds, 1962.

Sanminiatelli, 1967
 Donato Sanminiatelli, *Domenico Beccafumi,* Milan, 1967.

Seidlitz, 1935
 Woldemar von Seidlitz, *Leonardo da Vinci, der Wendepunkt der Renaissance,* Vienna, 1935.

Sirén, 1928
 Osvald Sirén, *Léonard de Vinci, l'artiste et l'homme,* 3 vols., Paris and Brussels, 1928.

Stampfle and Bean, 1967
 Drawings from New York Collections, II, The 17th Century in Italy, exhibition catalogue by Felice Stampfle and Jacob Bean, The Pierpont Morgan Library, New York, 1967.

Strong, 1900
 S. Arthur Strong, *Reproductions in Facsimile of Drawings by the Old Masters in the Collection of the Earl of Pembroke and Montgomery at Wilton House,* London, 1900.

Sturge Moore, 1906
 T. Sturge Moore, *Correggio,* London, 1906.

Szabo, 1978
 XV Century Italian Drawings from the Robert Lehman Collection, exhibition catalogue by George Szabo, The Metropolitan Museum of Art, New York, 1978.

Szabo, 1979
 XVI Century Italian Drawings from the Robert Lehman Collection, exhibition catalogue by George Szabo, The Metropolitan Museum of Art, New York, 1979.

Thiem, 1977
 Christel Thiem, *Florentiner Zeichner des Frühbarock,* Munich, 1977.

Thiem, Stuttgart, 1977
 Italienische Zeichnungen, 1500-1800, exhibition catalogue by Christel Thiem, Staatsgalerie, Stuttgart, 1977.

Tietze, 1944
 Hans Tietze and E. Tietze Conrat, *The Drawings of the Venetian Painters in the 15th and 16th Centuries,* New York, 1944.

Vasari
 Le vite de' più eccellenti pittori scultori ed architettori scritte da Giorgio Vasari pittore Aretino con nuove annotazioni e commenti di Gaetano Milanesi, 9 vols., Florence, 1906.

Vasari Society
 The Vasari Society for the Reproduction of Drawings by Old Masters, first series, 10 parts, London, 1905-1915, second series, 16 parts, Oxford, 1920-1935.

Venturi
 Adolfo Venturi, *Storia dell'arte italiana,* 11 vols., from VI onward subdivided into parts, Milan, 1901-1939.

Virch, 1962
 Claus Virch, *Master Drawings in the Collection of Walter C. Baker,* New York, 1962.

Vitzthum, Florence, 1967
 Cento disegni napoletani, Sec. XVI-XVIII, exhibition catalogue by Walter Vitzthum, Gabinetto Disegni e Stampe degli Uffizi, Florence, 1967.

Vivant Denon, *Monuments*
 Monuments des arts du dessin chez les peuples tant anciens que modernes, recueillis par le baron Vivant Denon . . . , décrits et expliqués par Amaury Duval, 4 vols., Paris, 1829.

Voss, 1920
 Hermann Voss, *Die Malerei des Spätrenaissance in Rom und Florenz,* 2 vols., Berlin, 1920.

Weigel, 1865
 Rudolph Weigel, *Die Werke der Maler in ihren Handzeichnungen. Beschreibendes Verzeichniss der in kupfer gestochenen, lithographirten und photographirten Facsimiles von Originalzeichnungen grosser Meister,* Leipzig, 1865.

Wickhoff, *Albertina*
 Franz Wickhoff, "Die italienischen Handzeichnungen der Albertina, II. Theil. Die römische Schule," *Jahrbuch der kunsthistorischen Sammlungen des allerhöchsten Kaiserhauses,* XIII, 1892, pp. CLXXV-CCLXXXIII.

Wohl, 1980
 Hellmut Wohl, *The Paintings of Domenico Veneziano,* New York and London, 1980.

Notices and Illustrations

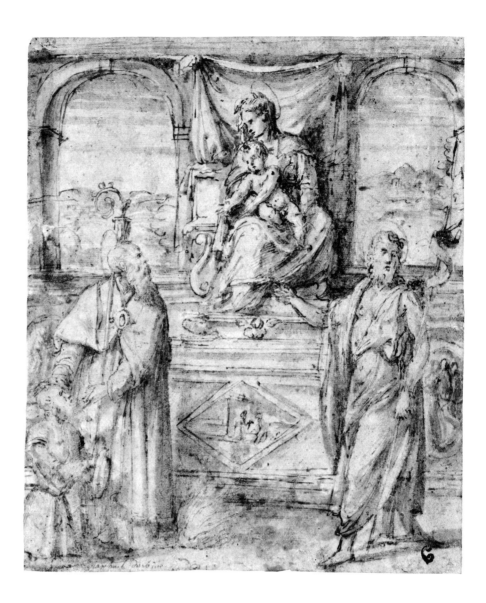

NICCOLÒ DELL'ABATE

Modena ca. 1509 – Paris 1571 ?

1. *Virgin and Child Enthroned, Attended by a Holy Prelate with Fire at His Feet, a Kneeling Donor, and St. John the Baptist*

Pen and brown ink, brown wash. 23.0 x 19.3 cm. Surface abraded at lower left; scattered losses. Lined.

Inscribed in pen and brown ink at lower left, *Raphael d'urbino;* numbered in pencil at upper left, *32.*

PROVENANCE: Mark mistakenly associated with Pierre Crozat (Lugt 474); sale, Lucerne, Galerie Fischer, June 19-20, 1967, no. 774, pl. 1, as Bagnacavallo; Harry G. Sperling, New York.

Bequest of Harry G. Sperling, 1971
1975.131.45

The drawing entered the collection in 1975 with an attribution to Bagnacavallo. In the following year, Sylvie Béguin made the convincing suggestion that it is an early work by Niccolò dell'Abate.

17

CHERUBINO ALBERTI

Borgo San Sepolcro 1553 – Rome 1615

or

GIOVANNI ALBERTI

Borgo San Sepolcro 1558 – Rome 1601

2. *Allegorical Figure of Religion* VERSO. *Study of a Griffin and a Seated Male Nude*

Red chalk and a little black chalk. 19.9 x 13.2 cm. Upper right corner replaced.

PROVENANCE: Sale, London, Sotheby's, December 7, 1976, part of no. 31, as Cherubino Alberti; purchased in New York in 1980.

BIBLIOGRAPHY: Macandrew, 1980, p. 251, under no. 70; K. Herrmann Fiore, *Bollettino d'arte,* LXV, 5, 1980, pp. 42, 44, fig. 6, as Giovanni Alberti.

Harry G. Sperling Fund, 1980
1980.17.2

Study for the figure of Religion that appears in the cove of the vault at one of the narrow ends of the Sala Clementina in the Vatican Palace, Rome. In the fresco Religion holds aloft in her right hand the keys of ecclesiastical power and holds in her left hand Aaron's rod (repr. K. Herrmann Fiore, *op. cit.,* p. 45, fig. 8). In the Ashmolean Museum, Oxford, there is a much larger design for this allegorical figure with her attendant putti (Parker II, no. 70, pl. XXIV, as Giovanni Alberti). Other drawings that may be related to this figure are in the Uffizi and the Farnesina (K. Herrmann Fiore, *op. cit.,* p. 44, fig. 7, p. 45, fig. 9).

The frescoes of the vault of the Sala Clementina were

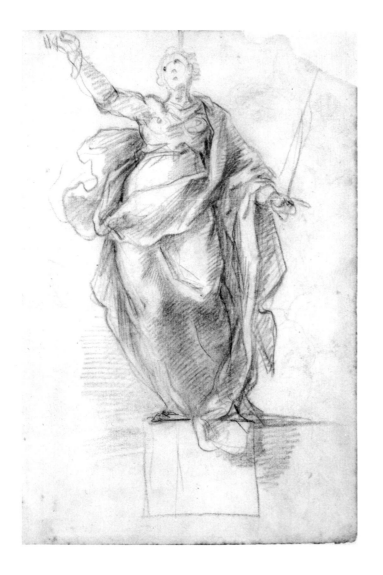

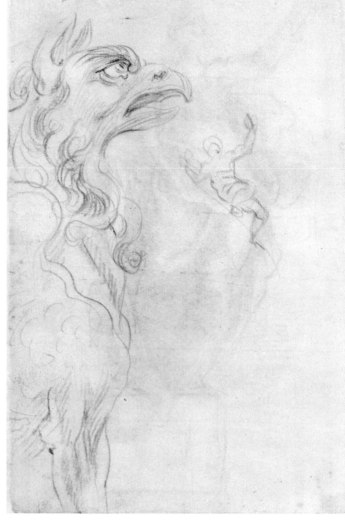

commissioned by Pope Clement VIII from Giovanni and Cherubino Alberti in 1596 and were no doubt finished by the last months of 1599 or in early 1600 (see M. C. Abromson, *Art Bulletin,* LX, 3, 1978, pp. 535-536). Attempts have been made to distinguish between the hands of the two brothers in the preparatory drawings that can be associated with the project, but so far the results have been inconclusive.

CHERUBINO ALBERTI or GIOVANNI ALBERTI

3. *Two Studies of a Seated Male Nude Seen from the Back*

Red chalk, a few contours reinforced in pen and brown ink. 19.9 x 13.4 cm. Upper right corner replaced.

PROVENANCE: Sale, London, Sotheby's, December 7, 1976, part of no. 31, as Cherubino Alberti; purchased in New York in 1980.

Harry G. Sperling Fund, 1980
1980.17.1

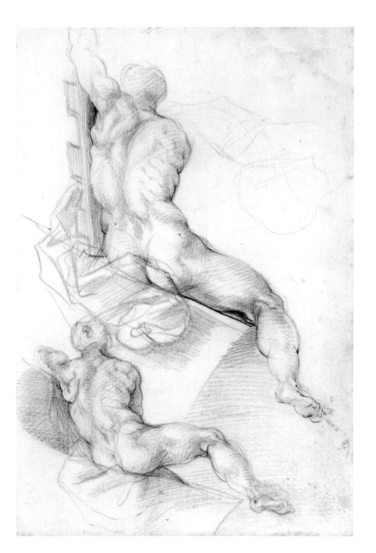

The nude figure above holds the sawlike "bretessed bend" that figures, with six stars, in the arms of Clement VIII Aldobrandini. Many such nude figures holding these emblems appear, in large or small scale, in the frescoed vault of the Sala Clementina in the Vatican. The dismembered sketchbook from which this drawing came contained at least five other chalk studies of *ignudi* associable with the Sala Clementina vault fresco. In addition, there are studies for these nude figures in the Ambrosiana in Milan (repr. Bora, 1976, no. 149, as Giovanni Alberti), and in the Philadelphia Museum of Art (1977-271-1; repr. *Bollettino d'arte,* LXV, 5, 1980, p. 51, fig. 22, as Giovanni Alberti).

ALESSANDRO ALLORI
Florence 1535 – Florence 1607

4. *The Judgment of Paris*

Pen and brown ink, brown wash, heightened with white, over black chalk, on blue paper. 36.6 x 47.4 cm. Vertical crease at center; horizontal crease just below center; scattered losses. Lined.

PROVENANCE: Purchased in London in 1963.

BIBLIOGRAPHY: *Drawings of Five Centuries. Peter Claas,* exhibition catalogue, London, 1963, no. 1, pl. 1; Bean and Stampfle, 1965, no. 137, repr.; D. Heikamp, *L'Oeil,* 164-165, 1968, p. 28; D. Heikamp, *Münchner Jahrbuch der bildenden Kunst,* XX, 1969, pp. 59-60, fig. 42.

Rogers Fund, 1963
63.96

Paris is seated at right with a giant golden apple in his hand, while Mercury at center presents Minerva, Juno, and Venus, who are about to disrobe in preparation for the judging. Above at the left are parked the attributes of the three goddesses: a pair of owls, a pair of peacocks, and a swan-drawn chariot.

Detlef Heikamp has pointed out that this is the model for one of four tapestry cartoons representing the story of Paris and the golden apple of Discord that were delivered to the Florentine weaver Benedetto Squilli on March 30, 1583. The tapestries, probably intended for the Medici villa at Poggio a Caiano, were finished by June 4th of the same year. The tapestry for which our drawing is a study has not survived, nor has that representing the *Feast of the Gods* for which there is a preparatory design by Allori in the Gabinetto Nazionale delle Stampe in Rome. Only two of the tapestries have been preserved: *Paris Presenting*

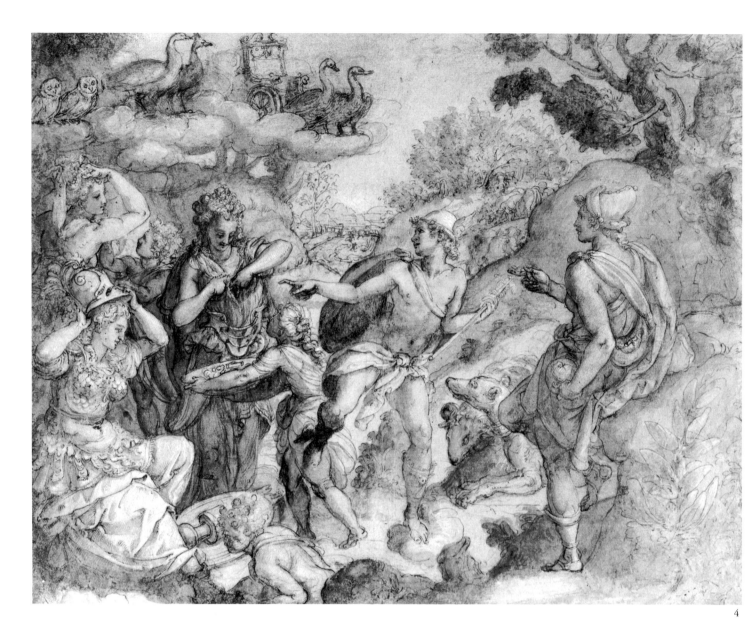

4

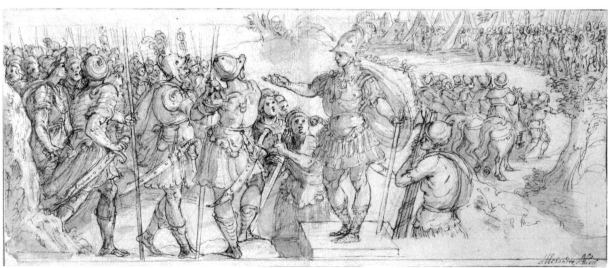

5

the *Apple to Venus* (on the art market), for which no preparatory drawing is known, and the *Triumph of Venus* (Galleria Nazionale, Parma) for which there is a study in Rome. For the two *modelli* in Rome see S. Prosperi Valenti Rodinò, *Disegni fiorentini 1560-1640,* exhibition catalogue, Gabinetto Nazionale delle Stampe, Rome, 1977, nos. 5-6, repr.

5. *Design for a Narrative Frieze: A Commander Addressing His Troops*

Pen and brown ink, gray-brown wash, heightened with a little white, over black chalk, on brownish paper. Framing lines in black chalk. 16.1 x 39.3 cm. Vertical crease at center; lower left corner replaced.

Inscribed in pen and brown ink at lower right, *Allesandro Allori*; on verso, *Alessandro Allori.*

PROVENANCE: Prof. John Isaacs; Isaacs sale, London, Sotheby's, February 27, 1964, part of no. 14; purchased in London in 1964.

BIBLIOGRAPHY: *Exhibition of Old Master Drawings. P. and D. Colnaghi and Co.,* London, 1964, no. 49; Byam Shaw, 1976, I, p. 81, under no. 190.

Rogers Fund, 1964
64.197.2

The commander is identified as Roman by the fasces held by a soldier in the right foreground.

A drawing in the Witt Collection, Courtauld Institute of Art, London, representing soldiers carrying the body of a wounded comrade across a river ford is close in style and format to our drawing and could be a study for the same or a similar narrative cycle (no. 1132; Courtauld photographs 125/51/43 and 44).

POMPONIO AMALTEO

Motta di Livenza 1505 – San Vito al Tagliamento 1588

6. *Susanna and the Elders before Daniel*
(Daniel 13:44-63)

Pen and brown ink, brown wash, heightened with white, over a little black chalk, on gray-green paper. The head of the woman with outstretched arm, to the right of Susanna, is a *pentimento* that has been pasted onto the sheet. Squared in black chalk. 38.9 x 55.5 cm. A

number of repaired losses; brown stain at lower left; a smaller red stain at lower right.

Numbered in pen and blue-green ink at lower left, *134.*

PROVENANCE: Paul Sandby (Lugt 2112); Sir Edward J. Poynter, Bt.; Poynter sale, London, Sotheby's, April 24-25, 1918, no. 133, as Pordenone; Earl of Harewood; sale, London, Christie's, July 6, 1965, no. 133, repr., as Pordenone; purchased in London in 1966.

BIBLIOGRAPHY: *Exhibition of Old Master Drawings. P. and D. Colnaghi and Co.,* London, 1966, no. 8, repr., as Pordenone; C. E. Cohen, *Pantheon,* XXXI, 3, 1973, pp. 248-251, fig. 14; Cohen, 1973, p. 249, pl. 5; Cohen, 1975, pp. 38-43, fig. 25; Cohen, 1980, p. 39, fig. 152; *Amalteo,* exhibition catalogue, Museo Civico, Pordenone, 1980, pp. 81, 83, fig. 13.

Rogers Fund, 1966
66.93.2

Frescoes representing scenes of judgment in the Municipal Loggia at Céneda (now merged with Serravalle to form Vittorio Veneto) have been alternatively attributed to Pordenone and to his pupil and son-in-law Pomponio Amalteo. Payments to Amalteo are said to have been made in 1534-1536, and it is probably he who executed the frescoes. However, Charles Cohen suggests that Pordenone may have assisted Amalteo at least to the extent of supplying him with preparatory drawings for the commission, which was an important one from Cardinal Grimani, patriarch of Aquileia and former prince-bishop of Céneda. The largest of the three now much-damaged frescoes represents the *Justice of Trajan,* on the main rear wall, while the *Judgment of Daniel* and the *Judgment of Solomon* occupy the shorter side walls. Cohen convincingly gives to Pordenone two studies for the *Justice of Trajan:* a small pen sketch in the Ambrosiana and a more elaborate composition study on colored paper in the Louvre (Cohen, 1980, figs. 110 and 111). A composition study for the *Judgment of Solomon* in the Louvre is also given by Cohen to Pordenone (Cohen, 1980, fig. 113). The vivacity of the abbreviated pen work of these studies by Pordenone clearly separates them from the somewhat dry and painstaking draughtsmanship of the present large and certainly impressive drawing. Though this sheet has been attributed to Pordenone in the past, Cohen's proposal that this is a work by Amalteo at "a particularly felicitous moment" seems a very reasonable suggestion. Another design for the *Judgment of Daniel,* differing in many ways from the composition as recorded in our drawing, is in the Louvre, and an old copy now in a Dutch private collection records another compositional proposal (Cohen, 1975, figs. 24 and 23, respectively). Cohen suggests that the Metropolitan's drawing is

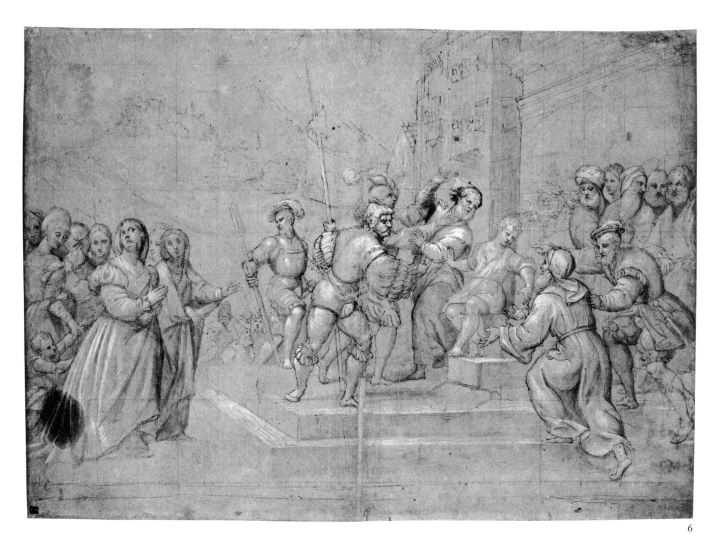

POMPONIO AMALTEO (NO. 6)

closest to the now almost entirely destroyed fresco be-
cause Ridolfi describes Susanna in the fresco as *"le mani
aggroppate mira il Cielo"*; indeed in our drawing Susanna
at the left gazes upward, her hands joined in prayer,
while in the two other composition studies Susanna
looks down and has her right hand at her hip. Every
feature of this drawing – the fine pen line and transpar-
ent wash, the use of extensive white highlighting on
colored paper, the complex dramatic grouping of the
many figures – manifests Amalteo's very close depen-
dence on Pordenone.

7. Design for a Pendentive: Youthful Musicians with Stringed Instruments

Pen and brown ink, brown wash, heightened with white, over red
chalk, on blue paper. 5.8 x 7.1 cm. Lined.

Numbered in pen and brown ink at upper right corner of old mount,
10.

PROVENANCE: Sir Peter Lely (Lugt 2092); William Gibson (see
Lugt Supp. 2885); Jonathan Richardson, Sr. (Lugt 2184); Worsley
collection; purchased in London in 1977.

BIBLIOGRAPHY: Edinburgh, 1969, no. 68 (10), as Pordenone; T.
Mullaly, *Burlington Magazine*, CXI, 1969, p. 631, as Pordenone;
Cohen, 1973, pp. 256-257, fig. 12; Cohen, 1975, pp. 64-69, fig.
42.

Harry G. Sperling Fund, 1977
1977.249a

This and the following two drawings (Nos. 8-9) come
from a small album (8.6 x 13.0 cm.) that opens on a page
inscribed in a seventeenth-century hand: *Disegni di Man
del / Purdenone / rarissimi.* William Gibson (1664-1702)
has added the note *.K. / 17 drawing* [sic] *of / Purdenone. /
5.4..* This traditional attribution is understandable,
since these charming drawings come so close in style and
technique to Pordenone. However, Charles Cohen has
established that they are preparatory drawings by Amal-
teo for pendentives in the choir of the church of S. Maria
delle Grazie at Prodolone, near San Vito al Tagliamento

(repr. Cohen, 1975, figs. 43, 45, 49). Amalteo signed the contract for this commission on December 13, 1538, and it is unlikely that Pordenone, who was to die just over a month later in distant Ferrara, could or would have supplied the designs for this unimportant rustic commission.

The album contained two further designs for the angel musicians at Prodolone. In fact all the drawings formerly in the little album seem to be by Amalteo, and none by Pordenone.

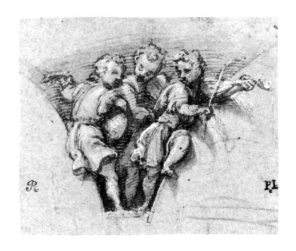

8. *Design for a Pendentive: Youthful Musicians with Wind Instruments and a Drum*

Pen and brown ink, brown wash, heightened with white, over red chalk, on blue paper. 6.0 x 6.0 cm. Lined.

Numbered in pen and brown ink at upper right corner of old mount, *11*.

PROVENANCE: Sir Peter Lely (Lugt 2092); William Gibson (see Lugt Supp. 2885); Jonathan Richardson, Sr. (Lugt 2184); Worsley collection; purchased in London in 1977.

BIBLIOGRAPHY: Edinburgh, 1969, no. 68 (11), as Pordenone; T. Mullaly, *Burlington Magazine,* CXI, 1969, p. 631, as Pordenone; Cohen, 1973, pp. 256-257, fig. 13; Cohen, 1975, pp. 64-69, fig. 47.

Harry G. Sperling Fund, 1977
1977.249b

See No. 7 above.

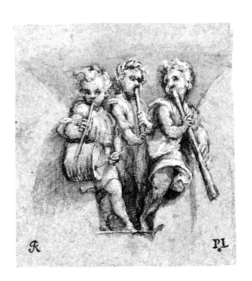

9. *Design for a Pendentive: Youthful Musicians with Wind Instruments*

Pen and brown ink, brown wash, heightened with white, over red chalk, on blue paper. 6.3 x 6.3 cm. Lined.

Numbered in pen and brown ink at upper right corner of old mount, *12*.

PROVENANCE: Sir Peter Lely (Lugt 2092); William Gibson (see Lugt Supp. 2885); Jonathan Richardson, Sr. (Lugt 2184); Worsley collection; purchased in London in 1977.

BIBLIOGRAPHY: Edinburgh, 1969, no. 68 (12), pl. 9, as Pordenone; T. Mullaly, *Burlington Magazine,* CXI, 1969, p. 631, as Pordenone; Cohen, 1973, pp. 256-257, fig. 14; Cohen, 1975, pp. 64-69, fig. 46.

Harry G. Sperling Fund, 1977
1977.249c

See No. 7 above.

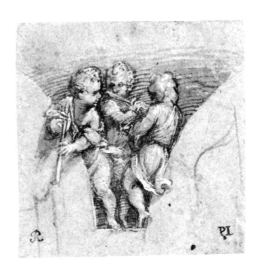

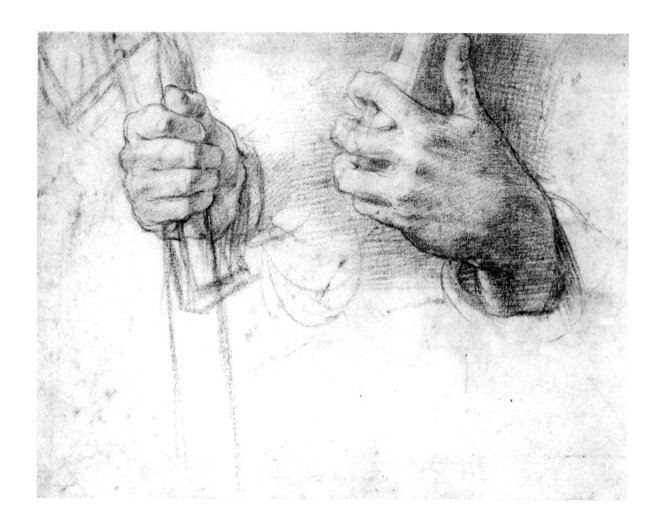

ANDREA DEL SARTO (Andrea d'Agnolo)

Florence 1486 – Florence 1530

10. *Studies of Hands*

Red chalk. 12.2 x 16.3 cm. Lined.

PROVENANCE: W. Holman Hunt (according to Shearman); Walter C. Baker, New York.

BIBLIOGRAPHY: J. Shearman, *Andrea del Sarto,* Oxford, 1965, I, pl. 174a, II, pp. 363-364.

Bequest of Walter C. Baker, 1971
1972.118.271

John Shearman first published this beautiful drawing, suggesting that the soft handling of the light would seem to indicate that the drawing was a late work. He cautioned, however, that "the attribution must be treated with reserve until the drawing's purpose can be determined."

MICHELANGELO ANSELMI

Lucca or Siena ca. 1492 – Parma 1554/1556

11. *The Young David Playing the Harp*

Black chalk, gray wash, on blue paper. Squared in pen and brown ink. 38.6 x 14.1 cm. Lined.

PROVENANCE: Purchased in London in 1961.

BIBLIOGRAPHY: Bean, 1962, p. 160, fig. 3; Bean and Stampfle, 1965, no. 74, repr.; M. Di Giampaolo, *Antichità viva,* XVI, 4, 1977, p. 46, fig. 9.

Rogers Fund, 1961
61.123.2

Study for the figure of David painted in monochrome by Anselmi on the entrance arch of the western apse of S. Maria della Steccata in Parma (repr. A. Ghidiglia Quintavalle, *Michelangelo Anselmi,* Parma, 1960, fig. 155). The placement of the figure, seated in a niche rounded at top and bottom, is directly inspired by and in imitation of motifs in Parmigianino's unfinished decoration in the vault of the eastern apse of the Steccata (see No. 153 below). Anselmi was one of the artists commissioned to continue the decoration of the church after Parmigianino's disgrace and death. Though his formal dependence on Parmigianino's example is evident in this study, his style as a draughtsman is here strikingly different – in its soft pictorial chiaroscuro – from that of Parmigianino.

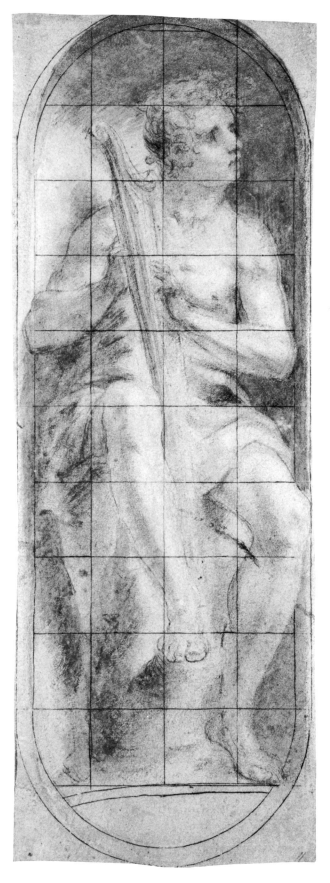

AMICO ASPERTINI

Bologna 1475 – Bologna 1552

12. *Nude Male Figure Seated on the Ground*

Black chalk, brown wash, heightened with white, on brown-washed paper. 24.7 x 36.3 cm. All four corners cut away; vertical crease at left of center; repaired triangular loss at upper margin.

Inscribed in pen and brown ink at lower margin of old mount in Richardson's hand, *Amico Aspertini.*

PROVENANCE: Jonathan Richardson, Sr. (Lugt 2184 and 2995); Earl of Gainsborough (according to Sotheby's); sale, London, Sotheby's, July 22, 1953, no. 2; Philip Pouncey, London; purchased in New York in 1967.

BIBLIOGRAPHY: *Exhibition of Old Master Drawings at the H. Shickman Gallery,* New York, 1968, no. 6, repr.; *Metropolitan Museum of Art Bulletin,* October 1969, p. 66, repr.

Purchase, Walter C. Baker Gift, 1967
68.78

The figure, posed on a shelflike projection ornamented with a scalloped valance, may be studied for one of the many monochrome façade decorations that Aspertini is said to have executed, above all in Bologna (Vasari, V, pp. 179-180). The reeds or long grasses indicated in the background are possibly intended to identify the figure as a river god. The stocky, thick-necked physical type is typical of Aspertini, but here the figure is invested with a certain monumental nobility. A similar nude figure in a drawing in the Uffizi (1269 F) is seated on a low projection and faces to the right. The flourish of drapery over his shoulders and the indication of foliage in the background suggest that both drawings may be studies for the same or similar façade decorations.

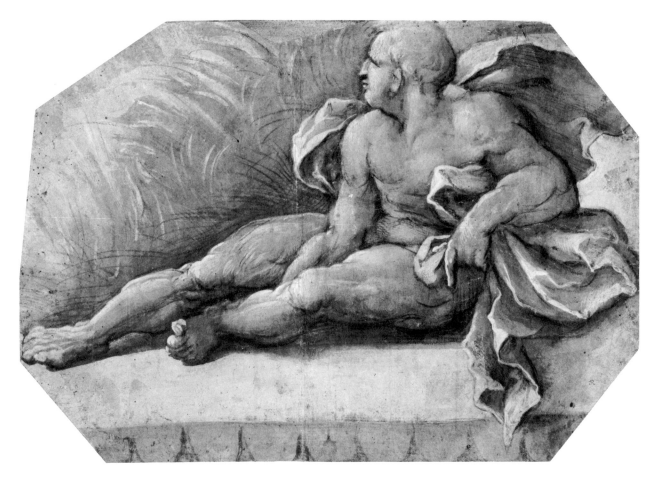

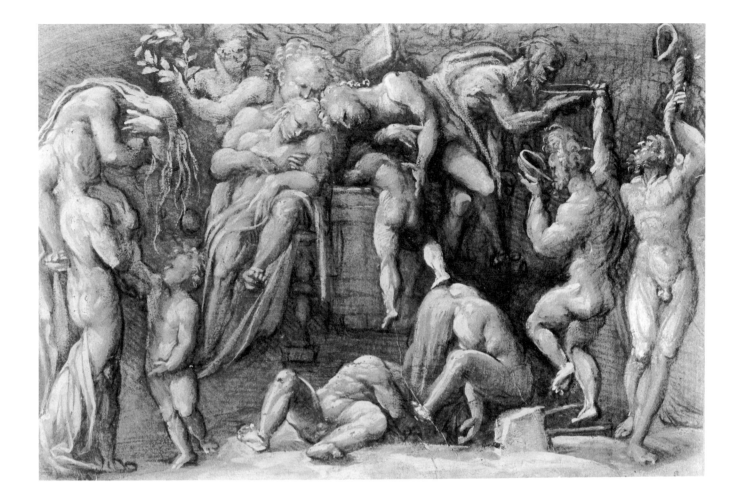

13. *Bacchanalian Scene*

Black chalk, heightened with white, on brown-washed paper. 27.6 x 42.5 cm. Three diagonal creases at lower margin. Lined.

PROVENANCE: Jonathan Richardson, Sr. (Lugt 2184); purchased in London in 1908.

BIBLIOGRAPHY: Fry, 1908, p. 224, as Leonbruno; Hellman, 1916, p. 167, repr. p. 169, as Leonbruno; Bean, 1964, no. 9, repr.; Bean and Stampfle, 1965, no. 35, repr.; *Apollo*, LXXXII, September 1965, p. 247, repr.; D. Scaglietti, *Paragone*, 233, 1969, p. 47, note 40, pl. 35; *Dizionario enciclopedico Bolaffi dei pittori e degli incisori italiani dall' XI al XX secolo*, I, Turin, 1972, p. 248, fig. 240.

Rogers Fund, 1908
08.227.27

The composition derives from Mantegna's engraving *Bacchanal with a Wine Press* (Bartsch, XIII, p. 240, no. 19). Aspertini, *uomo capriccioso e di bizzarro cervello*, according to Vasari, has transformed Mantegna's stately, measured composition into a curiously animated and rather sinister scene of alcoholic debauch.

The drawing entered the collection in 1908 with an attribution to Lorenzo Leonbruno, a minor figure known

for his imitations of Mantegna. Philip Pouncey, in 1958, was the first to point out that the drawing is a characteristic work of Aspertini.

14. *Studies after the Antique: The Fall of Phaëthon, Horses, Reclining Women with Children*
VERSO. *Studies after the Antique: An Altar or Urn, Lion Attacking a Horse*

Black chalk, pen and brown ink (recto); pen and brown ink over a little black chalk (verso). 37.2 x 26.0 cm. Margins irregular; lower right corner replaced.

Inscribed in pen and brown ink at lower left, *Trecitellio;* and numbered, *n⁰ 10.*

PROVENANCE: Unidentified and illegible circular collector's mark at lower right; Sir Edward J. Poynter, Bt. (Lugt 874); Poynter sale, London, Sotheby's, April 24-25, 1918, no. 2, purchased by the Metropolitan Museum.

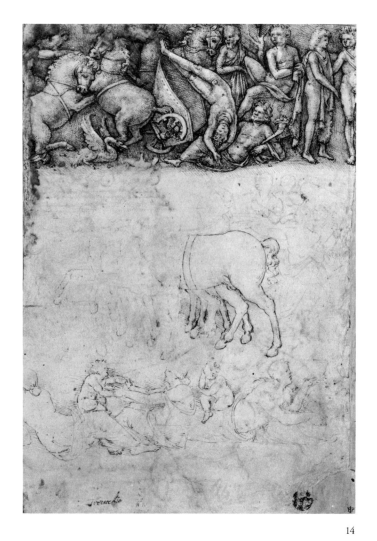

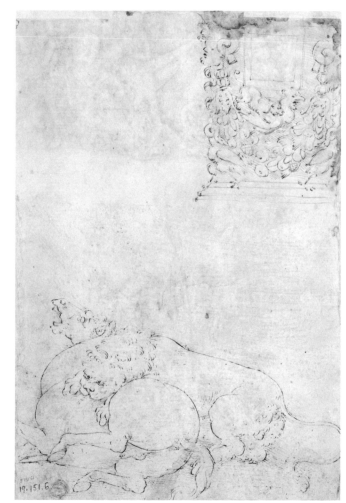

14

14 v.

AMICO ASPERTINI (NO. 14)

BIBLIOGRAPHY: *Metropolitan Museum, Italian Drawings,* 1942, no. 6, recto repr.; *Antiquity in the Renaissance,* exhibition catalogue by W. Stedman Sheard, Smith College Museum of Art, Northampton, Massachusetts, 1978 (published in 1980), no. 22, recto repr.

Rogers Fund, 1919
19.151.6

The relief with the fall of Phaëthon at the top of the recto is a free copy after an antique sarcophagus, now in the Uffizi but which in the sixteenth century was in Rome, at the right of the main door of S. Maria in Aracoeli (repr. G. A. Mansuelli, *Galleria degli Uffizi, le sculture,* 1, Rome, 1958, no. 251a). Aspertini's copy represents only the center and most of the right extension of the relief, and it has been suggested that the left part of the relief might have been drawn on the adjoining page of a now dismembered album. Wendy Stedman Sheard points out that the horses at the center of the sheet with two figures indicated in chalk to the right are copied from the *Triumph of Titus* relief on the arch of Titus in Rome (repr.

B. Andreae, *The Art of Rome,* New York, 1977, fig. 396). The antique source for the sketches of reclining women with children at the bottom of the recto has yet to be identified.

On the verso Aspertini has copied an antique altar or urn, and below, the colossal Roman marble group of a lion attacking a horse that is now in the garden courtyard of the Museo Nuovo of the Palazzo dei Conservatori (repr. H. Siebenhüner, *Das Kapitol in Rom,* Munich, 1954, pl. 4). Aspertini copied the same group in a sketchbook now in the British Museum (P. Pray Bober, *Drawings after the Antique by Amico Aspertini. Sketchbooks in the British Museum,* London, 1957, p. 76, fig. 103).

Two sheets with studies after the antique by Aspertini of comparable dimensions, similar inscriptions, and the same unidentified collector's mark were sold in London at Sotheby's on July 9, 1973, nos. 1 and 2 (from the collection of Earl Beauchamp). They are numbered *10* and *16* respectively.

GIOVANNI BALDUCCI (Cosci)

Florence ca. 1560 – Naples after 1631

15. *The Feast of Belshazzar* (Daniel 5:1-4)

Pen and brown ink, brown wash, over black chalk. 16.4 x 11.5 cm. Loss at upper right corner; surface abraded, especially at upper right.

Inscribed in pen and brown ink at lower right of old mount, *Bº. Luino;* in red pencil on verso, *Vasari.*

PROVENANCE: Giuseppe Vallardi (Lugt 1223); James Jackson Jarves; Cornelius Vanderbilt.

BIBLIOGRAPHY: *Metropolitan Museum Hand-book,* 1895, no. 227, as Bernardino Luini (?).

Gift of Cornelius Vanderbilt, 1880
80.3.227

The old attribution to Vasari noted on the verso is surely nearer the mark than that to Bernardino Luini on the mount. In fact, the drawing is a typical example of Balducci's pen work at its freest, and the example of Vasari is indeed evident.

16. *The Visitation of the Virgin to St. Elizabeth*

Pen and brown ink, pale brown wash, over black and red chalk. Framing lines in pen and brown ink. Squared lightly in black chalk. 33.2 x 25.9 cm. Margins irregular; upper left corner and both lower corners replaced; scattered stains (one on the face of St. Elizabeth).

Inscribed in pen and dark brown ink at lower margin, *Balducci.*

PROVENANCE: Sale, London, Christie's, July 1, 1969, no. 21; purchased in New York in 1979.

BIBLIOGRAPHY: *Old Master Drawings and Paintings. Yvonne Tan Bunzl,* exhibition catalogue, London, 1970, no. 6, repr.

Harry G. Sperling Fund, 1979
1979.61

A drawing of angel musicians, plausibly attributed to Balducci by the same hand as that responsible for the inscription on our sheet, was sold at Sotheby's in London on July 9, 1968, part of no. 17.

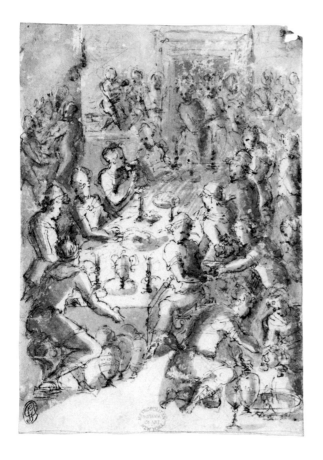

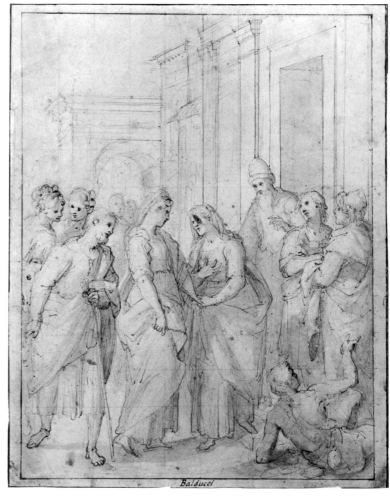

BACCIO BANDINELLI

Florence 1493 – Florence 1560

17. *The Holy Family*

Pen and brown ink. 33.2 x 21.0 cm. Several scattered tears and losses. Lined.

PROVENANCE: Sir Charles Greville (Lugt 549); Earl of Warwick (Lugt 2600); Warwick sale, London, Christie's, May 20-21, 1896, part of no. 7; J. P. Richter, London; purchased in London in 1912.

BIBLIOGRAPHY: B. Burroughs, *Metropolitan Museum of Art Bulletin*, May 1912, p. 99.

Roger Fund, 1912
12.56.6

The Holy Family is the subject of a group of pen studies by Bandinelli in the Uffizi; of these the drawing that comes closest in composition to ours is 542 F (Gernsheim photograph 9091).

18. *Three Male Heads*

Pen and brown ink. 32.1 x 20.7 cm. Several repaired losses.

Inscribed in pen and brown ink at lower left of verso, *Baccio Bandinelli;* illegible inscription at lower right in another hand, *Vig . . .* [?].

PROVENANCE: J. Goll van Franckenstein (*N° 369.* in brown ink on verso, Lugt 2987); Dr. Francis Springell; Springell sale, London, Sotheby's, June 28, 1962, no. 18, repr.; purchased in London in 1963.

BIBLIOGRAPHY: *Apropos,* n.d. [1946 ?], p. 6, fig. 7; Popham and Wilde, 1949, p. 189, under no. 81; *Loan Exhibition of Drawings by Old Masters from the Collection of Dr. and Mrs. Francis Springell,* P. and D. Colnaghi and Co., London, 1959, no. 22, pl. XI; Bean and Stampfle, 1965, no. 75, repr.

Rogers Fund, 1963
63.125

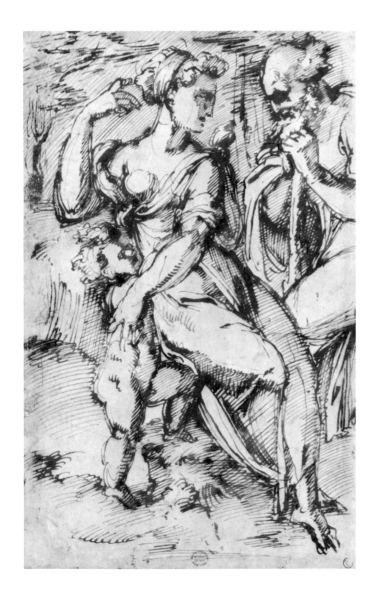

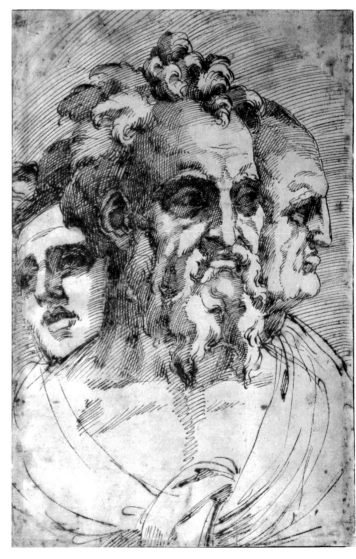

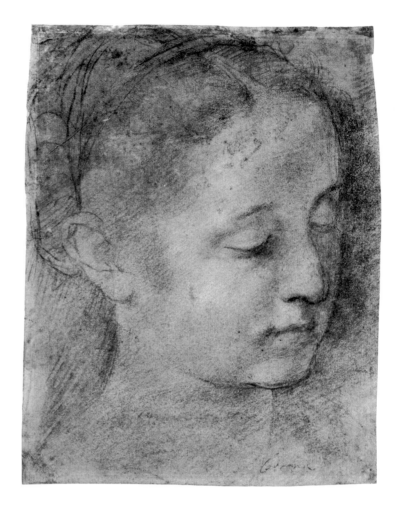

BACCIO BANDINELLI (NO. 18)

Three male heads, to the left that of a youth, at center a mature bearded man, and at the right in profile a bald old man, are grouped together in a way that suggests that Bandinelli intended to represent the Three Ages of Man; the bearded man at center may be an idealized portrait of the artist. The group could also be interpreted as a three-headed emblem of Prudence, attentive to the past (the old man), the present (the mature man), and the future (the youth); for such emblematic representations see Irwin Panofsky, *Meaning in the Visual Arts,* Garden City, New York, 1955, pp. 146-168.

FEDERICO BAROCCI

Urbino ca. 1535 – Urbino 1612

19. *Head of a Young Woman Looking to Lower Right*

Black, red, and yellow chalk. 24.0 x 18.8 cm. Surface much abraded; some repaired losses; lower left corner replaced.

Inscribed in pen and brown ink at lower right, *Cortona* [?]; on verso, *Barocci.*

PROVENANCE: Pratt Institute, Brooklyn; purchased from that institution in 1964.

BIBLIOGRAPHY: *Pratt Alumnus Quarterly,* 68, 2, 1966, p. 12, repr.; Pillsbury, 1976, p. 60; Pillsbury, 1978, no. 16, repr.

Pfeiffer Fund, 1964
64.136.3

Identified in 1976 by Edmund Pillsbury as a study for the head of the Virgin in the *Madonna di San Giovanni* of ca. 1565 (Galleria Nazionale delle Marche, Urbino; repr. Emiliani, 1975, pl. 20). The surface has, unfortunately, been much damaged by abrasion.

31

20. *Head of a Bearded Man Looking to Lower Left*

Pink, brown, beige, black, and white oil paint on paper. 38.7 x 27.3 cm. Lined with canvas.

PROVENANCE: English private collection; purchased in London in 1976.

BIBLIOGRAPHY: Emiliani, 1975, no. 115, repr.; J. Shearman, *Burlington Magazine,* CXVIII, 1976, pp. 51-52, fig. 1; Pillsbury, 1976, pp. 56, 62; *Metropolitan Museum of Art, Annual Report 1975-1976,* p. 35, repr.; Pillsbury, 1978, no. 43, repr.; G. Smith, *Burlington Magazine,* CXX, 1978, p. 333; E. Pillsbury, *Apollo,* CVIII, September 1978, pp. 170-173, pl. II; *Notable Acquisitions,* 1979, p. 56, repr.

Harry G. Sperling Fund, 1976
1976.87.1

Full-scale study in colored oil paint on paper for the head of one of the bearers of the body of the dead Christ in the *Entombment* in S. Croce, Senigallia, a painting begun in 1579 and finished in 1582 (repr. Emiliani, 1975, pl. 118). In 1979 the National Gallery of Art in Washington, D.C., acquired a recently discovered oil study for the head of St. John the Evangelist in the Senigallia *Entombment* (B-30,639; repr. *Apollo,* CVIII, September 1978, pl. I).

21. *Head of an Old Woman Looking to Lower Right*

Pink, red, brown, beige, gray, and white oil paint on paper. 39.1 x 27.4 cm. Lined with canvas.

PROVENANCE: English private collection; purchased in London in 1976.

BIBLIOGRAPHY: Emiliani, 1975, no. 160, repr.; J. Shearman, *Burlington Magazine,* CXVIII, 1976, pp. 51-52; Pillsbury, 1976, pp. 56, 63; Pillsbury, 1978, no. 53, repr.; G. Smith, *Burlington Magazine,* CXX, 1978, p. 333, fig. 106; E. Pillsbury, *Apollo,* CVIII, September 1978, pp. 170-173, pl. IV; *Notable Acquisitions,* 1979, p. 56, repr.

Harry G. Sperling Fund, 1976
1976.87.2

Full-scale study in colored oil paint on paper for the head of St. Elizabeth in the *Visitation* in the Chiesa Nuova, Rome, a painting begun in 1583 and finished in 1586 (repr. Emiliani, 1975, pl. 162).

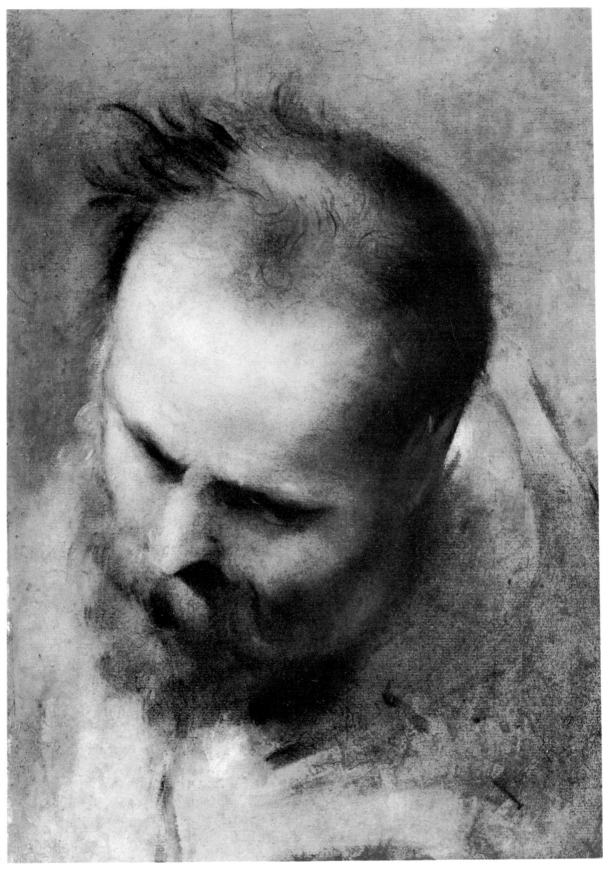

20

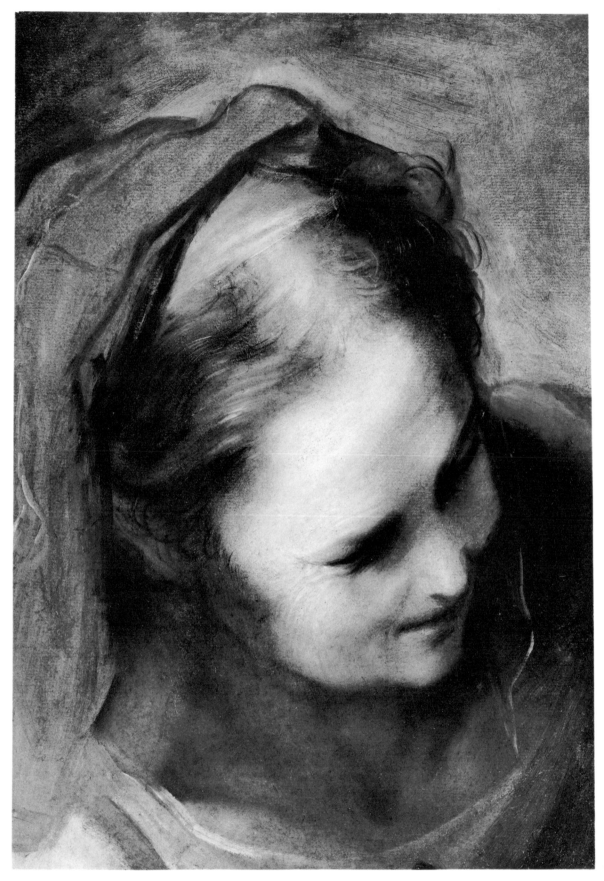

FEDERICO BAROCCI

22. *Studies of a Man's Head and of His Hands*

Black, and a little red chalk, heightened with white, on blue paper. 27.8 x 41.3 cm. Lower right corner replaced.

PROVENANCE: Earl Spencer (Lugt 1530); Spencer sale, London, T. Philipe, June 10-17, 1811, part of no. 22; Lionel Lucas (Lugt 1733a); Claude Lucas; sale, London, Christie's, December 9, 1949, no. 54; purchased in London in 1950.

BIBLIOGRAPHY: M. Aronberg Lavin, *Metropolitan Museum of Art Bulletin,* May 1955, pp. 266-271, repr.; H. Olsen, *Federico Barocci, A Critical Study in Italian Cinquecento Painting* ("Figura," no. 6), Stockholm, 1955, p. 158; H. Olsen, *Federico Barocci,* Copenhagen, 1962,

p. 203, pl. 92a; Bean, 1964, no. 24, repr.; Bean and Stampfle, 1965, no. 119, repr.; Pillsbury, 1978, no. 64, repr.

Rogers Fund, 1950
50.143

Studies for the head and the hands, joined in devotion, of the third apostle to the left of the central figure of Christ in the *Last Supper* in the Chapel of the Blessed Sacrament of the Cathedral in Urbino, painted between 1592 and 1599 (repr. Emiliani, 1975, pl. 240).

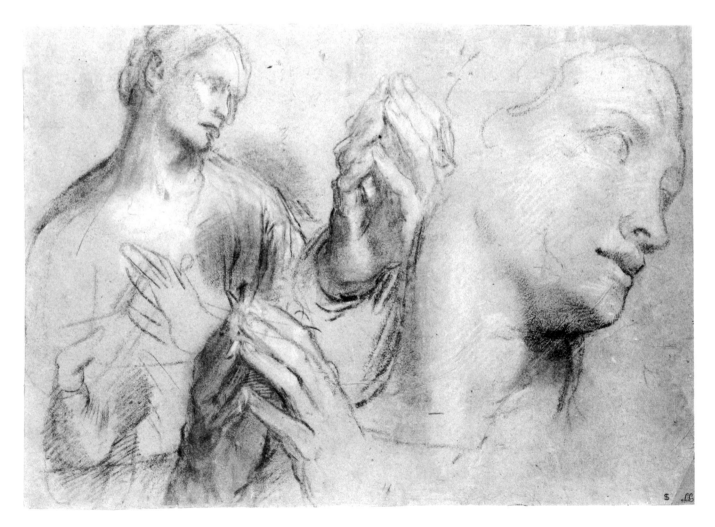

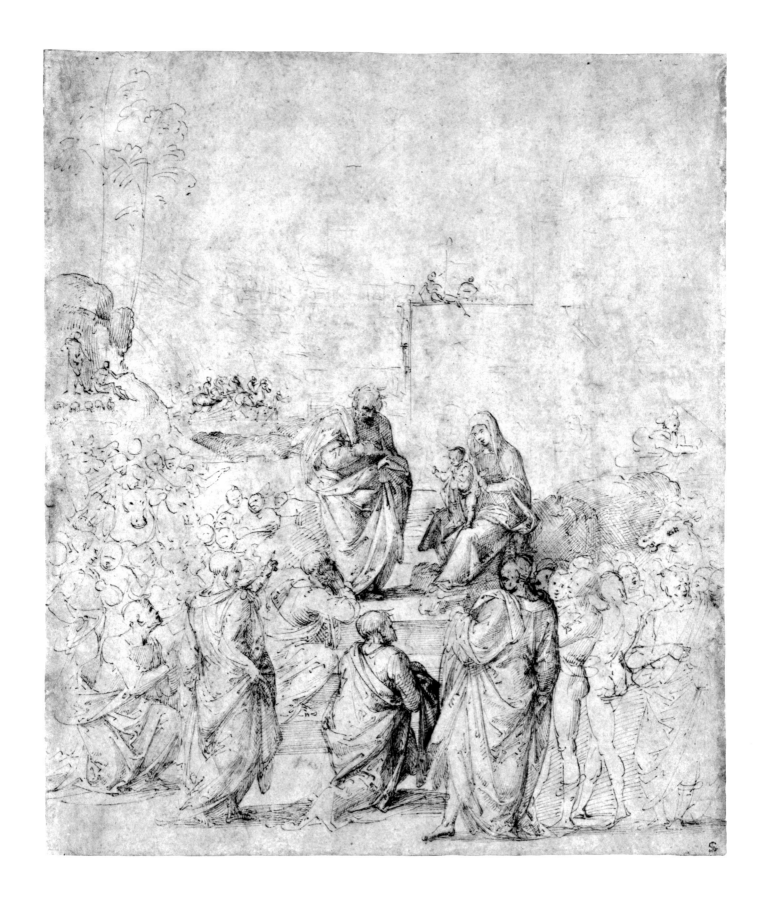

Pen and brown ink, over traces of black chalk. 27.8 x 23.9 cm. Lined.

PROVENANCE: Nathaniel Hone (according to *Lawrence Gallery*); Earl Spencer (Lugt 1530); Spencer sale, London, T. Philipe, June 10-17, 1811, no. 644, as Raphael; Sir Thomas Lawrence (Lugt 2445); Samuel Woodburn; Woodburn sale, London, Christie's, June 4-14, 1860, no. 738, as Raphael; Sir John Charles Robinson; Lord Spencer Compton; Marquess of Northampton, Castle Ashby; Northampton sale, London, Christie's, May 1, 1959, no. 1, repr.; Walter C. Baker, New York.

BIBLIOGRAPHY: *Lawrence Gallery. Seventh Exhibition. A Catalogue of One Hundred Original Drawings by Zucchero, Andrea del Sarto, Polidore da Caravaggio, and Fra Bartolomeo, Collected by Sir Thomas Lawrence,* London, 1836, p. 22, no. 63, as Fra Bartolomeo; Berenson, 1903, no. 438; *Vasari Society,* first series, X, 1914-1915, no. 2, repr.; H. von der Gabelentz, *Fra Bartolommeo . . . ,* Leipzig, 1922, II, p. 135, no. 315; Berenson, 1938, no. 438; Berenson, 1961, no. 459H; Virch, 1962, no. 6, repr.; Bean and Stampfle, 1965, no. 27, repr.; *Notable Acquisitions,* 1980, p. 47, repr.

Bequest of Walter C. Baker, 1971
1972.118.241

In this early drawing the Holy Family appears on a raised platform; the seated Virgin holds the standing, blessing Christ Child on her knee, and the pensive St. Joseph stands at left. The Magi are grouped at the foot of the steps leading to the platform, and a great retinue on foot and on horseback surrounds the central group. On the horizon appear more cavaliers, two watching shepherds are seen on the hill at left, and further spectators are perched on the top of a building that is lightly indicated at upper right.

Berenson noted that Fra Bartolomeo's composition was inspired by the example of representations of the Adoration of the Magi by Leonardo da Vinci and Botticelli; the pyramidal composition with the Holy Family on a raised platform derives directly from Botticelli's *Adoration of the Magi* in the Uffizi.

The same composition was studied by Fra Bartolomeo in a drawing in the Uffizi (452 E; repr. Berenson, 1938, no. 235, fig. 439). In that drawing the Magi are placed on the platform from which rises a ruined arcade. The center foreground is empty, though the group of spectators, dominated by a heavily draped male figure seen from behind, appears at lower right, as in our drawing. The Uffizi composition was utilized almost verbatim in a painting now in the Brooks Memorial Art Gallery, Memphis, Tennessee, that Everett Fahy attributes to Giovanni Antonio Sogliani (repr. Venturi, IX, 1, fig. 335, as Bacchiacca).

24. *The Annunciation*

Pen and brown ink (kneeling angel at left), faint black chalk (the hardly legible standing figure of the Virgin at right). Faint view of buildings in pen and brown ink on verso. 10.7 x 15.1 cm.

PROVENANCE: Anne D. Thomson, New York.

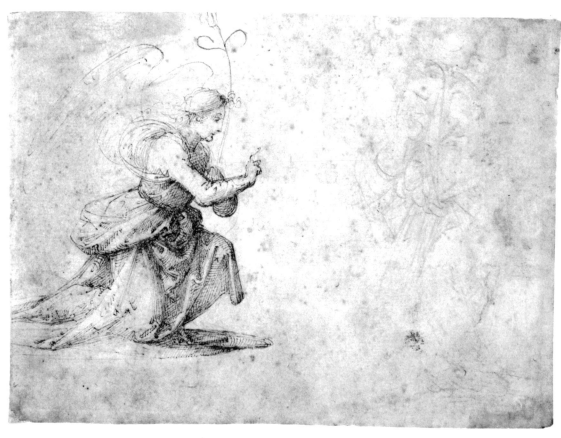

BIBLIOGRAPHY: Berenson, 1938, no. 459B; *Metropolitan Museum, Italian Drawings*, 1942, no. 7, repr.; Berenson, 1961, no. 459B*; S. Grossman in *Recent Acquisitions and Promised Gifts. Sculpture, Drawings, Prints*, exhibition catalogue, National Gallery of Art, Washington, D.C., 1974, p. 47, under no. 12.

Bequest of Anne D. Thomson, 1923
23.280.7

BIBLIOGRAPHY: J. Fleming, *Connoisseur*, CXLI, 1958, p. 227 (discussion of the provenance of the whole group); R. W. Kennedy, *Smith College Museum of Art Bulletin*, no. 39, 1959, pp. 1-12 (discussion of the whole group); Berenson, 1961, II, p. 71, no. 433F**; Bean and Stampfle, 1965, no. 31, repr.

Rogers Fund, 1957
57.165

The archangel Gabriel kneels at the left; his right arm is raised, and he holds a lightly indicated lily in his left hand. The Virgin, faintly sketched in black chalk, stands at the left facing Gabriel. The angel of the Annunciation is the subject studied in a good many early pen drawings by Fra Bartolomeo: particular mention might be made of studies in the Uffizi in Florence; in an American private collection; in the Ashmolean Museum, Oxford; and in the Bonnat album in the Cabinet des Dessins, Musée du Louvre, Paris (Berenson, 1961, nos. 236, 438A, 463A-1**, and 494A, fol. 6 verso, respectively). On a sheet recently acquired by the National Gallery of Art in Washington, D.C., Gabriel is sketched in pen and ink standing at the left and bowing toward the Virgin who is very faintly indicated in chalk at the right. Like our drawing, the Washington sheet bears on the verso a faint pen cityscape (B-26,220; S. Grossman, *op. cit.*, pp. 46-47, no. 12, recto and verso repr.; not listed by Berenson).

25. *A Small Town on the Crest of a Slope*

Pen and brown ink. 27.9 x 21.8 cm. Lower left corner replaced.

PROVENANCE: Fra Paolino da Pistoia, Florence; Suor Plautilla Nelli; Convent of St. Catherine, Piazza S. Marco, Florence; Cavaliere Francesco Maria Niccolò Gabburri, Florence; William Kent (?); private collection, Ireland; sale, London, Sotheby's, November 20, 1957, no. 7, repr., purchased by the Metropolitan Museum.

This drawing and No. 26 below once formed part of an album containing forty-one landscape studies by Fra Bartolomeo. The album, broken up and sold at auction in 1957, bore the arms of the Florentine art historian Cavaliere Gabburri (1675-1742) on its frontispiece and had a title page that attributed the drawings to Andrea del Sarto. However, the pen style of these sketches, which are among the earliest pure landscape studies in European art, is characteristic of Fra Bartolomeo.

Since Bartolomeo was a masterful painter of landscapes, it is surprising that only one drawing from the album can be associated with a picture. This is a drawing now in the Seilern collection that was used for the landscape in the background of Giuliano Bugiardini's *Rape of Dinah* in the Kunsthistorisches Museum at Vienna, a picture Vasari described as begun by Fra Bartolomeo and finished by Bugiardini (I. Härth, *Mitteilungen des kunsthistorischen Institutes in Florenz*, IX, 2, 1960, pp. 125-130).

In the Robert Lehman Collection at the Metropolitan Museum there is another pen landscape drawing from the Gabburri album (Bean and Stampfle, 1965, no. 30, repr.; Szabo, 1978, no. 34, repr.). The Pierpont Morgan Library possesses a double-faced sheet from the group (Bean and Stampfle, 1965, no. 33, recto repr.; C. D. Denison in *European Drawings 1375-1825*, Pierpont Morgan Library, New York, 1981, no. 11, recto and verso repr.). In addition, there are two sheets from this source in private collections in New York (nos. 18 and 29 of the 1957 sale).

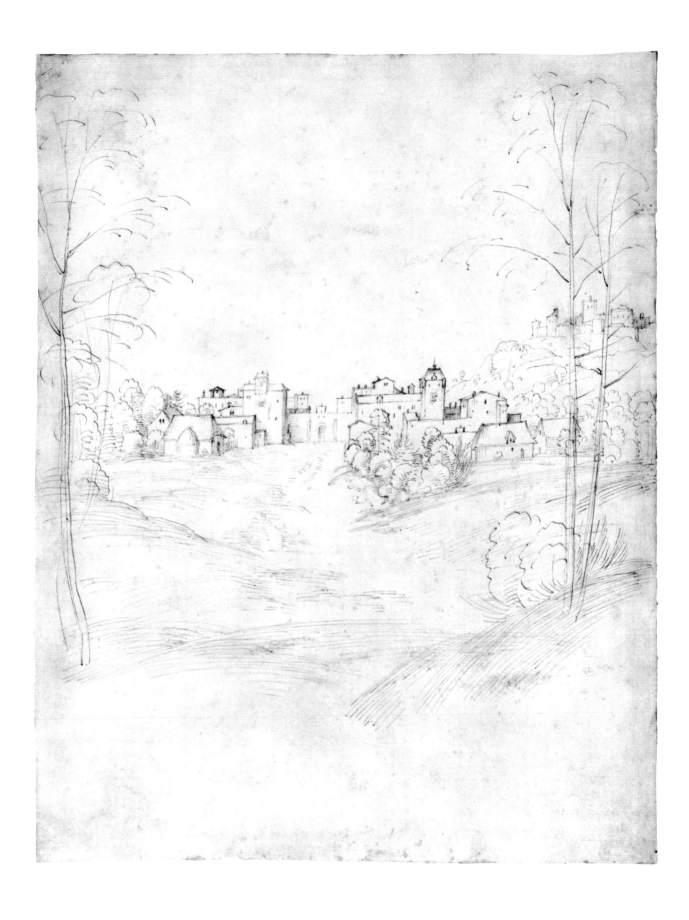

26. *Wooded Approach to a Town*

Pen and brown ink. 21.4 x 29.2 cm.

PROVENANCE: Fra Paolino da Pistoia, Florence; Suor Plautilla Nelli; Convent of St. Catherine, Piazza S. Marco, Florence; Cavaliere Francesco Maria Niccolò Gabburri, Florence; William Kent (?); private collection, Ireland; sale, London, Sotheby's, November 20, 1957, no. 26, repr.; Walter C. Baker, New York.

BIBLIOGRAPHY: J. Fleming, *Connoisseur,* CXLI, 1958, p. 227 (discussion of the provenance of the whole group); R. W. Kennedy, *Smith College Museum of Art Bulletin,* no. 39, 1959, pp. 1-12 (discussion of the whole group); Berenson, 1961, II, p. 71, no. 433F**, Virch, 1962, no. 8, repr.; Bean and Stampfle, 1965, no. 34, repr.

Bequest of Walter C. Baker, 1971
1972.118.239

See No. 25 above.

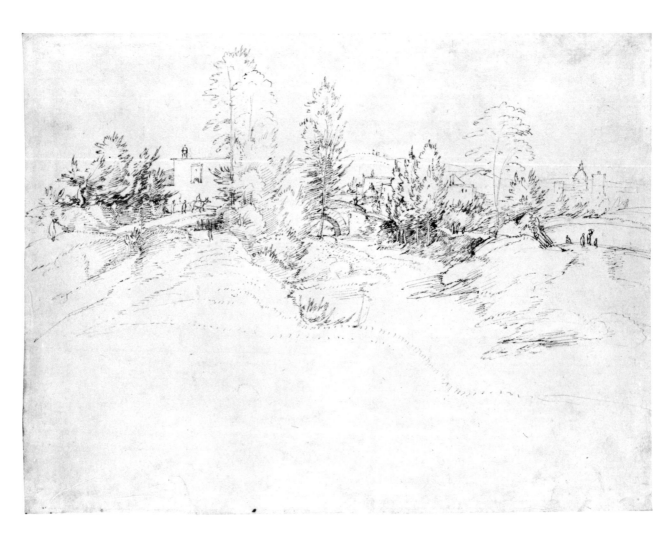

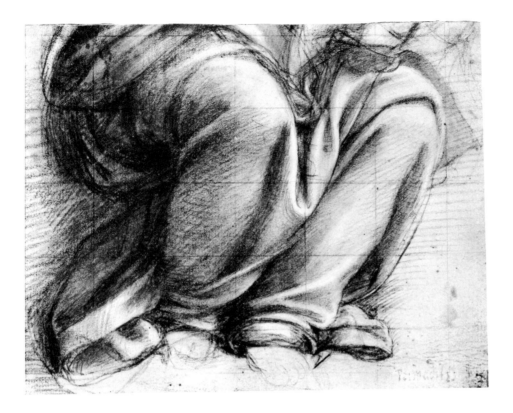

FRA BARTOLOMEO ?

27. *Study of Drapery over the Knees of a Seated Figure*

Black chalk, heightened with white. Squared in black chalk. 12.4 x 16.3 cm. Lined.

Faint, partly effaced inscription in pen and brown ink at lower right, *Primadite* [?]; numbered in pen and brown ink at lower right, *3*.

PROVENANCE: Walter C. Baker, New York.

BIBLIOGRAPHY: *Exhibition of Old Master Drawings. P. and D. Colnaghi and Co.*, London, 1961, no. 10, pl. 1, as Fra Bartolomeo; Virch, 1962, no. 7, as Fra Bartolomeo.

Bequest of Walter C. Baker, 1971
1972.118.240

In 1961 James Byam Shaw attributed this drapery study to Fra Bartolomeo, deeming it an early work, still Leonardesque in style. More recently Everett Fahy has proposed that the drawing is instead the work of Innocenzo da Imola. Neither attribution is entirely convincing.

JACOPO BASSANO (Jacopo da Ponte) ?

Bassano ca. 1515 – Bassano 1592

28. *The Annunciation to the Shepherds*

Pen and brown ink, brown wash, heightened with white, on green-washed paper. 28.7 x 24.1 cm. Some repaired losses; horizontal crease below center. Lined.

PROVENANCE: Bianconi (according to the Lagoy manuscript inventory); Marquis de Lagoy (Lugt 1710; p. 39, no. 163 of Lagoy's manuscript inventory as Jacopo Bassano); purchased in London in 1908.

BIBLIOGRAPHY: Fry, 1909, p. 7, as Francesco Bassano; Hellman, 1916, pp. 176-178, repr., as Leandro Bassano.

Rogers Fund, 1908
08.227.28

The lower part of the composition corresponds very closely to a painting by Jacopo Bassano of which autograph versions are in the National Gallery in Washington, D.C., and in the Accademia di S. Luca, Rome (the former repr. F. Rusk Shapley, *Paintings from the Samuel H. Kress Collection. Italian Schools, XVI-XVIII Century*, London, 1973, no. K258, fig. 83; the latter repr. *Jacopo*

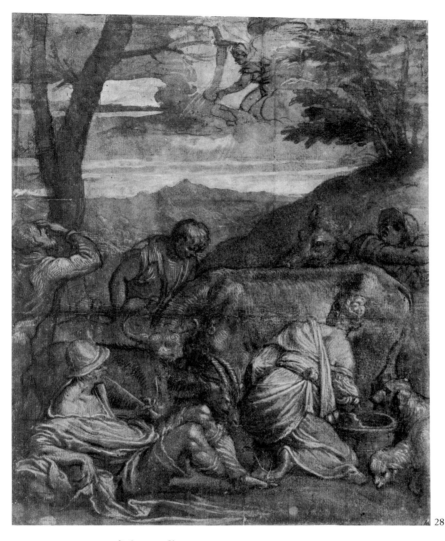

28

JACOPO BASSANO ? (NO. 28)

Bassano, exhibition catalogue, Palazzo Ducale, Venice, 1957, no. 51). The painted composition is recorded in reverse in an engraving by Ægidius Sadeler II (F. W. H. Hollstein, *Dutch and Flemish Etchings, Engravings, and Woodcuts, ca. 1450-1700,* XXI, Amsterdam, 1980, p. 13, no. 31). Our drawing differs from the paintings in the size, position, and action of the angel who appears above. In the paintings the figure is a large, winged putto with arms outspread; in the drawing the angel is smaller, seemingly older, and holds in both hands a banderole that is absent in the paintings.

Chiaroscuro drawings such as this, in which colored wash is contrasted with white highlights, were not at all unusual in the Veneto (see, for example, the Paolo Veronese *Allegory,* No. 151 below). The quality here is high, and it could be argued that this is a *modello* or *ricordo* produced in the Bassano workshop.

DOMENICO BECCAFUMI

Valdibiena, near Siena, ca. 1486 – Siena 1551

29. *St. Matthew*

Brown, beige, and cream-colored tempera and emulsion. 38.7 x 21.6 cm.

PROVENANCE: Henry Scipio Reitlinger; Reitlinger sale, London, Sotheby's, December 9, 1953, part of no. 24; Mrs. Edward Fowles.

BIBLIOGRAPHY: D. Sanminiatelli, *Burlington Magazine,* XCVII, 1955, pp. 35-40, fig. 11; Bean and Stampfle, 1965, no. 63, repr.; Sanminiatelli, 1967, p. 129, no. 27, repr.; Bean, 1975, no. 2; Baccheschi, 1977, pp. 104-105, no. 126[1], repr.

Gift of Jean Douglas Fowles, in memory of R. Langton Douglas, 1974
1974.216

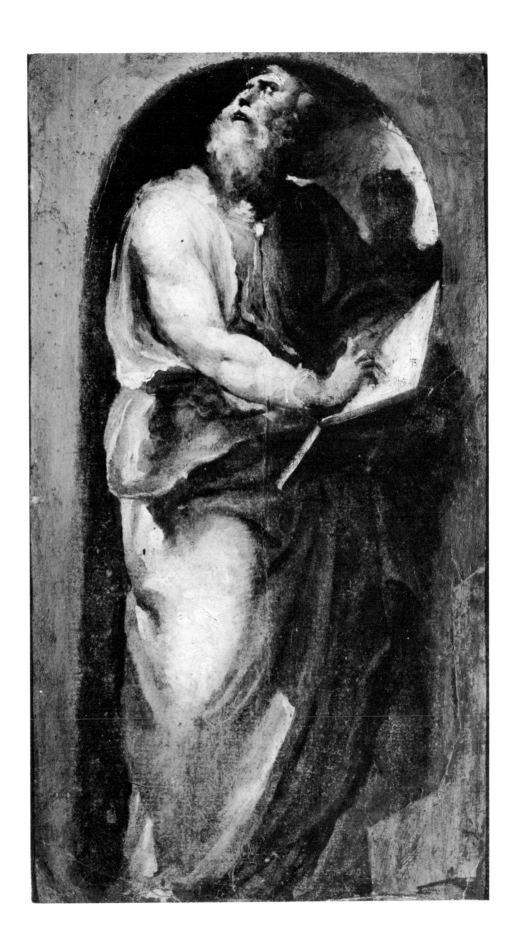

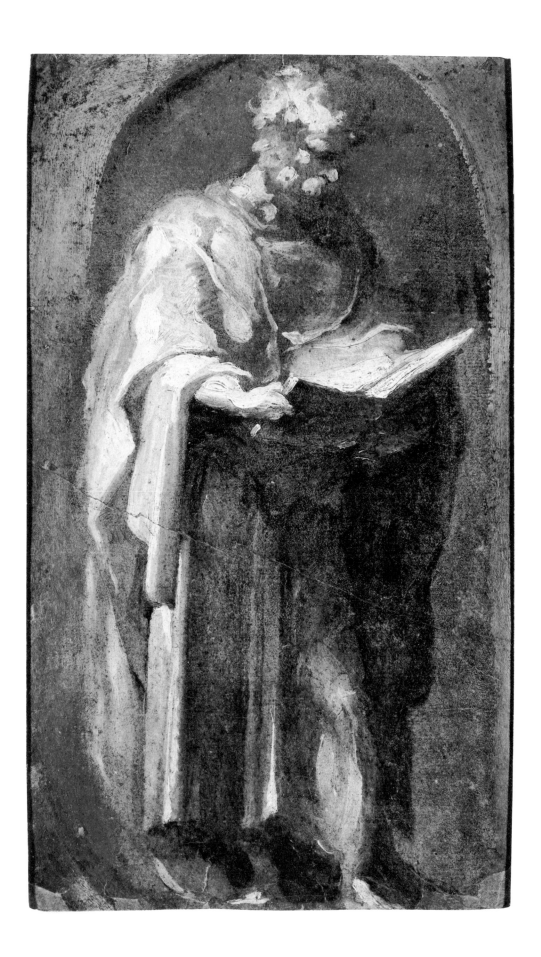

Study for one of the four panels with figures of the
Evangelists painted in Siena by Beccafumi for the
Duomo in Pisa, where they still hang (repr. San-
miniatelli, 1967, fig. 57a; Baccheschi, 1977, no. 126,
both wrongly titled St. Luke). Payments for the panels
representing St. John the Evangelist and St. Luke were
made in July of 1538, and for the St. Matthew and St.
Mark at the end of December of the same year. For the
latter figure see No. 30 below.

30. *St. Mark*

Brown, beige, and cream-colored tempera and emulsion. 40.0 x 23.2
cm.

PROVENANCE: Henry Scipio Reitlinger; Reitlinger sale, London,
Sotheby's, December 9, 1953, part of no. 24; Mrs. Edward Fowles.

BIBLIOGRAPHY: D. Sanminiatelli, *Burlington Magazine,* XCVII,
1955, pp. 35-40, fig. 10; A. Forlani, *I disegni italiani del Cinquecento,
scuole fiorentina, senese, romana, umbro marchigiana e dell'Italia
meridionale,* Venice, 1962, p. 194, under no. 52; Bean and Stampfle,
1965, p. 47, under no. 63; Sanminiatelli, 1967, p. 129, no. 26, repr.;
Bean, 1975, no. 3; Baccheschi, 1977, pp. 104-105, no. 127[1], repr.

Gift of Jean Douglas Fowles, in memory of R. Langton Douglas,
1975
1975.97

Study for the *St. Mark,* one of four panels with repre-
sentations of the Evangelists, painted by Beccafumi for
the Pisa Duomo (repr. Sanminiatelli, 1967, fig. 57b;
Baccheschi, 1977, no. 127). There are differences be-
tween this *bozzetto* and the finished panel, especially in
the pose of the saint's head — in the painting it is turned
toward the spectator rather than in near profile to the
right as here. It is interesting to note that the solution
adopted in the painting is adumbrated by the incised
lines that appear under and to the left of the summary
brush work modeling the head turned to the right. In a
pen and wash study for this figure in the Cabinet des
Dessins, Musée du Louvre, St. Mark's head is turned
very slightly to the right (Inv. 252; repr. A. Forlani, *op.
cit.,* pl. 52).

FILIPPO BELLINI
Urbino 1550/1555 – Macerata 1604

31. *Christ in Limbo: Design for the
Standard of a Confraternity*

Black chalk, pen and brown ink, brown wash. Squared in black
chalk. 35.2 x 24.0 cm.

Inscribed in pen and brown ink at lower right, *K.ᵉ Malosso;* on verso,
Noi deputati accettiamo il disegno qui . . . / . . . stro stendardo, followed by
a number of signatures.

PROVENANCE: Purchased in London in 1973.

BIBLIOGRAPHY: C. Monbeig Goguel, *Master Drawings,* XIII, 4,
1975, p. 365, no. 47, pl. 9.

Rogers Fund, 1973
1973.87

The old inscription gives the drawing to Malosso (G. B.
Trotti), but Philip Pouncey supplied the correct attribu-
tion to Filippo Bellini in the early 1970s when the
drawing was on the London market. The inscription on
the verso identifies the drawing as a design for the
standard of a confraternity, and Bellini is known to have
executed many commissions for such pious associations
in the Marches.

Christ, bearing the banner of the Resurrection and
standing on the fallen gates of the underworld, reaches
out to touch the raised arm of Moses. Adam and Eve
appear at the right, and at the left stand St. John the
Baptist and the Good Thief, holding his cross. God the
Father appears above surrounded by putti holding the
symbols of the Passion. The arms of the confraternity are
lightly indicated at lower center.

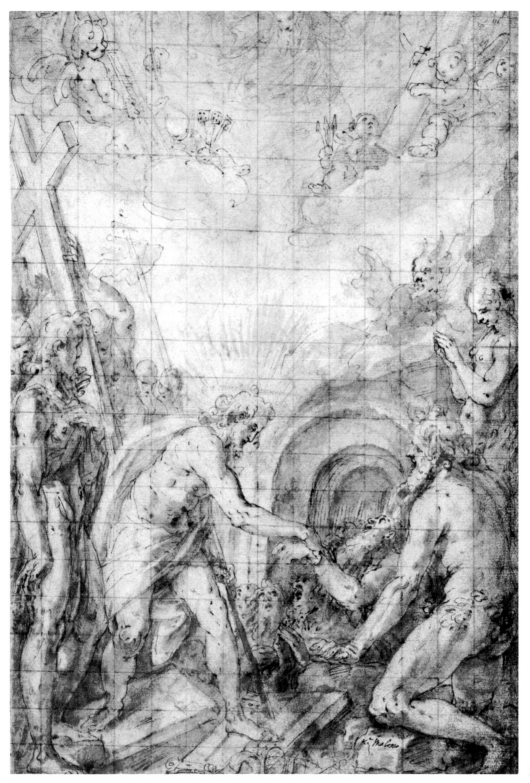

JACOPO BERTOIA

Parma 1544 – Parma 1574

32. Music-Making Figures and Lovers

Pen and brown ink, brown wash, heightened with a little white, over traces of black chalk. Squared in black chalk. 13.1 x 24.7 cm. Gray stain at upper center. Lined.

PROVENANCE: Caleb Whitefoord (when engraved by Metz); Louis Rorimer, Cleveland, Ohio; James J. Rorimer, New York.

BIBLIOGRAPHY: Metz, 1798, pl. 74, repr. in reverse as Parmigianino; Weigel, 1865, p. 489, no. 5836, as Parmigianino; Popham, 1953, p. 18; A. Ghidiglia Quintavalle, *Il Bertoja,* Milan, 1963, pp. 35, 54-55 (the Metz facsimile mentioned but not connected with the present drawing), pl. XXXVIIa (wrongly described as being in the Ecole des Beaux-Arts, Paris); Bean and Stampfle, 1965, no. 144, repr.

Gift of James J. Rorimer, 1966
66.32

A. E. Popham, who knew this sheet through the reversed eighteenth-century facsimile reproduction published as Parmigianino, was the first to recognize that the drawing is a study by Bertoia for a group of figures that appears on one of the walls of the Sala del Bacio in the Palazzo del Giardino at Parma (repr. A. Ghidiglia Quintavalle, *op. cit.,* pls. XXXIV, XXXVI). The frescoes in the Sala del Bacio (the Room of the Kiss) form a felicitous and fantastic late mannerist complex; the singers of the present drawing are seen on one of the walls of the room, surrounded by embracing couples, in a hall supported by transparent crystal columns. These frescoes, a project in which the mysterious Girolamo Mirola collaborated with Bertoia, are datable about 1570-1573. Other drawings for the Sala del Bacio are in the Uffizi and the Ecole des Beaux-Arts in Paris (A. Ghidiglia Quintavalle, *op. cit.,* figs. 57, 58, pl. XXXVIIb, respectively).

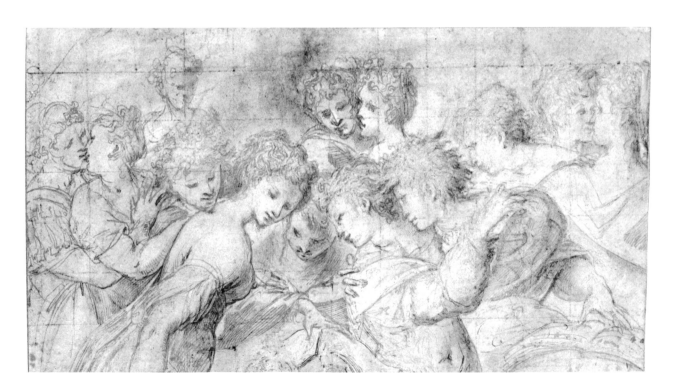

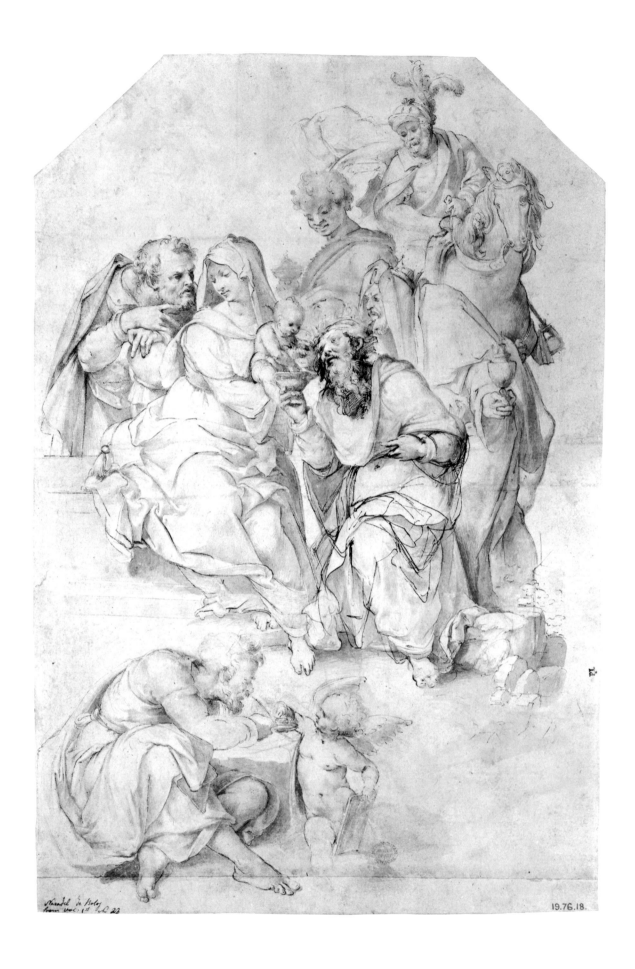

GIOVANNI FRANCESCO BEZZI,
called Il Nosadella

Active in Bologna from ca. 1550 – Bologna 1571

33. *The Adoration of the Magi*

Pen and brown ink, brown wash, heightened with a little white, over traces of black chalk. 36.4 x 24.5 cm. (overall). A horizontal strip 1.6 cm. in height has been added at lower margin and drawing continued in the same hand. Upper corners cut away.

Inscribed in pen and brown ink at lower left, *Nosadel de Bolog | from vol: 1ˢᵗ no 23* (indicating the drawing's place in the Pembroke albums).

PROVENANCE: Sir Peter Lely (Lugt 2092); Earls of Pembroke; Pembroke sale, London, Sotheby's, July 5-6, 9-10, 1917, part of no. 444, as Lorenzo Sabbatini, purchased by the Metropolitan Museum.

Hewitt Fund, 1917
19.76.18

St. Matthew is seated conspicuously in the foreground and is aided in his writing by an attendant angel. Matthew's presence emphasizes the fact that the story of the visit of the Magi to the Christ Child is told only in the Gospel that bears his name.

The drawing could be a design for a representation of this subject painted in fresco on the walls of the choir of the church of S. Maria Maggiore, Bologna. The altarpiece, representing the *Circumcision,* still survives; it is said to have been begun by Nosadella and finished by Prospero Fontana. Malvasia reports that on the lateral walls of the choir were frescoed representations of the *Nativity* and the *Adoration of the Magi* (Malvasia, 1686, p. 42, the altarpiece fig. 53/5). These lateral frescoes had disappeared under whitewash by the eighteenth century, but Catherine Johnston has kindly reported that the lateral spaces could have easily accommodated a vertical composition such as that studied in our drawing. Furthermore, the scale of the figures and the rhythm of the composition would have harmonized with the *Circumcision* altarpiece.

The attribution of the drawing to Nosadella is traditional and convincing. Christine Baltay points out that the figure of the old Magus standing at the right is quoted almost verbatim in a painting of the *Presentation in the Temple* that was sold most recently at Christie's in London (April 24, 1981, no. 95, repr.). In the painting the Magus is transformed into a temple attendant.

34. *Kneeling Bearded Old Man*

Red chalk, pen and brown ink, brown and red wash, heightened with a little white. Pen sketch of a seated, bearded man, and a red chalk drapery (?) study on verso. 22.8 x 17.7 cm. Loss at lower left margin; most of the verso blackened as if for transfer.

Inscribed in pen and brown ink at lower right, *dell | Greche*; on verso, *nosadella.*

PROVENANCE: Giuseppe Vallardi (Lugt 1223); James Jackson Jarves; Cornelius Vanderbilt.

BIBLIOGRAPHY: *Metropolitan Museum Hand-book,* 1895, no. 487, as El Greco.

Gift of Cornelius Vanderbilt, 1880
80.3.487

The attribution to G. F. Bezzi was proposed by Lawrence Turčić, in 1979, and his suggestion received confirma-

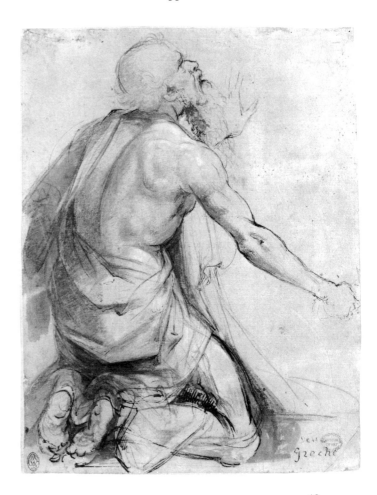

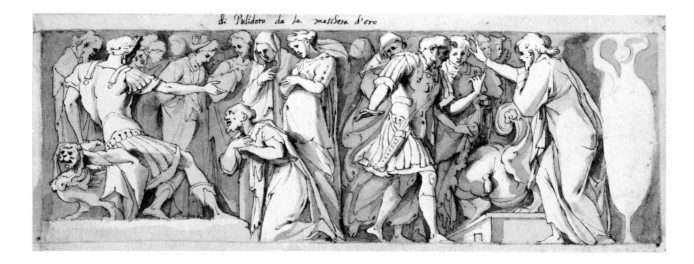

GIOVANNI FRANCESCO BEZZI (NO. 34)

tion in the old inscription, *nosadella,* that was revealed when the drawing was removed from its old mount in 1980. The handling of pen and wash in our drawing may be usefully compared with that in a study of the kneeling Virgin by Nosadella in the National Gallery of Scotland, Edinburgh (D 1530; repr. Andrews, 1968, fig. 155). The Edinburgh drawing is related to a painting of the *Presentation in the Temple* recently on the London market (Sotheby's, July 15, 1970, no. 73; Christie's, April 24, 1981, no. 95, repr.; see also No. 33 above).

ANDREA BOSCOLI

Florence ca. 1560 – Florence 1607

35. *Scenes from Ancient History,*
after Polidoro da Caravaggio

Pen and brown ink, brown wash, over a little black chalk. Framing lines in black chalk. 11.9 x 33.3 cm. Scattered pinholes.

Inscribed in pen and brown ink at upper margin, *di Pulidoro da la maschera d'oro.*

PROVENANCE: Eric M. Wunsch, New York.

BIBLIOGRAPHY: *Exhibition of Old Master Drawings. H. Shickman Gallery,* New York, 1968, no. 20, repr.

Gift of Eric M. Wunsch, 1968
68.123.1

Free copy of two of Polidoro's now lost frescoes on the façade of the Palazzo Milesi, via della Maschera d'Oro, Rome (repr. E. Maccari, *Graffiti e chiaroscuri esistenti*

nell'esterno delle case, Rome, n.d., pl. 37). These scenes, thought to represent the Family of Darius before Alexander (on the left) and Prisoners before a Roman Magistrate (on the right) appeared in the painted frieze between the first and second stories. In the fresco they were separated by representations of vases and a military trophy. Boscoli drew many copies after Roman façade frescoes (Farnesina, Rome, Uffizi and Horne Foundation, Florence, Victoria and Albert Museum, Witt Collection, Courtauld Institute, London, Princeton Art Museum, etc.). These copies were presumably executed during Boscoli's stay in Rome, which Anna Forlani dates in the early 1580s (*Mostra di disegni di Andrea Boscoli,* Gabinetto Disegni e Stampe degli Uffizi, Florence, 1959, p. 7).

CARLETTO CALIARI

Venice 1570 ? – Venice 1596

36. *Bust of a Bearded Old Man,*
Profile to Right

Black and red chalk, heightened with a little white, on blue paper. 26.9 x 19.9 cm.

Inscribed in pen and brown ink on verso, *436 Lapis.*

PROVENANCE: Maurice Marignane, Paris (according to A. Ballarin); Harry G. Sperling, New York.

BIBLIOGRAPHY: A. Ballarin in *Studi di storia dell'arte in onore di Antonio Morassi,* Venice, 1971, pp. 148, 151, note 37; Bean, 1975, no. 7; Rearick, 1980, p. 58, under no. 34; Byam Shaw, 1981, p. 39, under no. 45.

Bequest of Harry G. Sperling, 1971
1975.131.4

This realistic head is one of a now widely dispersed group of portrait drawings in colored chalks on blue paper that bear numbers and technical indications like the *436 Lapis* on the reverse of this sheet. These portraits have been attributed to Jacopo Bassano, to his son Leandro, and more recently to Carletto Caliari, son of Paolo Veronese, who was sent to study in the Bassano workshop where drawn and painted portraiture was a specialty.

The attribution of these portraits to Carletto was made independently by Alessandro Ballarin and W. R. Rearick. The latter points out that our study was used for the head of a balding, bearded senator who appears somewhat to the left of the central column in a painting in the Sala del Maggior Consiglio, Palazzo Ducale, Venice, *Venetian Ambassadors Dispatched to Pavia* (repr. Venturi, IX, 4, fig. 791). This painting was a late enterprise of the "heirs of Paolo," Benedetto and Gabriele, with Carletto supplying the portraits in the narrative scene. Rearick has identified drawings in the National Gallery of Ireland, Dublin; the British Museum, London; and the Janos Scholz Collection, Pierpont Morgan Library, New York, as studies for other portrait heads in the same painting.

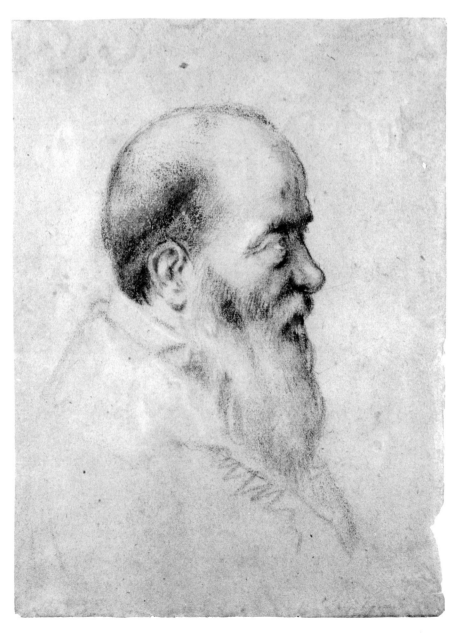

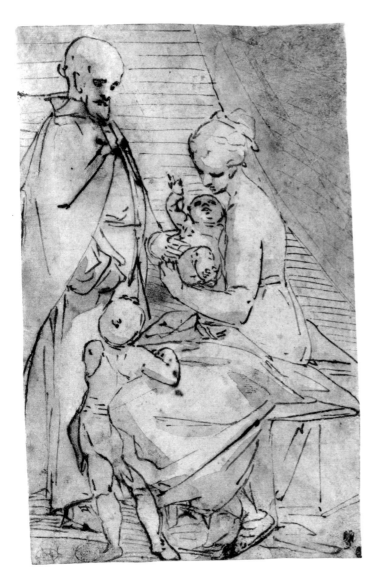

LUCA CAMBIASO
Moneglia 1527 – Madrid 1585

37. *The Holy Family with the Infant Baptist*

Pen and brown ink, brown wash. 24.7 x 15.6 cm. Upper right corner replaced. Lined.

PROVENANCE: Baron Vivant Denon (Lugt 779); A.-P.-E. Gasc (Lugt 1131); Charles Gasc (Lugt 543); Alfred A. De Pass; presented by him to the Royal Institution of Cornwall, Truro (Lugt Supp. 2014e); sale, London, Christie's, November 30, 1965, no. 135; Harry G. Sperling, New York.

Bequest of Harry G. Sperling, 1971
1975.131.13

38. *Chariot of the Rising Sun*

Pen and brown ink, brown wash, over black chalk. Squared in red and a little black chalk. 24.3 x 35.5 cm. Scattered stains; repaired loss at lower center.

Inscribed in pen and brown ink at lower center, *sole oriente.*

PROVENANCE: Purchased in New York in 1962.

Rogers Fund, 1962
62.168

A companion drawing, representing the chariot of the setting sun and inscribed *sole cadente,* was sold at Sotheby's in London on May 21, 1963, no. 131. A copy of the *sole cadente* composition is in the Ecole des Beaux-Arts, Paris (Ancien fonds no. 384).

39. *The Three Fates*

Pen and brown ink. 11.4 x 28.5 cm.

PROVENANCE: Harry G. Sperling, New York.

Bequest of Harry G. Sperling, 1971
1975.131.12

Sole oriente.

DOMENICO CAMPAGNOLA

Venice 1500 – Padua 1564

40. *Landscape with an Old Woman Holding a Spindle*

Pen and brown ink. 25.5 x 37.0 cm. Lined.

Lettered in pen and brown ink at lower margin, right of center, *P.*

PROVENANCE: Prosper Henry Lankrink (Lugt 2090); Mark Oliver; R. E. A. Wilson, London (according to Virch); Walter C. Baker, New York.

BIBLIOGRAPHY: *Drawings by Old Masters. Savile Gallery,* exhibition catalogue, London, 1930, no. 7, repr., as Cariani; Virch, 1962, no. 11.

Bequest of Walter C. Baker, 1971
1972.118.243

Almost exactly the same landscape occurs in a Campagnolesque drawing at Turin (Bertini, 1958, no. 76, repr.).

The Metropolitan Museum possesses a red chalk copy by Antoine Watteau of this Campagnola composition (1972.118.237, bequest of Walter C. Baker; K. T. Parker and J. Mathey, *Antoine Watteau. Catalogue complet de son oeuvre dessiné,* Paris, 1957, I, no. 439, repr.).

DOMENICO CAMPAGNOLA ?

41. *Imaginary Coastal Landscape with Ruins*

Pen and brown ink. 22.2 x 36.0 cm.

Inscribed in pen and brown ink at upper right, *d. Canpagnole;* at lower right, *campagnole* [lower part of inscription cut off].

PROVENANCE: William Sharp (Lugt 2650); purchased in London in 1907.

BIBLIOGRAPHY: Hellman, 1916, pp. 162-164, repr., as Domenico Campagnola; Tietze, 1944, no. 505, as "late shop"; *Landscape in Art,* exhibition catalogue, Columbia Museum of Art, Columbia, South Carolina, 1967, no. 21, repr., as school of Domenico Campagnola.

Rogers Fund, 1907
07.283.15

BERNARDINO CAMPI

Cremona 1522 – Reggio Emilia 1591

42. *Bearded Old Man Seated with Left Arm Extended*

Black chalk, heightened with white, on blue-gray paper. Squared in black chalk. 14.8 x 11.4 cm.

PROVENANCE: H. M. Calmann, London.

Gift of H. M. Calmann, 1961
61.158.1

The facial type and the long, gaunt arms and legs of this figure may be compared with a study by Bernardino for a standing Jupiter in the Ashmolean Museum, Oxford (Parker II, no. 137; repr. T. Pignatti, *Italian Drawings in Oxford,* Oxford, 1977, no. 32). The model in our drawing is close to a seated prophet holding a tablet painted by Bernardino in one of the spandrels in S. Sigismondo, Cremona (repr. A. Perotti, *I pittori Campi da Cremona,* n.p., n.d., p. 74, fig. 48).

VITTORE CARPACCIO

Venice 1460/1465 – Venice ca. 1526

43. *Studies of a Seated Youth in Armor*

Point of brush and gray wash, heightened with white, on blue paper. 19.0 x 18.0 cm. (overall). A horizontal strip averaging .3 cm. in height has been added at the upper margin.

PROVENANCE: Purchased in New York in 1954.

BIBLIOGRAPHY: *Exhibition of Old Master Drawings. P. and D. Colnaghi and Co.,* London, 1954, no. 12, repr.; A. Mongan in *Atti del*

XVIII Congresso Internazionale di Storia dell'Arte, 1955, Venice, 1956, p. 304, fig. 201; G. Fiocco, *Carpaccio,* Novara, 1958, pl. 100; J. Lauts, *Carpaccio, Paintings and Drawings,* London 1962, pp. 273-274, no. 37, pl. 122; *Vittore Carpaccio,* exhibition catalogue, Palazzo Ducale, Venice, 1963, p. 295, no. 14, repr.; Bean, 1964, no. 7, repr.; Bean and Stampfle, 1965, no. 23, repr.; G. Perocco, *L'opera completa del Carpaccio,* Milan, 1967, p. 100, repr.; T. Pignatti, *Vittore Carpaccio,* Milan, 1972, pl. 13; M. Muraro, *I disegni di Vittore Carpaccio,* Florence, 1977, pp. 63-64, fig. 54.

The Elisha Whittelsey Collection
The Elisha Whittelsey Fund, 1954
54.119

Carpaccio has drawn a young model dressed in a full suit of armor and posed as though he were on horseback, his arm raised with indication of a spear in his gloved hand. The artist may have intended to use this study in a composition representing the youthful St. George fighting the dragon, but the saint is quite differently represented in the series of canvases painted for the Scuola di S. Giorgio degli Schiavoni about 1502-1508.

BERNARDO CASTELLO

Albaro 1557 – Genoa 1629

44. *Empty Papal Coat of Arms Surrounded by Angels, Allegorical Figures, and Putti*

Pen and brown ink, brown wash, heightened with white, on blue paper. Squared in black chalk. 32.3 x 15.6 cm. Lined.

PROVENANCE: Jonathan Richardson, Jr. (Lugt 2170); purchased in New York in 1971.

BIBLIOGRAPHY: *Exhibition of Old Master Drawings. Alfred Brod Gallery,* London, 1963, no. 15, repr., as Italian school, 16th century; Bean, 1972, no. 6; M. Newcome, *Genoese Baroque Drawings,* exhibition catalogue, Binghamton, New York, and Worcester, Massachusetts, 1972, no. 18, repr.

Rogers Fund, 1971
1971.142

Mary Newcome has very recently identified this drawing as a study for a ceiling decoration executed by Bernardo Castello in the Quirinal Palace in Rome during the reign of Pope Paul V Borghese (1605-1621). The fresco survives, but the arms of Pius IX (1846-1878) were painted on the shield in the course of the nineteenth-century partial redecoration of the palace. Miss Newcome's interesting discovery will be the subject of a forthcoming publication.

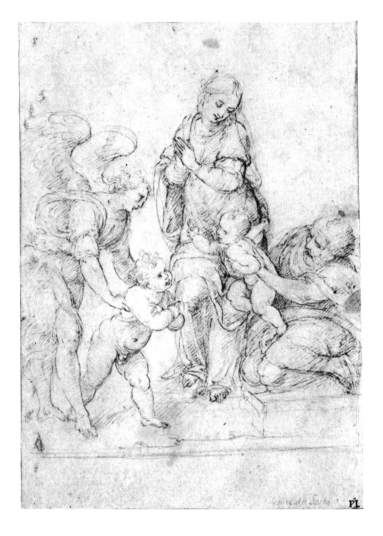

CESARE DA SESTO

Sesto Calende 1477 – Milan 1523

45. *The Holy Family with the Infant Baptist and an Angel*

Pen and brown ink, over red chalk. 16.9 x 12.0 cm. A few brown stains; repaired loss at lower left. Lined.

Inscribed in pencil at lower right, *Cesare da Sesto;* in pen and brown ink at lower margin of old mount, *Cesare da Sesto.*

PROVENANCE: Sir Peter Lely (Lugt 2092); Earls of Pembroke; Pembroke sale, London, Sotheby's, July 5-6, 9-10, 1917, no. 401; Harold K. Hochschild, New York.

BIBLIOGRAPHY: Strong, 1900, part I, no. 5, repr.; H. Williams, Jr., *Metropolitan Museum of Art Bulletin,* August 1940, p. 156; *Metropolitan Museum, Italian Drawings,* 1942, no. 13, repr.

Gift of Harold K. Hochschild, 1940
40.91.4

GIUSEPPE CESARI (Il Cavaliere d'Arpino)

Arpino 1568 – Rome 1640

46. *The Resurrection*

Pen and brown ink, brown wash, heightened with white, over black chalk. 42.2 x 32.5 cm. (overall). A vertical strip averaging 6.0 cm. in width has been added at left. Water stain near upper left margin; scattered tears and losses. Lined.

Inscribed in pen and brown ink at lower margin of old mount, *Cav. D'Arpino;* and *Cavaliere Giuseppe Cesari.*

PROVENANCE: Cephas G. Thompson.

BIBLIOGRAPHY: *Metropolitan Museum Hand-book,* 1895, no. 704, as G. Cesari.

Gift of Cephas G. Thompson, 1887
87.12.34

The traditional attribution to Giuseppe Cesari is certainly correct, and the drawing is in fact a study for one section of the frescoed ceiling decoration in the Olgiati chapel in S. Prassede, Rome, commissioned in 1587, but not executed until 1593-1595. The painting of the Resurrection occupies a vertical rectangular space with an arched top above the cornice over the altar and immediately beneath the vault of the chapel (repr. Venturi, IX, 5, fig. 554). There are notable variations, in the poses of Christ and of the astonished soldiers, between the painting and the preparatory drawing. The latter is unusual for Cesari in technique and degree of elaboration. It is interesting that one of the few surviving pen and wash composition studies by the artist is a design in the Uffizi for the overall decorative scheme of the Olgiati chapel ceiling (906 E; repr. *Il Cavalier d'Arpino,* exhibition catalogue by Herwarth Röttgen, Rome, 1973, no. 70). The Uffizi possesses a study in the artist's favorite medium, red chalk, for the figure of the Risen Christ, in a pose that differs both from the present composition drawing and from the painting (2170 F; H. Röttgen, *op. cit.,* no. 93). A red chalk study in the Louvre may be associated with the figure of the soldier in the right foreground of the Resurrection composition (Inv. 2993, repr. H. Röttgen, *op. cit.,* no. 120).

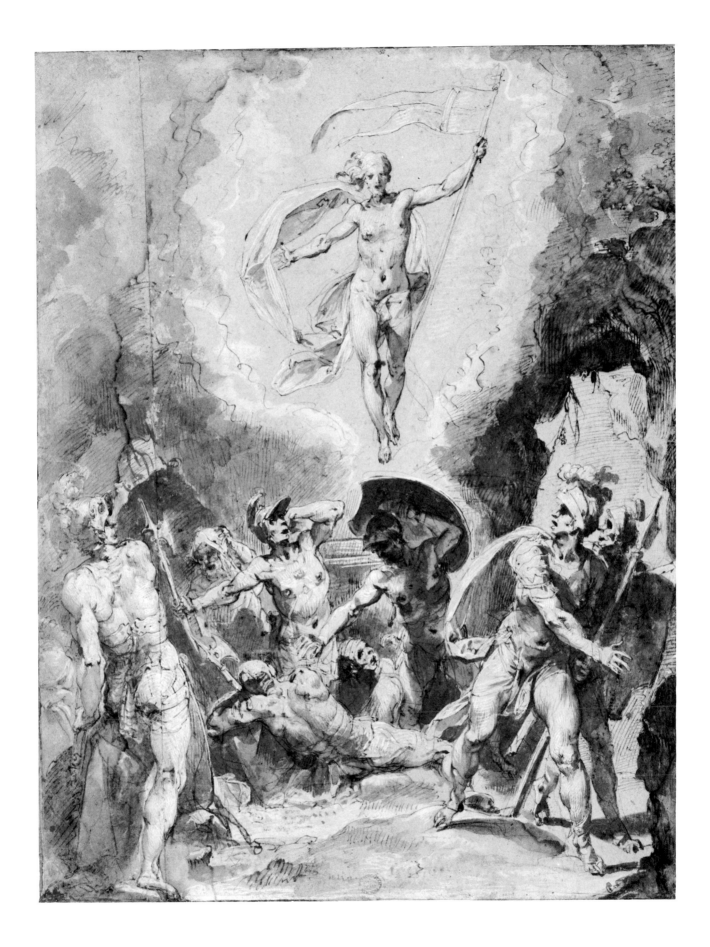

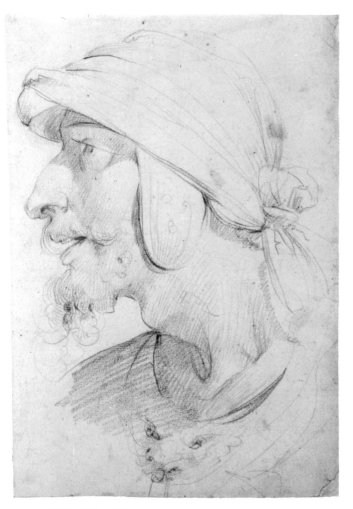

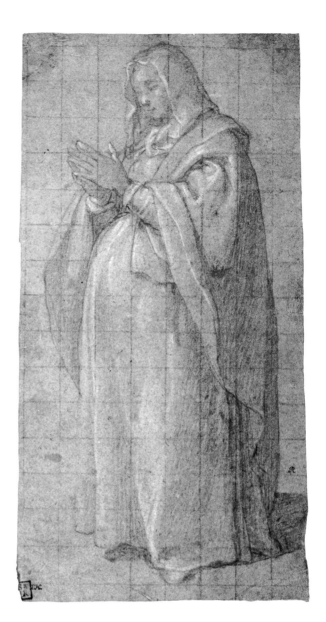

GIUSEPPE CESARI

47. *Head of a Warrior*

Red chalk. 28.2 x 19.4 cm. Lower right corner replaced.

PROVENANCE: Walter C. Baker, New York.

BIBLIOGRAPHY: Virch, 1962, no. 29.

Bequest of Walter C. Baker, 1971
1972.118.247

This drawing was acquired by Walter C. Baker as a work of the "circle of Bellange"; the correct attribution was supplied by Philip Pouncey in 1959. As he put it at the time: "Everything – style, handling, and the sitter's half-witted expression – makes this conclusion inevitable."

BARTOLOMEO CESI
Bologna 1556 – Bologna 1629

48. *Standing Pregnant Woman*

Red chalk, heightened with white, on blue paper. Squared in black chalk. 28.0 x 14.1 cm. Lined.

Inscribed in pen and red ink at lower margin of old mount in Richardson's hand, *Dionisio Calvert*.

PROVENANCE: Jonathan Richardson, Sr. (Lugt 2184 and 2984); Thomas Hudson (Lugt 2432); Sir Joshua Reynolds (Lugt 2364); purchased in New York in 1976.

BIBLIOGRAPHY: *Old Master Drawings. Armando Neerman,* exhibition catalogue, London, 1976, no. 10, repr.

Harry G. Sperling Fund, 1976
1976.187.1

BARTOLOMEO CESI (NO. 48)

Richardson's attribution to Denys Calvaert can be over-looked, for the drawing is a typical example of the chalk draughtsmanship of Bartolomeo Cesi. In fact it is a study for the Pregnant Virgin (*la Beata Vergine in atto di gravidanza*) painted in fresco by the artist in the church of the Madonna di Miramonte, Bologna, and at the suppression of that church moved to the Chiostro delle Madonne of the Bologna Certosa (Malvasia, 1686, pp. 136-137, fig. 206/9, repr. with incorrect caption). The correspondence with the fresco is quite close, though in the fresco the Virgin holds an open book in her joined hands.

Alberto Graziani, who identified the fresco in the Certosa as Cesi's work, suggested that a pen and wash drawing in the Uffizi was a preparatory study for this somewhat unusual representation (Uffizi 12736 F; Gernsheim photograph 21374; A. Graziani, *Critica d'arte*, XX-XXII, 1939, pp. 85, 95). However, the Uffizi drawing represents the Annunciation in a space occupied in part by a dedicatory tablet. The Virgin is of course not yet pregnant, though her stance and drapery are paralleled in our drawing and the fresco.

AGOSTINO CIAMPELLI
Florence 1565 – Rome 1630

49. *The Martyrdom of St. Clement I, Pope*

Pen and brown ink, brown wash, heightened with white, over black chalk, on brownish paper. 28.6 x 44.3 cm. Arched top. Lined.

PROVENANCE: Karl Ewald Hasse (Lugt 860); purchased in New York in 1979.

BIBLIOGRAPHY: *Dessins anciens. Pietro Scarpa, Venise,* exhibition catalogue, Grand Palais, Paris, 1978, no. 28, repr.; S. Prosperi Valenti Rodinò in *Disegni dei toscani a Roma (1580-1620),* exhibition catalogue, Gabinetto Disegni e Stampe degli Uffizi, Florence, 1979, p. 63, under no. 40.

Harry G. Sperling Fund, 1979
1979.286.2

Study, with notable variations, for a fresco painted by Ciampelli in 1596-1597 on one of the end walls of the Canon's Sacristy in S. Giovanni in Laterano, Rome, on the commission of Pope Clement VIII Aldobrandini (repr. *Paragone,* XXIII, 265, 1972, pl. 57). The lunette-shaped fresco is pierced by a central door, and the reserves at lower left and right in the drawing indicate places for cupboards.

The apocryphal acts of Pope Clement I (died ca. A.D. 99) recount that he was banished by Trajan to Crimea where he had to work in the quarries. As the nearest

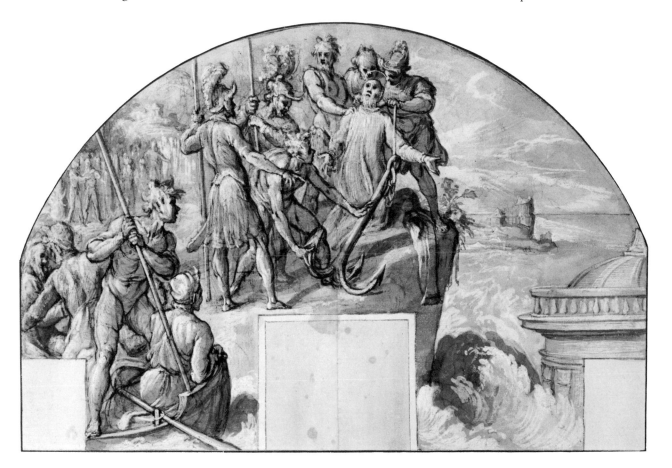

drinking water was six miles away, Clement miraculously found a nearer spring for the use of the numerous Christian captives (the subject of Ciampelli's fresco on the opposite end wall of the sacristy). Clement preached among the people with great success and was therefore thrown into the sea with an anchor tied round his neck. Angels built him a tomb beneath the waves which once a year was revealed by a miraculous ebbing of the tide. These last two events are recorded in our drawing and the related fresco.

This composition study seems to be the only surviving preparatory drawing by Ciampelli for his work in the Lateran sacristy.

IL CIGOLI (Ludovico Cardi)

Castelvecchio di Cigoli 1559 – Rome 1613

50. *Study for a Male Figure Lowered into a Grave*
VERSO. *Kneeling Female Figure in Profile to Left*

Point of brush, blue wash, heightened with white, over black chalk, on blue paper. 24.9 x 39.1 cm. Water stains at left margin; horizontal crease above lower margin.

Inscribed in pen and brown ink at upper margin, *vignali*; in pen and black ink at lower margin of the Ottley mount, *Jacopo Vignali Pittore.* (recto), and *Jacopo Vignali.* (verso).

PROVENANCE: William Young Ottley (the drawing on an Ottley mount, see Lugt Supp. 2662); Ottley sale, London, T. Philipe, June 6-23, 1814, no. 1409, as Jacopo Vignali; Sir Thomas Lawrence (Lugt 2445); H. M. Calmann, London; sale, London, Christie's, April 7, 1981, no. 49, purchased by the Metropolitan Museum.

Harry G. Sperling Fund, 1981
1981.128

The figures on both recto and verso are studied for the *Burial of St. Paul* painted by Cigoli for the apse of S. Paolo fuori le Mura, Rome. The painting was commissioned in 1606-1607, and, though unfinished at Cigoli's death, it was placed in the apse of the basilica where it remained until the destructive fire of 1823. The painting, considered by Cigoli's contemporaries to be one of his masterpieces, is documented in a group of preparatory studies preserved in the Uffizi (see M. L. Chappell in *Disegni*

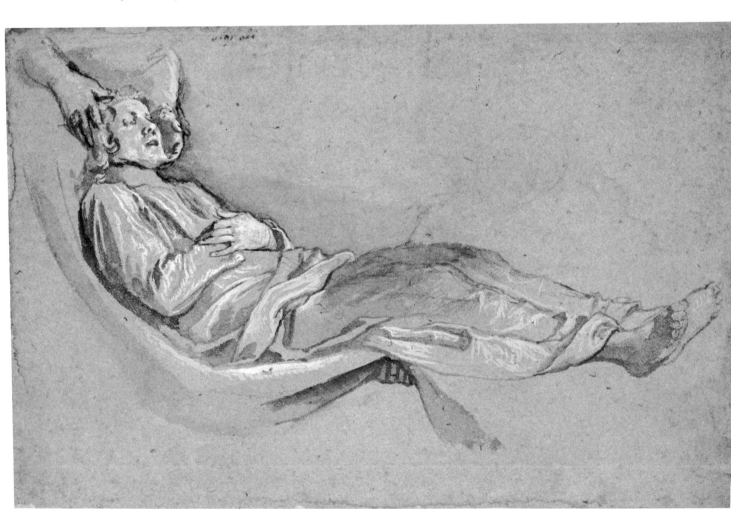

dei toscani a Roma, 1580-1620, exhibition catalogue, Gabinetto Disegni e Stampe degli Uffizi, Florence, 1979, nos. 98-103).

On the recto, a studio assistant reclining in a hammock (?) is studied for the figure of St. Paul being lowered into his tomb. The two hands at upper left indicate the action of reuniting St. Paul's head with his body at the moment of burial (the Apostle was beheaded), while the hand indicated below the figure's knees is intended for one of the bearers of the corpse. The kneeling figure on the verso is a Roman matron who assists devoutly at the interment.

In style and in technique (blue wash on blue paper) the drawing is characteristic of the draughtsmanship of the mature Cigoli, and the mistaken old attribution to Jacopo Vignali can perhaps be explained by the preponderant influence of Cigoli on the work of that Florentine artist of the following generation.

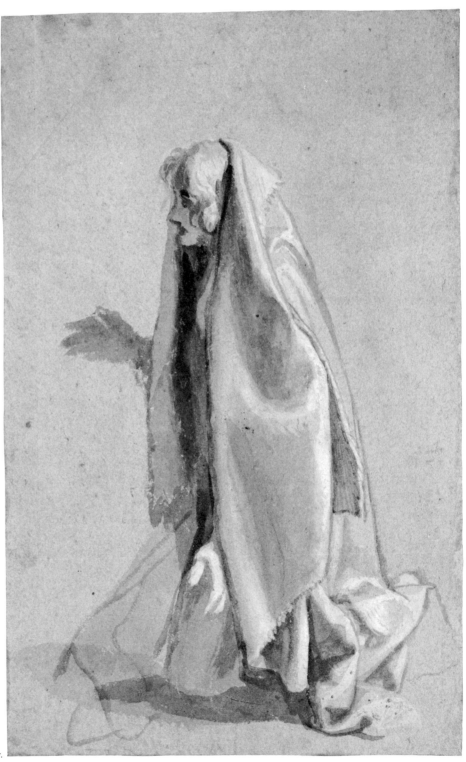

50 v.

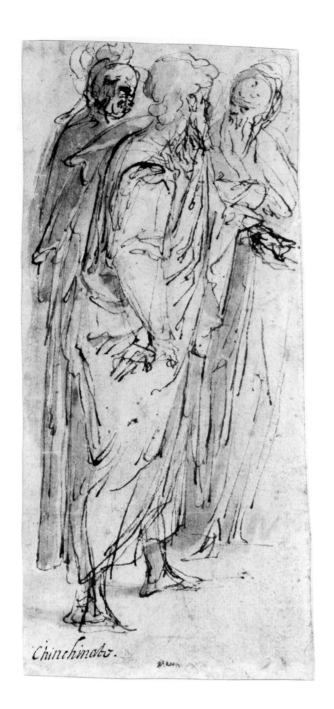

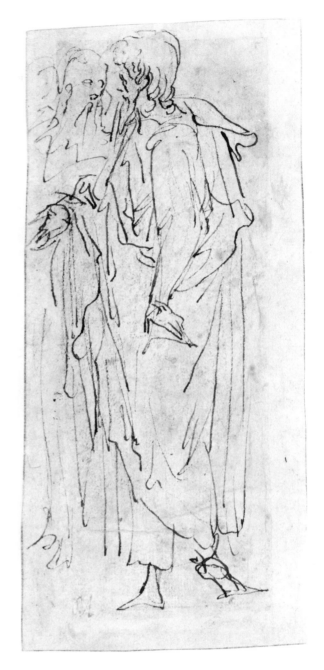

ROMULO CINCINNATO

Florence ca. 1540 – Madrid 1597 ?

51. *Three Standing Male Figures*
VERSO. *Two Standing Male Figures*

Pen and brown ink, brown wash (recto); pen and brown ink, over a
little black chalk (verso). 20.3 x 9.2 cm.

Inscribed in pen and brown ink at lower left, *Chinchinato*.

PROVENANCE: Prof. Einar Perman, Stockholm; purchased in Stockholm in 1970.

BIBLIOGRAPHY: Bean, 1972, no. 7; Macandrew, 1980, p. 258, under no. 200.

Rogers Fund, 1970
1970.101.1

The old inscription, very plausibly attributing the drawings to Cincinnato, appears to be in the same hand as an old attribution to this artist on a drawing in the Ashmolean Museum, Oxford (*Raising of Lazarus;* Parker II, no. 200, pl. XLVIII), and on another that was formerly at Gijón (*Martyrdom of the Theban Legion;* repr. A. E. Pérez Sánchez, *Catálogo de la colección de dibujos del Instituto Jovellanos de Gijón,* Madrid, 1969, p. 51, no. 67, pl. 106). Cincinnato worked extensively in Spain, and the Spanish form of his name, *Chinchinato,* rather than the Italian, *Cincinnato,* is used in all three inscriptions. The following drawings, Nos. 52 and 53 below, were acquired by the Metropolitan at the same time as the sheet described here. The attribution of Nos. 52 and 53 to Cincinnato is traditional, though they bear no inscriptions. In any case, their style is compatible with that of the present drawing.

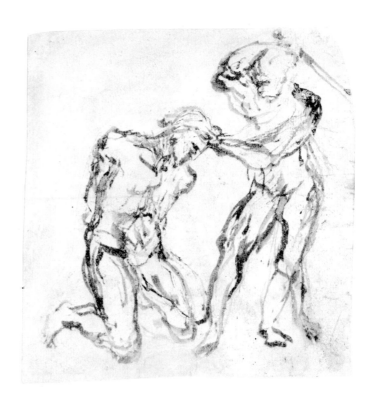

52. *Christ Crowned with Thorns*

Brush and brown wash. 13.3 x 12.9 cm. Upper left corner replaced. Water stain at center of lower margin.

PROVENANCE: Prof. Einar Perman, Stockholm; purchased in Stockholm in 1970.

Rogers Fund, 1970
1970.101.2

See No. 51 above.

53. *Standing Male Figure with Right Arm Extended*

Pen and brown ink (recto); seated male figure in pen and brown ink on verso (in part cut off). 18.5 x 9.9 cm. Margins extremely irregular.

PROVENANCE: Prof. Einar Perman, Stockholm; purchased in Stockholm in 1970.

Rogers Fund, 1970
1970.101.3

See No. 51 above.

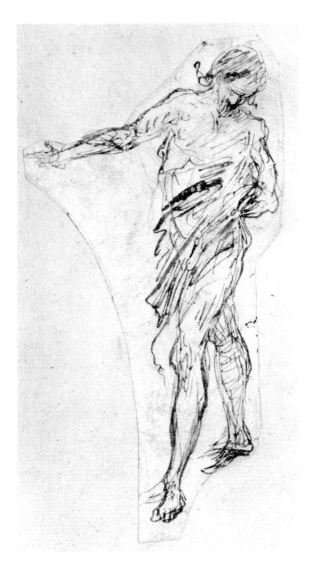

BELISARIO CORENZIO

Naples ca. 1560 – Naples ca. 1643

54. *Mounted Warrior with a Baton Giving Orders to His Troops*

Pen and brown ink, blue wash, over black chalk. Squared in black chalk. 26.9 x 39.2 cm. All four corners cut off. A few tears and some foxing.

Inscribed in pen and brown ink at lower margin, *più lontano un da l'altro.*

PROVENANCE: Sale, London, Sotheby's, July 1, 1936, part of no. 95; Sir Robert Witt; purchased in New York in 1966.

BIBLIOGRAPHY: *Old Master Drawings. H. Shickman Gallery,* exhibition catalogue, New York, 1966, no. 14, repr.; W. Vitzthum, *Disegni napoletani del Sei e del Settecento nel Museo di Capodimonte,* exhibition catalogue, Naples, 1966, mentioned p. 9; Vitzthum, Florence, 1967, mentioned p. 16.

Rogers Fund, 1966
66.127

This drawing and No. 55 below were part of a group of eleven "Scenes from the Life of Don John of Austria, and relating to the Battle of Lepanto, 1571" sold at Sotheby's in London on July 1, 1936, as lot no. 95. They were purchased by Sir Robert Witt who retained only three of the drawings; these three are now in the Witt Collection at the Courtauld Institute, London (nos. 2789A, repr. *Burlington Magazine,* CIII, 1961, p. 315, fig. 22; 2789B; 2789C). Of the remaining eight, two found their way to the Metropolitan Museum, one is in the collection of Joseph McCrindle, New York (from the Blunt collection, see *The Sir Anthony Blunt Collection,* exhibition catalogue, Courtauld Institute Galleries, London, 1964, no. 8), while the present whereabouts of five is unknown. All six here mentioned are characterized by a delicate use of transparent blue wash contrasting with a rather fine brown pen line. The old attribution to Coren-

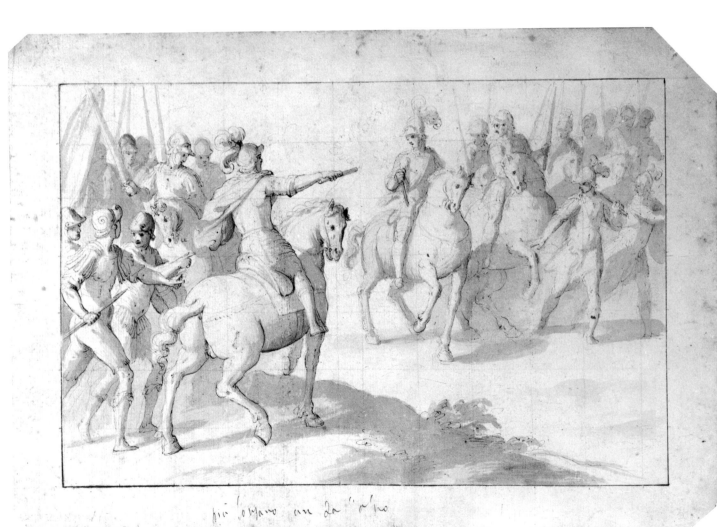

zio was supported by Walter Vitzthum, the specialist in such questions. He thought, as well, that the identification of the subject as a narrative cycle devoted to Don John of Austria, natural son of Charles V, captain general of the allied fleet that defeated the Turks at Lepanto and resident of Naples from 1573 to 1576, was quite plausible. To this narrative series he assigned an early date in Corenzio's career when Tuscan influence was paramount in his draughtsmanship. Similarity of style and subject matter led Vitzthum to associate two further drawings with the Don John series: *Moors or Turks Paying Homage to a Victorious General* in the Cooper-Hewitt Museum (no. 1938-88-7080; repr. *The Two Sicilies, Drawings from the Cooper-Hewitt Museum,* exhibition catalogue, Finch College Museum of Art, New York, 1970, no. 1), and a *Battle Scene* in the Biblioteca Nacional, Madrid (A. M. de Barcia, *Catálogo de la colección de dibujos originales de la Biblioteca Nacional,* Madrid, 1906, no. 8105, as anonymous Italian).

55. *Battle Scene*

Pen and brown ink, blue wash, over black chalk. Squared in black chalk. 25.4 x 37.5 cm. Scattered stains.

Numbered in pencil at lower left corner, *2789 1.*

PROVENANCE: Sale, London, Sotheby's, July 1, 1936, part of no. 95; Sir Robert Witt; sale, London, Christie's, June 25, 1968, no. 25; purchased in New York in 1968.

Rogers Fund, 1968
68.203

See No. 54 above.

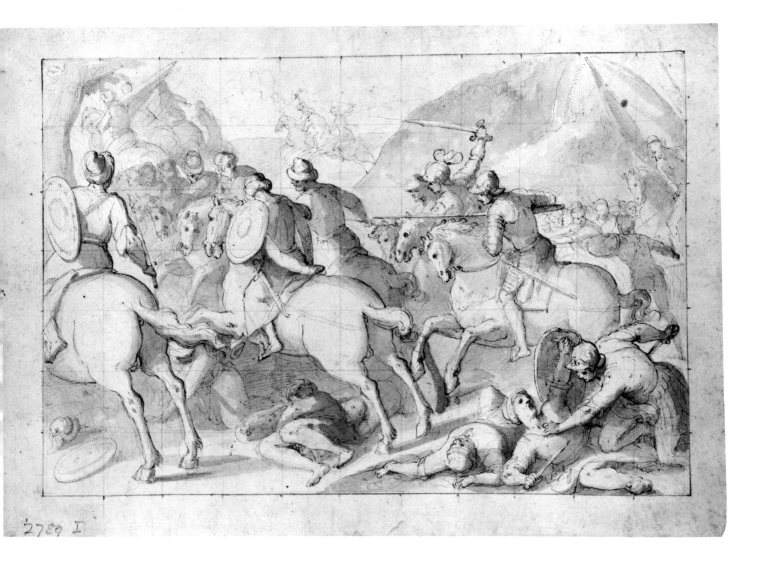

2789 I

56. *Study for the Decoration of an Apse: Saints and Angels in Glory with God the Father Above*

Brush, blue and brown wash, heightened with white, over a little black chalk, on beige paper. 38.6 x 56.2 cm. The support consists of four sheets of paper joined horizontally and vertically at center. Scattered stains, tears, and losses. Lined.

Inscribed in pen and brown ink at lower margin of old mount, *Belizarius.*

PROVENANCE: Purchased in London in 1963.

Rogers Fund, 1963
63.76.2

A typical and rather run-of-the-mill example of Corenzio's painterly draughtsmanship of the mature and late years. This is no doubt a project for one of the innumerable decorative schemes that Corenzio executed in Naples.

57. *The Presentation of the Virgin in the Temple*

Pen and brown ink, brown wash, heightened with white, on gray-green paper. 14.1 x 20.4 cm. Some repaired losses.

Inscribed in pen and brown ink at lower right, *Belisario 22*; numbered on verso, 68.

PROVENANCE: Don Sebastien Gabriel de Borbón y Braganza (1811-1875); Don Pedro Alcántara de Borbón y Borbón, Duke of Dúrcal (1862-1892); Dúrcal sale, New York, American Art Galleries, April 10, 1889, part of no. 207, as Belisario Corencio, "A bishop giving alms at the door of a church"; Henry Walters.

Gift of Henry Walters, 1917
17.236.3

Some of the scenes of the life of the Virgin painted by Corenzio in the church of S. Maria la Nova in Naples are rectangular in format like the present drawing (see D.

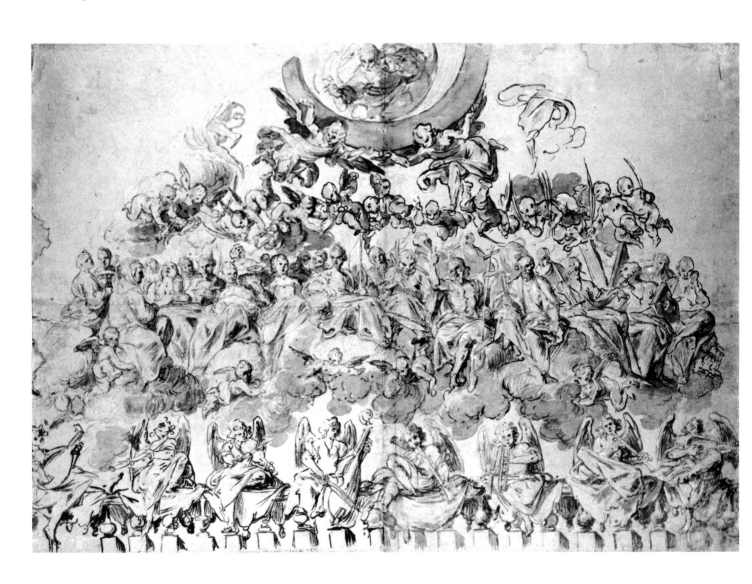

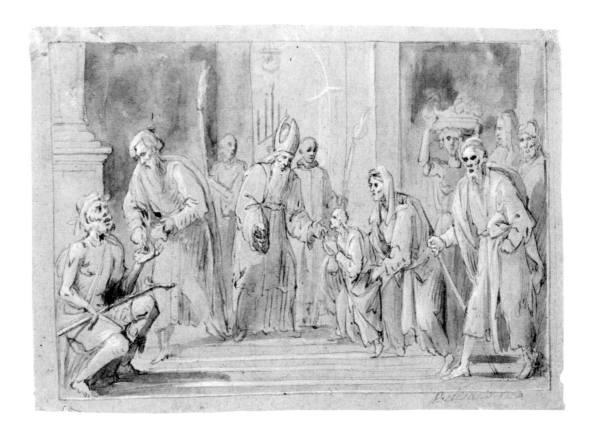

Capone, O.F.M., *La chiesa di S. Maria la Nova, il soffitto,* Naples, 1978, pls. X-XIII). However, Father Capone kindly informs us that the representation of the *Presentation of the Virgin in the Temple* in S. Maria la Nova is a large vertical composition in the choir differing in a great many ways from the present design.

58. *Study for a Pendentive: Figures of St. Peter and St. Paul*

Brush and brown wash, heightened with white, on blue paper. 25.9 x 21.5 cm. Margins irregular, cut to the shape of a pendentive. Vertical crease at center; a number of brown stains; several repaired losses.

Inscribed in pen and brown ink on cartouche held by putti above, *Belisario Co....*

PROVENANCE: Don Sebastien Gabriel de Borbón y Braganza (1811-1875); Don Pedro Alcántara de Borbón y Borbón, Duke of Dúrcal (1862-1892); Dúrcal sale, New York, American Art Galleries, April 10, 1889, part of no. 207, as Belisario Corencio; Henry Walters.

Gift of Henry Walters, 1917
17.236.2

CORREGGIO (Antonio Allegri)

Correggio 1489/1494 – Correggio 1534

59. *The Adoration of the Magi*

Red chalk, heightened with white. 29.1 x 19.7 cm. Scattered losses.
Lined.

Inscribed in pen and brown ink on Pembroke mount, *Cor: first manner*
*Vol: 2.*nd *13* (indicating the drawing's place in the Pembroke albums).

PROVENANCE: Sir Peter Lely (Lugt 2092); Earls of Pembroke; Pem-
broke sale, London, Sotheby's, July 5-6, 9-10, 1917, no. 464,
purchased by the Metropolitan Museum.

BIBLIOGRAPHY: Strong, 1900, part II, no. 14, repr.; Sturge Moore,
1906, pp. 215, 262-263; Ricci, 1930, p. 184, as Bertoia ?; *Metropoli-*
tan Museum, Italian Drawings, 1942, no. 20, repr.; Heaton-Sessions,
1954, pp. 224-225, fig. 5, as not by Correggio; Popham, 1957, pp.
16, 56, 150, no. 5, pl. VI; Bean, 1964, no. 16, repr.; Bean and
Stampfle, 1965, no. 66, repr.

Hewitt Fund, 1917
19.76.10

An early drawing by Correggio, datable toward the end
of the second decade of the sixteenth century. Red chalk
and white highlights are used to create the soft luminos-
ity that also characterizes Correggio's paintings of this
same period. Popham has suggested that the drawing
may be a stage of the artist's preparation for the *Adoration*
of the Magi, now in the Brera in Milan (repr. Popham,

1957, p. 18, fig. 3) and has drawn attention to the
Northern influences apparent in both the drawing and
the picture — echoes of Hugo van der Goes in composi-
tion and of Dürer in several details. The prototype of the
rather awkwardly drawn horse may be Mercury's steed in
the *Parnassus* of Mantegna, now in the Louvre. Doubts
about Correggio's authorship of this drawing have occa-
sionally been expressed: Ricci, who presumably knew
the drawing only through a reproduction, proposed an
untenable attribution to Bertoia; Mrs. Heaton-Sessions
questioned the drawing without suggesting an alterna-
tive solution. Popham, however, has insisted on the
authenticity of the drawing. The way in which chalk and
white lights are used, the facial notations, and the treat-
ment of the drapery all proclaim this drawing to be an
original by Correggio, and to be an early work in which
some of the most striking pictorial elements of his ma-
ture style are already present.

60. *The Annunciation*

Pen and black ink, gray wash, extensively heightened with white, on
red-washed paper. Squared in red chalk. 9.5 x 17.2 cm. Some repaired
losses.

CORREGGIO (NO. 60)

Inscribed in pen and ink on Pembroke mount (now lost), . . . *from vol 2:ⁿᵈ No 11* (indicating the drawing's place in the Pembroke albums).

PROVENANCE: Earls of Pembroke; Pembroke sale, London, Sotheby's, July 5-6, 9-10, 1917, no. 465, purchased by the Metropolitan Museum.

BIBLIOGRAPHY: Strong, 1900, Part III, no. 25, repr.; Sturge Moore, 1906, pp. 121, 217, repr. opposite p. 242; Burroughs, 1919, pp. 136-137, repr.; Ricci, 1930, p. 167, pl. CCLIIb; *Metropolitan Museum, Italian Drawings,* 1942, no. 19, repr.; *Metropolitan Museum, European Drawings,* 1944, no. N.S.8, repr.; Heaton-Sessions, 1954, p. 224, fig. 1; Popham, 1957, pp. 63, 159, no. 49, pl. LVa; Bean, 1964, no. 18, repr.; Bean and Stampfle, 1965, no. 68, repr.; C. Gould, *The Paintings of Correggio,* London, 1976, p. 268, pl. 94B.

Hewitt Fund, 1917
19.76.9

In this small brush drawing Correggio suggests with magical ease and authority the pictorial effect of the fresco for which it is a study. The drawing, a miniature *modello,* must represent one of the last stages in the artist's preparation for the lunette painted for the church of the Annunziata at Capo di Ponte in Parma, now exhibited in a much-damaged state in the gallery of that city (repr. Popham, 1957, pl. LVb; C. Gould, *op. cit.,* pl. 94A). The fresco and the present drawing are dated about 1522-1524 by Popham, who compares them to Correggio's contemporary work in S. Giovanni Evangelista in Parma. Several of the artist's preparatory drawings for this latter enterprise display the same vigorous and summary use of thick white highlights to indicate modeling in light and shade.

61

BALDASSARE CROCE

Bologna ca. 1558 – Rome 1628

61. *Thanksgiving for the Acquittal of Susanna* (Daniel 13:63)

Black chalk, brown wash, heightened with white, on brownish paper. 32.2 x 25.1 cm. Upper right and left, and lower right corners replaced; several repaired losses; surface somewhat abraded. Lined.

PROVENANCE: James Jackson Jarves; Cornelius Vanderbilt.

BIBLIOGRAPHY: *Metropolitan Museum Hand-book,* 1895, no. 413, as Tintoretto.

Gift of Cornelius Vanderbilt, 1880
80.3.413

Philip Pouncey rescued this drawing from anonymity in 1968 when he identified it as a preparatory study by Baldassare Croce for one of the scenes in the story of Susanna and the Elders painted by Croce in fresco on the walls of the nave and inner façade of S. Susanna in Rome (M. C. Abromson, *Painting in Rome during the Papacy of Clement VIII . . . ,* New York and London, 1981, pp. 139-141, figs. 132-133). The decoration of the nave was commissioned from Croce by Girolamo Cardinal Rusticucci in 1598. In this scene, the last of the cycle, Susanna, her parents, and her husband give thanks to God for her acquittal; in the fresco Susanna, instead of kneeling on the lowest step in the right foreground as she does in the drawing, occupies a more conspicuous and central position facing the spectator.

FRANCESCO CURIA

Naples 1538 – Naples ca. 1610

62. *The Annunciation*

Pen and brown ink, traces of black chalk. 19.4 x 16.0 cm. Scattered stains.

PROVENANCE: Nicodemus Tessin, the younger, Stockholm; Count Carl Gustav Tessin, Stockholm; Baron Jean-Gabriel Sack, Bergshammar (brother-in-law of Count Carl Gustav Tessin); Baron C. Sack, Bergshammar; Prof. Einar Perman, Stockholm; purchased in Stockholm in 1970.

BIBLIOGRAPHY: Vitzthum, Florence, 1967, p. 14, under no. 1.

Rogers Fund, 1970
1970.101.4

This and the following seven pen sketches (Nos. 63-69 below) figured in an album containing "97 pezzi di Francesco Curia" that was in Sweden in the eighteenth century, belonging first to Nicodemus Tessin, the younger, and then to his son Carl Gustav. It seems to have been broken up in the latter's lifetime. Eighty-two of these sheets are now in the Nationalmuseum in Stockholm; those in the Metropolitan Museum came to New York by way of a Swedish collector who acquired them from a collateral descendant of Tessin.

Per Bjurström and Walter Vitzthum have pointed out the importance of this group of drawings, which forms a touchstone for our knowledge of Curia as a draughtsman; one of the Stockholm sketches is on a letter addressed to Curia, and another is a study for a painting in the Duomo at Naples (P. Bjurström, *Italienska Barockteckningar,* exhibition catalogue, Nationalmuseum, Stockholm, 1965, p. 21, no. 81). A *Scene of Baptism* from the Stockholm group is reproduced in the catalogue of an exhibition of *Drawings from Stockholm* (New York, Boston, Chicago, 1969, no. 23) as is a *God the Father and Other Figure Studies* in the exhibition catalogue *Dessins du Nationalmuseum de Stockholm* (Paris, Brussels, Amsterdam, 1970-1971, no. 21).

FRANCESCO CURIA

63. *Lamentation over the Dead Christ*

Pen and brown ink, violet wash, over traces of black chalk. 13.6 x 16.6 cm. Upper and lower margins irregular.

PROVENANCE: Nicodemus Tessin, the younger, Stockholm; Count Carl Gustav Tessin, Stockholm; Baron Jean-Gabriel Sack, Bergshammar (brother-in-law of Count Carl Gustav Tessin); Baron C. Sack, Bergshammar; Prof. Einar Perman, Stockholm; purchased in Stockholm in 1970.

BIBLIOGRAPHY: Vitzthum, Florence, 1967, p. 14, under no. 1.

Rogers Fund, 1970
1970.101.5

See No. 62 above.

64. *Woman Kneeling before a Standing Man, and Supplicant Kneeling before an Enthroned Male Figure*

Pen and brown ink. 11.7 x 19.6 cm. Scattered stains.

On verso, text of a letter beginning, *Padron mio Ho Pensato che*

PROVENANCE: Nicodemus Tessin, the younger, Stockholm; Count Carl Gustav Tessin, Stockholm; Baron Jean-Gabriel Sack, Bergshammar (brother-in-law of Count Carl Gustav Tessin); Baron C.

Sack, Bergshammar; Prof. Einar Perman, Stockholm; purchased in Stockholm in 1970

BIBLIOGRAPHY: Vitzthum, Florence, 1967, p. 14, under no. 1.

Rogers Fund, 1970
1970.101.6

See No. 62 above.

65. *Standing and Kneeling Figures, and Studies of Flying Putti*

Pen and brown ink, a little black chalk. 19.3 x 28.5 cm.

PROVENANCE: Nicodemus Tessin, the younger, Stockholm; Count Carl Gustav Tessin, Stockholm; Baron Jean-Gabriel Sack, Bergshammar (brother-in-law of Count Carl Gustav Tessin); Baron C. Sack, Bergshammar; Prof. Einar Perman, Stockholm; purchased in Stockholm in 1970.

BIBLIOGRAPHY: Vitzthum, Florence, 1967, p. 14, under no. 1.

Rogers Fund, 1970
1970.101.7

See No. 62 above.

64

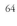
65

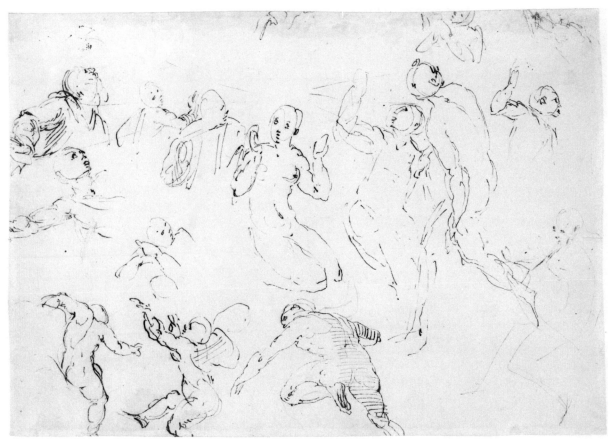

66. *Figure Studies: Warrior on Horseback, and Groups of Standing Female Figures*

Pen and brown ink, brown wash. 20.2 x 27.5 cm. Scattered stains, tears, and creases.

Numbered in pen and brown ink at lower right, *116*.

PROVENANCE: Nicodemus Tessin, the younger, Stockholm; Count Carl Gustav Tessin, Stockholm; Baron Jean-Gabriel Sack, Bergshammar (brother-in-law of Count Carl Gustav Tessin); Baron C. Sack, Bergshammar; Prof. Einar Perman, Stockholm; purchased in Stockholm in 1970.

BIBLIOGRAPHY: Vitzthum, Florence, 1967, p. 14, under no. 1; Bean, 1972, no. 12.

Rogers Fund, 1970
1970.101.8

See No. 62 above.

67. *Figure Studies: The Holy Family, a Running or Dancing Child, Drapery Studies*

Pen and brown ink, pale violet wash. 18.8 x 27.0 cm. Repaired losses; scattered stains and creases.

PROVENANCE: Nicodemus Tessin, the younger, Stockholm; Count Carl Gustav Tessin, Stockholm; Baron Jean-Gabriel Sack, Bergshammar (brother-in-law of Count Carl Gustav Tessin); Baron C. Sack, Bergshammar; Prof. Einar Perman, Stockholm; purchased in Stockholm in 1970.

BIBLIOGRAPHY: Vitzthum, Florence, 1967, p. 14, under no. 1.

Rogers Fund, 1970
1970.101.9

See No. 62 above.

68. *Figure Studies: Woman Carrying a Basket, Woman Carrying a Vase, and Woman Seated at a Table*

Pen and brown ink, violet wash. 18.5 x 25.2 cm. Scattered stains.

PROVENANCE: Nicodemus Tessin, the younger, Stockholm; Count Carl Gustav Tessin, Stockholm; Baron Jean-Gabriel Sack, Bergshammar (brother-in-law of Count Carl Gustav Tessin); Baron C. Sack, Bergshammar; Prof. Einar Perman, Stockholm; purchased in Stockholm in 1970.

66

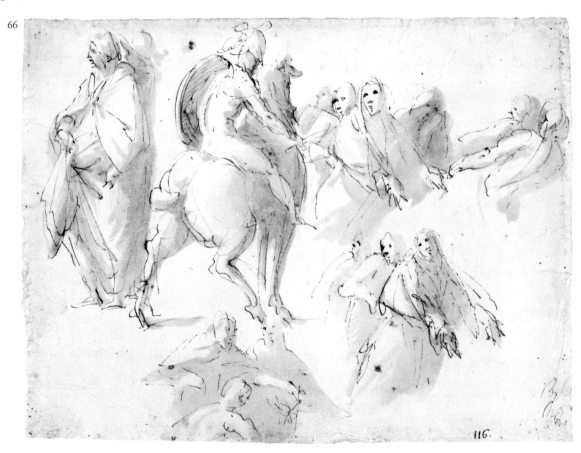

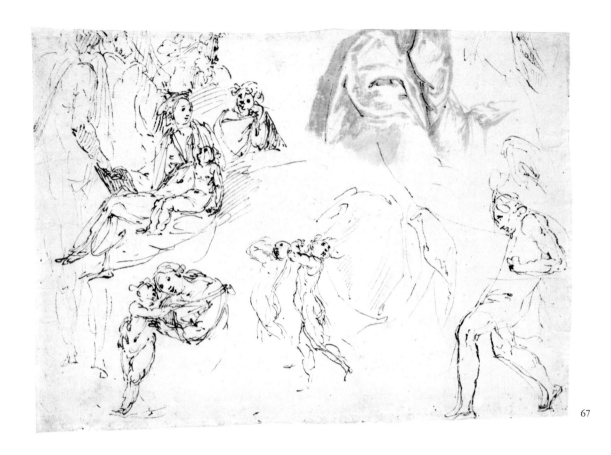

67

68

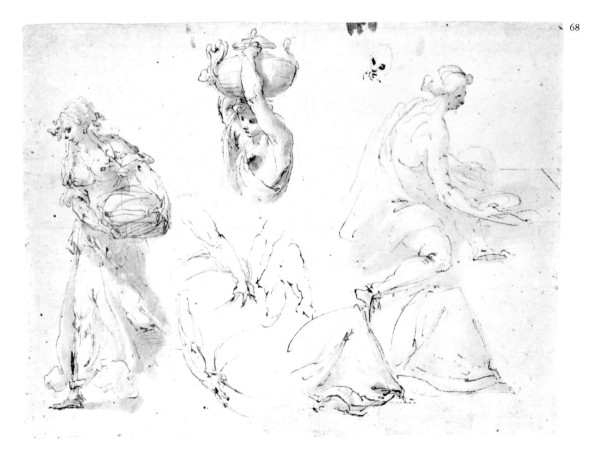

69

FRANCESCO CURIA (NO. 68)

BIBLIOGRAPHY: Vitzthum, Florence, 1967, p. 14, under no. 1; Bean, 1972, no. 13.

Rogers Fund, 1970
1970.101.10

See No. 62 above.

69. *Standing and Seated Figures*

Pen and brown ink. 12.0 x 16.9 cm.

Inscribed in pen and brown ink at lower right, *fr. .cesco curia.*

PROVENANCE: Nicodemus Tessin, the younger, Stockholm; Count Carl Gustav Tessin, Stockholm; Baron Jean-Gabriel Sack, Bergshammar (brother-in-law of Count Carl Gustav Tessin); Baron C. Sack, Bergshammar; Prof. Einar Perman, Stockholm; purchased in Stockholm in 1970.

BIBLIOGRAPHY: Vitzthum, Florence, 1967, p. 14, under no. 1.

Rogers Fund, 1970
1970.101.11

See No. 62 above.

70. *The Last Supper*

Pen and brown ink, brown wash, on beige paper. 30.1 x 26.4 cm. Vertical crease at right of center; scattered tears and losses. Lined.

Inscribed in pencil on reverse of old mount, *F. Curia.*

PROVENANCE: Don Sebastien Gabriel de Borbón y Braganza (1811-1875); Don Pedro Alcántara de Borbón y Borbón, Duke of Dúrcal (1862-1892); Dúrcal sale, New York, American Art Galleries, April 10, 1889, no. 210, as Francisco Curia; Henry Walters.

Gift of Henry Walters, 1917
17.236.37

The draughtsmanship here is a great deal less vivacious and the figures more stilted than in the lively pen sketches reproduced above (Nos. 62-69). We can recognize, however, Curia's distinctive hand in this rather stiff compositional exercise. Three similarly finished drawings with old attributions to Curia are in the British Museum: a *Madonna and Child with Saints,* a *Pentecost,* and a *Presentation of Jesus in the Temple* (1946-7-13-323, 1946-7-13-324, 1946-7-13-325: A. E. Popham, *Catalogue of Drawings in the Collection Formed by Sir Thomas Phillipps . . . ,* London, 1935, p. 51, nos. 1-3).

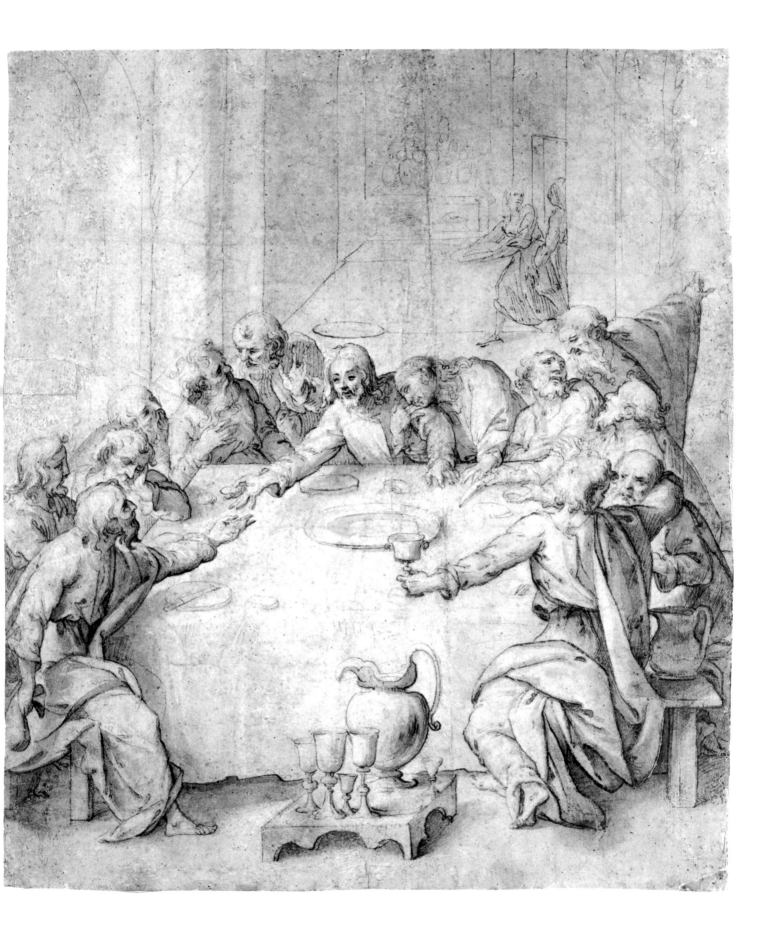

DOMENICO VENEZIANO ?

Venice ca. 1410 – Florence 1461

71. *Standing Youth Holding a Club*

Brush and gray wash, heightened with white, on faded blue paper (recto); fragment of the Temptation of Adam and Eve on verso, in pen and brown ink, over black chalk, on blue paper that has not faded. 21.0 x 9.7 cm.

PROVENANCE: James Jackson Jarves; Cornelius Vanderbilt.

BIBLIOGRAPHY: *Metropolitan Museum Hand-book,* 1895, no. 115, as Pollaiuolo; Degenhart, 1941-1942, pp. 79-85, as circle of Domenico Veneziano; Degenhart, 1959, pp. 100-101, recto fig. 14 (before restoration); Degenhart and Schmitt, 1968, I-2, no. 341, I-4, pl. 294, recto and verso repr. (before restoration); Bellosi, 1978, p. xxv, not Domenico Veneziano; Wohl, 1980, p. xxv, not Domenico Veneziano.

Gift of Cornelius Vanderbilt, 1880
80.3.115

Like No. 72 below, this drawing was first attributed to Domenico Veneziano by Bernhard Degenhart in 1941, and he reiterated this attribution in 1959 and 1968. His proposal has not met with acceptance by other specialists, but the drawings are classified here under the name of Domenico Veneziano because of the lack of any positive alternative. Berenson ascribed no drawings to Domenico Veneziano nor does Hellmut Wohl in his recent monograph on the artist. Wohl comments: "The absence of drawings – Domenico Veneziano must have been a tireless as well as brilliant draftsman – is the oddest of the many gaps in our knowledge of this great artist."

Since the drawings were reproduced by Degenhart in 1959 and 1968, the foxing that disfigured the sheets has been removed, but even in their improved state they appear to be fairly mediocre products of some late fifteenth-century Florentine studio. In addition, Luciano Bellosi remarks that the sketch of Adam and Eve on the verso of this sheet has an outright sixteenth-century air to it.

72. *Standing Youth Leaning on a Long Staff*

Brush and gray wash, heightened with white, on faded blue paper. Faint black chalk sketch of a seated man on verso. 21.1 x 11.0 cm.

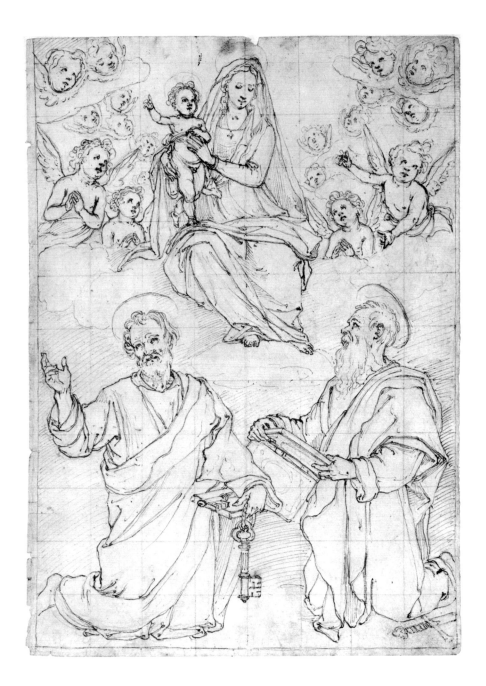

PROVENANCE: James Jackson Jarves; Cornelius Vanderbilt.

BIBLIOGRAPHY: *Metropolitan Museum Hand-book*, 1895, no. 114, as Pollaiuolo; Degenhart, 1941-1942, pp. 79-85, as circle of Domenico Veneziano; Degenhart, 1959, pp. 100-101, recto fig. 13 (before restoration); Degenhart and Schmitt, 1968, I-2, no. 340, I-4, pl. 294, recto and verso repr. (before restoration); Bellosi, 1978, p. XXV, not Domenico Veneziano; Wohl, 1980, p. XXV, not Domenico Veneziano.

Gift of Cornelius Vanderbilt, 1880
80.3.114

See No. 71 above.

JACOPO DA EMPOLI (Jacopo Chimenti)

Florence 1551 – Florence 1640

73. *Virgin and Child Appearing in a Glory of Angels to St. Peter and St. Paul*

Pen and dark brown ink, over black chalk. Squared in red chalk. 40.7 x 28.8 cm. Scattered stains and losses. Lined.

Modern pencil inscription on old mount, *JACOPO DA EMPOLI*.

PROVENANCE: Purchased in London in 1962.

Rogers Fund, 1962
62.130.1

A characteristic if rather dry example of Empoli's pen work. In 1969 Lenore Street pointed out that in the Uffizi there is a black chalk study by Empoli (3447 F) for the St. Peter, more or less as he appears in our composition drawing. In the Uffizi study Peter looks upward and to the right, not out toward the spectator as in the present drawing. Otherwise, in pose and drapery the figures in the two drawings correspond almost exactly.

Uffizi 3447 F has been described as a study for the figure of Peter in Empoli's painting of 1607 in S. Trinità, Florence, *Christ Giving the Keys* (*Mostra di disegni di Jacopo da Empoli,* exhibition catalogue by Anna Forlani, Gabinetto Disegni e Stampe degli Uffizi, Florence, 1962, no. 29, fig. 17). However, in the painting and in the Uffizi composition design for it, St. Peter has not yet received the keys which he awaits with extended open hands, and his drapery is very different (for the painting and composition study see Thiem, 1977, p. 274, fig. 234, and pl. 17).

PAOLO FARINATI
Verona 1524 – Verona 1606

74. *Virgin and Child with St. John the Baptist and St. Paul*

Pen and brown ink, brown wash, over traces of black chalk, on blue paper. 40.9 x 27.6 cm. Lined.

Numbered in pen and brown ink at upper right corner, 72.

PROVENANCE: Sir Peter Lely (Lugt 2092); H. J. L. Wright (according to Sotheby's); sale, London, Sotheby's, February 21, 1962, no. 165; purchased in London in 1962.

BIBLIOGRAPHY: *Exhibition of Old Master Drawings. P. and D. Colnaghi and Co.,* London, 1962, no. 4; U. Ruggeri, *Disegni veneti della Biblioteca Ambrosiana anteriori al secolo XVIII,* Florence, 1979, p. 65, under no. 57.

Rogers Fund, 1962
62.132.1

In 1962, Terence Mullaly identified the drawing as a study for an altarpiece (dated 1584) in the church of S. Vito at Belfiore d'Adige. The correspondence is close, though in the painting the Virgin turns her head to the left, and two cherubs pluck roses from the tree behind the figures. There is an old copy of this drawing in the Ambrosiana, Milan (repr. U. Ruggeri, *op. cit.,* p. 65).

75. *Project for the Decoration of a Spandrel: Winged Female Figure Holding a Tablet and a Crown*

Brush and brown wash, over black chalk, on blue paper. 40.1 x 28.0 cm. Water stain at upper right. Lined.

Inscribed in pen and brown ink at lower left in the artist's hand, *p. far pilore cōtra la peste . . .* (a recipe for pills against the plague supplied to Farinati by "Zuane Copino"); and in another hand at lower center, *P: Farinat.*

PROVENANCE: William Roscoe, Liverpool (according to inscription on reverse of old mount); Studley Martin, Liverpool; Studley Martin sale, Liverpool, January 29, 1889, no. 396 (according to inscription on reverse of old mount); O'Byrne collection (according to Christie's); sale, London, Christie's, May 1, 1962, no. 70, repr., purchased by the Metropolitan Museum.

BIBLIOGRAPHY: Bean, 1963, p. 235, fig. 7; Bean, 1964, no. 23, repr.

Rogers Fund, 1962
62.119.9

74

p̃ far pilore cõtra l[...]
peste piliandone ogni ṡ[...]
la matina 2 ore inãti ma[...]

Pilia prima ũ quarto mira
 ũ quarto zafra
 dui quarti aloe epista insieme
 inpoluere E poi pilia [...]apo acetoso
 di cedro p̃ inpastar dite poluere
 et far lepilove piliandone una
 al sopra scrito modo
Receta de m[...] znane copino

M̃ Farinat

75

FERRAÙ FENZONI

Faenza 1562 – Faenza 1645

76. *Lamentation over the Dead Christ at the Foot of the Cross* VERSO. *Studies for the Burial of Christ*

Pen and brown ink, on blue paper. 22.3 x 28.0 cm. Repaired tear at lower right; pale brown stain at lower left.

Inscribed in pen and brown ink at left margin of recto, *di ferrau fenzone;* numbered at upper left of verso, *N.º 13;* inscribed in pencil at lower right, *48* and *Ferrau Fenzoni;* at right margin, *Ferrau Faenzone 1562-1648.*

PROVENANCE: Henry Scipio Reitlinger (Lugt Supp. 2274a); sale, London, Sotheby's, December 10, 1979, no. 236, recto repr., purchased by the Metropolitan Museum.

Harry G. Sperling Fund, 1980
1980.20.3

The themes of the Deposition and Burial of Christ were studied by Fenzoni in a number of drawings in the Uffizi (12200 F, 12651 F, 12671 F, 12680 F, 12685 F, 12686 F, 12688 F), a drawing in a private collection in Bergamo (repr. *Critica d'arte,* 123, 1972, p. 71), and another at Göttingen (repr. *Master Drawings,* IV, 1, 1966, pl. 5). The Deposition is the subject of two paintings by Fenzoni in the Pinacoteca at Faenza (repr. *Master Drawings,* IV, 1, 1966, pp. 14 and 16).

A weak copy of the recto of the present drawing, exact to the point of imitating the inscription at the left margin, is in the Uffizi (4324 Santarelli; formerly attributed to F. Fontana, but transferred in 1967 to the Fenzoni portfolios).

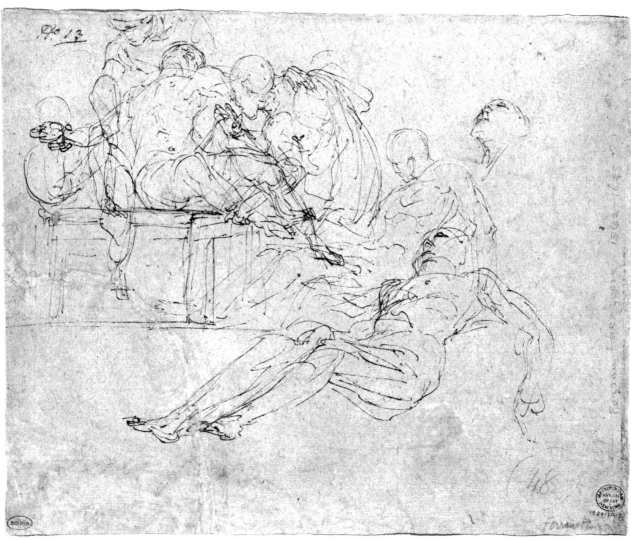

76 v.

FERRAÙ FENZONI

77. *St. John the Evangelist, St. Paul, St. Peter, and St. Stephen*

Black chalk, pen and brown ink, a little brown wash. 35.6 x 24.8 cm.

PROVENANCE: Purchased in New York in 1961.

BIBLIOGRAPHY: G. Scavizzi, *Master Drawings,* IV, 1, 1966, mentioned pp. 6, 20; U. Ruggeri, *Critica d'arte,* 123, 1972, p. 60, fig. 4.

The Elisha Whittelsey Collection
The Elisha Whittelsey Fund, 1961
61.212.1

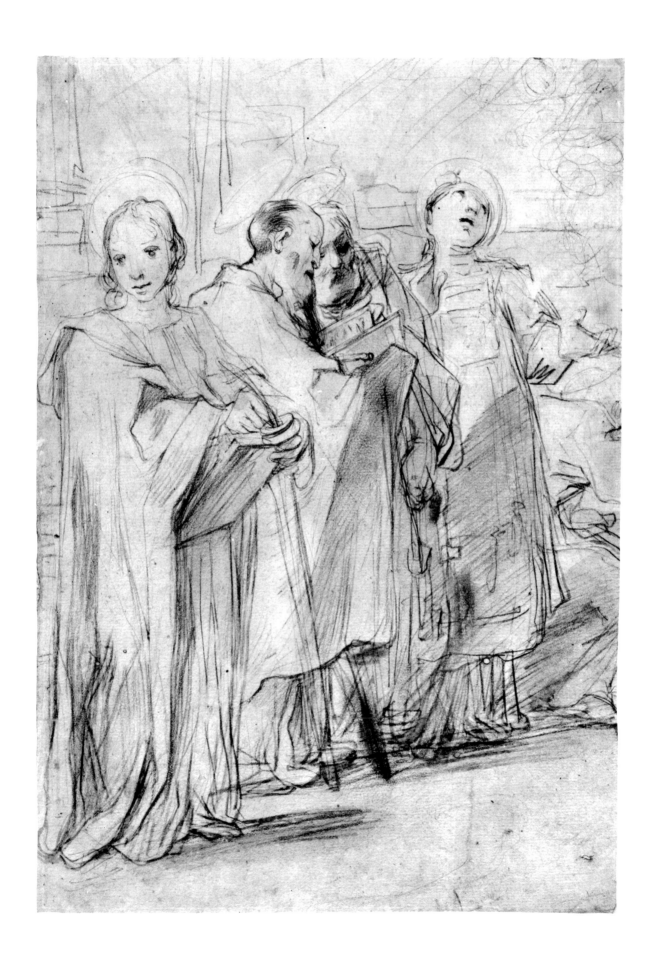

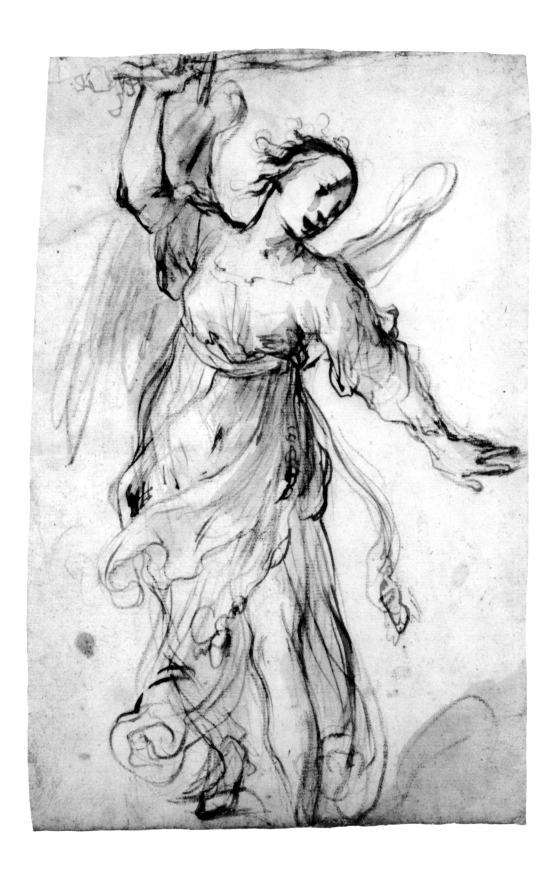

78. *Angel Brandishing a Sword*

Pen and brown ink, brown wash, over black chalk. 27.2 x 17.6 cm. Repaired tear at upper left; brown stains at lower left and right. Lined.

PROVENANCE: Sale, Florence, Sotheby's, October 18, 1969, no. D61, repr.; purchased in London in 1971.

BIBLIOGRAPHY: Bean, 1972, no. 15.

Rogers Fund, 1971
1971.64.1

GAUDENZIO FERRARI

Valduggio ca. 1480 – Milan 1546

79. *Standing Virgin Holding the Christ Child*

Pen and brown ink, brown wash, heightened with white, on blue paper. Squared in red chalk. 29.0 x 10.1 cm. Surface much abraded; repaired losses; horizontal crease near lower margin. Lined.

PROVENANCE: Charles Fairfax Murray (according to Oppenheimer sale catalogue); Henry Oppenheimer, London; Oppenheimer sale, London, Christie's, July 10, 13-14, 1936, no. 82; A. Wilson, London (according to Virch); Walter C. Baker, New York.

BIBLIOGRAPHY: Virch, 1962, no. 10.

Bequest of Walter C. Baker, 1971
1972.118.251

The Virgin supports with her right hand that of the Christ Child, which is raised in benediction. This passage of the drawing is somewhat obscured by damage and restoration (?). The gestures are more legible in a painting by Gaudenzio, *Virgin Enthroned with St. Maurice and St. Martin of Tours,* in the Pinacoteca Sabauda, Turin (repr. L. Mallé, *Incontri con Gaudenzio,* Turin, 1969, pl. 229). The poses of the Virgin and Child in the drawing are comparable to those in the painting in Turin, though in the latter the Virgin is seated.

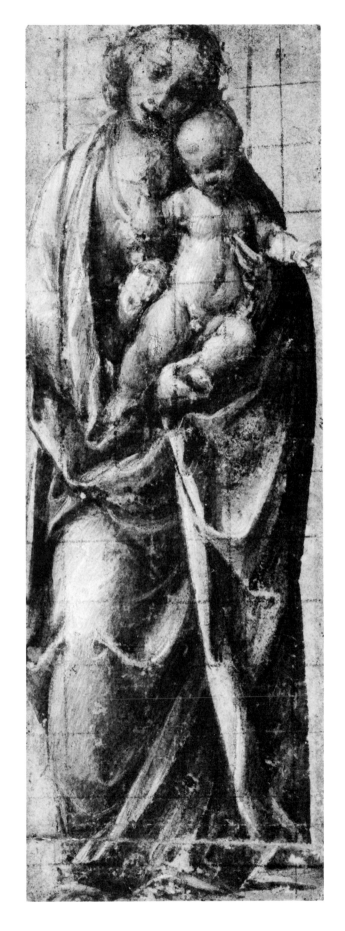

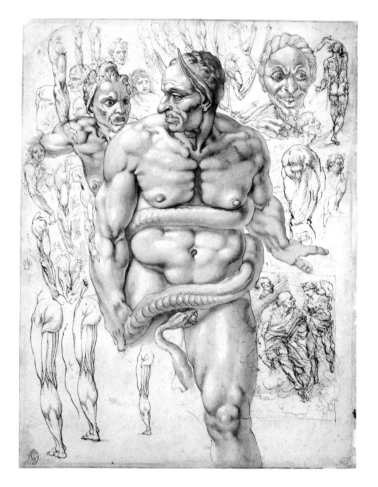

AMBROGIO FIGINO

Milan 1548 – Milan 1608

80. *Nude Demon Encircled by a Serpent, after Michelangelo; and Other Figure Studies*
VERSO. *Figure Studies*

Pen and brown ink, brown wash, over red chalk (recto); pen and brown ink, over red chalk (verso). 28.1 x 21.5 cm. Upper left corner replaced.

Faint inscription in black chalk at lower margin of verso, *Ambrogio Figino*.

PROVENANCE: Giuseppe Vallardi (Lugt 1223); Carlo Prayer (Lugt 2044); Mrs. David F. Seiferheld, New York.

BIBLIOGRAPHY: P. Pouncey, *Master Drawings*, VI, 3, 1968, p. 253.

Gift of Mrs. David F. Seiferheld, 1961
61.179.2

The central figure on the recto is copied after the so-called Minos, Prince of Hell, who appears at the lower right of Michelangelo's *Last Judgment*. On the other hand, Philip Pouncey has pointed out that the sketch of a seated St. Matthew with attendant angel at lower right of recto is one of Figino's own studies for his altarpiece representing this subject in S. Raffaele, Milan (repr. P. Pouncey, *op. cit.,* p. 254).

On the verso, at the upper right, Figino has copied the flying figure of God the Father from Michelangelo's *Creation of the Fruits of the Earth* in the Sistine ceiling. Immediately to the right is a group of standing figures taken from Raphael's *Allotment of the Promised Land,* in the Vatican *Logge.* The sketch of a prelate enthroned (St. Ambrose?) attended by standing female figures is possibly a design for an original composition by Figino. Other sketches for this group at the Accademia in Venice and at Windsor Castle are reproduced by Roberto Paolo Ciardi, who suggests they are studies for a lost altarpiece painted for the church of S. Barnaba, Milan, which a sixteenth-century text described as representing St. Ambrose with "due Vergini" (*Giovan Ambrogio Figino,* Florence, 1968, pp. 119-120, figs. 86 and 87, respectively).

MARCELLO FOGOLINO ?

Vicenza 1483/1488 – Trent after 1558 ?

81. *Man on Horseback, Study of a Man's Head*
VERSO. *Head of a Young Woman*

Pen and brown ink, gray wash (the man on horseback), red chalk (the man's head at upper right); black chalk on blue-washed paper (verso). 19.2 x 20.2 cm. Scattered stains.

PROVENANCE: Purchased in London in 1965.

BIBLIOGRAPHY: L. Puppi, *Marcello Fogolino pittore e incisore*, Trent, 1966, p. 64, pl. 36 (recto), pl. 37 (verso).

Rogers Fund, 1965
65.136.1

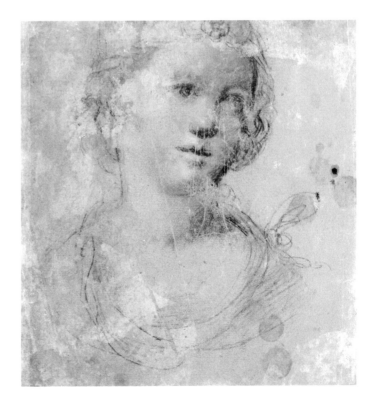

In pose and physical type the cavalier on the recto comes close to one of the Roman emperors in lunettes painted by Fogolino in 1533 in the Stanza del Torrione of the Castello del Buonconsiglio, Trent (repr. L. Puppi, *op. cit.,* pl. 29). The derivation of the equestrian figure from

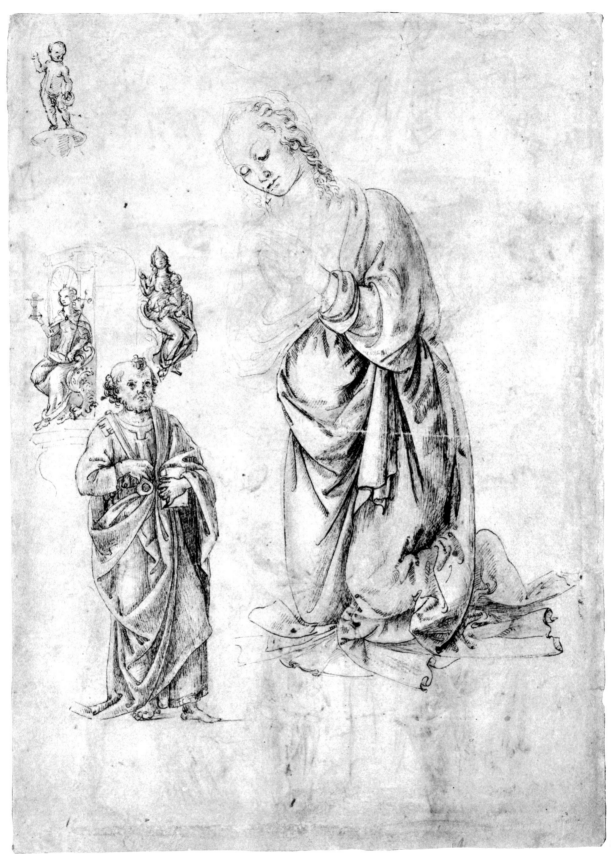

the antique statue of Marcus Aurelius on horseback is obvious, and indeed Fogolino made an engraving after the statue (repr. A. M. Hind, *Early Italian Engraving,* London, 1948, part II, VII, pl. 802).

Our drawing is executed by a draughtsman whose hand has been recognized by Philip Pouncey in four further sheets. Though he convincingly suggests that these drawings are the work of an artist in the circle of Fogolino, Pouncey is reluctant to make an unqualified attribution to Fogolino himself. The other drawings in the group are: (1) Bayonne, Musée Bonnat, Inv. 131, *Triumphal Procession,* recto, *St. Jerome Penitent,* verso (repr. J. Bean, *Les Dessins italiens de la collection Bonnat,* Paris, 1960, no. 30); (2) Dijon, Musée des Beaux-Arts, T.67, *Dead Christ,* recto, *Landscape,* verso (repr. *Arte veneta,* XV, 1961, pp. 224-225); (3) London, British Museum, 1920-4-2-5, *Miracle of St. John the Evangelist,* recto, *St. John the Evangelist Preaching* (?), verso (verso repr. *Arte veneta,* XV, 1961, p. 223); (4) New York, Janos Scholz, *The Real Son Refusing to Shoot His Arrow at His Father's Body,* recto, *Annunciation after Dürer,* verso (repr. *Sixteenth Century Italian Drawings from the Collection of Janos Scholz,* Washington, D.C., 1973, p. 91).

FRANCESCO DI SIMONE ?

Fiesole 1437 – Florence 1493

82. *Figure Studies: The Virgin Kneeling, St. Peter Standing, Seated Allegorical Figures of Faith and Charity, and the Christ Child Standing on a Chalice* VERSO. *Figure Studies: St. Sebastian, and the Virgin and Child with Angels*

Pen and brown ink, over black chalk or metalpoint indications, on rose-washed paper. 27.4 x 19.8 cm.

Inscribed in pen and brown ink on verso, *m.53.*

PROVENANCE: Lord Brownlow; sale, London, Sotheby's, July 14, 1926, no. 17, recto repr.; Philip Hofer, Cambridge, Massachusetts; Walter C. Baker, New York.

BIBLIOGRAPHY: Berenson, 1938, I, p. 48, note 3, III, fig. 129 (recto); Popham and Pouncey, 1950, pp. 39-40; O. Kurz, *Journal of the Warburg and Courtauld Institutes,* XVIII, 1955, pp. 35-46, pl. 18c (recto); Berenson, 1961, I, p. 108; Virch, 1962, no. 3, recto and verso repr.; Bean and Stampfle, 1965, no. 9, recto repr.; S. Grossman, *Master Drawings,* X, 1, 1972, pp. 15-19, fig. 1 (recto).

Bequest of Walter C. Baker, 1971
1972.118.252

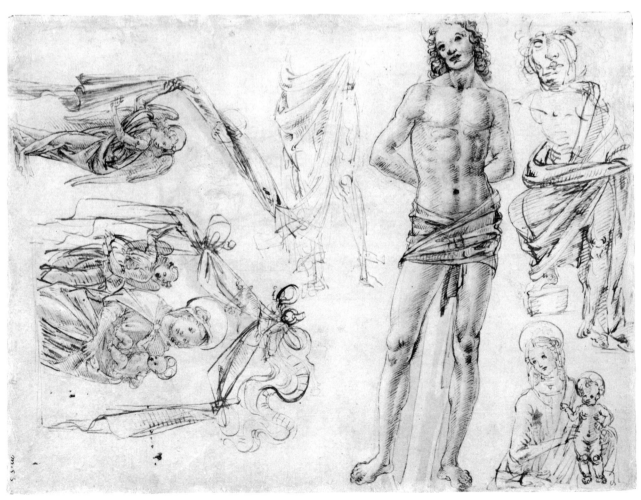

This double-faced drawing is one of a group of twenty scattered in a number of collections (Berlin, Chantilly, Dijon, Hamburg, the British Museum, London, the Louvre and the Ecole des Beaux-Arts, Paris, and a private collection). Two of the sheets are dated 1487, one 1488, and stylistic evidence suggests that they are the working sketches of a Tuscan sculptor strongly influenced by Verrocchio. Some of the drawings were traditionally attributed to this sculptor, but the draughtsmanship is not his. Giovanni Morelli was the first to propose the name of the Verrocchiesque Francesco di Simone, and this attribution has been generally accepted. The drawings are close in style to a design in the Nationalmuseum in Stockholm that may well be Francesco di Simone's original study for the tomb of Alessandro Tartagni in S. Domenico, Bologna. On the other hand, some of the inscriptions on the sheets conflict with the thesis of Francesco's authorship. The vexed question was summed up by Popham and Pouncey in a discussion of the sheets in the British Museum.

BATTISTA FRANCO

Venice ca. 1510 – Venice 1561

83. *Figure Studies: Three Sketches of Cain Killing Abel, with an Altar of Sacrifice at Center, Two Standing Women, a Hand, and a Seated Child with a Squirrel*

Pen and brown ink. 21.9 x 30.0 cm. Diagonal crease at right; brown stains at lower right.

Inscribed in pen and brown ink on verso in W. Gibson's hand, *Semoleo·8·2·*; and at lower margin of old mount, *Becca Fume* (the capital letters B and F in one hand, the lower case letters in another).

PROVENANCE: Sir Peter Lely (Lugt 2092); William Gibson (see Lugt Supp. 2885); Earls of Pembroke; Pembroke sale, London, Sotheby's, July 5-6, 9-10, 1917, no. 398, as Beccafumi, purchased by the Metropolitan Museum.

Hewitt Fund, 1917
19.76.15

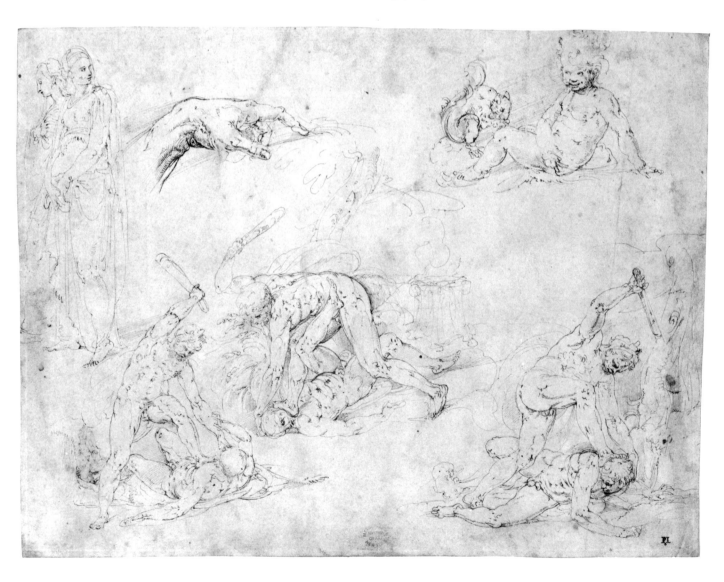

Gibson's inscription on the verso giving the drawing to Semolei (another name for Battista Franco) is certainly correct. The initials *B.F.* on the old mount must also refer to Battista Franco, though a later hand has mistakenly interpreted them as an attribution to Beccafumi, under whose name the drawing figured in the Pembroke sale.

84. *Standing Male Nude with Hands behind Back*

Red chalk. 38.7 x 16.9 cm. Upper left and lower right corners replaced; a number of brown stains. Lined.

Inscribed in pen and red ink at lower center of old mount in Richardson's hand, *Battista Franco.*

PROVENANCE: Jonathan Richardson, Sr. (Lugt 2183, 2984, 2995); Mrs. E. E. James (according to Sotheby's); sale, London, Sotheby's, May 16, 1962, no. 158, purchased by the Metropolitan Museum.

BIBLIOGRAPHY: Bean and Stampfle, 1965, no. 78, repr.

Rogers Fund, 1962
62.119.10

In 1967 James Draper identified the drawing as Battista Franco's study for the figure of Christ in the *Flagellation* (Bartsch, XVI, p. 122, no. 10), an engraving in which the figure appears in reverse. In the drawing the column of the Flagellation is lightly indicated behind Christ's legs. At Windsor Castle there is a red chalk study for the figure of the scourger who appears at the extreme left in Franco's print (Popham and Wilde, 1949, no. 329, pl. 171).

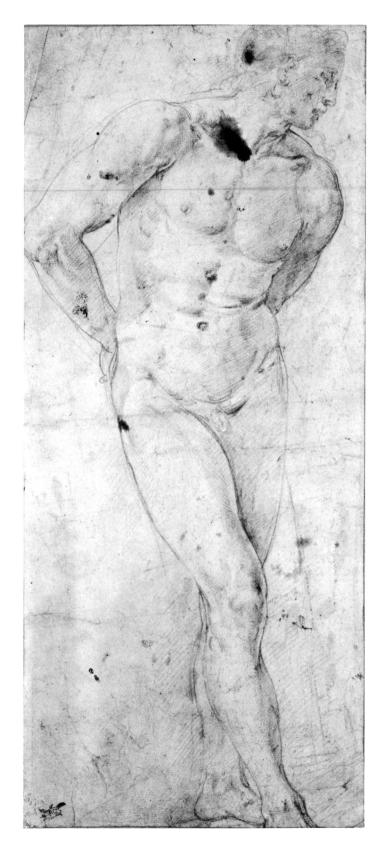

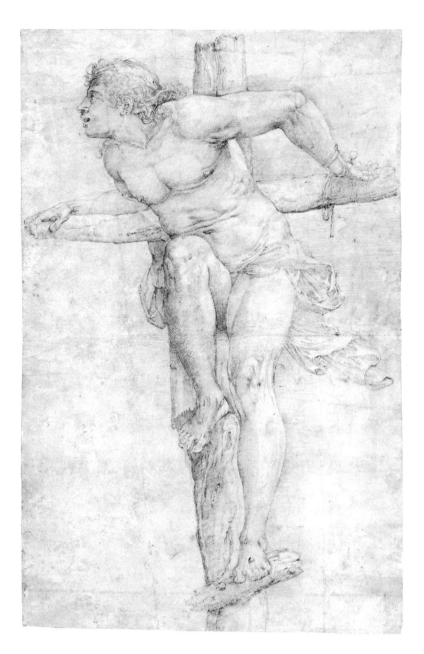

BATTISTA FRANCO

85. *The Penitent Thief on the Cross*

Pen and brown ink. Outlines incised for transfer. 39.9 x 25.6 cm. Diagonal creases at left of center; horizontal creases at center; a number of repaired losses.

PROVENANCE: Earls of Pembroke; Pembroke sale, London, Sotheby's, July 5-6, 9-10, 1917, part of no. 415; Walter C. Baker, New York.

BIBLIOGRAPHY: Virch, 1962, no. 13; Bean, 1975, no. 19.

Bequest of Walter C. Baker, 1971
1972.118.8

Study for the figure of the Penitent Thief who looks up at the face of the crucified Christ in Battista Franco's large engraving, *Christ on the Cross between the Two Thieves* (Bartsch, XVI, p. 123, no. 12). In the print the figure is reversed, and the Penitent Thief's left hand and forearm are hidden in a knot of drapery. See No. 86 below.

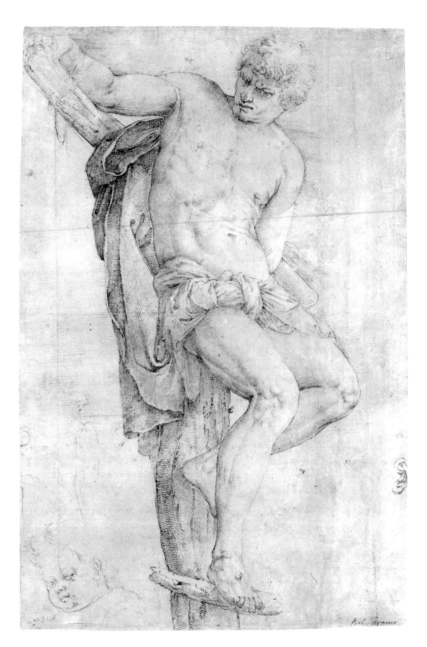

86. The Unrepentant Thief on the Cross, Study of a Child's Head at Lower Left, and of an Ear at Lower Right Margin

Pen and brown ink. 33.3 x 21.8 cm. Several repaired losses.

Inscribed in pen and brown ink at lower right, *Bat: Franco.*

PROVENANCE: Earls of Pembroke; Pembroke sale, London, Sotheby's, July 5-6, 9-10, 1917, part of no. 415; Walter C. Baker, New York.

BIBLIOGRAPHY: Virch, 1962, no. 12; Bean, 1975, no. 18.

Bequest of Walter C. Baker, 1971
1972.118.7

Study for the Unrepentant Thief who turns away from Christ in Battista Franco's large engraving, *Christ on the Cross between the Two Thieves* (Bartsch, XVI, p. 123, no. 12). In the print, where the figure appears in reverse, one of the thief's arms hangs awkwardly over the bar of the cross, while in the drawing it is extended along the crossbar. The purpose of the faint sketches at lower left and right is uncertain. See No. 85 above.

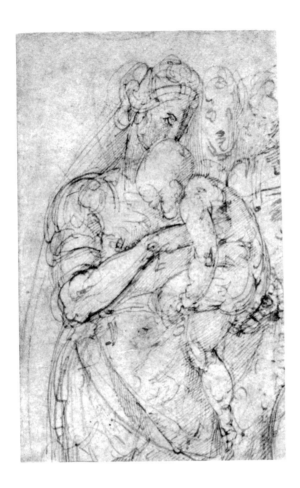

BATTISTA FRANCO

87. *Standing Virgin with Child, Two Heads at Upper Right*

Pen and brown ink, over black chalk. Pen sketch of steps (?) on verso. 12.3 x 8.0 cm.

PROVENANCE: Harry G. Sperling, New York.

Bequest of Harry G. Sperling, 1971
1975.131.29

88. *Three Allegorical Figures in a Roundel*

Pen and brown ink, brown wash. Illegible scribbles in black chalk on verso. Diameter 19.3 cm. Scattered stains.

Inscribed in pen and brown ink on verso, *di . . . batista simol . . .* (the rest illegible).

PROVENANCE: Jonathan Richardson, Sr. (Lugt 2183); Harry G. Sperling, New York.

Bequest of Harry G. Sperling, 1971
1975.131.28

The symbolism of these three allegorical figures defies interpretation: at the left a woman holding a miniature organ is attended by a winged putto; at center a winged female figure holds a dove on a staff in her right hand and a flowering branch in her left, while her foot rests on a diminutive prostrate figure; at right a standing male nude is seen in a steep perspective that suggests the drawing may be a project for a roundel in a ceiling decoration. The figures all wear crowns of foliage. These three figures, with the same attributes, reappear in a pen drawing in the Ashmolean Museum that is also a study for a round ceiling decoration (repr. Macandrew, 1980, no. 236 C, pl. XXI).

89. *Half Figure of a Youth with Outstretched Left Arm and Bowed Head*

Red chalk (recto). On verso, sketches in pen and brown ink of two women, one holding a vase, the other a book, and a fragmentary sketch of a seated man (the ink of this latter study has bled through at lower left of recto). 18.6 x 31.9 cm. (overall). A vertical strip averaging 0.7 cm. in width has been added at right. Scattered brown stains.

Inscribed in pen and brown ink on verso, *Bona . . .* (the rest illegible).

PROVENANCE: James Jackson Jarves; Cornelius Vanderbilt.

BIBLIOGRAPHY: *Metropolitan Museum Hand-book,* 1895, no. 58, as Raphael.

Gift of Cornelius Vanderbilt, 1880
80.3.58

In 1958 Philip Pouncey recognized here the hand of Battista Franco.

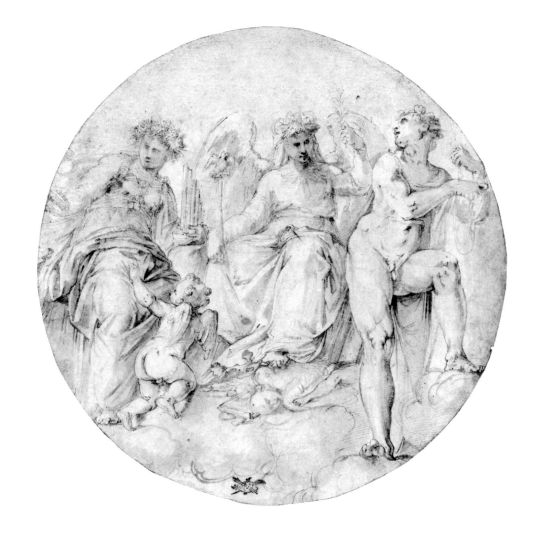

90. *Figure Studies: Flying Victory, and a Seated Old Man with a Book*

Pen and brown ink, brown wash. 19.0 x 20.5 cm. Scattered stains; large stain at center of right margin. Lined.

Faint inscription in black chalk at lower left, *B. Franco;* in pen and brown ink at lower center of old mount, *Battista Franco.*

PROVENANCE: Mark mistakenly associated with Pierre Crozat (Lugt 474); purchased in London in 1963.

Rogers Fund, 1963
63.76.3

91. *Roman Telamones in the Egyptian Style*

Pen and brown ink, over traces of black chalk. 38.2 x 27.2 cm. Two sheets of paper joined vertically at center.

Inscribed in pen and brown ink on base of statue at left, *sula piaza di tivollo tuti dua;* on the base of statue at right, *CHARIA^cHCO alt° piedi. 12.;* at lower margin, *Anticha mente srvièno* [?] *p portta . . . di pietra granitta dl marmo medemo dle Collone d larotondo.*

PROVENANCE: Purchased in Switzerland in 1979.

BIBLIOGRAPHY: *Dai manieristi ai neoclassici, disegni italiani. W. Apolloni,* exhibition catalogue, Rome, 1978, no. 8, as Roman school, end of the sixteenth century.

Harry G. Sperling Fund, 1979
1979.62.2,3

Battista Franco copies here the red granite telamones that now flank the entrance to the Museo Pio-Clementino in the Vatican (repr. G. Lippold, *Die Skulpturen des Vaticanischen Museums,* Berlin and Leipzig, 1936, III, pls. 49, 50). In the sixteenth century these figures flanked the entrance to the episcopal palace in Tivoli; they are thought to have come from Hadrian's villa nearby. The drawing was exhibited in Rome in 1978 as an anonymous work, but the hand of Battista Franco is recognizable in the fine, brittle pen work and in certain passages of parallel shading. The contours of the figure on the left have been indented, and the reverse of the left half of the sheet blackened, possibly to facilitate transfer of the image to an engraver's plate.

92. *Head and Front Quarters of a Bull*

Pen and brown ink, on beige paper. 10.8 x 8.1 cm. Lower right corner replaced. Lined.

PROVENANCE: Colonel Count E. R. Lamponi-Leopardi (Lugt 1760); purchased in London in 1906.

Rogers Fund, 1906
06.1042.12

Formerly classified in the school of Raphael, the drawing was identified in 1958 as the work of Franco by Philip Pouncey.

RAFFAELLINO DEL GARBO

Florence ca. 1466 – Florence 1524

93. *Virgin and Child Attended by Angels*

Pen and brown ink, brown wash, heightened with white. 17.5 x 22.2 cm. All four corners cut off. Lined.

Inscribed in pen and brown ink on verso, *Bramantino da milano 1458.*

PROVENANCE: Sir Fairfax Cartwright, Aynhoe, Oxfordshire; sale, London, Christie's, June 25, 1968, no. 62, repr.; purchased in London in 1968.

BIBLIOGRAPHY: [L. Vertova], *Antichità viva,* VII, 3, 1968, p. 62, repr.; *Old Master and English Drawings. P. and D. Colnaghi and Co.,*

exhibition catalogue, London, 1969, no. 2, repr.; *Metropolitan Museum of Art Bulletin,* October 1969, p. 66, repr.; *Notable Acquisitions,* 1975, p. 59, repr.

Rogers Fund, 1968
68.204

The attribution to Raffaellino was made by Philip Pouncey in 1955 when the drawing was still in the Cartwright collection at Aynhoe.

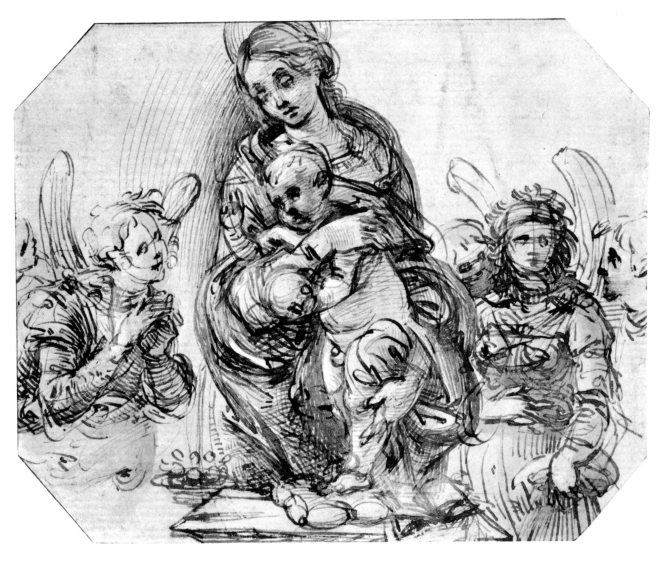

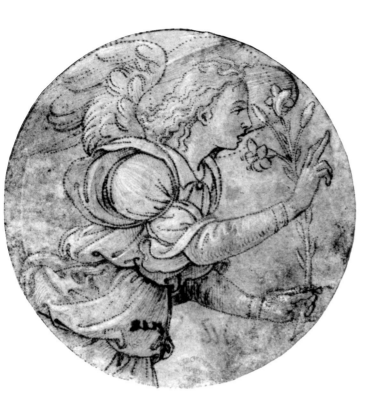

95. *A Seraph*

Pen and brown ink, rose wash, heightened with white, over black chalk. Contours pricked for transfer. 11.0 x 7.1 cm. Margins irregular. Lined.

Inscribed in pen and brown ink on Ottley mount, *Raffaello del Garbo.*

PROVENANCE: William Young Ottley (the drawing on an Ottley mount, see Lugt Supp. 2662); Sir Thomas Lawrence (Lugt 2445); C. R. Rudolf (Lugt Supp. 2811b); Walter C. Baker, New York.

Bequest of Walter C. Baker, 1971
1972.118.253

Probably a design for embroidery; the attribution to Raffaellino goes back at least to the time of Ottley.

94. *The Angel of the Annunciation*

Pen and brown ink, brown wash, heightened with white, on brown paper. Contours pricked for transfer. Diameter 9.7 cm. Lined.

PROVENANCE: Sir Charles Eastlake, London; Lady Eastlake, London; Eastlake sale, London, Christie's, June 2, 1894, part of no. 14; J. P. Richter, London; purchased in New York in 1912, as Filippino Lippi.

BIBLIOGRAPHY: Hellman, 1916, pp. 157-161, repr. p. 159, as Filippino Lippi; Berenson, 1938, no. 766A; *Metropolitan Museum, Italian Drawings,* 1942, no. 12, repr.; Berenson, 1961, no. 766E; Bean, 1964, no. 8, repr.; Bean and Stampfle, 1965, no. 25, repr.; D. Robertson, *Sir Charles Eastlake and the Victorian Art World,* Princeton, New Jersey, 1978, p. 277.

Rogers Fund, 1912
12.56.5a

The inner and outer contour lines of this study are carefully pricked for transfer, and it may well be a design for embroidery. Published as the work of Filippino Lippi by Hellman, the more convincing attribution of the drawing to Raffaellino del Garbo seems to have been proposed by Berenson.

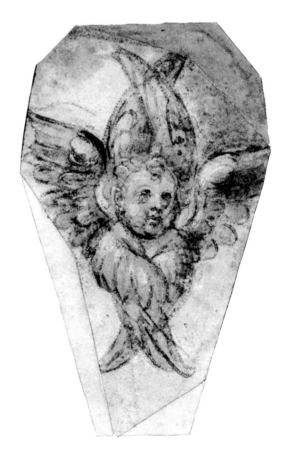

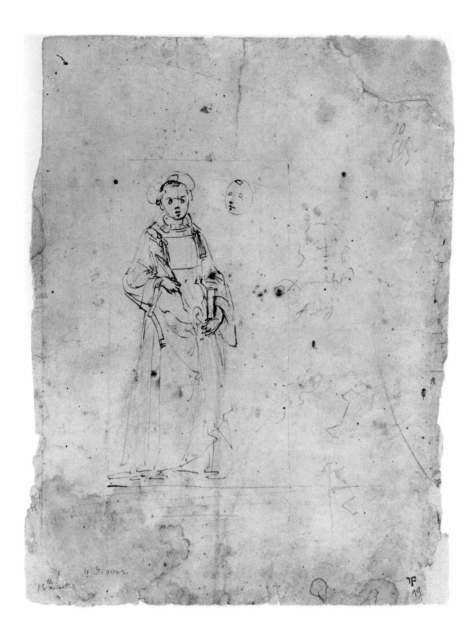

DOMENICO GHIRLANDAIO

Florence ca. 1449 – Florence 1494

96. *Standing Figure of St. Stephen and Two Studies of His Head*

Pen and brown ink, black chalk. Ground plan of a fortification (?) in black chalk at lower right. 29.0 x 21.5 cm. Margins irregular; upper right corner, lower corners, and portions of the right margin replaced; scattered stains.

Inscribed in pencil at lower left corner, *15th cent / St Steven;* illegible black chalk inscriptions at right of center.

PROVENANCE: Unidentified collector's mark at lower right; Walter C. Baker, New York.

BIBLIOGRAPHY: Virch, 1962, no. 5, as Florentine, 15th century.

Bequest of Walter C. Baker, 1971
1972.118.11

Classified in the collection of Walter C. Baker as a Florentine work of the fifteenth century, the drawing was convincingly ascribed to Domenico Ghirlandaio by Everett Fahy in 1976. The abbreviated facial indications are characteristic of Domenico. The dalmatic worn by the figure, the palm of martyrdom, and the rocks

sketched on his nimbused head identify him as St. Stephen. Mr. Fahy has suggested that this may be Ghirlandaio's study for the central figure of St. Stephen in an altarpiece painted after 1492 for the Boni chapel in the church of Cestello in Florence and now in the Academy of that city (see A. Luchs, *Cestello: A Cistercian Church of the Florentine Renaissance,* New York and London, 1977, pp. 95-96, fig. 76). The Boni altarpiece, in which St. Stephen is flanked by figures of St. James and St. Peter, was attributed by Berenson and Van Marle to Sebastiano Mainardi, but Fahy believes that it was planned and in large part executed by Domenico Ghirlandaio.

NICCOLÒ GIOLFINO

Verona 1476 – Verona 1555

97. *The Arrest of Christ*

Brush and brown wash, heightened with white, over traces of black chalk, on greenish paper. 23.1 x 26.7 cm. Scattered brown stains.

Inscribed in pen and brown ink at lower right, *Il. Giolfino. Fece./:C:;* in another hand at lower left, *Giottino, La Pittura é in . . .* (the rest illegible; written over an inscription that has been erased); on verso, *:C:/ Di Tomaso detto Giottino f.*

PROVENANCE: Earls of Pembroke; Pembroke sale, London, Sotheby's, July 5-6, 9-10, 1917, no. 395, purchased by the Metropolitan Museum.

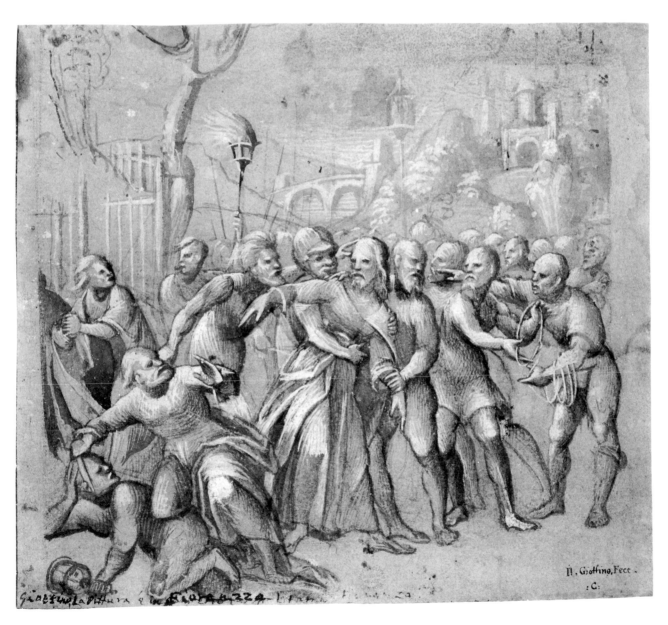

BIBLIOGRAPHY: Strong, 1900, part I, no. 4, repr.; Bean and Stampfle, 1965, no. 38, repr.; U. Ruggeri, *Disegni veneti dell' Ambrosiana*, exhibition catalogue, Fondazione Cini, Venice, 1979, p. 22, under no. 11; Frerichs, 1981, p. 38, under no. 71.

Hewitt Fund, 1917
19.76.17

The old attribution to Giolfino (read by later annotators of the sheet as *Giottino*) is convincing on stylistic grounds, and, at least from the time of Strong's publication of the drawings then at Wilton House, the sheet has been associated with a painting on canvas by Giolfino of this subject in the Cappella della Croce, S. Bernardino, Verona.

GIORGIONE (Giorgio da Castelfranco) ?

Castelfranco Veneto 1477 ? – Venice 1510

98. *Putto Bending a Bow*

Red chalk. Original sheet, 15.7 x 6.6 cm.; this has been made up (probably by Mariette) to a sheet 23.7 x 15.2 cm. on which a base and a surrounding niche for the putto have been indicated in pen and brown ink, red chalk and red wash. Lined.

Inscribed in pen and brown ink at lower right of what remains of the Mariette mount, *1476-1512.*

PROVENANCE: Pierre-Jean Mariette (Lugt 2097); Mariette sale, Paris, 1775-1776, part of no. 445, "Giorgion, Un Amour ployant son arc"; Count Moriz von Fries (Lugt 2903); Lord Ronald Sutherland Gower; sale, London, Christie's, January 28, 1911, part of no. 17, purchased by the Metropolitan Museum.

BIBLIOGRAPHY: *Exhibition of Venetian Art, The New Gallery, Regent Street, 1894-5,* exhibition catalogue, London, 1894, no. 342; E. Tietze-Conrat, *Art Quarterly,* III, 1, 1940, p. 32, fig. 14; *Metropolitan Museum, Italian Drawings,* 1942, no. 18, repr.; Tietze, 1944, no. 712, pl. XLVIII, 1; *Metropolitan Museum, European Drawings,* 1944, no. N.S. 7, repr.; T. Pignatti, *Giorgione,* Milan, 1955, p. 132, as Titian ?; T. Pignatti, *Giorgione,* Venice, 1969, p. 127, no. A 36, pl. 188, as Titian; T. Pignatti, *Giorgione,* London, 1971, p. 130, no. A 36, pl. 188, as Titian; H. E. Wethey, *The Paintings of Titian, III, The Mythological and Historical Paintings,* London, 1975, p. 6, fig. 7; D. A. Brown, *Berenson and the Connoisseurship of Italian Painting,* exhibition catalogue, National Gallery of Art, Washington, D.C., 1979, p. 32, fig. 69, p. 57, note 84, p. 65, no. 69; B. W. Meijer, *Master Drawings,* XIX, 3, 1981, p. 287, note 5, as Emilian.

Rogers Fund, 1911
11.66.5

The steep perspective in which the putto is seen suggests that the figure may have been intended for placement high on a painted palace façade, and Mariette's addition of a base and surrounding niche for the figure would seem to indicate that he thought the putto could have served just such a purpose. E. Tietze-Conrat called attention to Vasari's mention of a similar figure on the façade of the Fondaco dei Tedeschi, *un angelo a guisa di Cupido* (Vasari, IV, p. 96).

The plausible attribution of the drawing to Giorgione goes back at least to the time of Mariette. On several occasions in the past Terisio Pignatti has ascribed this sheet to the young Titian, but he seems to have abandoned this notion, since our drawing is not mentioned in his 1979 book on Titian as a draughtsman.

GIROLAMO DA CARPI ?

Ferrara 1501 – Ferrara 1556

99. *Sheet of Figure Studies, Probably after the Antique*
VERSO. *Ornamental Designs*

GIROLAMO DA CARPI ? (NO. 99)

Pen and brown ink, brown wash (recto); pen and brown ink (verso). 28.9 x 18.9 cm. Scattered stains.

PROVENANCE: Thomas Banks (Lugt 2423); Spencer Bickerton, New York.

Gift of Spencer Bickerton, 1934
34.114.1 (recto), 34.114.2 (verso)

The drawing was classified as anonymous Florentine until Philip Pouncey in 1958 proposed the name of Girolamo da Carpi, with a warning that "the quality perhaps indicates that this is by a faithful assistant."

99 v.

100. *Apparition of St. Andrew in Glory*

Pen and brown ink, brown wash, heightened with white, on blue paper. Partially squared in black chalk. 18.6 x 26.7 cm.

Inscribed in pen and brown ink in Robinson's hand on verso, *Giulio Romano / purchased at Rimini Oct 22, 1860 / J. C. Robinson / 645.*

PROVENANCE: Sir John Charles Robinson (Lugt Supp. 2141b); Earl of Harewood; sale, London, Christie's, July 6, 1965, no. 137, as "God the Father Holding the Cross"; Lt.-Col. Sir Michael Peto, Bt.; sale, London, Sotheby's, June 25, 1970, no. 19, repr., purchased by the Metropolitan Museum.

Rogers Fund, 1970
1970.176

St. Andrew, holding his transverse cross, appears in glory and attended by angels. The group was used at the top of a fresco representing the Rediscovery of the Sacred Blood in Mantua, executed ca. 1534 by Rinaldo Mantovano after Giulio Romano's designs in a chapel in the basilica of S. Andrea, Mantua (see Hartt, 1958, I, pp. 208-211, II, fig. 439). The connection between the drawing and the fresco in S. Andrea was noted when the drawing was sold at Sotheby's in 1970; in the Harewood sale at Christie's in 1965, the drawing had been described as a representation of God the Father Holding the Cross.

101. *Design for a Flask with Chain Handles*

Pen and brown ink, brown wash. Two fragments, 10.7 x 7.7 cm. and 27.7 x 15.5 cm., mounted on a sheet measuring 27.7 x 22.3 cm. Repaired losses at upper right. Lined.

Inscribed in pen and brown ink at lower center, *fiascho fatto / a lo R^{mo} / Cardinalla / di Mantoa*; at lower center of old mount in Richardson's hand, *Giulio Romano*; on verso in W. Warrington's hand, *Girolamo Romanino / Born at Rome 1504 / Lot 250 / D / W Warrington / 23-2-39.*

PROVENANCE: Jonathan Richardson, Sr. (Lugt 2183, 2984, 2995); W. Warrington (Lugt 2548); purchased in Paris in 1961.

Rogers Fund, 1961
61.136.1

The cardinal of Mantua referred to in the inscription is certainly Ercole Cardinal Gonzaga (1505-1563), whom Giulio served at Mantua from 1540 to 1546.

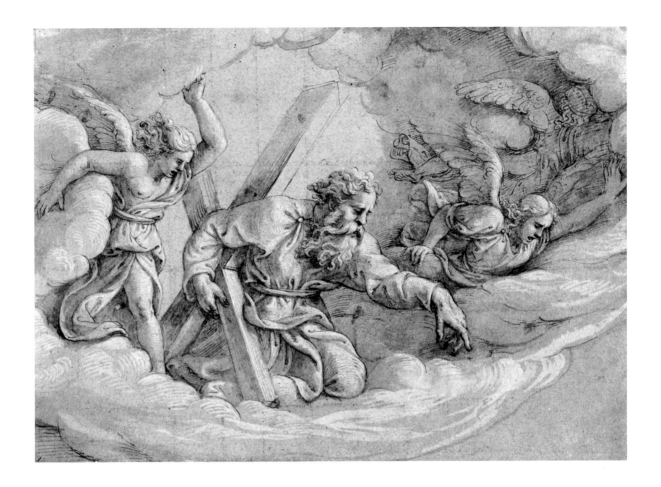

102. *Design for a Casket with the Gonzaga Eagle*

Pen and brown ink, brown wash, heightened with a little white, over black chalk. 10.1 x 16.7 cm., the design silhouetted and pasted to a sheet measuring 11.6 x 17.7 cm. Lined.

Inscribed in pen and brown ink at lower center of old mount, *Iulio Romano.*

PROVENANCE: Purchased in Paris in 1965.

Rogers Fund, 1965
65.125.3

103. *Neptune Holding a Trident and Standing on a Dolphin*

Pen and brown ink, brown wash, over black chalk. 20.7 x 9.2 cm.

PROVENANCE: Thomas Banks (Lugt 2423); Ambrose Poynter (Lugt 161); Sir Edward J. Poynter, Bt.; Poynter sale, London, Sotheby's, April 24-25, 1918, part of no. 57, as Italian School, late XVIth century; R. G. Mathews (Lugt 2213); Harry G. Sperling, New York.

Bequest of Harry G. Sperling, 1971
1975.131.30

The pose of this figure of Neptune reflects almost in mirror image, except for variations in the placement of the right hand and foot, a drawing of a standing figure of Mars in the British Museum (Pouncey and Gere, 1962, no. 92, pl. 85).

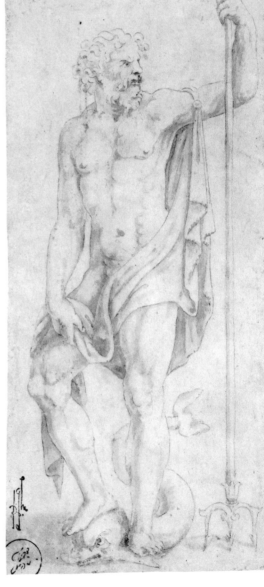

GIOVANNI GUERRA

Modena ca. 1540 – Rome 1618

104. *St. Paul Surrounded by Disciples after His Lapidation at Lystra* (Acts 14:20)

Pen and brown ink, pale brown wash. 12.0 x 16.5 cm. Lined.

Inscribed in pen and brown ink on a slip of paper pasted to the top margin of old mount, [P]AULUS PAENE OBRUTUS LAPIDIBUS SURGIT, ET CUM BARNABA IN DERBEN PROFICISCI / CONSTITUIT AD EVANGELIZANDUM *Acta 14.20.*

PROVENANCE: William Sharp (Lugt 2650); William Bates (Lugt 2604); Janos Scholz, New York; purchased in New York in 1950; transferred from the Department of Prints, 1978.

The Elisha Whittelsey Collection
The Elisha Whittelsey Fund, 1950
1978.376

Formerly classified in the Print Department at the Metropolitan Museum as the work of an anonymous Flemish artist, the drawing is a typical example of Giovanni Guerra's work as an illustrator of Scripture.

Fourteen scenes from the life of St. Paul by Guerra have been identified by Philip Pouncey in the Ecole des Beaux-Arts, Paris, two more are in the Musée des Beaux-Arts, Poitiers, and two are in the Louvre (see C. Monbeig Goguel, *Arte illustrata,* 58, 1974, p. 167, figs. 7 and 18, note 18). A *St. Paul and St. Barnabas Preaching* was sold at Sotheby's on November 25, 1971, no. 60, as Guerra, and a *St. Paul Preaching to the Jews at Antioch in Pisidia* was on the New York art market a few years ago. Both these latter drawings figured, like the present

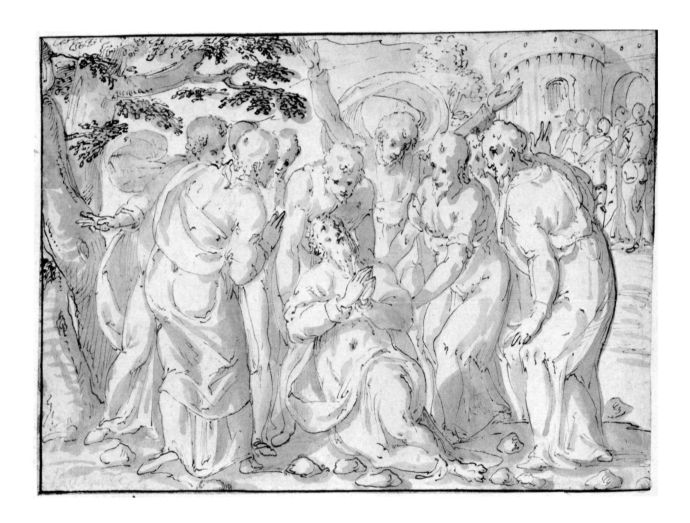

sheet, in the collections of W. Sharp and W. Bates, and they also have identifying Latin inscriptions on strips pasted to the tops of the old mounts.

Two more scenes from the series, *The Embarkation of St. Paul* and *St. Paul Baptizing at Ephesus,* appeared in a sale at Sotheby's in London on December 10, 1979, nos. 406 and 407, the former repr., no provenance supplied. Both these drawings have Latin captions affixed to the tops of the old mounts. Drawings by Guerra representing *Pentecost* and *St. Paul and Companions Praying on the Beach at Tyre* were on the London art market in 1980.

BERNARDINO INDIA
Verona 1528 – Verona 1590

105. *Design for a Wall Decoration over an Arched Doorway*

Pen and brown ink, brown wash. 16.5 x 31.3 cm. Lined.

PROVENANCE: Sale, London, Sotheby's, December 13, 1973, no. 17, repr.; purchased in London in 1974.

Harry G. Sperling Fund, 1974
1974.389

The female figures may be identified as allegorical representations of, from left to right, *Magnanimity* (or *Venice Triumphant*), *Justice, Peace,* and *Constancy;* the arms are those of the Venetian noble family Grimani.

This is a typical example of India's draughtsmanship, which is well characterized and illustrated by Licisco Magagnato in the exhibition catalogue, *Cinquant'anni di pittura veronese, 1580-1630,* Verona, 1974.

BERNARDINO LANINO ?

Mortara ca. 1512 – Vercelli 1583

106. *The Virgin and Child with St. Roch and Two Other Male Saints*

Pen and brown ink, brown wash, heightened with white, over black chalk, on brown-washed paper. Traces of squaring in black chalk. 33.9 x 23.1 cm. Lined.

Inscribed in pen and brown ink at lower margin of old mount, *Pietro Perugino. 1445-1524. / from vol 1.st n. 5 –teacher to Ra:Urbin* (indicating the drawing's place in the Pembroke albums).

PROVENANCE: Earls of Pembroke; Pembroke sale, London, Sotheby's, July 5-6, 9-10, 1917, part of no. 444, as Pietro Perugino, purchased by the Metropolitan Museum.

BIBLIOGRAPHY: Strong, 1900, part III, no. 23, repr., as Bernardino Lanino; G. C. Sciolla, *Il Biellese dal Medioevo all'Ottocento,* Turin, 1980, pp. 150 (drawing and painting repr.), 153, 169, note 95.

Hewitt Fund, 1917
19.76.1

Though S. Arthur Strong had proposed the name of Bernardino Lanino in 1900, the drawing figured in the Pembroke sale catalogue under an earlier attribution to Pietro Perugino. Then in 1980 Gianni Carlo Sciolla noted the connection between the drawing and Lanino's altarpiece representing the Virgin and Child with four saints in the basilica of the sanctuary of Oropa, near Biella in Piedmont. The drawing has been trimmed on the right, for the standing figure of St. Andrew that appears in the altarpiece is lacking here. There are minor differences between painting and drawing: for example, the tree that appears above the head of the second saint from the left in the painting is absent in the drawing. Since the sheet is both damaged and amputated, it is difficult to decide whether it is an autograph *modello* or an old copy.

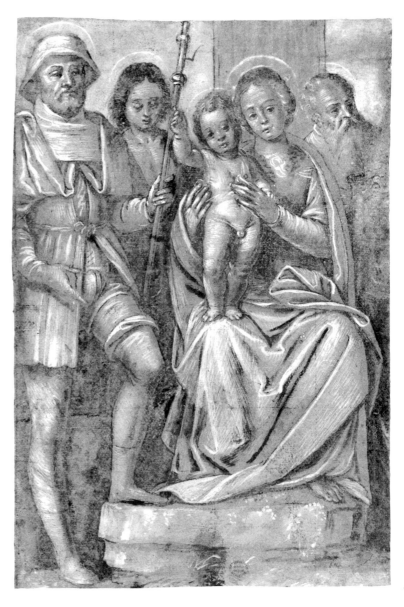

LEONARDO DA VINCI

Vinci 1452 – Cloux 1519

107. *Studies for a Nativity*

Pen and brown ink, over preliminary sketches in metalpoint, on pink prepared paper; ruled lines added in black chalk or metalpoint (recto). Three slight geometrical diagrams in the center and a faint caricature of a head in profile to left by the right margin, in pen and brown ink on verso. 19.3 x 16.2 cm.

Inscribed in pen and brown ink at upper margin of old mount, *de la main de Leonardo da Vinci.*

PROVENANCE: Jacques-Guillaume Legrand, Paris; J. Allen Smith, London; Thomas Sully; Francis T. S. Darley; Thomas Nash, New York; purchased in New York in 1917.

BIBLIOGRAPHY: Burroughs, 1918, pp. 214-217, repr. p. 215; *Raccolta Vinciana,* X, 1919, pp. 259-260, repr. p. 263; Popp, 1928, no. 19, repr.; W. Suida, *Leonardo und sein Kreis,* Munich, 1929, pp. 51, 270, pl. 49; *Commissione Vinciana,* II, 1930, pl. 40; Bodmer, 1931, repr. p. 149; Berenson, 1938, no. 1049C, fig. 484; *Metropolitan Museum, Italian Drawings,* 1942, no. 8, repr.; *Metropolitan Museum, European Drawings,* 1944, no. N.S.2, repr.; Popham, 1949, pl. 159; Heydenreich, 1954, pl. 34; K. Clark, *Leonardo da Vinci, an Account of His Development as an Artist,* rev. ed., Baltimore, 1959, p. 50, pl. 20; Berenson, 1961, no. 1049C, fig. 475; C. de Tolnay, *Raccolta Vinciana,* XIX, 1962, pp. 110-111, fig. 13 (the hitherto unpublished verso of the sheet); Ames, 1962, no. 153, repr.; Bean, 1964, no. 3, recto repr.; Bean and Stampfle, 1965, no. 15, recto repr.; Pedretti, 1973, pp. 13-17, 31-34, recto fig. 4.

Rogers Fund, 1917
17.142.1

In these sketches of the Virgin kneeling in humility before the Christ Child, who lies on the ground, Leonardo investigated a theme that was to become the *Madonna of the Rocks,* where the Virgin kneels facing the spectator, her right hand raised in benediction over the seated Infant Jesus. The sketches at the center and at the lower left corner of the sheet, where the Virgin raises both arms in devotional wonder, are close to a small composition study on a sheet at Windsor (12560; Popham, 1949, pl. 160). These sketches are related to a design by Leonardo that must have been brought at least to the stage of a complete cartoon, for several painted copies have survived.

Recent controversy over the chronology of the Paris and London versions of the *Madonna of the Rocks* makes it difficult to date the Metropolitan drawing. If, as had generally been assumed, the Louvre *Madonna of the Rocks* was the picture commissioned in Milan in 1483, then the drawing may be dated at about that time. If, however, the National Gallery *Madonna,* a work finished in Leonardo's late style, was the altarpiece originally commissioned in 1483, and the Louvre picture was painted in Florence before the artist's departure for Milan, as Martin Davies and Kenneth Clark contended, then the present drawing could be appreciably earlier and assignable to Leonardo's first Florentine period. However, Carlo Pedretti has recently proposed a dating on stylistic grounds in the last years of the century.

LEONARDO DA VINCI

108. *Allegorical Design*
VERSO. *Designs for a Stage Setting*

Pen and brown ink. 20.2 x 13.3 cm.

Inscribed in pen and brown ink in the artist's hand on recto, reading from right to left: *El ramarro fedele allomo vedēdo quello adormētato cōbatte cholla biscia esse vede nōlla potere vincere core sopa, il volto dellomo ello dessta accioche essa biscia no noffenda lo adormentato homo;* in pen and brown ink in the artist's hand at upper left of verso, reading from right to left, *acrissio giācristofano / acriso, siro tachō / danae francº romano / merchurio. gianbatista da Ossmo / giove. giāfrancº tantio / servo / ānuntiatore della festa* [Acrisius – Gian Cristophano / Sirus – Taccone / Danae – Francesco Romano / Mercury – Gian Battista of Osimo (?) / Jove – Gian Francesco Tantio / a servant / announcer of the performance]; to the right of this listing are a number of arabic numerals in Leonardo's hand written from left to right. The inscription continues, + *i quali si maravigliano / della nova stella essinginochiano / e quella adorano essingino / chiano e cō musicha finisscha / no la fessta* [Those who marvel at the new star and kneel down and worship it and kneeling down with music close the performance]; to the left of flaming mandorla, *anūtiatore.* Inscribed in pen and brown ink at top of old mount, *de la main de Leonardo da Vinci,* at the bottom, *Parmegianino.*

PROVENANCE: Jacques-Guillaume Legrand, Paris; J. Allen Smith, London (according to an inscription on the old mount that reads: *Souvenir d'amitié a J. allen Smith par J. G. Legrand en floréal an 9.*); Thomas Sully; Francis T. S. Darley; Thomas Nash, New York; purchased in New York in 1917.

BIBLIOGRAPHY: Burroughs, 1918, pp. 214-217; *Raccolta Vinciana,* X, 1919, pp. 259-260, recto repr. p. 261, verso p. 262; M. Herzfeld, *Raccolta Vinciana,* XI, 1920-1922, pp. 226-228 (verso); Popp, 1928, no. 27, recto repr.; Bodmer, 1931, recto repr. p. 233; *Commissione Vinciana,* III, 1934, pl. 106 (recto); Berenson, 1938, no. 1049B; *Commissione Vinciana,* V, 1939, pl. 183 (verso); J. P. Richter, *The Literary Works of Leonardo da Vinci,* Oxford, 1939, I, no. 705A (verso), II, no. 1264A (recto); *Metropolitan Museum, Italian Drawings,* 1942, no. 9, recto and verso repr.; Popham, 1949, pl. 111 (recto); Heydenreich, 1954, verso pl. 81 (wrongly said to be verso of No. 107 above); Berenson, 1961, no. 1049B; Bean, 1964, no. 5, recto repr.; Bean and

Stampfle, 1965, no. 17, recto repr.; K. T. Steinitz in *Le Lieu théâtral à la Renaissance,* Paris, 1968, pp. 35-40, pl. 1, fig. 1 (verso); Pedretti, 1973, p. 16; C. Pedretti, *The Literary Works of Leonardo da Vinci, Commentary,* Berkeley and Los Angeles, 1977, I, p. 402 (verso), II, p. 265 (recto); C. Pedretti, *Leonardo architetto,* Milan, 1978, pp. 112, 291-293, figs. 163, 435, 436 (verso); M. Angiolillo, *Leonardo, feste e teatri,* Naples, 1979, pp. 57-58, fig. 37 (verso).

Rogers Fund, 1917
17.142.2

This mysterious allegorical representation of a man asleep, with his head resting perilously near the entangled group of a lizard struggling with a serpent, is open to as many interpretations as Leonardo's own reversed left-handed inscription will allow. Popham, who entitled the composition *Allegory of the Lizard Symbolizing Truth,* offered the following translation of the text: "The lizard faithful to man, seeing him asleep, fights with the serpent and, if it sees it cannot conquer it, runs over the face of the man and thus wakes him in order that the serpent may not harm the sleeping man." The circular form of the design suggests that it may have been intended for an emblem, possibly done for the Sforza court in Milan.

On the reverse are Leonardo's notes on the cast of characters and his designs for (or records of) the staging of *Danae,* a masque by Baldassare Taccone that was presented in Milan on January 31, 1496, in the house of Gian Francesco Sanseverino, Conte di Cajazzo. The floor plan and a perspective sketch of the setting are indicated at center; at left of center the *anūtiatore* (heavenly messenger?) appears within a flaming mandorla in an arched niche.

109. *Head of a Man in Profile to Left*

Pen and brown ink, over black chalk. 11.7 x 5.2 cm. Edges of sheet torn irregularly. Lined.

PROVENANCE: Sir Peter Lely (Lugt 2092); purchased in London in 1909.

BIBLIOGRAPHY: *Vasari Society,* first series, VII, 1911-1912, no. 2, repr.; Seidlitz, 1935, pl. 88; Berenson, 1938, no. 1049D; *Metropolitan Museum, Italian Drawings,* 1942, no. 10, repr.; Popham, 1949, pl. 140C; Berenson, 1961, no. 1049D*, fig. 495; Bean, 1964, no. 4, repr.; Bean and Stampfle, 1965, no. 16, repr.

Rogers Fund, 1909
10.45.1

In this profile of an old man with sharply aquiline nose, downslanted mouth, and knotted brow, Leonardo has brought the "ideal" head almost to the limits of the grotesque. It is not likely that this is a portrait or caricature; it is more probably a conscious recollection of the ideal portrait of Darius by Leonardo's master, Verrocchio. Verrocchio's relief, sent by Lorenzo the Magnificent to the king of Hungary, is now lost, but the profile is recorded in a Della Robbia workshop terracotta relief in Berlin (repr. G. Passavant, *Verrocchio,* London, 1969, fig. 51). A highly finished early drawing by Leonardo in the British Museum (repr. Popham, 1949, pl. 129) must have been directly inspired by the original Verrocchio relief. Popham dated the British Museum drawing about 1480, and placed the Metropolitan's sketch, where the powerful features of the imaginary Darius are recorded in a more schematized fashion, about 1490. Leonardo's truly grotesque heads, exaggerated works of pure fantasy, were, on the whole, done a good deal later in his career.

110. *Head of the Virgin*

Black and colored chalks. Traces of framing line in pen and brown ink at upper right. 20.3 x 15.6 cm. Repairs at right margin. Lined.

Faint inscription in pen and brown ink at upper left, *leonardo* [?]. Inscribed in pen and brown ink on reverse of old mount, *i20. R. V͗*.

PROVENANCE: Sir Charles Greville (Lugt 549); Earl of Warwick (Lugt 2600); Warwick sale, London, Christie's, May 20-21, 1896, no. 213; Dr. Ludwig Mond, London; Lady Melchett; Melchett sale, London, Sotheby's, May 23-24, 1951, no. 7, repr. frontispiece, purchased by the Metropolitan Museum.

BIBLIOGRAPHY: Berenson, 1903, I, p. 158, II, no. 1045; J. P. Richter, *The Mond Collection,* II, London, 1910, pp. 323-335, pl. XIX; G. Frizzoni, *Rassegna d'arte,* XI, 1911, p. 43, fig. 6; O. Sirén, *Leonardo da Vinci,* New Haven, Connecticut, and London, 1916, p. 137; Venturi, IX, I, 1925, fig. 138; A. de Rinaldis, *Storia dell'opera pittorica di Leonardo da Vinci,* Bologna, 1926, p. 235, pl. 69; Sirén, 1928, I, p. 112; Berenson, 1938, no. 1045, fig. 514; Berenson, 1961, no. 1049D-1, fig. 499; Bean and Stampfle, 1965, no. 19, repr.

Harris Brisbane Dick Fund, 1951
51.90

This finished drawing, heightened in colored chalk, is certainly related to and is possibly a study for the head of the Virgin in Leonardo's *Virgin and Child with St. Anne,* now in the Louvre, a picture probably painted during Leonardo's second stay in Milan and datable about 1508-1510. At Windsor there is a much freer black chalk drawing that is generally accepted as a study for the head of St. Anne in the same painting.

All the authors cited in the bibliography—with Berenson first and foremost—have accepted the present drawing as an original work by Leonardo and as a study for the Louvre picture. No doubts as to its authorship have to our knowledge been published by writers on Leonardo, but its omission from several recent publications on the artist and his drawings seems to reflect critical skepticism in certain circles. The problem is difficult, because though Leonardo is said to have used colored chalks, no other example that can be surely attributed to him has survived. The Milanese followers of Leonardo were quick to adopt this technical innovation of their master; Lombard head studies in colored chalk, often directly inspired by Leonardo, are known, but none of them approaches the exceptional quality or the poetic power of this head, subtly modeled in light and shade. Corrections or restorations by a later hand may account for the dark passages at nostril and lips. An old copy of the drawing is in the Albertina (Wickhoff, *Albertina,* 1892, p. CLXXXV, S.R. 62).

LEONARDO DA VINCI, copy after

111. *Grotesque Head: Man in Profile to Right*

Pen and brown ink, on beige paper. 9.1 x 5.4 cm. Lined.

PROVENANCE: Jacques-Guillaume Legrand, Paris; J. Allen Smith, London; Thomas Sully; Francis T. S. Darley; Thomas Nash, New York; purchased in New York in 1917.

BIBLIOGRAPHY: Seidlitz, 1935, pl. 122, as Leonardo; Pedretti, 1973, p. 16, fig. 2, as Leonardo.

Rogers Fund, 1917
17.142.3

This drawing was discovered *underneath* Leonardo's *Allegorical Design* (No. 108 above) at the time of the acquisition of the latter from Thomas Nash in 1917. At that time No. 108 was hinged to a blue mount bearing inscriptions in an early nineteenth-century French hand: *de la main de Leonardo da Vinci* and *l'écriture est à gauche, et doit se lire dans une glace.* These comments obviously refer to No. 108 with its long left-handed inscriptions. At the bottom of the old mount is penned the name *Parmegianino,* which seems to indicate the attribution preferred by the French collector J.-G. Legrand for the present drawing. Though the pen work in this head bears little resemblance to that of Parmigianino, the attribution is not entirely misdirected because the Parmese master did draw heads in profile that have in the

past been confused with the work of Leonardo (see No. 162 below). By placing the present drawing in such close proximity to an autograph work by Leonardo, Legrand may have wished to suggest that the "Parmegianino" head derives from an original by Leonardo.

Carlo Pedretti, who reproduced this drawing in 1973 as an autograph and hitherto unpublished work by Leonardo, does not seem to have been aware that it was illustrated in the 1935 edition of Seidlitz's work on the master. This grotesque head also occurs in the same direction on a sheet of Leonardesque studies from Vivant Denon's collection that is now in the British Museum (Popham and Pouncey, 1950, no. 122, pl. CX). Pedretti suggested that the London head is copied after the present drawing; this seems unlikely because the copy in London painstakingly imitates the left-handed shading characteristic of Leonardo, while the shading here is ambiguously vertical. The present drawing, dry and awkward in execution, seems a good deal further from Leonardo than is the copy in the British Museum.

LEONARDO DA VINCI, follower of

112. *Head of a Woman in Profile to Lower Left*

Metalpoint, heightened with white, on pale blue-green prepared paper. 15.4 x 12.7 cm. Upper corners cut away; lower right corner replaced; repaired diagonal tear at top of sheet.

Inscribed in pen and brown ink at lower margin of old mount (now lost), L: *da V: vol 2^{nd} No 3* (indicating the drawing's place in the Pembroke albums).

PROVENANCE: Sir Peter Lely (Lugt 2092); Earls of Pembroke; Pembroke sale, London, Sotheby's, July 5-6, 9-10, 1917, no. 468, as Leonardo, purchased by the Metropolitan Museum.

BIBLIOGRAPHY: Strong, 1900, part III, no. 28, repr., as Milanese school; Burroughs, 1919, p. 137, as Leonardo (with an incorrect reference to Berenson); *Metropolitan Museum, Italian Drawings*, 1942, no. 11, repr., as follower of Leonardo; *Metropolitan Museum, European Drawings*, 1944, no. N.S.3, repr., as follower of Leonardo; *Le Dessin italien dans les collections hollandaises*, exhibition catalogue, Paris, Rotterdam, Haarlem, 1962, under no. 54, as school of Leonardo; Haverkamp-Begemann, 1964, I, pp. 10-11, under no. 7, fig. 11, as

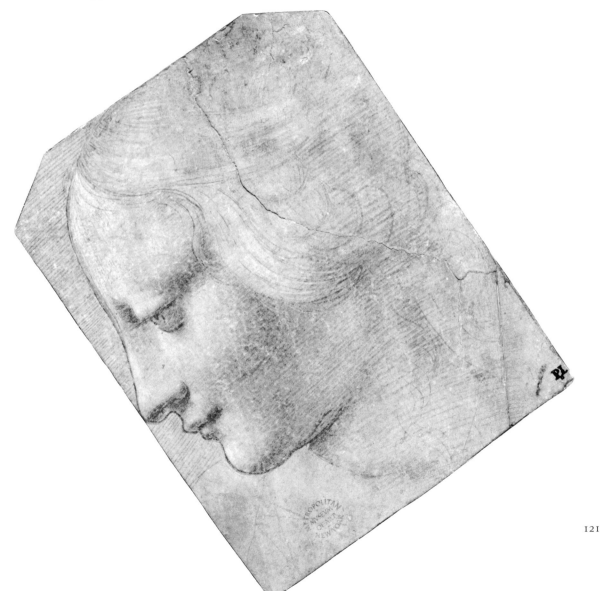

follower of Leonardo; C. Pedretti, *Revue de l'Art,* 25, 1974, pp. 26-28, 33, note 21, repr. p. 26, as studio of Leonardo.

Hewitt Fund, 1917
19.76.3

Carlo Pedretti seems to have been the first to point out that this head was probably intended to be seen inclined toward the left, instead of in vertical profile, as it was mounted in the seventeenth century judging from the position of Lely's collector's mark. The slant of the right-handed metalpoint strokes and the placement of the shoulder line at left give weight to the suggestion. It is reproduced here at this angle.

S. Arthur Strong seems to have been the first to reject the traditional attribution of this fine but damaged drawing to Leonardo himself; he rather tentatively proposed the names of Ambrogio de Predis and Boltraffio. The drawing is very probably the work of some talented (right-handed) Milanese follower of Leonardo, but present-day knowledge of this school is so incomplete that it is not possible to assign the sheet with certainty to an individual artist in this milieu.

PIRRO LIGORIO

Naples 1513/1514 – Ferrara 1583

113. *Two Princes of the House of Este*

Pen and brown ink, yellow-brown wash, over black chalk. 22.3 x 12.6 cm.

Inscribed in pen and brown ink on a strip pasted onto the sheet near lower margin, ERNESTUS· VI HENRICI / XX· FILIUS, and FRANCISCUS· II HENRICI / XX· FILIUS; at lower margin, *fratres Luneburgenses duce/ obijt 1456* and *obijt 1549·*.

PROVENANCE: Purchased in London in 1963.

BIBLIOGRAPHY: Bean and Stampfle, 1965, no. 109, repr.; F. Gibbons, *Catalogue of Italian Drawings in the Art Museum,* Princeton, New Jersey, 1977, pp. 121-122, under no. 406; Harprath, 1977, p. 78, under nos. 49-52; Thiem, Stuttgart, 1977, p. 207, under no. 383; Macandrew, 1980, p. 263, under nos. 256-279.

Rogers Fund, 1963
63.106

This sheet is part of a series of some forty drawings by Pirro Ligorio, each representing a pair of distinguished members of the House of Este, that once may have

formed a long continuous scroll. Many of these sheets have been discussed by Jean Seznec (*Revue des Arts,* IV, 1954, pp. 24-26), David R. Coffin (*Art Bulletin,* XXXVII, 1955, pp. 167-185), and Parker (Parker II, nos. 256-279). The drawings were probably made by Ligorio to illustrate Giovanni Battista Pigna's *Historia de'principi d'Este,* the first edition of which appeared, without the illustrations, in Ferrara in 1570. This work attempted to establish the unbroken descent of the Este family from the Roman Caius Atticus, and Ligorio's chronology is based on the genealogical tree supplied by Pigna. Ligorio's drawings were no doubt used as models for the monochrome frescoes representing two hundred notables of the Este family painted by two minor artists, Bartolomeo and Girolamo Faccini, on the four walls of the courtyard of the Este castle at Ferrara before 1577. If all the figures painted by the Faccini brothers were

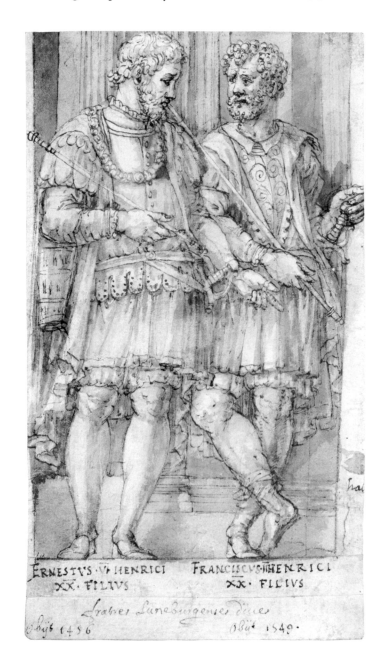

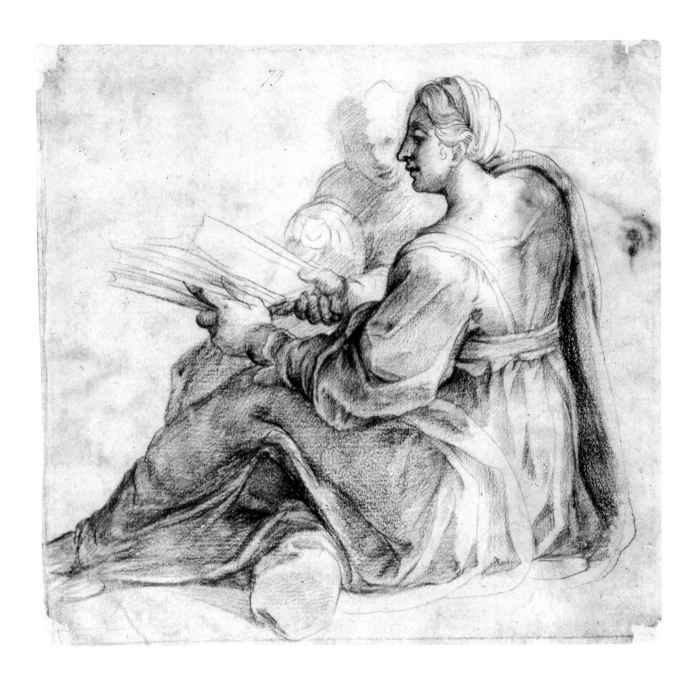

modeled after Pirro Ligorio's drawings, then at the rate of two figures to an architectural framework, as is the case with all the surviving drawings, more than half of Ligorio's designs have disappeared. Twenty-four of the drawings are in the Ashmolean Museum at Oxford, four in the British Museum, four in Munich, one in the Uffizi, one in Stuttgart, one at Princeton, and at least three in private collections. Ligorio's designs served as models for book illustrations only much later, when thirteen of them were used for engravings illustrating a text by Antonio Cariola, *Ritratti de' ser.^(mi) principi d'Este sig.^(ri) di Ferrara,* published in Ferrara in 1641.

114. *Seated Sibyl and Attendant Genius*

Red chalk on beige paper. Pen study of a horse's head on verso. 24.5 x 26.5 cm. A number of brown stains; all four corners replaced. Partially lined.

Numbered in pen and brown ink at upper center, 79.

PROVENANCE: Hugh N. Squire, London; purchased in London in 1962.

BIBLIOGRAPHY: Bean, 1963, pp. 232-235, fig. 6, as Sebastiano del Piombo; Bean, 1964, no. 14, repr., as Sebastiano; Bean and Stampfle, 1965, no. 57, repr., as Sebastiano; J. A. Gere, *Master Drawings,* IX, 3, 1971, p. 244, pl. 15.

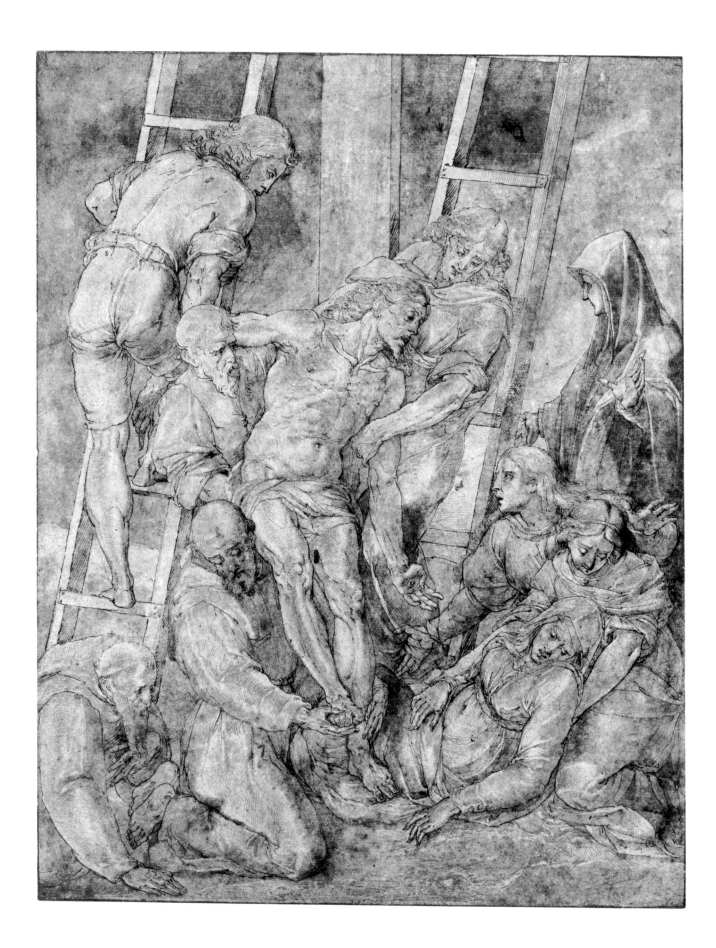

Pfeiffer Fund, 1962
62.120.7

An attribution to Sebastiano del Piombo had been proposed by Philip Pouncey when this drawing was in the Squire collection in London, and the drawing was published and exhibited with this attribution after it came to the Metropolitan Museum. Then in 1971 J. A. Gere proposed the name of Pirro Ligorio, and his suggestion has since been accepted by Mr. Pouncey. If the amplitude of form and the sensitive lighting of the seated female figure suggested the name of Sebastiano, Gere points out that "the monstrous hands, clumsily attached to the arms by grotesquely malformed wrists, show this characteristic mannerism [of Ligorio] exaggerated to the point of actual deformity."

JACOPO LIGOZZI

Verona 1547 – Florence 1627

115. *The Descent from the Cross with St. Francis and Another Friar*

Pen and brown ink, brown and gray wash, heightened with gold. 36.4 x 28.3 cm. Scattered losses. Lined.

PROVENANCE: William Russell (Lugt 2648); purchased in London in 1965.

BIBLIOGRAPHY: *Exhibition of Old Master Drawings.* W. R. Jeudwine, London, 1965, no. 9, pl. IV.

Rogers Fund, 1965
65.112.3

W. R. Jeudwine identified the drawing as a study for a painting by Ligozzi, signed and dated 1591, now in the Museo Civico, San Gimignano (repr. Venturi, IX, 7, fig. 260). There are a good many slight variations between drawing and painting.

ANDREA LILIO

Ancona ca. 1555 – Ascoli Piceno 1610

116. *Cartouche and Two Shields Surrounded by Allegorical Figures*

Pen and brown ink, brown wash, heightened with white, over red and black chalk. 18.2 x 23.5 cm. Contours in right half are incised. Lined.

Inscribed in pen and brown ink at upper center, *Andrea d.| Ancona;* illegible inscription at lower right corner (lower half cut off).

PROVENANCE: Purchased in London in 1963.

BIBLIOGRAPHY: Bean, 1972, no. 28; Macandrew, 1980, p. 40, under no. 284-1A.

Rogers Fund, 1970
1970.113.4

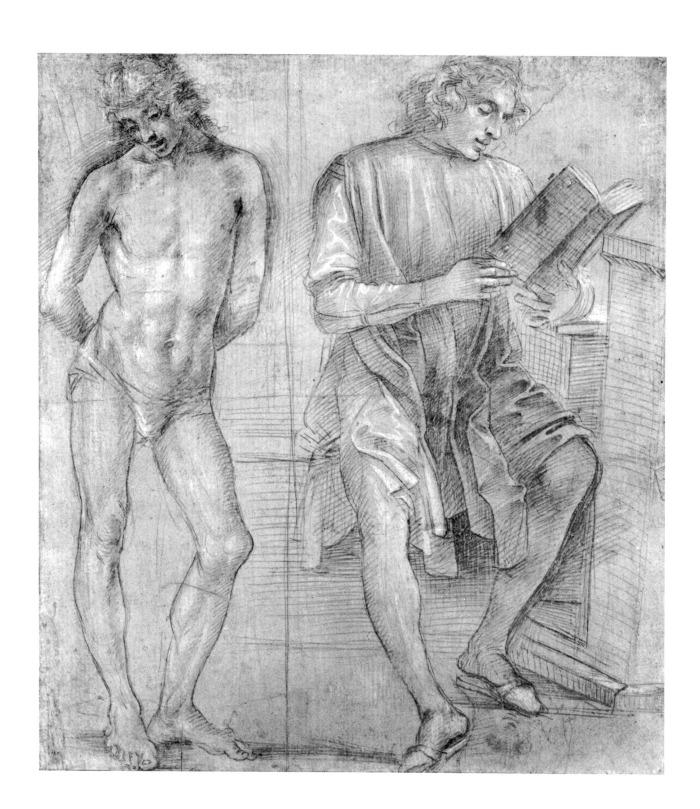

FILIPPINO LIPPI

Prato 1457/1458 – Florence 1504

117. *Standing Youth with Hands Behind His Back, and a Seated Youth Reading* VERSO. *Two Studies of Hands*

Metalpoint, heightened with white, on pink prepared paper (recto and verso). 24.5 x 21.6 cm. Greenish pigment stain at lower right of verso.

PROVENANCE: Lord De L'Isle; J. P. Heseltine; Henry Oppenheimer; Oppenheimer sale, London, Christie's, July 10, 13-14, 1936, no. 112, recto repr., purchased by the Metropolitan Museum.

BIBLIOGRAPHY: H. Ulmann, *Repertorium für Kunstwissenschaft*, XVII, 1894, p. 113, as Raffaellino del Garbo; H. Ulmann, *Jahrbuch der königlich preussischen Kunstsammlungen*, XV, 1894, p. 244, as Raffaellino del Garbo; Berenson, 1903, no. 1349; Heseltine Collection, 1913, no. 22, repr., as Domenico Ghirlandaio; Popham, 1931, p. 14, no. 46, pl. XL; A. Scharf, *Filippino Lippi*, Vienna, 1935, p. 124, no. 229, pl. 101, fig. 148; Berenson, 1938, no. 1353B; *Metropolitan Museum, Italian Drawings*, 1942, no. 5, repr.; *Metropolitan Museum, European Drawings*, 1944, no. N.S.1, repr.; Berenson, 1961, no. 1353B; Bean, 1964, no. 6, repr.; Bean and Stampfle, 1965, no. 22, repr.

Harris Brisbane Dick Fund, 1936
36.101.1

A characteristic example of Filippino's figure draughtsmanship from life, using youthful assistants posed in the studio. The nearly nude figure at left with his hands behind his back is presumably studied for a St. Sebastian. Ulmann attributed the drawing to Raffaellino del Garbo, Heseltine to Domenico Ghirlandaio. However, Berenson's proposal of Filippino's name, first made in 1903, has met with general acceptance.

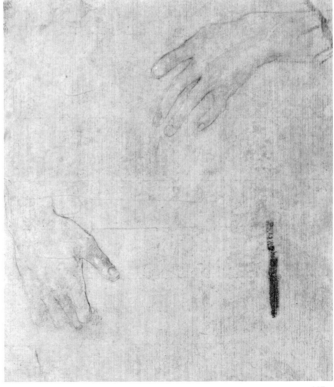

117 v.

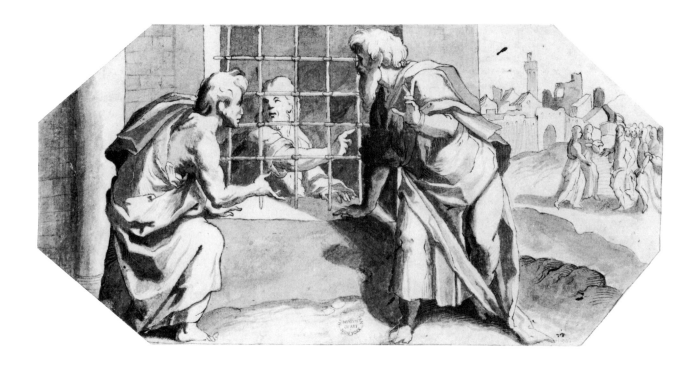

ERMENEGILDO LODI

Cremona, notices from 1598–1616

118. *St. John the Baptist in Prison Sends His Disciples to Question Jesus*

(Matthew 11:2-6; Luke 7:18-23)

Pen and brown ink, gray wash. 13.7 x 28.1 cm. All four corners cut off.

Inscribed in pen and brown ink on verso, *di Ermenegildo Ladi Lodi scolaro di malosso v'è un suo quadro in S. Pietro a pò di cremona non sò se pa o 2a capella entrando a man sinistra, è la predica di S. Gio: Batta al deserto;* and in another hand, *Di questo Ermenegildo Lodi vi sono altre molte Pitture in Cremona, e altrove. Erà uomo assai accreditato.*

PROVENANCE: G. Locarno (Lugt 1691); Pacini (Lugt 2011); James Jackson Jarves; Cornelius Vanderbilt.

BIBLIOGRAPHY: *Metropolitan Museum Hand-book,* 1895, no. 195, as Lodi.

Gift of Cornelius Vanderbilt, 1880
80.3.195

Ermenegildo Lodi was a pupil of G. B. Trotti (Il Malosso), and his style as a draughtsman is almost an imitation of that of his master. He shares Malosso's partiality for pale brown contour lines constrasting with pale gray washes.

GIOVANNI BATTISTA LOMBARDELLI, called Giovanni Battista della Marca

Montenovo (now Ostra Vétere) ca. 1532 – Perugia 1592

119. *Scenes from the Life of St. Anthony Abbot*

Pen and brown ink, red chalk, red wash. Traces of squaring in black chalk. 26.0 x 36.3 cm. Vertical crease at center.

Inscribed in pen and brown ink at upper margin, *xi.a / xij.a / xiij;* at lower left corner of old mount, *Baltasar de Sienne.*

PROVENANCE: Purchased in London in 1974.

BIBLIOGRAPHY: Bean, 1975, no. 25.

Purchase, David L. Klein, Jr., Memorial Foundation Inc. Gift and Rogers Fund, 1974
1974.16

Study for four scenes from the life of St. Anthony Abbot that are compressed into three sections of a narrative sequence painted by Lombardelli in the mid 1580s on the interior walls of the church of S. Antonio Abate, Rome (Baglione, 1642, p. 47). On the left, St. Anthony crosses a river; immediately above, he stands inside a fort after casting out serpents and partially blocking the entrance; in the center, he emerges from his refuge after twenty years of seclusion and works miracles of healing;

at the right, the devil, disguised as a monk, stands outside Anthony's cell while the saint kneels in prayer to God who appears above.

Only twenty-three scenes in the narrative fresco cycle that originally covered the walls of S. Antonio Abate have survived. Four were entirely repainted in the eighteenth century, and many were covered with whitewash when the church was given to the Russian College in 1932. The present drawing is a study, with slight variations, for frescoes still to be seen in the second bay of the left nave of the church.

The naïve character of these crowded narrative scenes and the archaic perspective may be accounted for by the anachronistic nature of the commission the artist received from the Order of the Hospitalers of St. Anthony, proprietors of the then newly reconstructed church of S. Antonio Abate on the Esquiline. Lombardelli was required to follow the representations of Anthony's life as recorded in an illuminated manuscript dated 1426, the work of Mâitre Robin Fournier of Avignon, that was sent specially to Rome from the mother house of the order at St.-Antoine-de-Viennois in France for this purpose. The

manuscript was in due course returned to France, and at the suppression of the Order of St. Anthony in 1775 it passed to the Order of Malta and is now in the public library at Valletta, Malta (see R. Graham, *A Picture Book of the Life of St. Anthony the Abbot Reproduced from a Manuscript of the Year 1426 in the Malta Public Library of Valletta,* Oxford, 1937). Here Lombardelli copies the manuscript fairly faithfully, though he imparts an elegant mannerist elongation to the figures. The illustrations in question appear on fol. xviii verso, fol. xix verso, and fol. xxi recto of the Malta manuscript (R. Graham, *op. cit.,* pp. 36-37, pls. IX, X).

This drawing was identified in 1973 as the work of Lombardelli by Philip Pouncey, who has since discovered in the Cabinet des Dessins of the Louvre a drawing that is clearly a study for another and now-destroyed part of the St. Anthony cycle (Inv. 22479, as anonymous Italian). In the Louvre composition study, St. Anthony listens to the advice of an old man, receives and distributes alms, and is tempted by the devil in the form of a well-dressed woman; the visual sources are Malta MS. fol. ix verso and fol. xii recto (R. Graham, *op. cit.,* pls. IV and VI).

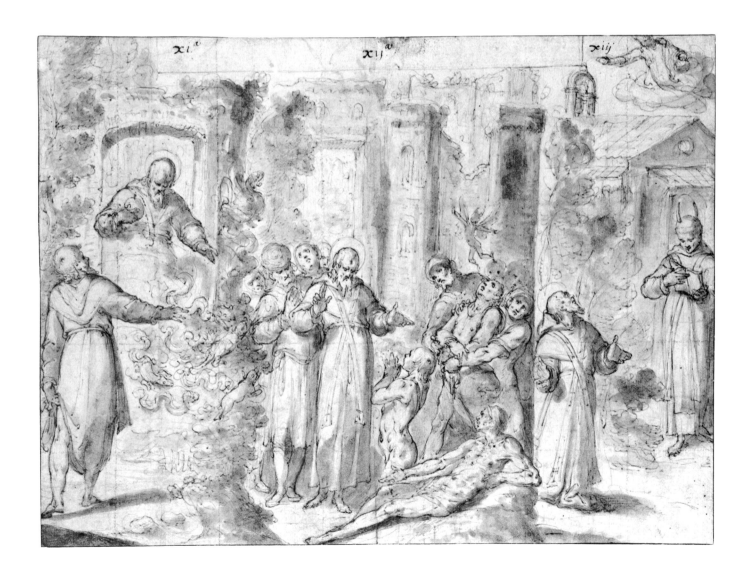

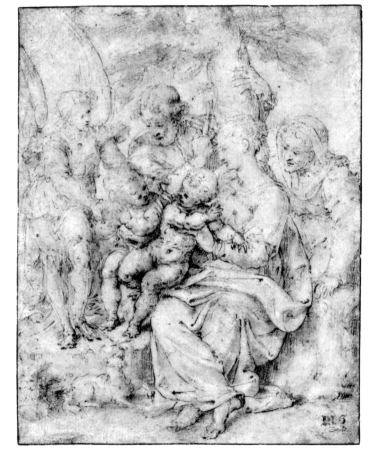

Baglione reported that Niccolò Circignani worked in S. Antonio Abate at the same time as Lombardelli, but all that survives of the work ascribed to the former are the paintings in the drum of the cupola of a side chapel (Baglione, 1642, p. 42; R. Enking, *S. Andrea cata Barbara e S. Antonio Abbate sull'Esquilino,* Rome, 1964, p. 74, fig. 21). Recent attempts to discover the hand of Circignani in the frescoed cycle devoted to the life of St. Anthony on the walls of the nave of the church itself — specifically attributed to Lombardelli by Baglione — seem to us inconclusive (see G. Sapori, *Storia dell'arte,* 38/40, 1980, p. 281, note 19).

120. *A Nun on Her Deathbed,* *the Holy Spirit Above*

Pen and brown ink, brown wash, over red chalk. 12.1 x 11.4 cm. Lined.

Numbered in faint black chalk at lower left, *no. 75;* inscribed in pen and brown ink at lower margin of old mount, *di Giov Batta della Marca.*

PROVENANCE: Sale, Geneva, Nicolas Rauch, June 18-19, 1962, no. 291; purchased in Zurich in 1962.

Rogers Fund, 1962
62.129.5

The facial types are characteristic of Lombardelli, and the old attribution is no doubt correct.

AURELIO LUINI

Milan ca. 1530 – Milan 1593

121. *The Holy Family with the Infant Baptist,* *St. Elizabeth, and an Attendant Angel*

Pen and brown ink, pale brown wash, on beige paper. 15.9 x 12.7 cm. Surface considerably abraded.

PROVENANCE: Maurice Marignane (Lugt 1872); Harry G. Sperling, New York.

Bequest of Harry G. Sperling, 1971
1975.131.35

BERNARDINO LUINI ?

Lombardy ca. 1480 – active until 1532

122. *Bust of Christ*

Black, red, and yellow chalk on brownish paper. 37.4 x 27.3 cm. A good many repaired losses.

PROVENANCE: Samuel Woodburn; Woodburn sale, London, Christie's, June 16-25, 1854, no. 38; purchased in London in 1906.

BIBLIOGRAPHY: W. Suida, *Art Quarterly*, VIII, 1, 1945, pp. 18, 23, fig. 5, as Andrea Solario.

Rogers Fund, 1906
06.1051.9

The head is much damaged and restored, but it appears to be the work of a Lombard artist strongly influenced by Leonardo da Vinci. The attribution to Bernardino Luini is traditional, and the physical type of Christ is close to comparable heads in Luini's paintings. In 1945 William E. Suida suggested an attribution to another contemporary Lombard master, Andrea Solario.

ALESSANDRO MAGANZA ?

Vicenza 1556 – Vicenza 1640

123. *The Martyrdom of St. Lucy: Her Last Communion before Being Dragged by Oxen*

Pen and brown ink, brown wash, over black chalk. 26.5 x 14.4 cm. Lined.

PROVENANCE: James Jackson Jarves; Cornelius Vanderbilt.

BIBLIOGRAPHY: *Metropolitan Museum Hand-book*, 1895, no. 154, as Barocci.

Gift of Cornelius Vanderbilt, 1880
80.3.154

Philip Pouncey suggested in 1958 that this sketch comes close in style to drawings that in recent years have been given to the Vicentine painter Alessandro Maganza. Typical examples of this group are in the F. Lugt Collection, Institut Néerlandais, Paris; the Museum Boymans-van Beuningen, Rotterdam; the Albertina, Vienna; the Pierpont Morgan Library, New York; and in

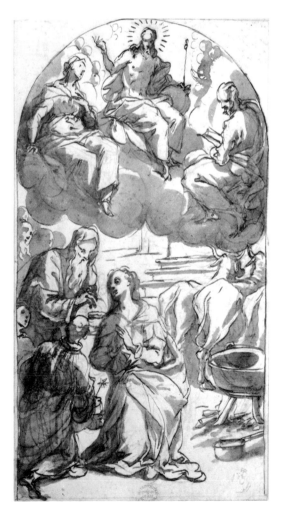

the collection of Janos Scholz (see Byam Shaw, 1981, nos. 57-62).

These drawings are similar in style to a study for a Crucifixion in the Uffizi (12862 F), which bears on the reverse an old inscription, *Alesandro Maganza Suo Vero* (see Tietze, 1944, p. 292, under no. A1757). The weight of this inscription is somewhat diminished by the presence of an old inscription, *Aless°. Maganza Vicentino,* on another drawing in the Uffizi (12846 F), representing Magistrates Venerating the Virgin that is clearly the work of quite another draughtsman. However, a drawing in the Hessisches Landesmuseum, Darmstadt, representing a Doge Receiving Petitioners (AE 1741, classified as Muttoni) bears an old ascription to Maganza; the Darmstadt drawing seems to be by the same hand as Uffizi 12862 F and the group of drawings mentioned above.

PIETRO MALOMBRA

Venice 1556 – Venice 1618

124. *The Emperor Frederick Barbarossa Submitting to Pope Alexander III in the Presence of a Doge*

Black, gray, red, brown, and yellow chalk, on faded blue paper. 29.1 x 43.1 cm. Vertical crease at center. Lined.

PROVENANCE: James Jackson Jarves; Cornelius Vanderbilt.

BIBLIOGRAPHY: *Metropolitan Museum Hand-book,* 1895, no. 364, artist unknown, "Pope Alexander III, and the Emperor Frederick Barbarossa"; E. Tietze-Conrat, *Art Quarterly,* III, 1940, p. 33, fig. 20, p. 36; Tietze, 1944, no. 789, pl. CXXXV, 3; *La pittura del Seicento a Venezia, catalogo dei disegni a cura di Terisio Pignatti,* Venice, 1959, no. 3, repr.

Gift of Cornelius Vanderbilt, 1880
80.3.364

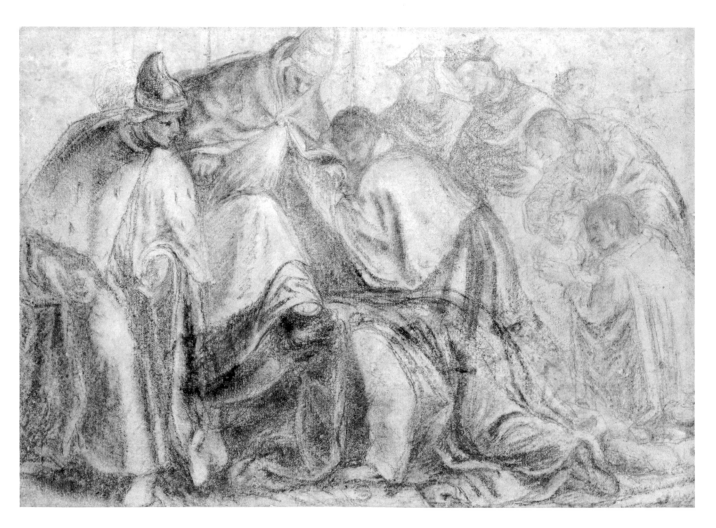

In 1940 E. Tietze-Conrat suggested that this drawing is Malombra's study for a lunette-shaped overdoor painted by the artist for the church of S. Giacomo di Rialto, Venice. The painting is now lost, but it was described by Ridolfi, who commented that the doge represented at the left was Marino Grimani (held office from 1595 to 1605) instead of Sebastiano Ziani who was doge in 1177 when this historic event is supposed to have occurred.

The figures are indeed grouped in such a way that they would comfortably fit into a lunette shape, and the connection with Malombra's lost picture is possible. It is difficult, however, to be certain because Malombra is otherwise almost unknown as a draughtsman. The artist here has borrowed his composition from the central group in Federico Zuccaro's celebrated representation of the same scene in the Palazzo Ducale, Venice (repr. Voss, 1920, II, fig. 181).

RUTILIO MANETTI

Siena 1571 – Siena 1639

125. *Studies for a Rest on the Flight into Egypt*

Pen and brown ink, brown wash, over red chalk (the faint sketch of St. Joseph and the donkey at left background is entirely in red chalk). 23.9 x 18.4 cm. Some foxing. Lined.

PROVENANCE: Philip Hofer, Cambridge, Massachusetts; Walter C. Baker, New York.

BIBLIOGRAPHY: Virch, 1962, no. 27, attributed to Annibale Carracci; P. Pouncey, *Revue de l'Art,* 14, 1971, p. 68, fig. 3; Bacou, 1981, under no. 47.

Bequest of Walter C. Baker, 1971
1972.118.259

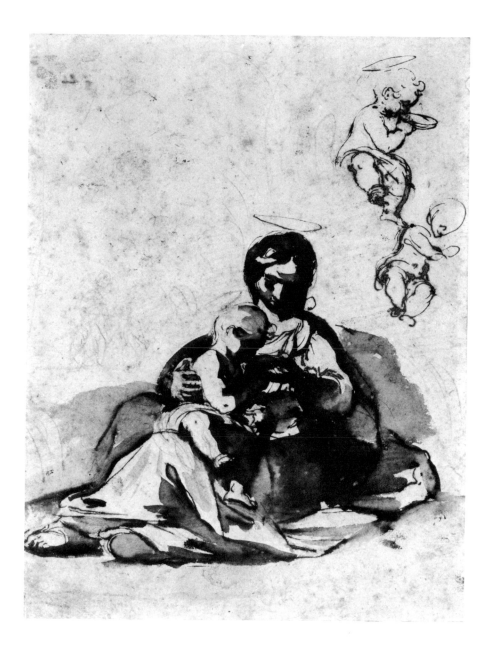

Listed by Claus Virch in his catalogue of the Baker collection with a tentative attribution to Annibale Carracci, the drawing was recognized by Philip Pouncey in 1965 as Manetti's study for a painting, *The Rest on the Flight into Egypt*, now in the Gemälde-Galerie at Kassel (repr. *Rutilio Manetti 1571-1639*, exhibition catalogue, Palazzo Pubblico, Siena, 1978, p. 81). In the drawing as in the painting the seated Virgin holds a drinking cup to the Christ Child's lips while St. Joseph and his donkey appear in the middleground at left. Another study for this subject, in oil paint on paper, is preserved in the Cabinet des Dessins at the Louvre; it comes from the collection of Pierre-Jean Mariette, who recognized it as the work of Manetti (Inv. 1285; Bacou, 1981, pl. 47).

ANDREA MANTEGNA ?

Isola di Carturo 1431 – Mantua 1506

126. *Design for a Rinceau*

Pen and brown ink. 4.7 x 28.5 cm. Vertical crease at center. Lined.

Inscribed in pen and brown ink at lower margin of old mount in Richardson's hand, *Andrea Mantegna*.

PROVENANCE: Padre Sebastiano Resta; John, Lord Somers (Lugt 2981; *g.88* as Andrea Mantegna–Lansdowne Ms.); Jonathan Richardson, Sr. (Lugt 2983, 2995); purchased in London in 1966.

Rogers Fund, 1966
66.618.1 (Department of Prints and Photographs)

The draughtsman here is certainly very close to Mantegna, though the delicate line may lack the vigor we expect from the master himself.

ANDREA MANTEGNA, circle of

127. *Seated Man Holding a Club*

Pen and brown ink, brown wash. Two grotesque profile sketches of men with hooked noses and chins in faint pen and brown ink on verso. 21.0 x 14.2 cm. A number of repaired losses; lower left corner cut off.

Inscribed in pen and brown ink at lower margin of old mount in Richardson's hand, *Mantegna;* and in pencil, *A Young Man sitting;* in pen and brown ink on reverse of old mount, *at M.ʳ Wadmore's Sale May 8. 1854.*

PROVENANCE: Padre Sebastiano Resta; John, Lord Somers (Lugt 2981; *g.52* as Mantegna–Lansdowne Ms., *lo copio d'una gioia anticha*); Jonathan Richardson, Sr. (Lugt 2983, 2995); James Wadmore; Wadmore sale, London, Christie's, May 8-10, 1854 (according to old inscription on mount); purchased in London in 1906.

BIBLIOGRAPHY: *Metropolitan Museum, Italian Drawings*, 1942, no. 3, repr., as Bernardo Parentino; Ames, 1962, no. 67, repr., as Bernardo Parentino.

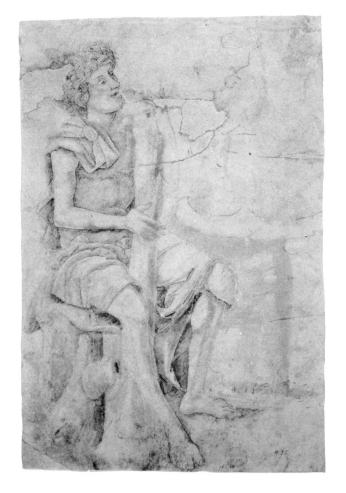

Rogers Fund, 1906
06.1051.6

Padre Resta attributed the drawing to Mantegna and seems to have thought the design was copied after an antique gem. This damaged sketch can be placed in the wide circle of Mantegna's influence; it does not bear much resemblance to the work of Bernardo Parentino, whose name was proposed in 1941 by H. B. Wehle.

MARCO MARCHETTI, called
Marco da Faenza

Faenza (birth date unknown) – Faenza 1588

128. *Studies of Two Helmets and of Two Soldiers Wearing Helmets*

Pen and brown ink, brown wash. 19.8 x 13.7 cm. Creases at upper right.

PROVENANCE: Mathias Komor (Lugt Supp. 1882a); purchased in New York in 1961.

Rogers Fund, 1961
61.21.1

The source of the attribution of the present sheet to Marco da Faenza is uncertain, but the sprightly, bizarre fashion in which the heads and helmets are delineated here recalls ornamental designs by Marchetti in the Louvre (see Monbeig-Goguel, 1972, nos. 59-77) and in Munich (see Harprath, 1977, nos. 53-56). These fantastic helmets inspired by the antique come close (though perhaps quite fortuitously) to those copied by Marten van Heemskerck in his Berlin sketchbook (repr. C. Hülsen and H. Egger, *Die römischen Skizzenbücher von Heemskerk im königlichen Kupferstichkabinett zu Berlin,* reprint ed., Soest, Holland, 1975, II, pl. 17, fol. 15r and 15v).

FRANCESCO MELZI ?

Milan 1493 – Vaprio d'Adda ca. 1570

129. *Two Grotesque Heads: Old Woman with an Elaborate Headdress and a Man with Large Ears*

Pen and brown ink. 5.4 x 9.9 cm. Lower margin irregular.

PROVENANCE: Earls of Pembroke; Pembroke sale, London, Sotheby's, July 5-6, 9-10, 1917, part of no. 466, as school of Leonardo; Bacri, Paris; Edward Fowles, New York.

BIBLIOGRAPHY: Strong, 1900, part II, no. 15, as after Leonardo.

Gift of Mrs. Edward Fowles, in memory of Edward Fowles, 1975
1975.96

This small sheet was one of twelve, each with two or three caricatured heads, that were mounted together when in the Pembroke collection, as can be seen from the reproduction in Strong. The twelve sheets have since been scattered: two are in the Pierpont Morgan Library

in New York; two in the Elmer Belt Library of Vinciana, University of California, Los Angeles; one in the Detroit Institute of Arts; and one in the National Gallery of Art, Washington, D.C.; while the whereabouts of the remaining five is uncertain.

All of these drawings are copies after surviving or lost caricatured heads by Leonardo, and the left-handed direction of Leonardo's stroke has been painstakingly reproduced. Some of the heads are copies of caricatures preserved at Chatsworth; the old woman at the left in our drawing reproduces Chatsworth no. 823B (Courtauld photograph 307/56/19). Carlo Pedretti has proposed a very plausible attribution to Leonardo's heir Francesco Melzi for the sheets from the Pembroke collection; Melzi is known to have made copies of a number of Leonardo's drawings (Pedretti, 1973, p. 40).

PIETRO MERA, called Il Fiammingo ?

Born in Brussels; active in Florence and Venice 1570 – 1639

130. *The Virgin and Child with Chaplets Appearing to St. Dominic and St. Catherine of Siena*

Pen and brown ink, brown wash, over black chalk. 22.1 x 15.3 cm.

Inscribed in pen and brown ink on verso, *S.F. n° 217.*

PROVENANCE: Unidentified Venetian collector (inscription similar to Lugt Supp. 2103a); sale, Los Angeles, Sotheby's, March 8, 1976, no. 365, as Ferrarese school, early 17th century; purchased in New York in 1981.

Purchase, David L. Klein, Jr., Memorial Foundation Inc. Gift, 1981
1981.281

It was Eliot W. Rowlands who recently pointed out that this drawing is clearly by the same hand as a pen and wash design in the collection of Ralph Holland, Newcastle-upon-Tyne, representing St. Anthony of Padua and other saints (J. Stock, *Disegni veneti di collezioni inglesi,* exhibition catalogue, Fondazione Giorgio Cini, Venice, 1980, no. 55, repr.). Mr. Holland suggested very convincingly of his drawing that it is by the same draughtsman as a sheet at Christ Church, Oxford, *Madonna and Child with Saints,* attributed to Pietro Mera since the time of Ridolfi (Byam Shaw, 1976, I, no. 836, II, pl. 493). Indeed, all three drawings do seem to be by the same hand. The name of the rather obscure Pietro Mera, who worked in Florence and in Venice, is plausible for these drawings, in which Central and North Italian sources are apparent.

MICHELANGELO BUONARROTI

Caprese 1475 – Rome 1564

131. *Studies for the Libyan Sibyl*
VERSO. *Further Studies for the Libyan Sibyl and a Small Seated Figure*

Red chalk (recto); black chalk (verso). 28.9 x 21.4 cm. Spots of brown wash at lower right of recto. Triangular section at right margin replaced.

Inscribed in pen and light brown ink at lower left, *di M . . . gelo bonarroti.*; numbered at upper right, *58;* paraph in pen and darker brown ink at lower center; numbered in pen and brown ink on verso at upper right, *58,* and at lower center, *nº.2i.*

PROVENANCE: Carlo Maratti ?; Andrea Procaccini ?; Aureliano de Beruete, Madrid; purchased in Madrid from Beruete's widow by the Metropolitan Museum in 1924.

BIBLIOGRAPHY: M. Utrillo, *Forma,* II, 1907, p. 194, repr. p. 198 (recto); H. Thode, *Michelangelo. Kritische Untersuchungen über seine Werke,* Berlin, I, 1908, pp. 254-255, no. LVI; III, 1913, p. 167, no. 378; K. Frey, *Die Handzeichnungen Michelagniolos Buonarroti,* Berlin, I, 1909, pl. 4 (recto), pl. 5 (verso); III, 1911, pp. 2-4; B. Burroughs, *Metropolitan Museum of Art Bulletin,* January 1925, pp. 7-14, repr. p. 8 (recto), p. 9 (verso); A. E. Brinckmann, *Michelangelo Zeichnungen,* Munich, 1925, p. 33, no. 32, pl. 32 (recto); Berenson, 1938, no. 1544D, fig. 631 (recto); *Metropolitan Museum, Italian Drawings,* 1942, no. 16, repr. (recto), no. 17, repr. (verso); *Metropolitan Museum, European Drawings,* 1944, no. N.S.6, repr. (recto); C. de Tolnay, *Michelangelo,* II, *The Sistine Ceiling,* Princeton, 1945, pp. 61, 204, no. 46, pl. 80 (recto), p. 209, no. 13A, pl. 236 (verso, as school of Michelangelo); R. Oertel, *Kunstchronik,* II, 1949, pp. 263-264; L. Goldscheider, *Michelangelo Drawings,* London, 1951, no. 30, repr. (recto); J. Wilde, *Italian Drawings in the Department of Prints and Drawings in the British Museum. Michelangelo and His Studio,* London, 1953, pp. 26, 101; L. Dussler, *Die Zeichnungen des Michelangelo,* Berlin, 1959, pp. 183-184, no. 339, fig. 39 (recto), fig. 174 (verso); Berenson, 1961, no. 1544D*, fig. 564 (recto), fig. 565 (verso); Ames, 1962, no. 192, repr. (recto); Bean, 1964, no. 10, repr. (recto); Bean and Stampfle, 1965, no. 36, repr. (recto and verso); L. Goldscheider, *Michelangelo Drawings,* 2nd ed., London, 1966, no. 39, repr. (recto); F. Hartt, *Michelangelo Drawings,* New York [1970], pp. 83-84, no. 87, repr. frontispiece (recto), p. 84, no. 88, repr. p. 100 (verso); J. A. Gere, *Drawings by Michelangelo,* exhibition catalogue, British Museum, London, 1975, no. 20, repr. p. 30 (recto); C. de Tolnay, *Corpus dei disegni di Michelangelo,* I, Novara, 1975, pp. 116-117, nos. 156 recto, 156 verso, repr. (recto and verso); A. Perrig, *Michelangelo Studien I. Michelangelo und die Zeichnungswissenschaft,* Frankfurt, 1976, pp. 42, 61, 72-73, 76, pl. 54, fig. 21 (detail), the attribution to Michelangelo rejected.

Purchase, Joseph Pulitzer Bequest, 1924
24.197.2

On the recto of this sheet there are a series of studies from a nude male model for the figure of the Libyan Sibyl that appears on the frescoed ceiling of the Sistine Chapel. The Sistine frescoes were commissioned in 1508 and finally unveiled in 1512. In the principal and highly finished drawing dominating the sheet Michelangelo has studied the turn of the sibyl's body, the position of the head and arms; in the fresco the sibyl turns to close a large book on the ledge behind her. The left hand of the figure is studied again below, as are the left foot and toes. A study of the sibyl's head, possibly the first drawing on the sheet, appears at the lower left, and a rough sketch of the torso and shoulders are immediately above it. A closely related drawing in the Ashmolean Museum at Oxford (Berenson, 1961, no. 1562, fig. 577) has red chalk studies for the sibyl's right hand and of the boy holding a scroll behind her. On the same sheet at Oxford occur studies for the slaves intended for the tomb of Julius II. The conjunction of studies for the Sistine ceiling and the tomb of Julius II gives evidence that the Libyan Sibyl, part of the very last phase of Michelangelo's work on the Sistine ceiling, was contemporary with the first plans for the ill-fated tomb. An old copy of the recto of the Metropolitan Museum's drawing with a few variations, possibly by a Northern artist, is in the Uffizi (repr. P. Barocchi, *Michelangelo e la sua scuola. I disegni di Casa Buonarroti e degli Uffizi,* Florence, 1962, no. 268, pl. CCCLXIII).

Several years ago Manuela Mena Marqués suggested that the hitherto unidentified paraph in pen and brown ink that appears on the recto of the sheet is very close to paraphs scribbled on some drawings in the Real Academia de San Fernando in Madrid. These were part of a large group of drawings known to have been acquired by the Academy in 1775 from the widow of the painter Andrea Procaccini, who had inherited them from his master Carlo Maratti. She also kindly pointed out that the Academy did not buy all of the drawings in the possession of Procaccini's widow, for a year later in 1776 another group with this provenance was offered for purchase to the Academy and turned down.

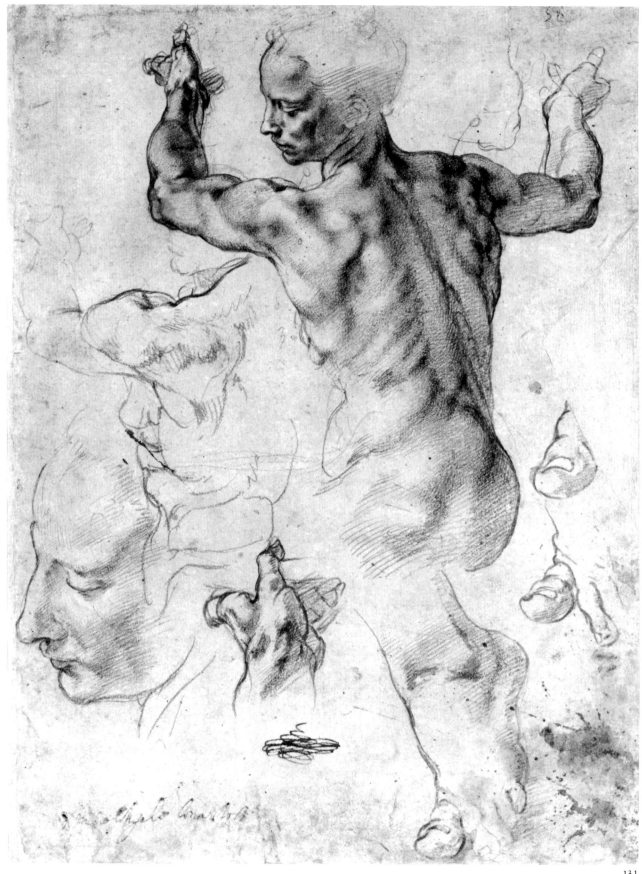

131

MICHELANGELO

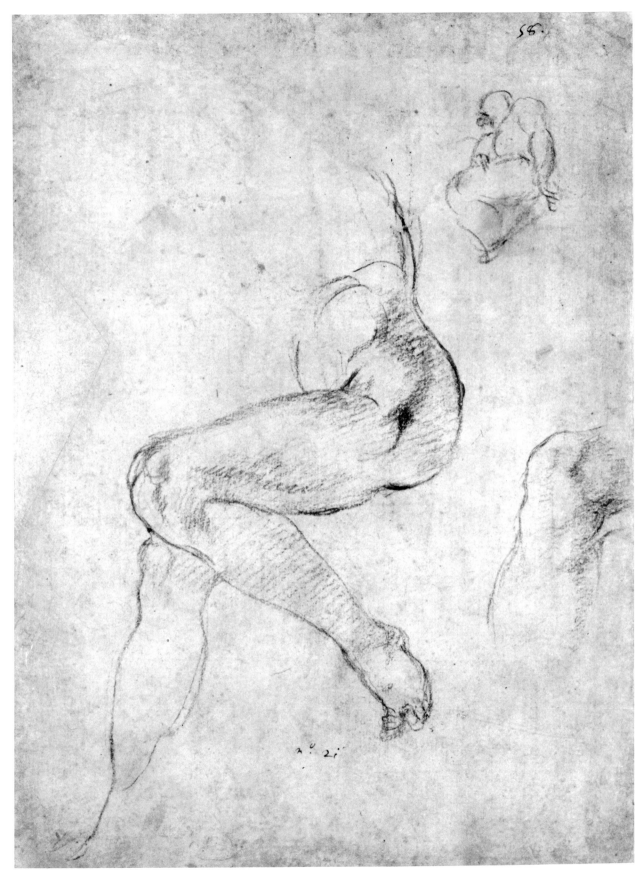

131 v.

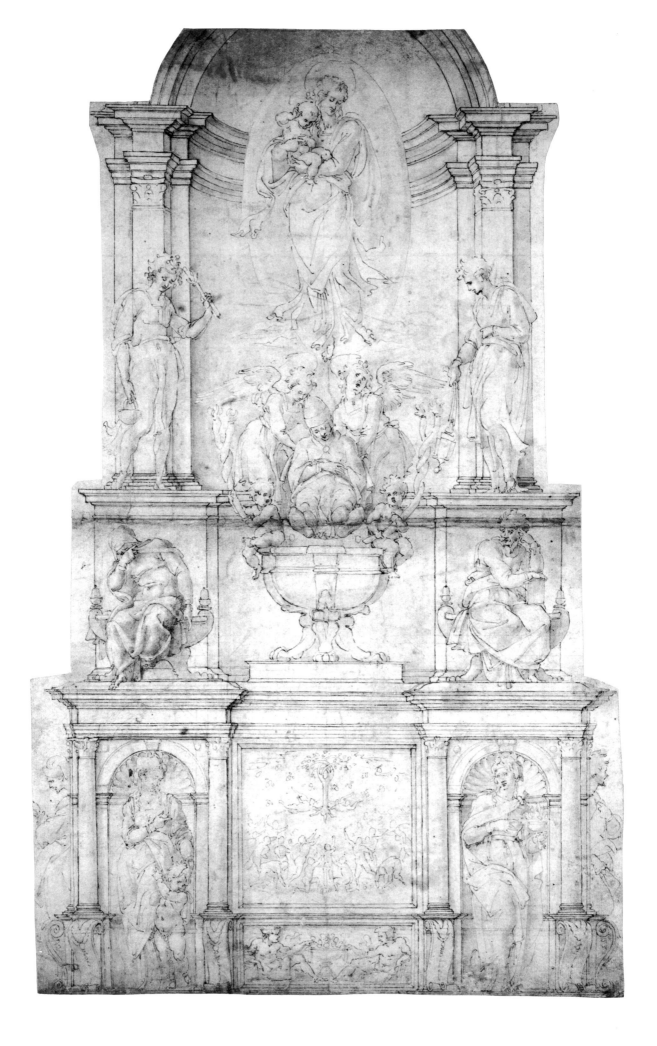

MICHELANGELO BUONARROTI ?

132. *Project for a Wall Tomb for Pope Julius II della Rovere*

Pen and brown ink, brown wash, over black chalk. 51.0 x 31.9 cm. The design has been roughly silhouetted and mounted on a larger sheet. Horizontal crease at center.

PROVENANCE: Purchased in London in 1962.

BIBLIOGRAPHY: C. de Tolnay, *Corpus dei disegni di Michelangelo*, I, Novara, 1975, p. 63, repr. without comment; M. Hirst, *Master Drawings*, XIV, 4, 1976, pp. 375-382, pls. 1-4; C. de Tolnay, *Corpus dei disegni di Michelangelo*, IV, Novara, 1980, p. 27, pl. 489 recto, as Michelangelo ?; P. Joannides, *Art Bulletin*, LXIII, 4, 1981, p. 680.

Rogers Fund, 1962
62.93.1

In 1976 Michael Hirst made the first detailed study of this fascinating drawing, which had been acquired by the Metropolitan Museum fourteen years earlier as a work of the school of Michelangelo, somehow associable with the planning for the tomb of Julius II. Hirst pointed out the close connection with (and important differences from) Michelangelo's comparably large but ruined design in Berlin for what is thought to be the 1513 project for the tomb of Julius. The Berlin drawing is best understood through the faithful if awkward copy of it by Jacomo Rocchetti that is also preserved in Berlin.

In our drawing the upper part of the wall tomb with its monumental niche is of approximately the same design though broader and lower than in the Berlin project. The Virgin and Child in a mandorla above (inspired by Raphael's *Sistine Madonna*), and the dead pope seen frontally lying on a sarcophagus and attended by angels and putti, are similar to those in the Berlin scheme. The figures of youths flanking and facing the niche in our drawing—that on the left with an aspergillum and bucket of holy water, that on the right with a censer—do not appear in the Berlin design; there the flanking figures are undifferentiated and look outward.

The lower part of our drawing differs radically from the Berlin scheme. The slaves and herm pilasters seen in the latter are eliminated, and the central relief, which is nearly a square, offers a bizarre and highly original representation of the Fall of the Manna, with acorns falling from the oak tree emblematic of the Della Rovere family. Della Rovere acorns figure elsewhere in the design: they fill a footed cup between two reclining nude youths at lower center, and they ornament the arms of

the chairs occupied by the sibyl and prophet in the middle story. The niches to the left and right of the lower story are occupied by allegorical figures of Charity and Faith. The projection of the tomb from the wall is indicated by statues of standing figures seen in profile at extreme left and right. It should be noted that the tomb would have been supported by a stepped base, which has been cut away here.

Hirst offered a number of persuasive arguments for the attribution of the present design to Michelangelo himself, not the least being the brilliance of the pen work. His attribution has been enthusiastically accepted by Frederick Hartt (in a paper read before the College Art Association in Washington, D.C., in February 1979). Charles de Tolnay reproduced the drawing in the fourth volume of his *Corpus* as Michelangelo, though he expressed some reservations in the accompanying text.

MICHELANGELO BUONARROTI, copy after

133. *The Last Judgment*

Black chalk on brownish paper. 27.2 x 43.3 cm. A number of repaired losses; many small brown stains.

PROVENANCE: Sir Peter Lely (Lugt 2092); V. L. Danvers, Hildenborough, Kent; purchased in New York in 1967.

BIBLIOGRAPHY: *Illustrated London News*, August 28, 1937, repr. p. 332, as Michelangelo; J. Q. van Regteren Altena in *Stil und Überlieferung in der Kunst des Abendlandes, Akten des 21. International Kongresses für Kunstgeschichte in Bonn 1964*, II, Berlin, 1967, pp. 178-179, pl. II, 46, 2, as possibly an autograph drawing by Michelangelo, known to the author only in a photograph; C. de Tolnay, *Corpus dei disegni di Michelangelo*, III, Novara, 1978, p. 24, repr., as school of Michelangelo.

Purchase, Arthur A. Houghton, Jr., Gift, 1967
67.152

This drawing is not a copy of the upper part of Michelangelo's fresco the *Last Judgment* in the Sistine chapel from which it differs in many significant ways, notably in the placement and poses of the Virgin and St. Lawrence. On the other hand, it is not a copy of any of the surviving preparatory drawings by Michelangelo for

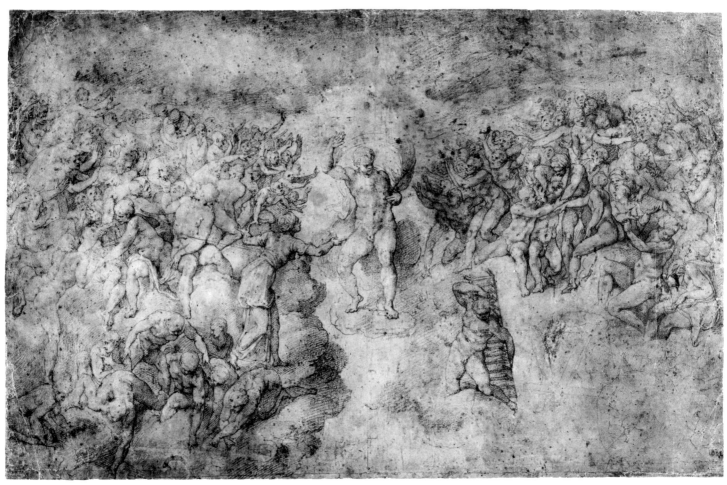

133

134

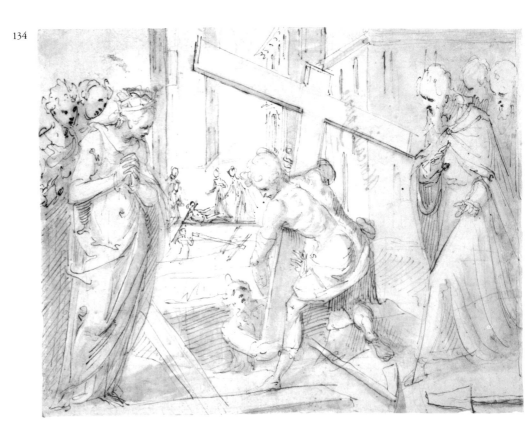

MICHELANGELO, copy after (NO. 133)

this fresco. It could well be a late sixteenth-century copy after a lost original drawing by Michelangelo; as such it has considerable documentary interest.

In 1976 Matthias Winner made the interesting observation that the draughtsmanship here comes quite close to that of Federico Zuccaro.

IL MONCALVO (Guglielmo Caccia)

Montabone (Acqui) 1568 – Moncalvo 1625

134. *The Invention of the Holy Cross*

Pen and brown ink, brown wash, over traces of black chalk. 16.4 x 21.5 cm. Red pigment stains at upper left.

Inscribed in pen and brown ink on verso, *Moncalvo pitore;* in black chalk, *nro 179./ Guglielmo Caccia.*

PROVENANCE: Carl Wiesböck (Lugt 2576); purchased in New York in 1961.

BIBLIOGRAPHY: *Italian Master Drawings from Three Centuries. Este Gallery,* exhibition catalogue, New York, 1960, no. 5, repr.

Rogers Fund, 1961
61.159

In the foreground St. Helena supervises the excavation of the True Cross, while in the background a young man is brought to life by being placed upon it. The crosses of the two thieves, which had failed to resuscitate the youth, lie rejected nearby.

135. *Designs for Ornamental Motifs and for a Herm Supporting a Chimney Piece*

Pen and brown ink, brown wash, over black chalk. 30.5 x 21.1 cm. A number of brown stains.

Numbered in pen and brown ink at upper right, 6 [?]; inscribed in pencil on verso, *Guglielmo Caccia / il Moncalvo.*

PROVENANCE: Purchased in London in 1962.

Rogers Fund, 1962
62.123.2

The ornamental vocabulary used here is sophisticated, with an almost *Régence* air to it. However, the head of the

putto-herm is unmistakably the work of Moncalvo; see for example, a similar head on a sheet by the artist in the Biblioteca Reale at Turin (repr. Bertini, 1958, no. 248). Three further studies, presumably from the same album as the present drawing, were on the London market in 1962.

RAFFAELLO MOTTA, called
Raffaellino da Reggio

Codemondo (Reggio Emilia) ca. 1550 – Rome 1578

136. *The Adoration of the Magi*

Pen and brown ink, brown wash, heightened with a little white, over black chalk, on gray-green paper. 39.1 x 31.3 cm. A modern triangular restoration at lower left corner including left calf and foot of standing man and hind legs of dog. Lined.

Inscribed in pencil at lower margin of old mount in John Skippe's hand, *Zuccaro;* in A. E. Popham's hand, RAFFAELLINO MOTTA DA REGGIO.

RAFFAELLO MOTTA (NO. 136)

PROVENANCE: John Skippe; his descendants, the Martin family, including Mrs. A. D. Rayner-Wood; Edward Holland-Martin; Skippe sale, London, Christie's, November 20-21, 1958, no. 170(A); purchased in London in 1965.

Rogers Fund, 1965
65.208

A. E. Popham pointed out in the catalogue of the 1958 Skippe sale that this design was utilized in reverse in an anonymous chiaroscuro woodcut that is inscribed RAPHAEL. REG. INVENT (Bartsch, XII, p. 31, no. 5).

An *Adoration of the Magi,* vertical in format like the present drawing but differently composed, appears as the altarpiece in a design by Raffaellino in Edinburgh for a semicircular chapel (repr. Andrews, 1968, II, fig. 704).

GIOVANNI BATTISTA NALDINI

Fiesole ca. 1537 – Florence 1591

137. *The Dead Christ Supported by Three Figures*

Pen and brown ink, brown wash, heightened with white, over black chalk, on brown-washed paper. 32.4 x 23.1 cm. Scattered losses. Lined.

PROVENANCE: Walter C. Baker, New York.

BIBLIOGRAPHY: Virch, 1962, no. 16, repr.; Bean and Stampfle, 1965, no. 139, repr.

Bequest of Walter C. Baker, 1971
1972.118.261

The attribution to Naldini was made by Philip Pouncey in 1958, when the drawing was in the collection of

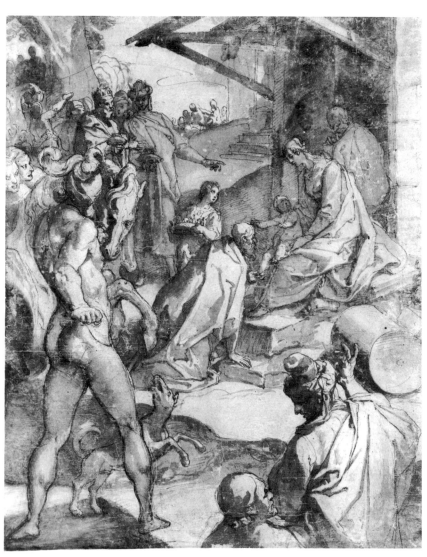

136

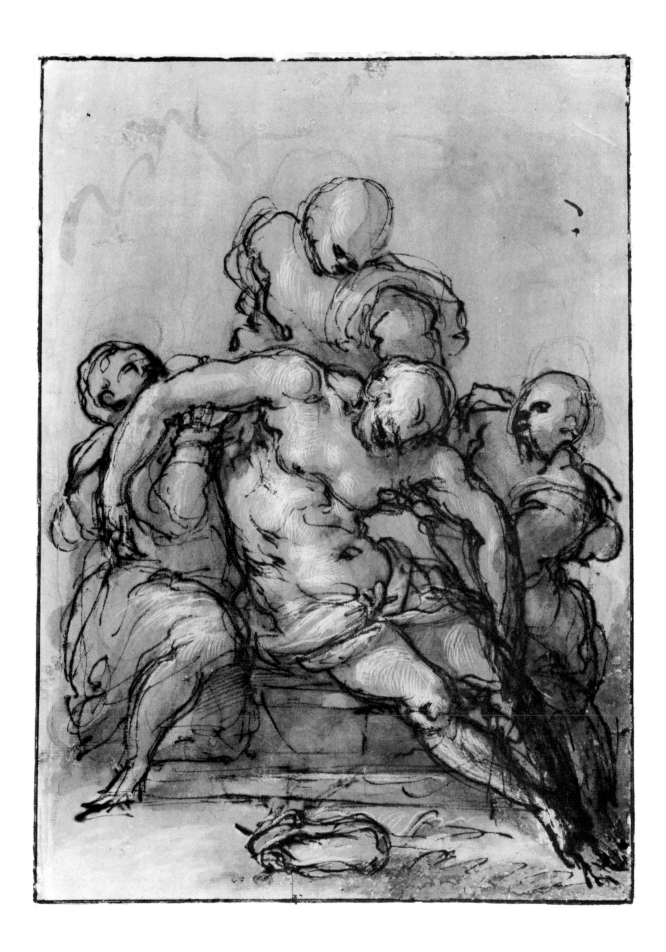

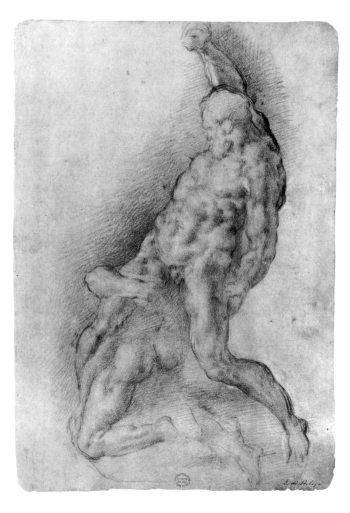

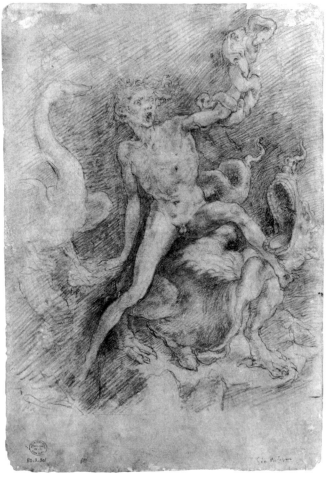

Walter C. Baker who had acquired it as the work of Palma Giovane. Another study by Naldini for the composition, with the bearing figures indicated as winged angels, is in a private collection in Paris (formerly C. R. Rudolf collection, London; repr. *Il primato del disegno*, exhibition catalogue, Palazzo Strozzi, Florence, 1980, p. 152, no. 328). A third version of the composition, in which the dead Christ is attended by five angels, is in the Brera, Milan (Inv. 323, as Francesco Salviati).

138. *Samson and the Philistines, after Michelangelo* VERSO. *Figure of Fury, after Rosso Fiorentino*

Red chalk (recto); black chalk (verso). 33.2 x 23.3 cm.

Inscribed in pen and brown ink at lower right, *G.di Bologn*[a], at lower right on verso, *Gio Bologna*.

PROVENANCE: James Jackson Jarves; Cornelius Vanderbilt.

BIBLIOGRAPHY: *Metropolitan Museum Hand-book,* 1895, no. 301, as Giovanni da Bologna.

Gift of Cornelius Vanderbilt, 1880
80.3.301

The sculptured group drawn by Naldini on the recto is based on a lost sketch-model by Michelangelo that was much copied in bronze during the sculptor's own lifetime. For a useful summary of information concerning the group by Michelangelo, see J. Pope-Hennessy, *The Frick Collection. III. Sculpture, Italian,* New York, 1970, pp. 186-195. The figure of Fury on the verso is copied from a print by Caraglio after Rosso (Bartsch, XV, p. 92, no. 58).

This drawing, which in the past had been assigned to Giambologna, was in 1958 identified as the work of Naldini by Philip Pouncey.

CESARE NEBBIA

Orvieto 1536 – Orvieto 1614

139. *The Assumption of the Virgin*

Pen and brown ink, brown wash. Squared in red and black chalk. 25.0 x 14.6 cm. Arched top. A number of repaired losses. Lined.

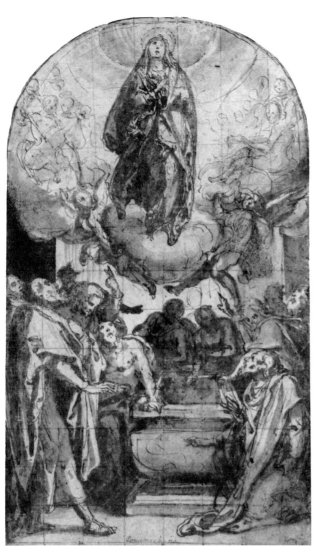

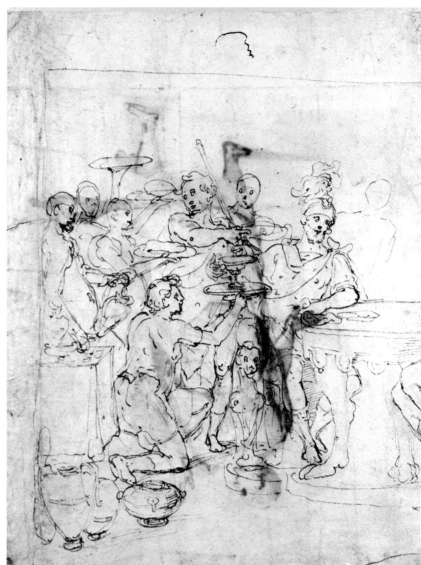

Inscribed in pencil at center of lower margin, *Domenichino*.

PROVENANCE: Benjamin West (Lugt 419); sale, London, Sotheby's, December 1, 1964, no. 179, as Jacopo da Empoli; Dr. and Mrs. Malcolm W. Bick; sale, London, Sotheby's, December 5, 1977, no. 46; purchased in New York in 1978.

BIBLIOGRAPHY: *The Bick Collection of Italian Religious Drawings,* exhibition catalogue, Ringling Museum of Art, Sarasota, Florida, 1970, no. 17, repr., as Jacopo da Empoli; *Italian Drawings from the Bick Collection,* exhibition catalogue, Dartmouth College, Hanover, New Hampshire, 1971, no. 10, repr., as Taddeo Zuccaro.

Purchase, Emma Swan Hall Gift, 1978
1978.94

Given in turn to Domenichino, Jacopo da Empoli, and Taddeo Zuccaro, the drawing was restored to Cesare Nebbia by Philip Pouncey, and it was sold under this name at Sotheby's in London in 1977.

140. *Banquet Scene: A Seated Warrior Attended by a Number of Servants* VERSO. *Back View of a Standing Man in a Long Cloak*

Pen and brown ink (recto); pen and brown ink, brown wash, over black chalk (verso). 27.9 x 21.0 cm.

Inscribed in pen and brown ink at upper margin on verso, *Cesare da orvieto.*

PROVENANCE: Purchased in New York in 1975.

BIBLIOGRAPHY: *Old Master Drawings. Armando Neerman,* exhibition catalogue, London, 1975, no. 15, recto repr.

Purchase, David L. Klein, Jr., Memorial Foundation Inc. Gift, 1975
1975.126

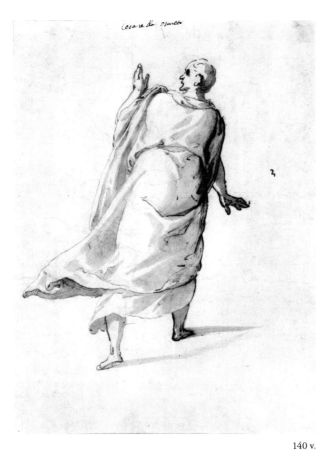

CESARE NEBBIA (NO. 140)

The traditional attribution to Cesare Nebbia may be accepted as correct. In 1979 Philip Pouncey pointed out that the drawing is a design for the left half of a *Banquet of Anthony and Cleopatra,* the composition of which is studied in its entirety by Nebbia in a drawing in the Nationalmuseum, Stockholm. This latter drawing was recognized in 1961 as the work of Nebbia by Pouncey; it had previously been classified under the name of Taddeo Zuccaro (O. Sirén, *Italienska Handteckningar... i Nationalmuseum,* Stockholm, 1917, p. 99, no. 388).

141. *Standing Figure of a Warrior King*

Pen and brown ink, brown wash, over black chalk. 21.5 x 11.2 cm. Upper margin irregular. Lined.

Faint red chalk inscription at upper left, *Ce,* at upper right, *Nebia;* inscribed in pen and brown ink on reverse of old mount, *Cesare Nebbia. d. 1614 A 78 / Disc. di Mutianus.*

PROVENANCE: Purchased in New York in 1962.

The Elisha Whittelsey Collection
The Elisha Whittelsey Fund, 1962
62.54

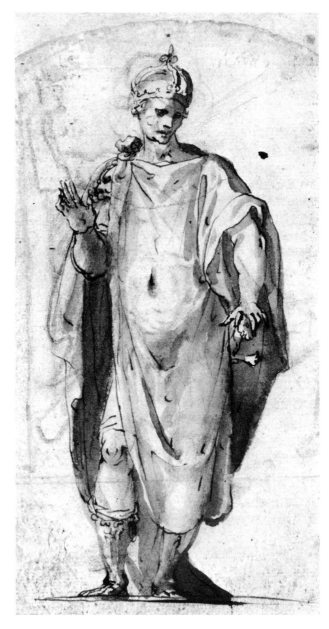

BARTOLOMEO NERONI, called Il Riccio

Siena ca. 1500 – Siena 1571

142. *Sibyl Announcing the Birth of Christ to the Emperor Augustus*

Pen and brown ink, pale brown wash, over black chalk. 26.6 x 20.4 cm. Repaired loss at upper left corner.

Inscribed in pen and brown ink at lower left, *Bald . . . da Siena* (in part cut away).

PROVENANCE: James Jackson Jarves; Cornelius Vanderbilt.

BIBLIOGRAPHY: *Metropolitan Museum Hand-book*, 1895, no. 147, as Baldassare Peruzzi; W. W. Kent, *The Life and Works of Baldassare Peruzzi*, New York, 1925, p. 84, pl. 68, as Peruzzi; E. Feinblatt, *Los Angeles County Museum, Bulletin of the Art Division*, 10, 3, 1958, pp. 16, 18, note 21; C. L. Frommel, *Baldassare Peruzzi als Maler und Zeichner*, Vienna and Munich, 1967, p. 146, note 741.

Gift of Cornelius Vanderbilt, 1880
80.3.147

The drawing entered the collection with an attribution to Baldassare Peruzzi, and W. W. Kent suggested a connection with Peruzzi's late fresco representing this tale from the Golden Legend in S. Maria di Fontegiusta,

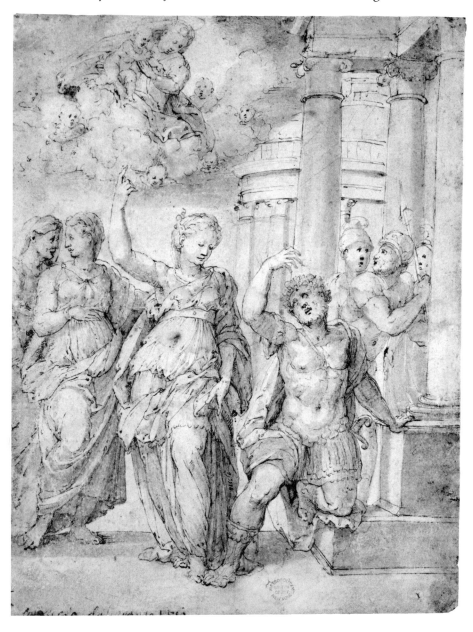

Siena (C. L. Frommel, *op. cit.,* pl. LXXXII). Then in 1958 Philip Pouncey recognized the drawing as the work of Bartolomeo Neroni, an artist strongly influenced by Peruzzi, from whom he borrowed the salient features of the Fontegiusta composition. The figure of the Sibyl, pointing with her right hand to the apparition of the Virgin and Child above, is a direct quotation from Peruzzi.

Ebria Feinblatt has pointed out that a curious feature of our drawing, the fact that Augustus's foot rests on that of the Sibyl, is also to be found in Giulio Romano's drawing of the same subject that once was in the Ellesmere collection (repr. Hartt, 1958, II, fig. 511).

BARTOLOMEO NERONI ?

143. *Arch of Constantine, Rome*

Pen and brown ink. 30.3 x 25.5 cm. Scattered losses.

Inscribed in pen and brown ink at lower margin, *Sc. di Cherubino Alberti.*

PROVENANCE: James Jackson Jarves; Cornelius Vanderbilt.

BIBLIOGRAPHY: *Metropolitan Museum Hand-book,* 1895, no. 585, as Cherubino Alberti.

Gift of Cornelius Vanderbilt, 1880
80.3.585

Like No. 144 below, this free and not very accurate copy of a Roman arch of triumph was attributed to the "school of Cherubino Alberti." Philip Pouncey in 1958 suggested that the figure style used in recording the reliefs indicated that they were *"probably* by Bartolomeo Neroni."

144. *Arch of Septimius Severus, Rome*

Pen and brown ink. 28.1 x 25.7 cm. Scattered losses.

Inscribed in pen and brown ink at lower margin, *Sc. di Cherubino Alberti* (in large part cut away).

PROVENANCE: James Jackson Jarves; Cornelius Vanderbilt.

BIBLIOGRAPHY: *Metropolitan Museum Hand-book,* 1895, no. 632, artist unknown.

Gift of Cornelius Vanderbilt, 1880
80.3.632

See No. 143 above.

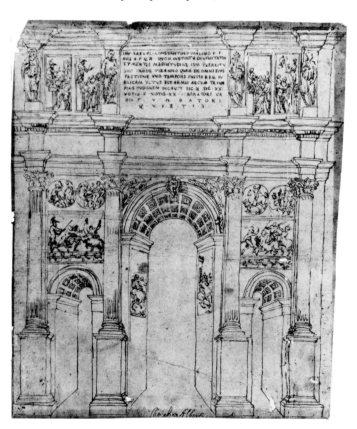

AVANZINO NUCCI

Città de Castello ca. 1552 – Rome 1629

145. *The Mystic Marriage of St. Catherine of Alexandria*

Pen and brown ink, brown wash, heightened with white, over traces of black chalk, on blue paper. 27.1 x 20.4 cm. Oval. Contours pricked for transfer. Lined.

PROVENANCE: Purchased in London in 1971.

BIBLIOGRAPHY: *Italian Old Master Drawings. Baskett and Day,* exhibition catalogue, London, 1971, no. 4, repr.; Bean, 1972, no. 32.

Rogers Fund, 1971
1971.221.2

The drawing was identified as the work of Nucci by J. A. Gere when it was on the market in London in 1971. A considerable group of drawings by this hand had been brought together under the provisional name "pseudo-Bernardo Castello" by Philip Pouncey, who in 1967 was able to identify the artist as Avanzino Nucci on the basis of drawings at Berlin and Liverpool (see Andrews, 1968, I, p. 81).

146. *Group of Angel Musicians*

Pen and brown ink, brown wash, over traces of black chalk. 27.2 x 20.2 cm. Scattered losses. Lined.

Inscribed in pencil at lower margin of old mount, *Francia;* and on reverse of old mount, *Francesco Francia.*

PROVENANCE: Cephas G. Thompson.

BIBLIOGRAPHY: *Metropolitan Museum Hand-book,* 1895, no. 696, as Francesco Francia.

Gift of Cephas G. Thompson, 1887
87.12.26

The drawing entered the collection under the name of Francesco Francia, and it lingered in anonymity until 1965 when Philip Pouncey attributed it to Avanzino Nucci, then still the "pseudo-Bernardo Castello" (see No. 145 above).

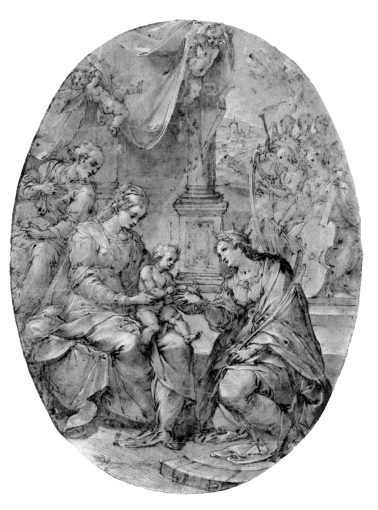

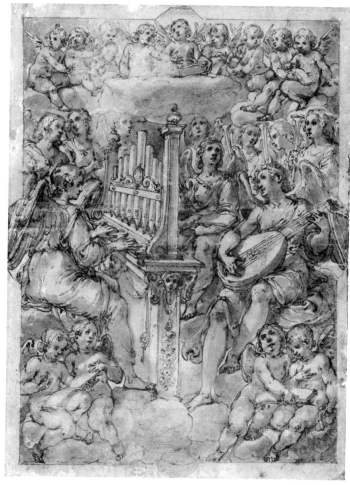

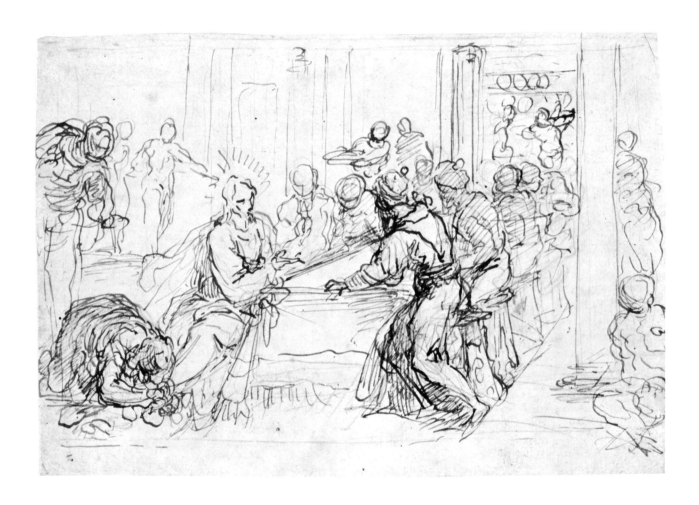

PALMA IL GIOVANE (Jacopo Palma)

Venice ca. 1548 – Venice 1628

147. *Penitent Woman Anointing the Feet of Christ at the Table of Simon the Pharisee* (Luke 7:36-50)

Pen and brown ink, over black chalk. 20.2 x 30.4 cm. Horizontal crease at upper margin; crease at upper right corner; scattered stains. Lined.

PROVENANCE: Purchased in London in 1967.

BIBLIOGRAPHY: *Exhibition of Old Master Drawings. P. and D. Colnaghi and Co.,* London, 1967, no. 4.

Rogers Fund, 1967
67.95.11

The same composition was studied by Palma in drawings at the Fitzwilliam Museum, Cambridge (repr. *European Drawings from the Fitzwilliam,* exhibition catalogue, New York, Fort Worth, Baltimore, Minneapolis, and Philadelphia, 1976-1977, no. 27), and in the Uffizi (repr. *Mostra di disegni di Jacopo Palma il Giovane,* exhibition catalogue by A. Forlani, Gabinetto Disegni e Stampe degli Uffizi, Florence, 1958, no. 57, fig. 21).

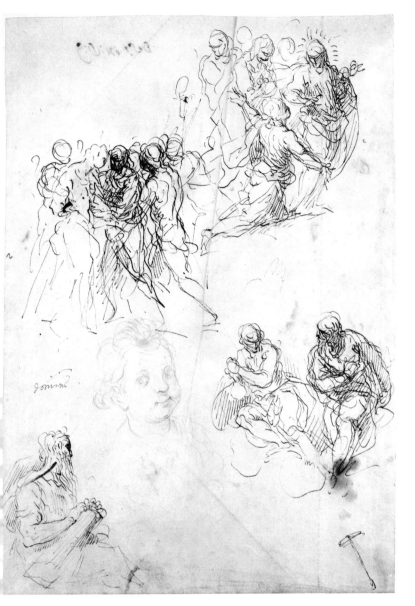

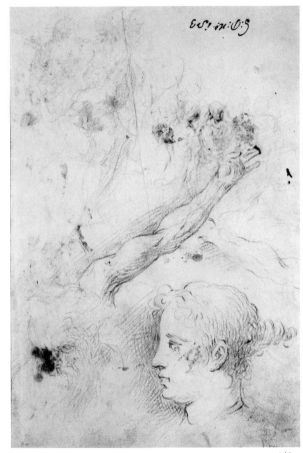

148 v.

148. *Figure Studies: The Arrest of Christ ?, Christ and the Canaanite Woman, Seated Male Figures, and the Head of a Child* VERSO. *Studies of an Arm, and of the Heads of an Old Man and a Young Woman*

Pen and brown ink, red chalk for the child's head (recto); black chalk (verso). 34.9 x 23.8 cm. Vertical crease at center; brown stain at lower right (recto); a number of brown stains (verso).

Inscribed in pen and brown ink at left below center in the artist's hand, *domani* [?]; on verso, in another hand, *G:P: nº. 153.*

PROVENANCE: Unidentified Venetian collector (inscription similar to but larger than Lugt Supp. 2103a); purchased in London in 1965.

BIBLIOGRAPHY: *Exhibition of Old Master Drawings. P. and D. Colnaghi and Co.,* London, 1965, no. 13; B. Nicolson, *Burlington Magazine,* CVII, 1965, p. 384, fig. 52; H. Schwarz in *Studi di storia dell'arte in onore di Antonio Morassi,* Venice, n.d. [1971], p. 213, fig. 10 (recto), p. 214, with the suggestion that the child's head is a portrait of one of the artist's own children.

Purchase, Mr. and Mrs. Arnold Whitridge Gift, 1965
65.138

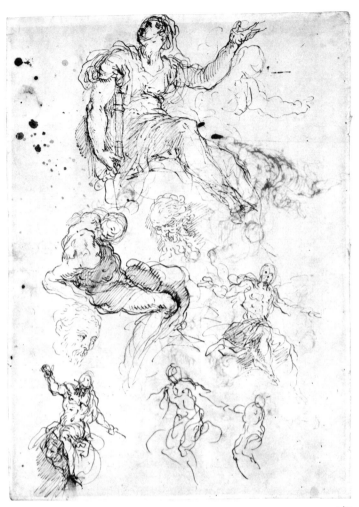

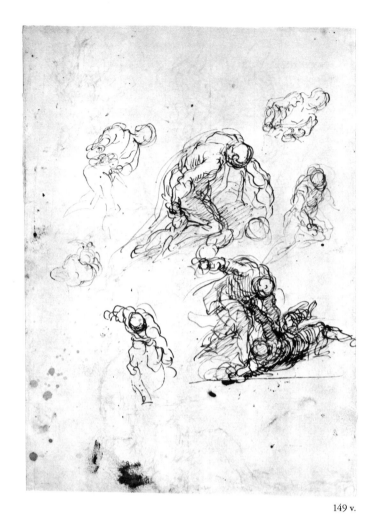

149

PALMA IL GIOVANE

149. *Figure Studies: Seated Female Holding a Book, Two Heads of Bearded Men, Seated Male Nude, and Four Sketches for Christ Judging ?*
VERSO. *Studies for Cain Slaying Abel*

Pen and brown ink. 26.3 x 18.8 cm. A number of brown stains at upper left (recto), at lower left (verso).

PROVENANCE: Walter C. Baker, New York.

BIBLIOGRAPHY: Virch, 1962, no. 15.

Bequest of Walter C. Baker, 1971
1972.118.263

The convincing attribution to Palma Giovane is due to Claus Virch (1960); the drawing had previously figured in the Baker collection under the name of Paolo Veronese.

154

PAOLO VERONESE (Paolo Caliari)
Verona ca. 1528 – Venice 1588

150. *Studies for The Allegories of Love*

Pen and brown ink, brown wash. 32.0 x 22.2 cm. Lower left corner torn away; small red pigment stain at lower right corner; repaired losses at all margins; scattered brown stains. Lined.

Faint inscriptions in black chalk above figure of standing warrior at lower left, *G...E / F* [?]; inscribed at lower margin in pen and a brown ink different from that of the drawing, *Carlito C.;* inscribed in pen and brown ink on reverse of old mount, *C.C.Nº. 8.*

PROVENANCE: Unidentified Venetian collector (inscription similar to but larger than Lugt Supp. 2103a); sale, Los Angeles, Sotheby Parke Bernet, May 21, 1975, no. 9, repr., purchased by the Metropolitan Museum.

BIBLIOGRAPHY: Bean, 1975, no. 32, repr.; J.-L. Bordeaux, *Burlington Magazine,* CXVII, 1975, pp. 600-603, fig. 1; *Notable Acquisitions,* 1975, p. 64, repr.; *Metropolitan Museum of Art. Annual Report 1974-1975,* repr. p. 49; T. Pignatti, *Veronese,* Venice, 1976, I, pp. 145-146, under nos. 233-236, II, pl. 551.

Harry G. Sperling Fund, 1975
1975.150

This sheet bears studies for all of the four *Allegories of Love* in the National Gallery, London (best reproductions in *National Gallery Catalogues. Sixteenth-Century Italian Schools. Plates,* London, 1964, pls. 246-249). The group at the upper right is studied for the picture in the series traditionally called *Happy Union,* though in the painting the composition is reversed and considerably changed. The dog studied at upper center appears at the lower right in the painting.

On the right, immediately below the studies for *Happy Union,* appear two sketches of an open keyboard instrument; above, it is seen from the front, below, it is seen from the side, played by a winged putto. This putto musician appears at lower left in the painting traditionally called *Infidelity.* This composition is rapidly sketched two-thirds of the way down the sheet at the right. Here there are a number of differences between drawing and painting, including the fact that the putto musician at the left of this sketch appears in back view.

At the upper left of the sheet the supine male nude, who in the painting called *Scorn* is beaten by Cupid, is sketched five times, and the women who witness his fustigation are studied several times at the left margin. At the lower margin of the sheet there are two studies for the painting once called *Respect.*

The rapid, vivacious pen notations on this sheet are entirely characteristic of Paolo, and the appearance of the name of his son Carletto Caliari, inscribed in ink of another color than that used in the drawing itself, may indicate that the sheet once belonged to the son. This inscription may account for the *C.C.* that appears on the old mount; it could be taken to mean C[arletto] C[aliari].

The purpose, the dating, and the allegorical significance of these four paintings elude exact definition, though valiant attempts have been made by Edgar Wind (*Pagan Mysteries in the Renaissance,* London, 1967, pp. 272-275), Allan Braham (*Burlington Magazine,* CXII, 1970, pp. 205-210), and Cecil Gould (*National Gallery Catalogues. The Sixteenth-Century Italian Schools,* London, 1975, pp. 326-330). The traditional descriptive titles used in this entry date from the early eighteenth century when the paintings were in the collection of the duc d'Orléans.

151. *Allegory of the Redemption of the World*

Pen and black ink, gray wash, heightened with white, on gray-washed paper. 61.3 x 42.0 cm. (overall). A horizontal strip ca. 7.0 cm. in height has been added at the bottom and the drawing continued in the artist's hand. Lined.

Inscribed in pen and brown ink on reverse of old mount in Richardson's hand, *This Divine Poetry represents the Final Completion of that Great & Sublime Mystery of the / Redemption of the World; Foretold, in various Manners & distant Times, by the Prophets / & Sibyls, & in its Due Time Fully Accomplish'd by the Virgin Mary's presenting ye / First Author of Original Sin to the Glorious Redeemer, her Son, (now returned again / to Heaven, after having performed his Great Work; & Sitting at the Right Hand of his / Father, in United Majesty with the Holy Ghost) for Remission & Forgiveness of his Sin, &, in His, of That of / All Mankind, which They had Incurred through Him. Which Solemn Authentic / Act of Divine Mercy is Lowdly Celebrated with the Universal Jubile of the Heavenly Quires. / N. The Prophet in ye middle, in front, holding the scrowl of his Prophecy, is Paolo himself. See Ridolfi. / N. The Prophets are plac'd Above, & Near their High Inspirers; fixing their Eyes with Transport / on the great Event; the Fullfilling and Completion of their own Prophecies, clearly Understood by Them: / : selves; while the Sibyls, whose Prophecies were by Compulsion; without Their being Let Into the / Knowledge and Tendency of their own high Illumination, are only attentive to one another, Below. / "Hà ancora il Sig. Giuseppe Caliari, nipote et unico Erede di quella Famiglia, molti Disegni a Chiaro Scuro in carte tinte; / "che non sono men à pregiarsi che le Opere Colorite; havendo Paolo con impareggiabile pratica, e felicità non me: / ":no, Disegnato. quali vengono dal Sig. Caliari detto con somma accuratezza conservati." Ridolfi, vit. di Paolo. I. 331.* [actually Ridolfi, 1648, pp. 329, 331] / *See also Vie des Peintres de M. d'Argenville, & Don Antoine Joseph Pernety.*

PROVENANCE: Sir Peter Lely (Lugt 2093); Jonathan Richardson, Jr. (Lugt 2170); Emile Norblin, Paris; Norblin sale, Paris, Hôtel Drouot, January 30, 1863, no. 12, mistakenly described as "Les Saintes Femmes au Tombeau . . ."; purchased in New York in 1961.

BIBLIOGRAPHY: Bean, 1962, p. 164, fig. 8; Bean, 1964, no. 25, repr.; Bean and Stampfle, 1965, no. 129, repr.; E. Panofsky, *Problems in Titian, Mostly Iconographic,* New York, 1969, pp. 65-66, note 20; R. Cocke, *Master Drawings,* xv, 3, 1977, p. 264; Rearick, 1980, p. 45, under no. 23.

Rogers Fund, 1961
61.203

This is the largest and compositionally most complex of the surviving chiaroscuro drawings by Paolo. Like other such brush drawings in grisaille, it seems to have been conceived as an independent work of art, not as a preparatory study for a painting.

Richardson's long description of the subject on the reverse of the old mount has the look of a translation of a rhetorical Italian text that may have been associated with the drawing; such explanations of allegorical subject matter occur on the reverse of several of the independent

chiaroscuro drawings. The text that Richardson has transcribed gives an elaborate explanation of the allegorical intentions of the artist, and it is particularly interesting concerning the presence of the sibyls at the bottom of the composition; holding prophetic scrolls, they are gathered around an empty tomb and are oblivious to the great revelation above them. Irwin Panofsky points out, however, that the description may err in describing the figure kneeling in intercession beside the standing Virgin as the "First Author of Original Sin," namely Adam. In placement and appearance this figure would seem to be John the Baptist, who often accompanies the Virgin as joint intercessor for mankind at the Last Judgment (see *Bibliotheca Sanctorum*, VI, Rome, 1965, col. 623; also the drawing by Federico Zuccaro, No. 276 below).

IL PARMIGIANINO (Francesco Mazzola)

Parma 1503 – Casalmaggiore 1540

152. *The Adoration of the Shepherds*

Pen and brown ink, brown wash, heightened with white, over traces of black and a little red chalk (at upper left), on brownish paper. 21.7 x 14.9 cm. Vertical and horizontal creases at center; a number of repaired losses. Lined.

PROVENANCE: C. M. Metz; Paignon-Dijonval; Vicomte Morel de Vindé, Paris (see Lugt 2520); Sir Thomas Lawrence (Lugt 2445); William Coningham (Lugt 476); J. H. Hawkins (according to Sotheby's); H. Gay Hewlett (according to Sotheby's); sale, London, Sotheby's, November 28, 1922, no. 14; Dr. Frederic Haussman, Switzerland; purchased in New York in 1946.

BIBLIOGRAPHY: Metz, 1798, pl. 72, repr. in reverse; M. Bénard, *Cabinet de M. Paignon Dijonval, état détaillé et raisonné des dessins et estampes dont il est composé*, Paris, 1810, part I, p. 26, no. 391; *Lawrence Gallery, Fourth Exhibition*, p. 12, no. 32; L. Fröhlich-Bum, *Parmigianino und der Manierismus*, Vienna, 1921, p. 95, fig. 113 (the Metz facsimile); G. Copertini, *Il Parmigianino*, Parma, 1932, II, p. 60, pl. CXLIIa (the Metz facsimile); L. Burroughs, *Metropolitan Museum of Art Bulletin*, December 1948, pp. 101-107, repr. p. 102; Freedberg, 1950, p. 171, fig. 47; Bean, 1964, no. 20, repr.; Bean and Stampfle, 1965, no. 91, repr.; Popham, 1967, pp. 52-53, under no. 86; Popham, 1971, I, no. 297, p. 66, under no. 72, II, pl. 148; L. Collobi Ragghianti, *Critica d'arte*, XIX, 121, 1972, pp. 44, 49, fig. 15.

Rogers Fund, 1946
46.80.3

Parmigianino arrived in Rome in 1524 and was active there until the sack of the city in 1527. From these years dates a group of drawings in which he studied alternative compositional schemes for an Adoration of the Shepherds with the Virgin bathing the Infant Christ. In addition to the present sheet, drawings in the Uffizi (747 E), the British Museum (1853-10-8-3 and 1856-6-14-2 verso), the Ecole des Beaux-Arts in Paris (37143), and the Louvre (Inv. 6385) have been related by Mrs. Burroughs and by Popham to these compositional researches. Important and inventive variants distinguish these designs, although the seated cross-legged figure of St. Joseph pointing up at the flying angel in the Metropolitan Museum's drawing also occurs in the Louvre sketch. None of the drawings gives us the solution used by Parmigianino in the *Adoration of the Shepherds*, a picture datable in his Roman period, now in the Doria Pamphilj Gallery (repr. Freedberg, 1950, fig. 46). The present drawing was engraved in reverse by Metz in 1798. An old copy of the drawing is in the Horne Foundation (repr. L. Ragghianti Collobi, *Disegni della Fondazione Horne in Firenze*, Florence, 1963, p. 24, no. 64, pl. 39, wrongly attributed to Pellegrino Tibaldi).

153. *Nine Studies of the Moses in the Steccata* VERSO. *Nine Studies for the Eve in the Same Church*

Pen and brown ink, brown wash, over traces of black chalk, on beige paper. 21.1 x 15.3 cm. (overall). A strip of paper 1.1 cm. wide has been added at left margin.

Numbered in pen and brown ink at upper margin of verso, *48*.

PROVENANCE: Cavaliere Francesco Baiardo ?; Earl of Arundel and A. M. Zanetti (according to the Lawrence Gallery catalogue); Baron Vivant Denon (Lugt 780); Sir Thomas Lawrence (Lugt 2445); Captain Richard Ford; sale, London, Sotheby's, April 25, 1934, no. 29; Sir Bruce S. Ingram; purchased in London in 1962.

BIBLIOGRAPHY: Vivant Denon, *Monuments*, III, pl. 157, recto and verso in reverse; *The Lawrence Gallery. Fourth Exhibition*, p. 10, no. 21; Popham, 1953, pp. 40, 64, pls. LVI (recto), LVII (verso); Bean, 1963, pp. 231-232, figs. 3 (recto), 4 (verso); Bean, 1964, no. 21, recto repr.; Bean and Stampfle, 1965, no. 94, recto and verso repr.; Popham, 1967, pp. 75, 77, 87; A. E. Popham in *Studies in Renaissance and Baroque Art Presented to Anthony Blunt*, London, 1967, p. 29; M. Fagiolo dell'Arco, *Il Parmigianino*, Rome, 1970, pp. 74, 277, figs. 253 (recto), 254 (verso); A. Ghidiglia Quintavalle, *Gli ultimi affreschi del Parmigianino*, Milan, 1971, p. 78, figs. 67 (verso), 68 (recto); Popham, 1971, I, no. 301, III, pl. 330 (recto and verso).

Pfeiffer Fund, 1962
62.135

These sketches of the figure of Moses holding aloft the Tables of the Law and of Eve picking the fatal apple are

152

153

IL PARMIGIANINO

48

153 v.

studies for part of one of Parmigianino's major commissions, the decoration of the eastern apse and vaulting of the church of S. Maria della Steccata in Parma. Other preparatory drawings – studies for individual figures and of the whole scheme – exist in the British Museum, the Louvre, Chatsworth, and elsewhere, and they reveal how elaborate were the artist's preparations for the project and how many alternative solutions came to his mind. Unfortunately, the artist was not as conscientious in his execution as in his preparation. He received the commission in 1531 with the understanding that the frescoes were to be completed within eighteen months. In 1535 the work was still unfinished, indeed hardly begun, and in 1539 Parmigianino was arrested on the order of his exasperated patrons. He escaped from Parma and died in exile the following year. The figures of Moses and the studies of Eve on the verso of the sheet are both related to the very small part of the decoration that was completed by Parmigianino himself. Moses and Eve appear painted in monochrome on the ribs of the vault of the eastern chapel of the church (repr. Freedberg, 1950, figs. 99, 101).

154

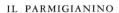

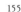

IL PARMIGIANINO

154. *An Apparition of Christ*

Pen and brown ink, brown wash. 14.5 x 12.6 cm. Jupiter enthroned with attendant eagle on verso, proof impression of the upper right corner of Caraglio's engraving *The Martyrdom of St. Peter and St. Paul,* after Parmigianino (Bartsch, xv, p. 71, no. 8). Dark gray stain (printer's ink?) at center of upper margin; repaired loss at upper left.

Inscribed in pen and brown ink at lower margin of old mount in Richardson's hand, *Parmeggiano.*; on reverse of old mount in W. Gibson's hand, *Fr:co Parmigiano. / 8.1.*; and in another hand, *V* [?] *31.*

PROVENANCE: William Gibson (see Lugt Supp. 2885); Jonathan Richardson, Sr. (Lugt 2184, 2984, 2995); Major E. W. J. Bagelaar (according to pencil inscription on reverse of old mount); L. D. van der Chys (according to pencil inscription on reverse of old mount); Hans van Leeuwen (Lugt Supp. 2799a); purchased in London in 1965.

BIBLIOGRAPHY: *Exhibition of Old Master Drawings. W. R. Jeudwine,* London, 1965, no. 5, pl. II; Popham, 1971, I, no. 302, II, pl. 199.

Rogers Fund, 1965
65.112.2

The scene is difficult to interpret, though the figure at upper left could be the Risen Christ in Glory. He appears to a crowd of kneeling supplicants; a figure at lower left holds what appears to be a cross, and at center an angel descends with a crown of martyrdom (?). The portico in the background is similar to that in Parmigianino's drawing of Christ Healing the Sick at the Musée Pincé in Angers (Popham, 1971, I, no. 5, II, pl. 189).

155. *Roman or Greek Warriors Congratulating Each Other after a Victory*

Pen and brown ink, brown wash, heightened with white, on beige paper. 11.8 x 22.5 cm. Scattered brown stains. Lined.

Inscribed in pen and brown ink at lower margin of old mount in Richardson's hand, *Parmeggiano / Lanier 2.4.*

PROVENANCE: Nicholas Lanier (according to Richardson's inscription on old mount); Jonathan Richardson, Sr. (Lugt 2183, 2984, 2995); Duke of Rutland (according to vendor); purchased in New York in 1961.

BIBLIOGRAPHY: *The Complete Collection of Drawings Formerly Owned by the Duke of Rutland,* exhibition catalogue, E. Gimpel and Wildenstein, New York, n.d., no. 54, "Il Parmigiano, Roman Soldiers"; Bean, 1962, p. 158, fig. 1; Popham, 1971, I, no. 299, III, pl. 280.

Rogers Fund, 1961
61.161.2

There is a fairly exact copy of this drawing in the Cabinet des Dessins of the Louvre (Inv. 6597).

156. *The Virgin Walking to the Right Carrying the Christ Child*

Red chalk, over stylus sketch. 17.3 x 14.1 cm. Scattered brown stains. Lined.

Inscribed in pen and brown ink at lower margin of old mount, *Parmigianino from vol 2ⁿᵈ No. 31* (indicating the drawing's place in the Pembroke albums).

PROVENANCE: Sir Peter Lely (Lugt 2092); Earls of Pembroke; Pembroke sale, London, Sotheby's, July 5-6, 9-10, 1917, no. 455, purchased by the Metropolitan Museum.

BIBLIOGRAPHY: Strong, 1900, part V, no. 45, repr.; Popham, 1971, I, no. 296, III, pl. 248.

Hewitt Fund, 1917
19.76.4

For A. E. Popham the style here is that of Parmigianino's Bolognese period (1527 to 1530/31).

157. *Justice Holding Scales*

Pen and brown ink. 8.8 x 6.3 cm. Lined.

PROVENANCE: Jonathan Richardson, Sr. (Lugt 2184); Hugh N. Squire, London; purchased in London in 1962.

BIBLIOGRAPHY: Popham, 1971, I, no. 300, II, pl. 181.

Pfeiffer Fund, 1962
62.120.3

158. *Diana, after Correggio*
VERSO. *Back of a Seated Male Nude and Study of a Leg*

Red chalk. 14.6 x 8.7 cm. Upper corners replaced; several repaired tears.

PROVENANCE: Jonathan Richardson, Sr. (Lugt 2183); John Barnard (Lugt 1419); Sir Joshua Reynolds (Lugt 2364); purchased in London in 1910.

BIBLIOGRAPHY: Popham, 1971, I, no. 295, II, pl. 10 (recto and verso); Rossi, 1980, p. 5, repr. p. 84.

Rogers Fund, 1910
10.45.4

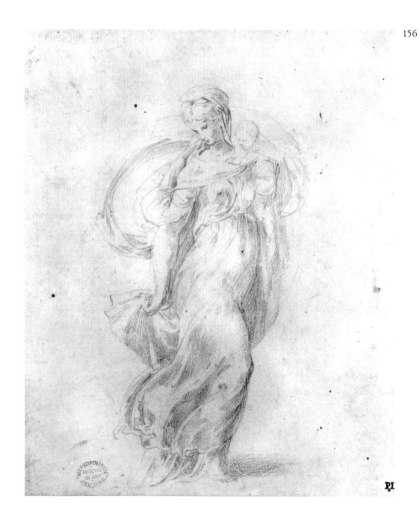

156

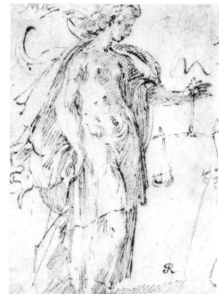

157

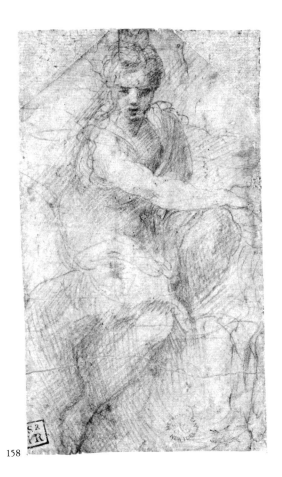

158

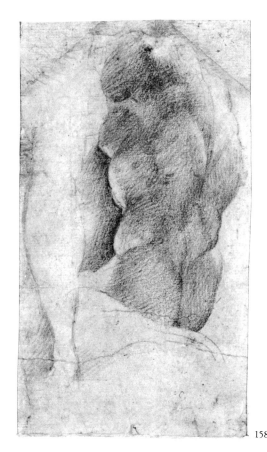

158 v.

IL PARMIGIANINO (NO. 158)

A. E. Popham pointed out that the Diana is a rough copy of Correggio's fresco of the goddess over the fireplace in the Camera di San Paolo, Parma. There are considerable differences, and it might well be a sketch from memory. The torso on the verso is apparently taken from the "Torso Belvedere."

159. *Torso of a Nude Man with Raised Arms*

Red chalk. 10.4 x 5.5 cm. Black stain at lower right. Lined.

PROVENANCE: Earl Spencer (Lugt 1530); Spencer sale, London, T. Philipe, June 10-17, 1811, no. 512; purchased in London in 1910.

BIBLIOGRAPHY: Popham, 1971, I, no. 294, II, pl. 10.

Rogers Fund, 1910
10.45.3

A. E. Popham suggested that this early, perhaps pre-Roman drawing may have been copied from an antique statue of Marsyas.

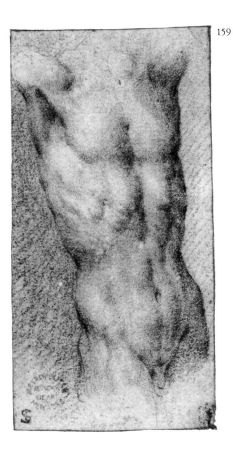

159

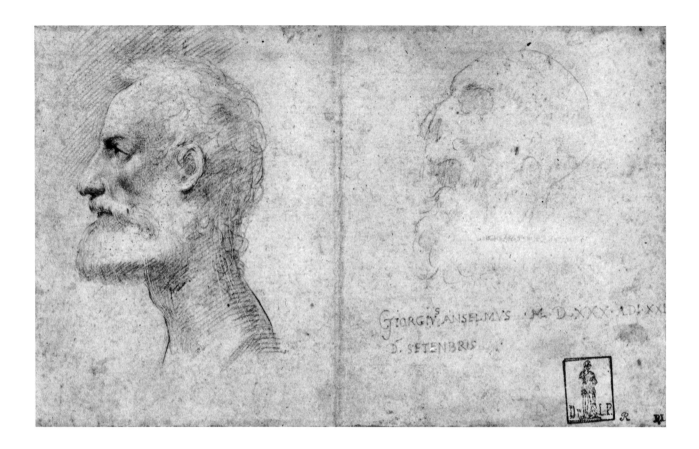

160. *Head of a Bearded Man in Profile to Left, Faint Sketch of a Skull-like Head*

Red chalk, the head at the left over a stylus sketch. 13.9 x 23.0 cm. Vertical crease at center; horizontal blue chalk line at right, above inscription. Lined.

Inscribed in red chalk at right in the artist's hand, GIORGIV^S AN-SELMUS·M·D·XXX·ADI·XXI· / D: SETENBRIS; in pen and red ink at lower margin of old mount in Richardson's hand, *Parmeggiano.*

PROVENANCE: Sir Peter Lely (Lugt 2092); Jonathan Richardson, Sr. (Lugt 2184, 2984, 2995); Dr. Ludwig Pollak (Lugt Supp. 788b); purchased in New York in 1954; transferred from the Department of Prints, 1973.

BIBLIOGRAPHY: Popham, 1971, I, no. 298, II, pl. 220.

The Elisha Whittelsey Collection
The Elisha Whittelsey Fund, 1954
1973.321

A. E. Popham suggested that the inscription might refer to the Parmesan poet Giorgio Anselmi *nepote,* but for the fact that he is said to have died of the plague in 1528. Here the inscription implies a death in 1530.

161. *Design for a Sepulchral Monument of a Youth*

Pen and brown ink, brown and a little yellow wash, over black chalk. 26.9 x 20.8 cm. Surface abraded and stained with gray pigment; repaired tear at lower center. Lined.

Inscribed in pen and brown ink on tablet at lower center in the artist's hand, ·D[eo]·O[ptimo]·M[aximo]; in a later hand at lower right, *Permeg. . . .*

PROVENANCE: Earl of Arundel ?; A. M. Zanetti ?; G. A. Armano ?; Rev. Dr. Henry Wellesley; Wellesley sale, London, Sotheby's, July 3, 1866, no. 1414; Prof. Einar Perman, Stockholm; purchased in Stockholm in 1970.

BIBLIOGRAPHY: Popham, 1971, I, no. 794, II, pl. 215; Bean, 1972, no. 36; G. Dillon in *Palladio e Verona,* exhibition catalogue, Palazzo della Gran Guardia, Verona, 1980, pp. 274-275, under no. XI, 34.

Rogers Fund, 1970
1970.238

The youth reclining on the sarcophagus holds a book, perhaps an allusion to a scholarly career cut short by death. This tomb scheme is similar to one in the Cabinet

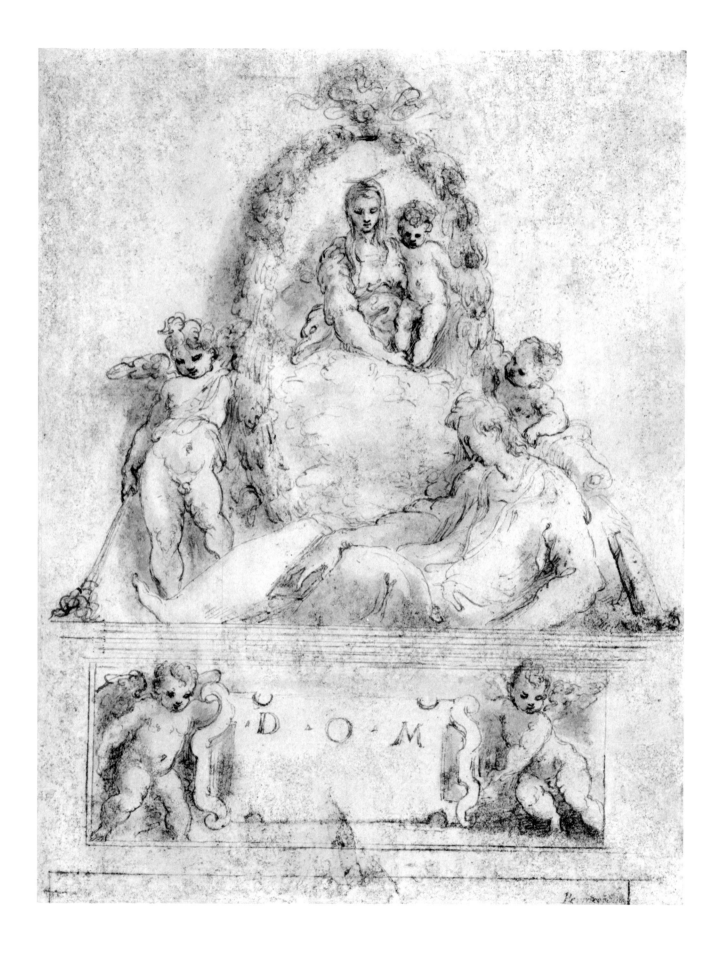

des Dessins at the Louvre projected for a bishop or an abbot, in that the deceased recline on the tombs, half-figures of the Virgin and Child appear above, and mourning putti flank the figures of the deceased (for the Louvre drawing, see Popham, 1971, I, no. 378, II, pl. 214). In the present drawing the putti hold overturned and extinguished torches.

The lower part of this tomb design — approximately one quarter of the original sheet — has been lost. This is clear from a print made after the design by Angelo Falconetto in the sixteenth century that reproduces the drawing in reverse, though the votive inscription, *DOM,* on the tablet has been omitted (Bartsch, XX, pp. 104-106, no. 13; G. Dillon, *op. cit.,* repr. p. 273). In this print the sarcophagus rests on a rectangular plinth ornamented with a scene of animal sacrifice that is strikingly Parmigianinesque in style. This frieze must have been cut from the sheet before Francesco Rosaspina (1762-1841) made a reversed facsimile of our drawing in its present form; an impression of this facsimile is in the British Museum (1919-4-15-195).

162. *Head of a Man in Profile to Right*

Pen and brown ink, over black chalk. 6.0 x 5.7 cm.

Inscribed in pencil on reverse of old mount, *Leonardo da V. . . .*

PROVENANCE: Alfred A. De Pass; presented by him to the Royal Institution of Cornwall, Truro (Lugt Supp. 2014e); sale, London, Christie's, November 30, 1965, part of no. 170, as "Leonardo"; Walter C. Baker, New York.

BIBLIOGRAPHY: *Exhibition of Old Master Drawings. P. and D. Colnaghi and Co.,* London, 1966, no. 74, repr.; Popham, 1971, I, no. 783, III, pl. 446.

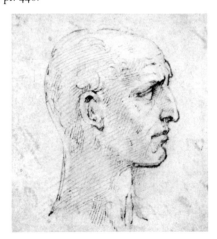

Bequest of Walter C. Baker, 1971
1972.118.264

The drawing was recognized as a late work of Parmigianino by Christopher White at the time of its sale in London in 1965. There is a similar profile head at the Rhode Island School of Design in Providence; this drawing was also formerly attributed to Leonardo da Vinci (Popham, 1971, I, no. 564, III, pl. 446).

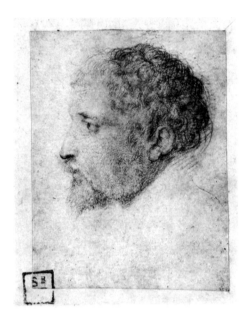

IL PARMIGIANINO?

163. *Head of a Man in Profile to Left*

Red chalk (face) and black chalk (hair, beard, and eyes). 7.1 x 5.6 cm. Lined.

Inscribed in pen and brown ink at lower left of old mount in Richardson's hand, [Parmegg]*iano.*

PROVENANCE: Sir Jonathan Richardson, Sr. (Lugt 2984, 2995); Sir Joshua Reynolds (Lugt 2364); purchased in London in 1963.

Rogers Fund, 1963
63.76.1

In 1964 Konrad Oberhuber pointed out that in the Wadsworth Atheneum in Hartford, Connecticut, there is a similar portrait study of the same head, the model in

profile to left but looking down (1956.768). The Hartford head was mounted to the left of our drawing on a Jonathan Richardson mount, which at some point was cut in two. The first part of the name, *Parmegg*[iano], appears at the lower right of the Hartford half.

The combination of red and black chalk used in these refined portrait heads is unexpected for Parmigianino. However, the Richardson attribution is certainly not implausible. A. E. Popham is said to have proposed an alternative attribution to the portraitist Sofonisba Anguissola.

PARRI SPINELLI

Arezzo ca. 1387 – Arezzo 1453

164. *Free Copy of Giotto's Navicella*

Pen and brown ink. Three sailing vessels in pen and brown ink on verso (a tracing repr. Degenhart and Schmitt, 1968, I-2, p. 277, fig. 383). 27.4 x 38.8 cm. Upper corners replaced; vertical crease at center. Drawing mounted on an old sheet that bears on its verso a Bandinellesque pen drawing after Masaccio's *Adam and Eve Expelled from Paradise* and a study of a seated male figure (Degenhart and Schmitt, 1968, I-2, p. 278, fig. 384; Ragghianti Collobi, 1974, II, fig. 14, attributed to Francesco da Sangallo).

Inscribed in pen and brown ink, probably in the artist's hand, along side of boat, *la nave di giotto chène* / *isanto pietro a roma di* / *Musaicho;* in another hand at lower left, *Giotto;* at lower margin of Pembroke mount, *Giotto. 1276-1336. The Picture is in mosaic about 30. feet broad & 20. ft. High, it is at ye top of ye entrance of St Peter's as big as ye Life. Ye bottom is about 50. feet High, a great Weight to be so* / *raised from ye Wall was saved & Fram'd out of old St. Peter's —this figure angling is mentioned in his Life, there is an other drawing without it.*

PROVENANCE: Giorgio Vasari ? (at the upper right margin there is an indication of a framing motif similar to those used in Vasari's *Libro de' Disegni*); Earls of Pembroke; Pembroke sale, London, Sotheby's, July 5-6, 9-10, 1917, no. 515, repr., as Giotto, purchased by the Metropolitan Museum.

BIBLIOGRAPHY: J. Richardson, Sr., and J. Richardson, Jr., *An Account of the Statues, Bas-reliefs, Drawings and Pictures in Italy, France, . . . ,* London, 1754, p. 293, the present drawing and that now in Cleveland mentioned as the work of Giotto; Strong, 1900, part IV, no. 39, repr., as a copy after Giotto; Venturi, v, p. 292, fig. 242; A. Muñoz, *Bollettino d'arte,* v, 1911, p. 182; Burroughs, 1919, p.

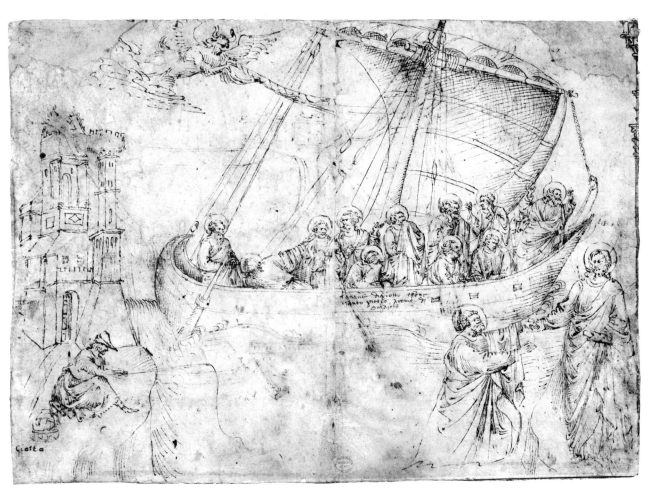

136, repr. p. 138, as a copy after Giotto; L. Venturi, *L'arte,* XXV, 1922, p. 50, fig. 2; Berenson, 1938, no. 1837J, fig. 7; W. Paeseler, *Römisches Jahrbuch für Kunstgeschichte,* V, 1941, pp. 49-162, figs. 85, 93; *Metropolitan Museum, Italian Drawings,* 1942, no. 1, repr., as unknown Florentine artist, XIV century; B. Degenhart, *Italienische Zeichnungen des frühen 15. Jahrhunderts,* Basel, 1949, p. 42, under no. 26; C. Refice, *Commentari,* II, 1951, p. 198, pl. LVII, fig. 239; Berenson, 1961, no. 1837J*, fig. 7; C. Virch, *Metropolitan Museum of Art Bulletin,* March 1961, pp. 185-193, fig. 4; Bean, 1964, no. 2, repr.; M. Fossi Todorow, *I disegni dei maestri. L'Italia dalle origini a Pisanello,* Milan, 1970, p. 84, pl. XXI; Degenhart and Schmitt, 1968, I-2, no. 181, and p. 634, I-4, pl. 203a; Ragghianti Collobi, 1974, I, p. 28, II, fig. 13; M. J. Zucker, *Master Drawings,* XIX, 4, 1981, pp. 431-441, pls. 18, 21.

Hewitt Fund, 1917
19.76.2

Once considered to be Giotto's own design for the great mosaic representing Christ Walking on the Waters (Matthew 14:22-32), formerly in the entrance courtyard of the old basilica of St. Peter in Rome, this nonetheless very early drawing is instead a free copy after the mosaic by Parri Spinelli. Other drawn copies of the composition in Parri's hand, reinterpreted each time with significant variants, are at Cleveland and Bayonne (Degenhart and Schmitt, I-2, nos. 183, 224, I-4, pls. 204a and b, 233a and b, respectively). Degenhart and Schmitt have questioned Berenson's attribution of these three drawings to Parri Spinelli, and given them to three different anonymous Tuscan artists of the first half of the fifteenth century. Quite recently, Mark J. Zucker has reaffirmed the attribution to Parri Spinelli. He has furthermore suggested that the Cleveland and New York drawings were consecutive double pages in one of the artist's sketchbooks, while the Bayonne drawing was a single page in the same book.

Traditionally called *La Navicella* (the small boat), Giotto's mosaic survives in the entrance portico of the new St. Peter's, though it was drastically "modernized" in the seventeenth century. The *Navicella* was one of the great monuments of fourteenth-century Rome, and it was much imitated and copied well into the fifteenth century. Zucker points out that Parri Spinelli need not have seen the original in Rome, and could have known the composition through copies and derivations available in Florence.

At the Musée Condé, Chantilly, there is what seems to be an old copy not of the mosaic but of our drawing; it is assigned by Degenhart and Schmitt to a Florentine artist of around 1440 (Degenhart and Schmitt, 1968, I-2, no. 182, I-4, pl. 203b).

BARTOLOMEO PASSAROTTI

Bologna 1529 – Bologna 1592

165. *Youthful Draped Figure Looking to Upper Right*

Pen and brown ink, over traces of black chalk, on beige paper. 42.6 x 25.7 cm. Upper corners replaced; several repaired losses.

Inscribed in pen and brown ink at lower right, *Bartholomeo Passarotto;* on verso, *n⁰. 1 mar 27 86.*

PROVENANCE: Jan Pietersz. Zoomer (Lugt 1511); purchased in London in 1964.

BIBLIOGRAPHY: *Exhibition of Old Master Drawings. P. and D. Colnaghi and Co.,* London, 1964, no. 11; Bean and Stampfle, 1965, no. 132, repr.; L. Collobi Ragghianti, *Critica d'arte,* XVIII, 116, 1971, p. 27, fig. 13 (with the mistaken suggestion that the drawing figured in the collection of Giorgio Vasari).

Rogers Fund, 1964
64.197.1

In a letter of December 5, 1977, Patrick Cooney pointed out that this drawing is Passarotti's study for the figure of the Archangel Michael holding the scales of Justice in his upraised right hand, as he appears in an altarpiece in the church of S. Giovanni Battista, Scanello di Loiano (Bologna). In this painting John the Baptist is the central figure, flanked by St. Michael and St. Lucy. For Mr. Cooney the drawing is by Passarotti himself, though the painting appears to be a workshop production.

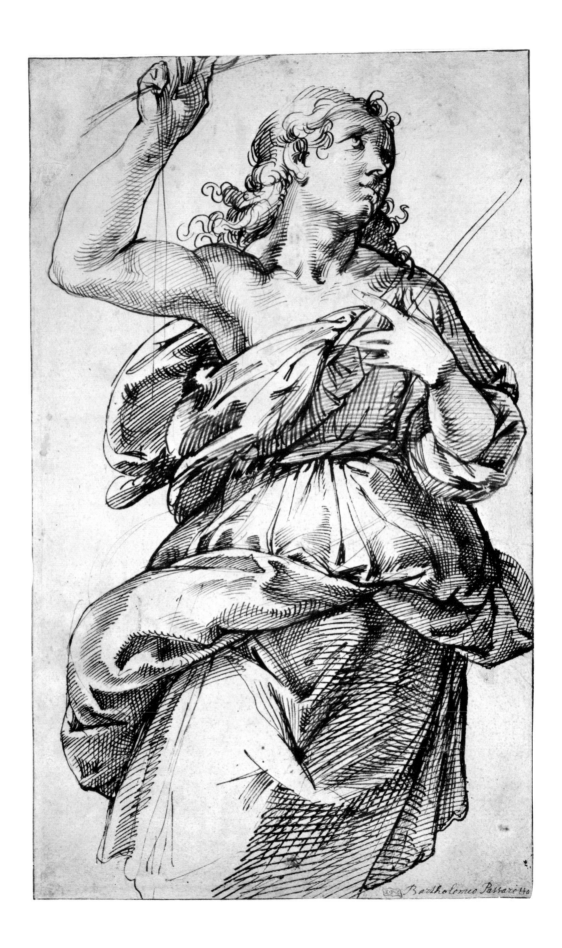

Bartholomeo Passarotto

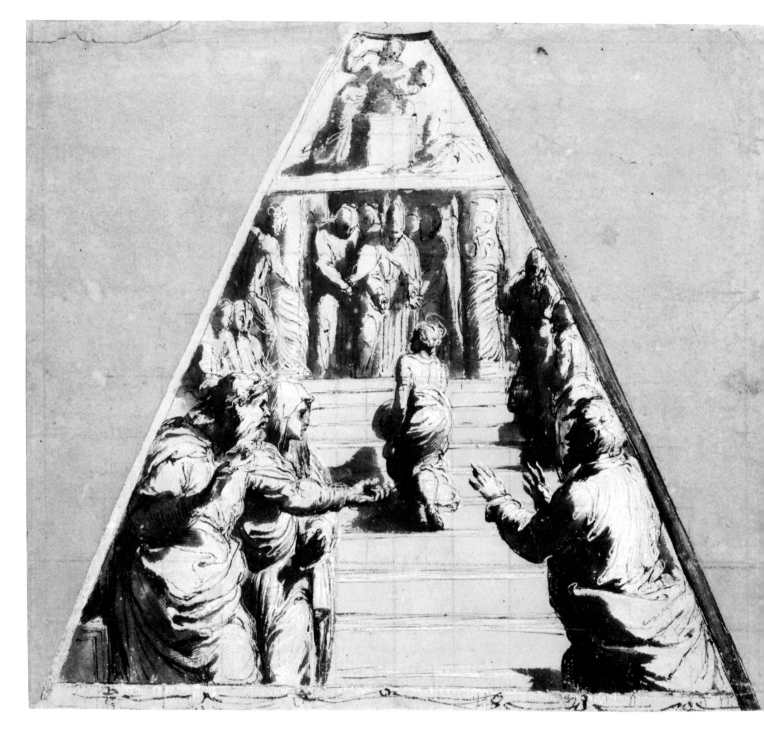

PERINO DEL VAGA (Piero Buonaccorsi)

Florence 1501 – Rome 1547

166. *The Presentation of the Virgin in the Temple* (below), *Abraham about to Sacrifice Isaac* (above)

Pen and brown ink, brown wash, heightened with white, on brownish paper. Squared in black chalk. The empty triangular corners are tinted in gray-green wash, the right diagonal border tinted in gray wash. 22.6 x 25.5 cm.

PROVENANCE: Prince Borghese, Rome (according to Lawrence Gallery catalogue); Sir Thomas Lawrence (though it does not bear Lawrence's mark); Samuel Woodburn, London; Woodburn sale, London, Christie's, June 4-8, 1860, no. 981; sale, London, Sotheby's, March 12, 1963, no. 20, repr., purchased by the Metropolitan Museum.

BIBLIOGRAPHY: *Lawrence Gallery, Fifth Exhibition*, p. 30, no. 89; B. Davidson, *Master Drawings*, I, 3, 1963, p. 16, pl. 7a; Bean, 1964, no. 19, repr.; Bean and Stampfle, 1965, no. 84, repr.; Davidson, 1966,

pp. 18-19, under no. 10; L. C. J. Frerichs, *Bulletin van het Rijksmuseum,* 26, 1978, 3, p. 110, fig. 5; F. Viatte in *Roman Drawings of the Sixteenth Century from the Musée du Louvre, Paris,* exhibition catalogue, Art Institute of Chicago, 1980, p. 96, under no. 39.

Rogers Fund, 1963
63.75.1

It was probably early in the third decade of the sixteenth century that Perino del Vaga was commissioned by Cardinal Lorenzo Pucci to ornament the chapel in the left transept of SS. Trinità dei Monti in Rome. Perino's frescoes high up on the vault of this chapel have survived in a damaged state, but the rest of the work remained unfinished when the artist left Rome for Genoa in 1527, and the decoration was completed a good deal later by Taddeo and Federico Zuccaro. On the four segments of the cross vault Perino painted scenes from the life of the Virgin. Preparatory drawings for three of these compositions – the *Meeting at the Golden Gate,* the *Birth of the Virgin,* and the *Annunciation* – have been identified in the

Albertina and the Louvre (repr. M. V. Brugnoli, *Bollettino d'arte,* XLVII, IV, 1962, pp. 332-333, figs. 9, 10, 11). The present drawing, a study for the segment with the *Presentation of the Virgin in the Temple,* reappeared in 1963. Like the Albertina drawing for the *Meeting at the Golden Gate,* it once belonged to Sir Thomas Lawrence.

167. *Kneeling, Seated, and Standing Figures* VERSO. *Seated, Kneeling, and Reclining Figures*

Pen and brown ink. 16.2 x 22.6 cm. Brown stains at margins of recto.

Inscribed in pen and brown ink at lower left, *del vaga / perri Dadicom ..o* [?].

PROVENANCE: August Artaria (Lugt 33); Harry G. Sperling, New York.

Bequest of Harry G. Sperling, 1971
1975.131.44

167 v.

PERINO DEL VAGA

Bernice Davidson calls attention to the close stylistic affinity of this drawing with figure studies for the Palazzo Doria in Genoa, from the early 1530s; see, for example, a double-faced sheet in the Akademie der Bildenden Künste, Vienna (repr. *Master Drawings,* IV, 2, 1966, pl. 44a, recto, 44b, verso).

168. *Allegorical Figure of Prudence*

Pen and brown ink, gray wash, over traces of black chalk. 25.7 x 14.1 cm. Repaired tear at left center and at center of lower margin. Scattered stains.

Inscribed in pen and brown ink at lower right, *P.D.V.*

PROVENANCE: Commendatore Gelosi (Lugt and Lugt Supp. 545); Prof. John Isaacs; Isaacs sale, London, Sotheby's, February 27, 1964, no. 15; purchased in London in 1964.

BIBLIOGRAPHY: Bean and Stampfle, 1965, no. 87, repr.; E. Gaudioso, *Bollettino d'arte,* LXI, 1-2, 1976, p. 32; R. Harprath, *Papst Paul III. als Alexander der Grosse. Das Freskenprogramm der Sala Paolina in der Engelsburg,* Berlin and New York, 1978, p. 73, pl. 72; *Gli affreschi di Paolo III a Castel Sant'Angelo, progetto ed esecuzione, 1543-1548,* exhibition catalogue by F. M. Aliberti Gaudioso and E. Gaudioso, Museo Nazionale di Castel Sant'Angelo, Rome, 1981, II, p. 135, no. 81, repr. though not exhibited.

Rogers Fund, 1964
64.179

As Bernice Davidson was the first to point out, this is a study for the allegorical figure of Prudence, part of Perino's frescoed decoration of the Sala Paolina in the Castel S. Angelo in Rome. Drawings by Perino for this very late decorative scheme, datable in the 1540s, have survived; principally a study in a private collection in London for the grisaille representing *Alexander the Great Placing in Safety the Writings of Homer.* This sheet bears an inscribed monogram, *P.D.V.,* similar to that on the present drawing (see J. A. Gere, *Burlington Magazine,* CII, 1960, pp. 9-19, fig. 25; also R. Harprath, *op. cit.,* pp. 73-74, pl. 73). A study for the grisaille depicting *Alexander Dedicating Altars* is in the Ian Woodner Family Collection, New York (R. Harprath, *op. cit.,* p. 74, pl. 74).

PERINO DEL VAGA

169. *Two Standing Male Figures*

Pen and dark brown ink, brown wash, heightened with white, over traces of black chalk, on brownish paper. 20.8 x 18.6 cm. All four corners replaced.

PROVENANCE: Sir Peter Lely (Lugt 2092); William, 2nd Duke of Devonshire (Lugt 718); purchased in New York in 1961.

BIBLIOGRAPHY: E. van Schaack, *Master Drawings in Private Collections,* New York, 1962, no. 5, repr.; Edinburgh, 1969, p. 28, under no. 60.

The Elisha Whittelsey Collection
The Elisha Whittelsey Fund, 1961
61.180

Two similar monumental but small-headed figures occur in a drawing by Perino in a private collection in London. Both drawings share the same Lely and Devonshire provenance. When the London drawing was exhibited in 1960, A. E. Popham, the cataloguer, commented: "obviously a drawing in Perino's latest style, after 1540" (*Italian Art and Britain,* Royal Academy of Arts, London, 1960, no. 583; also Edinburgh, 1969, no. 60, pl. 19).

170. *Virgin and Child Enthroned with St. Anthony Abbot, St. Peter, St. Paul, St. Julian the Hospitaler, St. Roch, and St. Mary Magdalene?*

Pen and brown ink, heightened with white, on brownish paper. 22.2 x 18.7 cm. Lower corners and center of right margin replaced; repaired tears at upper left. Lined.

PROVENANCE: Jonathan Richardson, Sr. (Lugt 2184, 2984); purchased in London in 1908.

Rogers Fund, 1908
08.227.32

The drawing was acquired for the Museum by Roger Fry in 1908 as a work of the Florentine school. In 1958 Philip Pouncey made the more specific attribution to Perino del Vaga.

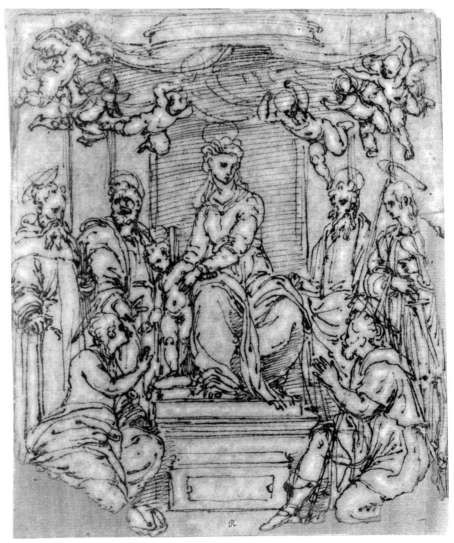

171. *St. Peter and St. John Healing a Cripple at the Gate of the Temple* (Acts 3:1-10)

Pen and brown ink, brown wash, heightened with white, on brownish paper. 24.8 x 15.5 cm. Surface considerably abraded. Lined.

PROVENANCE: Purchased in London in 1908.

BIBLIOGRAPHY: Pouncey and Gere, 1962, p. 103, under no. 172.

Rogers Fund, 1908
08.227.34

The drawing entered the Metropolitan Museum with the correct designation "school of Raphael," and when A. E. Popham saw the sheet in 1958 he assigned it to Perino del Vaga.

The composition was engraved in the same direction by Giulio Bonasone with the indication PIRINO DEL VAGA IVENTOR (Bartsch, XV, p. 130, no. 73).

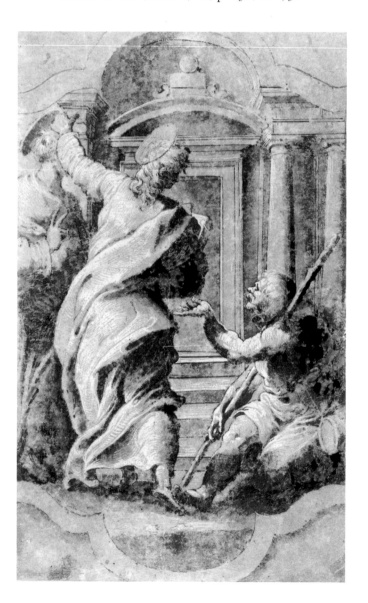

Other versions of this drawing exist: one in the Uffizi (1501 E; H. Voss, *Teekeningen der late Italiaansche Renaissance,* Zutphen, 1928, pl. 2); another in the collection of the Earl of Plymouth (Courtauld photograph 364/7/6); while a third, from the Gelosi collection, was in the *Lawrence Gallery, Fifth Exhibition,* no. 77. Damage and old restoration so obscure our drawing as to make it difficult to determine whether it is an original or a competent old copy.

The composition forms part of a group of drawings representing scenes from the lives of St. Peter and St. Paul that are sometimes identified as designs for embroideries on a cope commissioned for Pope Paul III (see Pouncey and Gere, 1962, pp. 103-104).

172. *Studies of Animal Heads and of a Cartouche*

Pen and brown ink, red chalk (only the animal head at upper left). 20.3 x 13.3 cm. Repaired losses in head at lower right. Lined.

Inscribed in pencil on reverse of old mount, *Pierino del Vaga / from the Coll. of Sir T. Lawrence / Design for decoration of armour.*

PROVENANCE: Sir Thomas Lawrence (Lugt 2445); Sir John Charles Robinson (Lugt 1433); Sir Robert Mond (Lugt Supp. 2813a); purchased in Boston in 1962.

BIBLIOGRAPHY: T. Borenius and R. Wittkower, *Catalogue of the Collection of Drawings by the Old Masters Formed by Sir Robert Mond,* London, n.d., no. 260, pl. XXVII(B); Davidson, 1966, p. 67, under no. 70.

Rogers Fund, 1962
62.247

Bernice Davidson compared our drawing with a sheet of studies of grotesque animal heads in the Uffizi that she attributed to Pellegrino Tibaldi (515 Orn.; Davidson, 1966, no. 70, fig. 61). The connection is so close, in motifs and *mise en page,* that Miss Davidson wondered if the younger Tibaldi may not have once even owned the Metropolitan's drawing. She made an interesting comparison between the two: "se anche il disegno di Perino è ricco di movimento e di vigore, l'artista, diversamente dal Tibaldi, si accostò al soggetto con distacco, e né la linea, né le facce delle bestie esprimono la stessa intensità folle del disegno del Tibaldi."

173. *Design for a Church Candlestick with a Circular Representation of the Ecce Homo on Its Base*

Pen and brown ink, gray-brown wash, over traces of black chalk. 41.4 x 22.3 cm. Support consists of two sheets of paper joined horizontally below center. Vertical tear at center of lower margin; horizontal creases above center. Lined.

PROVENANCE: Dr. Max A. Goldstein, St. Louis; Janos Scholz, New York; purchased in New York in 1950.

BIBLIOGRAPHY: Byam Shaw, 1976, I, p. 141, under no. 480; *Janos Scholz, Musician and Collector,* exhibition catalogue, University of Notre Dame, Indiana, 1980, no. 104.

The Elisha Whittelsey Collection
The Elisha Whittelsey Fund, 1950
50.605.30 (Department of Prints and Photographs)

Acquired by the Print Department in 1950 with an attribution to the Nuremberg artist Virgilius Solis the elder, the drawing was recognized as the work of Perino del Vaga by Philip Pouncey in 1965. At Christ Church, Oxford, there is a design for the same or a similar candlestick with a relief showing the *Ecce Homo* on the base, as here (Byam Shaw, 1976, I, no. 480, II, pl. 260). The Christ Church drawing also includes a similar central element with figures in arched niches. In the Oxford drawing the design continues above this element and shows the top of the candlestick; this suggests that the upper third of the present design has been lost.

PERINO DEL VAGA, follower of

174. *Design for a Festival Float or Barge ?*

Pen and brown ink, brown wash, heightened with white, over a little black chalk, on faded blue paper. 26.1 x 42.8 cm. A number of brown stains. Lined.

Numbered in pen and brown ink at lower right, *32;* inscribed in pen and brown ink at lower margin of old mount, *Beau dessin de Polidoro da Caravaggio élève de Raphael; ce dessin a dû faire partie de la collection Mariette et fut possédé par M.ʳ· Percier.*

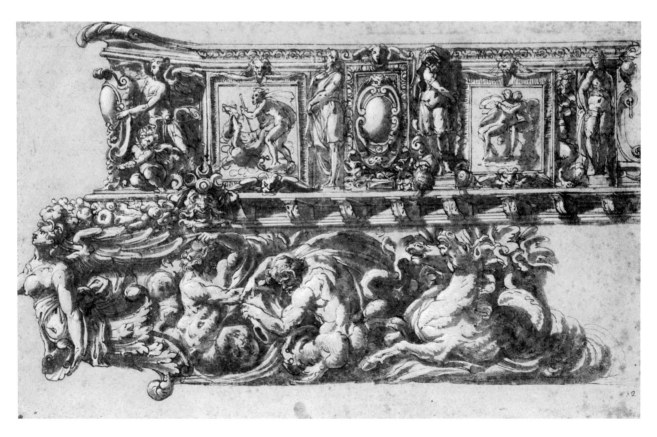

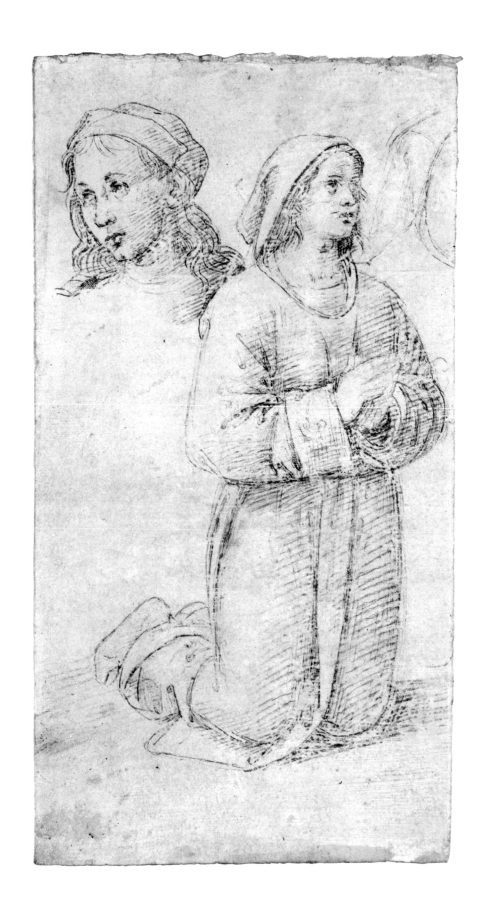

PROVENANCE: Pierre-Jean Mariette (Lugt 2097); Percier (according to inscription on old mount); purchased in London in 1971.

BIBLIOGRAPHY: Bean, 1972, no. 37.

Rogers Fund, 1971
1971.85

Bernice Davidson associates this drawing with two other studies by the same hand for a fanciful construction (a festival float or barge, or a richly carved piece of furniture ?). One is in the Musées de Rennes (C 65.1, as Polidoro), the other in a private collection in Paris. She points out that clusters of three crescents appear as heraldic and ornamental motifs in all three of the designs; in our drawing they appear as an ornamental device below and to the left of the panel with the representation of Neptune. It has not so far been possible to identify these arms. All the projects involve marine motifs and all terminate at the left in an exuberant prow-shaped projection.

All three drawings have in the past been attributed to Polidoro da Caravaggio. The drawing in Paris, like ours, once belonged to P.-J. Mariette; it bears his mark but lacks a cartouche with an attribution. Miss Davidson points out most convincingly that on stylistic grounds all three drawings must be the work of some mid-sixteenth-century follower of Perino del Vaga.

PIETRO PERUGINO
(Pietro di Cristoforo Vannucci)

Città della Pieve ca. 1445 – Fontignano (Perugia) 1523

175. *Study of a Kneeling Youth and of the Head of Another*

Metalpoint on off-white prepared paper. 22.0 x 11.5 cm.

Inscribed in pen and brown ink on verso, *Rafaelo;* and on a slip of paper pasted to verso, *Nᵒ 29* [?] *Rafaello.*

PROVENANCE: Conestabile (according to Heseltine); J. P. Heseltine (Lugt 1507); Henry Oppenheimer, London; Oppenheimer sale, London, Christie's, July 10, 13-14, 1936, no. 135, as Perugino or Raphael; Philip Hofer, Cambridge, Massachusetts; Walter C. Baker, New York.

BIBLIOGRAPHY: Heseltine Collection, 1913, no. 37, repr., as Raphael; O. Fischel, *Die Zeichnungen der Umber,* Berlin, 1917, p. 122, no. 58, p. 124, fig. 128; Virch, 1962, no. 4, repr.; Haverkamp-

Begemann, 1964, I, p. 12, under no. 8, fig. 13 (only the upper half of our drawing repr.).

Bequest of Walter C. Baker, 1971
1972.118.265

Fischel was the first to point out that this kneeling youth wearing a hooded habit is a study for one of the members of the Confraternity of St. Augustine who are represented venerating their enthroned patron in a painting by Perugino from about 1500 that is now in the Museum of Art, Carnegie Institute, Pittsburgh (repr. O. Fischel, *op. cit.,* p. 126, fig. 130b; Haverkamp-Begemann, 1964, I, p. 12, fig. 12; C. Castellaneta and E. Camesasca, *L'opera completa del Perugino,* Milan, 1969, no. 68). The youth appears at the left margin of the picture, one of a pair of kneeling penitents. The hood of the Confraternity member at his side is lightly indicated at the upper right margin of the drawing. The head at the upper left, sketched from a model in the studio, does not seem to have any connection with the painting, which was executed for the Confraternity of Sant'Agostino in Perugia.

In the Clark Art Institute in Williamstown, Massachusetts, there is a related metalpoint study by Perugino for one of the kneeling Confraternity members at the right in the painting. Like our drawing, the Williamstown sheet belonged to Conestabile and Heseltine, but it was purchased by Robert Sterling Clark in 1917 from Colnaghi and thus did not figure in the Oppenheimer collection as did ours (O. Fischel, *op. cit.,* p. 122, no. 59, p. 125, fig. 129; Haverkamp-Begemann, 1964, I, no. 8, II, pl. 7).

FRANCESCO PESELLINO
(Francesco di Stefano)

Florence ca. 1422 – Florence 1457

176. *St. Philip, Apostle, Seated, Holding Cross and Book*

Brush and brown wash, heightened with white, over black chalk. 27.3 x 19.1 cm.

Inscribed in pencil on verso, *Lorenzo di Gaddi Pittor.. Fiorentino / Gaddi Antico / Fiorentino / N 69.*

PROVENANCE: Dr. and Mrs. Victor Bloch; Bloch sale, London, Sotheby's, November 12, 1964, no. 4, as Florentine school, fifteenth century; purchased in London in 1965.

BIBLIOGRAPHY: *Exhibition of Old Master Drawings. W. R. Jeudwine,*

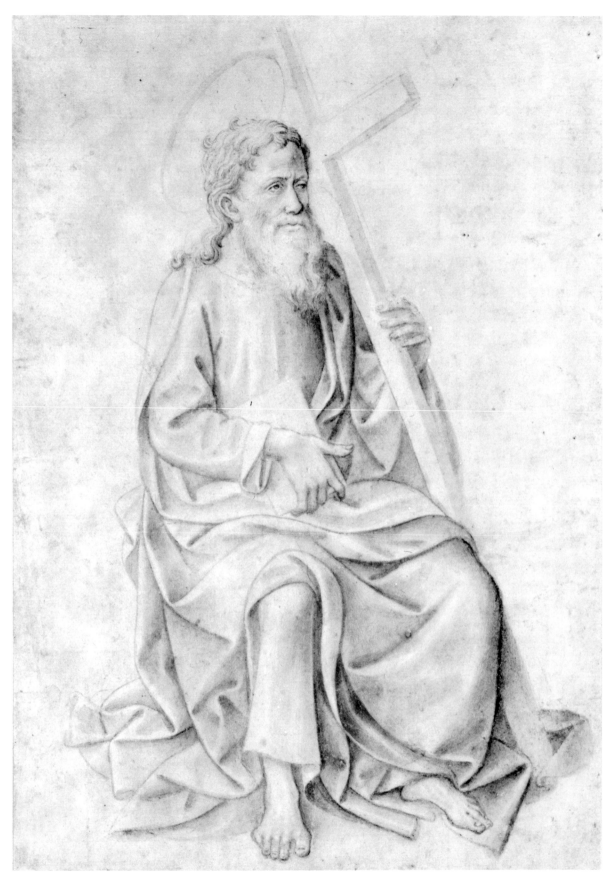

London, 1965, no. 3, pl. I; Bean and Stampfle, 1965, no. 2, repr.; Degenhart and Schmitt, 1968, I-2, no. 551, I-4, pl. 371d, as a copy after Pesellino; *Notable Acquisitions,* 1975, p. 55, repr.

Rogers Fund, 1965
65.112.1

This study of a seated Apostle was identified as the work of Pesellino by W. R. Jeudwine in 1965. He pointed out its close correspondence with a drawing in the Uffizi of similar technique representing a seated draped youth, convincingly given to Pesellino by Berenson (234 E; Berenson, 1938, no. 1838B, fig. 186). The elaborate modeling in brush and brown wash, the Northern complexity of the drapery folds, the drawing of the broad, rather flat hands and feet, even the facial types, are strikingly similar in both drawings. All the stylistic characteristics that distinguish these two drawings can be recognized in Pesellino's only documented work, the altarpiece representing the *Trinity with Four Male Saints* now in the National Gallery in London, a work left unfinished at the artist's death in 1457 and completed in Fra Filippo Lippi's studio (repr. B. Berenson, *Italian Pictures of the Renaissance. Florentine School,* London, 1963, II, pl. 833).

There is an old and much damaged pen copy of the present drawing in the Uffizi (2 F, as circle of Agnolo Gaddi). Degenhart and Schmitt rather confusingly reverse the relationship, claiming that Uffizi 2 F is the original, and our drawing the copy (Degenhart and Schmitt, 1968, I-2, no. 519, I-4, pl. 362a). This is all the more confusing in that they accept as the work of Pesellino Uffizi 234 E, the brush drawing mentioned above as so similar to the present sheet (Degenhart and Schmitt, 1968, I-2, no. 527, I-4, pl. 364c).

PIERO DI COSIMO ?

Florence ca. 1462 – Florence 1521 ?

177. *Bust of a Young Woman*

Metalpoint, heightened with white, on pale blue prepared paper. 16.4 x 13.4 cm.

PROVENANCE: Walter C. Baker, New York.

BIBLIOGRAPHY: *Drawings by Old Masters,* exhibition catalogue, Diploma Gallery, Royal Academy of Arts, London, 1953, no. 34, as Piero di Cosimo; *Exhibition of Old Master Drawings. P. and D. Colnaghi and Co.,* London, 1964, no. 6, repr. as Piero di Cosimo; Bean and Stampfle, 1965, no. 24, repr.

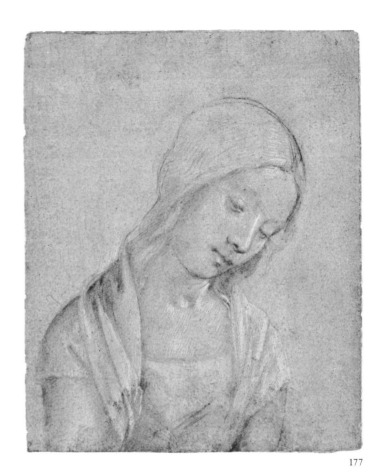

177

Bequest of Walter C. Baker, 1971
1972.118.268

It was J. Byam Shaw who proposed the attribution to Piero di Cosimo of this head of a young woman, possibly a study for the Virgin in a Nativity or Adoration. The use of metalpoint with white heightening is typical of Florence in the late fifteenth century, and, as Byam Shaw suggested, the shape of the head, the heavy-lidded eyes, the tinge of Flemish influence, and the Filippinesque style of draughtsmanship would seem to point to the early phase of the activity of Piero di Cosimo. However, no drawings in metalpoint by Piero that can be connected with pictures have survived, and the attribution to Piero of this fine sheet remains speculative.

FRANCESCO PINNA

Active in Sardinia, late 16th, early 17th century

178. *The Virgin and Child with the Infant Baptist, St. Elizabeth, a Kneeling Prelate, and Three Attendant Angels*

FRANCESCO PINNA (NO. 178)

Pen and black ink, gray wash, heightened with white, on blue-washed paper. 29.9 x 21.9 cm.

Inscribed in pen and black ink at lower right, *m⁰ / fran. pinna Sar / dus inventor.*

PROVENANCE: Théophile de Baranowicz (Lugt. Supp. 335a); John Steiner, Larchmont, New York.

BIBLIOGRAPHY: *Catalogue "Callot"* 1966. *Paul Prouté et ses fils,* Paris, 1966, p. 7, no. 9, repr.; R. Serra, *Annali delle Facoltà di Lettere Filosofia e Magistero dell'Università di Cagliari,* XXX, 1967, Cagliari, 1968, pp. 3-43, fig. 1.

Gift of John Steiner, 1977
1977.12

The discovery of this signed drawing prompted Renata Serra to assign to Francesco Pinna a group of paintings in Sardinian churches and museums. These paintings do indeed share with the drawing a *retardataire,* late mannerist savor. Previously, the only mention of the artist was the reference to a "Francesco Pinna pittore" in an archival document of 1612 preserved in Cagliari.

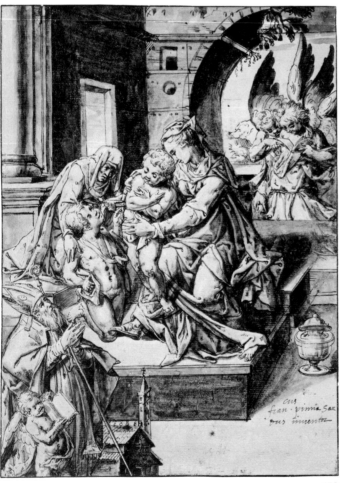

GIOVANNI BATTISTA PITTONI

Vicenza 1520 – Vicenza 1583

179. *Landscape with Classical Ruins and Resting Gypsies*

Pen and brown ink. 21.3 x 18.4 cm. Brown and rose stains. Lined.

PROVENANCE: John Skippe; his descendants, the Martin family, including Mrs. A. D. Rayner-Wood; Edward Holland-Martin; Skippe sale, London, Christie's, November 20-21, 1958, no. 263(A), as Venetian school, XVI century; Harry G. Sperling, New York.

Bequest of Harry G. Sperling, 1971
1975.131.1

Françoise Viatte in January of 1980 recognized this drawing as a characteristic example of the work of G. B. Pittoni, a Veronese specialist in fantastic landscapes with Roman ruins. Previously the drawing had been attributed to the Venetian school (Skippe sale) and to the circle of Niccolò dell'Abate (Harry G. Sperling). Pittoni's sprightly personality as a draughtsman has been defined in relation to his documented prints, and indeed drawings in the Witt Collection, London, the Ecole des Beaux-Arts, Paris, the Nationalmuseum, Stockholm,

178

186

and the collection of Emile Wolf, New York, are preparatory studies for engraved landscapes. Alessandro Ballarin supplied a brief summary of Pittoni's work as a draughtsman in *Arte veneta*, XXV, 1971, pp. 104-105.

BERNARDINO POCCETTI
(Bernardino Barbatelli)

Florence 1548 – Florence 1612

180. *The Youthful St. Antoninus Kneeling before a Crucifix in Orsanmichele*

Black chalk, pale brown wash, on beige paper. Squared in red chalk. 17.4 x 27.8 cm. Arched top. Scattered stains and losses; lower right corner irregular. Lined.

Inscribed in pen and brown ink at lower left, *56. G;* at lower margin in another hand, *nº 8* πωκκεττη *Poccetti.*

PROVENANCE: Unidentified seventeenth-century Florentine collector; John Clerk, Lord Eldin; Eldin sale, Edinburgh, Winstanley and Sons, March 14-29, 1833, part of lot 333; Sir Archibald Campbell, Bt.; Sir Ilay Campbell, Bt.; sale, London, Christie's, March 26, 1974, no. 65, pl. 27; John Steiner, Larchmont, New York.

BIBLIOGRAPHY: W. Vitzthum, *Die Handzeichnungen des Bernardino Poccetti* (doctoral dissertation submitted in 1955 to Ludwig-Maximilians-Universität, Munich) Berlin, 1972, p. 80; Bean, 1975, no. 27; Byam Shaw, 1976, I, pp. 11-12; Thiem, 1977, no. 9, repr.; Hamilton, 1980, under nos. 62, 63, 112.

Gift of John Steiner, 1974
1974.367

Walter Vitzthum in 1955 identified this drawing as a study for one of the lunette-shaped frescoes representing scenes from the life of the Dominican archbishop of Florence, St. Antoninus, painted by Poccetti ca. 1602-1604 in the cloister of St. Antoninus of the Dominican priory of St. Mark in Florence (this fresco repr. Venturi, IX, 7, fig. 331; Thiem, 1977, fig. 227). In both the drawing and the fresco Poccetti gives an accurate view of the interior of Orsanmichele with a side view of Andrea Orcagna's tabernacle in the background. There are other studies related to this composition in the Uffizi and in Berlin-Dahlem (Hamilton, 1980, pp. 74-77).

The old and certainly correct attribution to Poccetti is due to the collector who inscribed his drawings with the artist's name, first in Greek and then in Italian. James Byam Shaw, in discussing the twelve drawings at Christ Church, Oxford, that bear such inscriptions, remarks

that the use of Greek letters seems to have been an affectation of Florentine scholar-collectors from the middle of the sixteenth century. A *Scene of Martyrdom* in the Ecole des Beaux-Arts, Paris (Masson 2381) is correctly attributed to Poccetti in a Greek inscription by the same hand.

181. *Figure Studies: Woman Holding a Shield, a Dancing Female, and a Priest Supported at an Altar before a Group of Onlookers*

Red chalk. 23.0 x 20.3 cm. Tear at upper right corner; scattered brown stains. Lined.

Inscribed in pen and brown ink at lower right, *Guido Reni;* and in darker brown ink, *1575-1642.*

PROVENANCE: James Jackson Jarves; Cornelius Vanderbilt.

BIBLIOGRAPHY: *Metropolitan Museum Hand-book,* 1895, no. 320, as Guido Reni; Thiem, 1977, no. 11, repr.; Hamilton, 1980, under nos. 66, 77, 103, 109.

Gift of Cornelius Vanderbilt, 1880
80.3.320

It was Philip Pouncey who in 1958 recognized the hand of Poccetti in this drawing, which had previously been classified as anonymous Florentine. He also pointed out that the group of figures in the lower half of the sheet are studied for the *Death of St. Buonagiunta Manetti at the Altar of the Servite Monastery at Monte Senario,* a fresco by Poccetti datable to 1612 in the Chiostro dei Morti of the SS. Annunziata, Florence (repr. Thiem, 1977, fig. 229). This scene is one of fourteen incidents from the history of the Order of the Servants of Mary painted by Poccetti in the last years of his life from 1604 to 1612 in the large cloister of their monastery of SS. Annunziata in Florence. Nos. 182 and 183 of this catalogue are also related to this cycle. Paul C. Hamilton has supplied a very complete account of the many surviving preparatory drawings for the project in his catalogue of the 1980 exhibition of drawings by Poccetti in the Uffizi (Hamilton, 1980, pp. 78-92).

The purpose of the sketches at the top of the sheet is unclear, but Hamilton points out that the dancing figure at upper right is studied in a red chalk sketch in the Uffizi (8395 F; Hamilton, 1980, no. 103, fig. 109).

182. *The Death of St. Alexis Falconieri at Monte Senario*

Pen and brown ink, brown wash, heightened with white, over red and some black chalk. Partially squared in black chalk. 16.2 x 28.1 cm. Pieces of paper cut to spandrel shape have been added at upper corners. Scattered stains. Lined.

Inscribed in pen and brown ink on reverse of old mount in Esdaile's hand, *1820 WE P6 N105 formerly in the coll^n of the Marquis Lelgroix / Barbatelli / call'd / B. Pocetti.*

PROVENANCE: John Thane (Lugt 1544); Lestevenon (according to manuscript inventory of the Lagoy collection); Marquis de Lagoy (Lugt 1710); William Esdaile (Lugt 2617); Esdaile sale, London, Christie's, June 18-23, 1840, part of no. 29; purchased in New York in 1961.

BIBLIOGRAPHY: Hamilton, 1980, p. 18 and under nos. 66, 76, 105, pl. IV.

The Elisha Whittelsey Collection
The Elisha Whittelsey Fund, 1961
61.178.2

Study for one of the lunettes in the Chiostro dei Morti, SS. Annunziata, Florence (see No. 181 above). Paul Hamilton discusses preparatory studies in the Uffizi for

182

183

this composition (Hamilton, 1980, p. 80 and nos. 76, 86), but he makes no mention of a red chalk study for the figure of the dying saint lying on the ground that is preserved in the F. Lugt Collection, Institut Néerlandais, Paris (T.4546).

183. *St. Philip Benizi Converting Two Wicked Women at Todi*

Brush and gray wash, heightened with white, on brownish paper. 25.3 x 34.5 cm. Upper left corner replaced; scattered stains.

PROVENANCE: Prof. John Isaacs, London; Isaacs sale, London, Sotheby's, February 27, 1964, no. 16, purchased by the Metropolitan Museum.

BIBLIOGRAPHY: Bean and Stampfle, 1965, no. 147, repr.; R. Bacou in *Le XVIᵉ siècle européen. Peintures et dessins dans les collections publiques françaises,* exhibition catalogue, Petit Palais, Paris, 1965, p. 175, under no. 219; C. Monbeig-Goguel in *Le Cabinet d'un grand amateur, P.-J. Mariette,* exhibition catalogue, Musée du Louvre, Paris, 1967, p. 85, under no. 104; Hamilton, 1980, under nos. 66, 72.

Rogers Fund, 1964
64.48.1

Composition study for one of Poccetti's lunette frescoes devoted to the history of the Servite order in the Chiostro dei Morti, SS. Annunziata, Florence (see Nos. 181 and 182 above). Our drawing records an early stage of Poccetti's plans for this fresco; here St. Philip Benizi faces the two women of loose life who appear at the right corner of the lunette. In the fresco the grouping is reversed, and the two women stand at the center of the composition; this solution is already indicated in the other surviving composition studies for the fresco, one of which is in the Musée Fabre, Montpellier (repr. R. Bacou, *op. cit.,* no. 219), while the other is in the Albertina, Vienna (repr. C. Monbeig-Goguel, *op. cit.,* no. 104).

184. *Seated Crowned Male Figure Holding a Book or Scroll* VERSO. *Seated Nude Boy*

Black chalk on blue paper. 30.8 x 21.4 cm. Horizontal creases at center and upper half of sheet; scattered brown stains.

Inscribed in pen and brown ink at lower left, *Poccetti;* numbered in pen and brown ink at upper right, 20 [?], and in pencil at lower right, 6.

PROVENANCE: Purchased in London in 1971.

BIBLIOGRAPHY: Bean, 1972, no. 40.

Rogers Fund, 1971
1971.63.2

The crowned figure on the recto has not yet been associated with any surviving painted work by Poccetti. As for the nude youth on the reverse of the sheet, Patrick Cooney (letter of October 1975) has suggested that it might be a study for one of the full-grown putti that appear around the frame of the central fresco field in a decoration scheme in the vault of the Carnesecchi chapel, S. Maria Maggiore, Florence, which is traditionally attributed to Poccetti (W. and E. Paatz, *Die Kirchen von Florenz,* III, Frankfurt, 1952, p. 626, dated ca. 1590; photograph of the chapel ceiling, Kunsthistorisches Institut, Florence, negative number 6151).

185. *Standing Dominican or Servite Holding a Book and Staff*

Red chalk. Black chalk sketch of standing warriors in another hand (?) on verso. 28.4 x 17.6 cm.

PROVENANCE: Purchased in London in 1964.

Rogers Fund, 1964
64.40

The drawing was recognized by Philip Pouncey as the work of Poccetti when it was on the London market in the early 1960s.

186. *The Assumption of the Virgin*

Red and some black chalk. Squared in black chalk. 22.0 x 18.0 cm. Lined.

PROVENANCE: Prof. John Isaacs; sale, London, Sotheby's, January 28, 1965, probably part of lot 162, attribution uncertain; purchased in London in 1965.

Rogers Fund, 1965
65.66.8

This composition study was attributed to Poccetti in 1965 by Philip Pouncey.

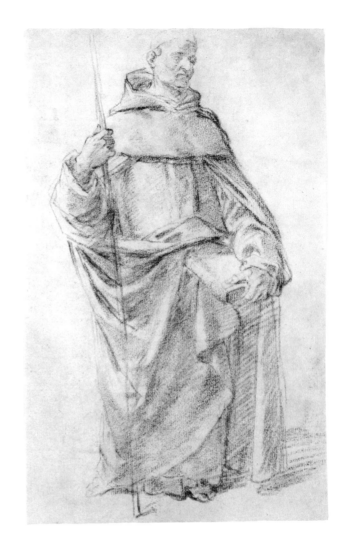

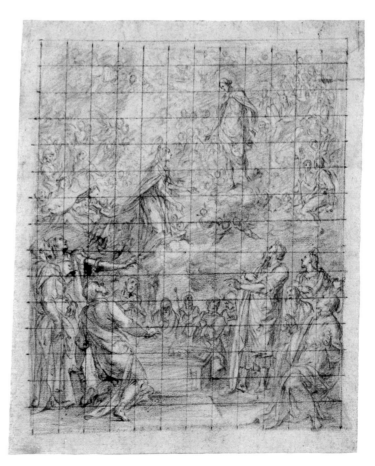

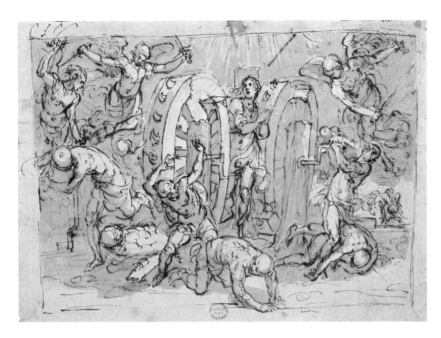

BERNARDINO POCCETTI

187. *The Martyrdom of St. Catherine of Alexandria*

Pen and brown ink, brown wash, over red chalk. 17.8 x 25.6 cm. Brown stain at center of upper margin; the hands of St. Catherine are a repaired loss. Lined.

Inscribed in pen and brown ink at lower margin of old mount, *Francisco Vanni.*

PROVENANCE: Cephas G. Thompson.

BIBLIOGRAPHY: *Metropolitan Museum Hand-book,* 1895, no. 693, as Francesco Vanni.

Gift of Cephas G. Thompson, 1887
87.12.23

Formerly classified under the name of Francesco Vanni, this composition study was attributed to Poccetti in 1958 by Philip Pouncey.

POLIDORO DA CARAVAGGIO
(Polidoro Caldara)

Caravaggio 1490/1500 – Messina 1543 ?

188. *Studies for an Altarpiece with the Virgin Enthroned, Attended by Four Saints* VERSO. *Various Figure Studies, Some Possibly for a Deposition of Christ*

Pen and brown ink, a little brown wash. 20.2 x 29.8 cm. Irregular left margin repaired; a number of brown stains.

Inscribed in pencil at upper right margin, *P. Veronese B.8.;* stamped number, *27,* in black ink at lower right corner of verso.

PROVENANCE: Ferruccio Asta (Lugt Supp. 116a); Walter C. Baker, New York.

BIBLIOGRAPHY: Bean and Stampfle, 1965, no. 73, recto repr.; A. Marabottini, *Polidoro da Caravaggio,* Rome, 1969, I, p. 339, no. 166, II, pl. CXV, 1, recto repr.; L. Ravelli, *Polidoro Caldara da Caravaggio,* Bergamo, 1978, p. 208, no. 235 (recto), no. 236 (verso), p. 210, recto and verso repr.

Bequest of Walter C. Baker, 1971
1972.118.270

The modern inscription on the recto of this double-faced sheet attributing the drawing to *P. Veronese* is erroneous; the frenzied but highly intelligent pen work is typical of the late style of Polidoro da Caravaggio. Other drawings related to the composition dominated by the enthroned Madonna are known. A study for two of the standing saints, once in Mariette's collection, is now the property of Philip Pouncey in London (repr. L. Ravelli, *op. cit.,* pp. 70, 209), and there is a study for the whole composition in an American private collection (repr. L. Ravelli, *op. cit.,* p. 97). Pouncey has identified another composition study in the Albertina (Wickhoff, *Albertina,* p. CLXXXII, S.R. 22, as Traini). The sketches on the verso of the present sheet cannot be connected with specific compositions known to have been painted by Polidoro but, like the drawing on the recto, they are quite close in style to pen drawings in the British Museum that are very probably studies for a Transfiguration painted for a church in Messina in the last years of the artist's life (see Pouncey and Gere, 1962, nos. 217, 218, pls. 188-191).

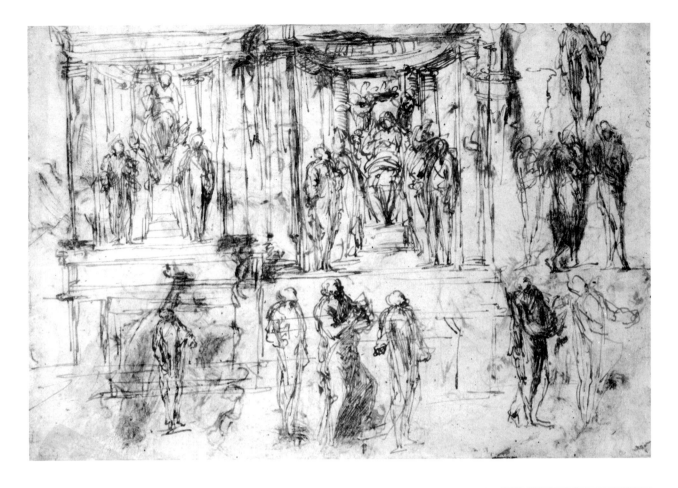

188 v.

27

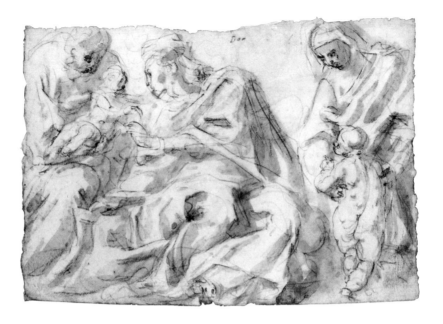

CESARE POLLINI

Perugia ca. 1560 – Perugia ca. 1630

189. *The Holy Family with St. Elizabeth and the Infant Baptist*

Pen and brown ink, brown wash, over red chalk. 14.1 x 20.5 cm. Repaired, circular loss at upper margin, right of inscription.

Inscribed in pen and brown ink over red chalk at upper center, *Dar* [?] (the rest torn away).

PROVENANCE: Purchased in London in 1971.

BIBLIOGRAPHY: *Old Master Drawings and Paintings. Yvonne Tan Bunzl,* exhibition catalogue, London, 1971, no. 41, repr.

Purchase, David L. Klein, Jr., Memorial Foundation Inc. Gift, 1973
1973.322

190. *The Holy Family with Attendant Putti*

Pen and brown ink, brown wash, over red chalk. 11.1 x 20.3 cm.

PROVENANCE: Purchased in Rome in 1960; transferred from the Department of Prints, 1978.

The Elisha Whittelsey Collection
The Elisha Whittelsey Fund, 1961
1978.375

In 1965 Konrad Oberhuber recognized the hand of Cesare Pollini in this drawing, which had up to then been kept among the anonymous Italian drawings in the Print Department.

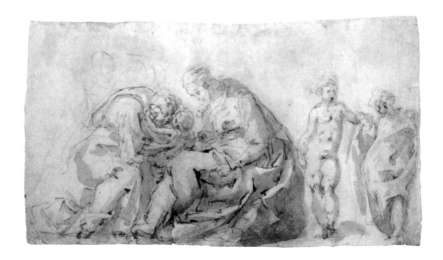

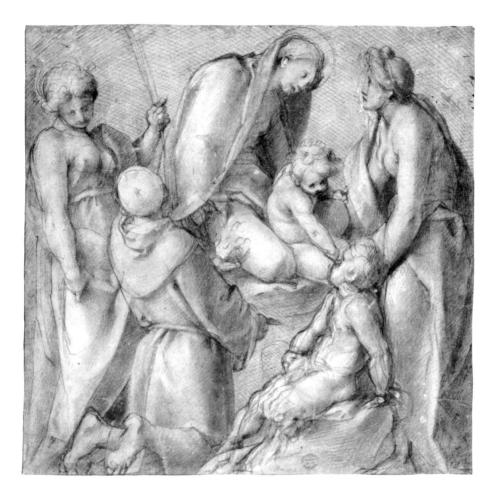

IL PONTORMO (Jacopo Carrucci)?

Pontorme 1494 – Florence 1557

191. *Virgin and Child with St. Elizabeth, the Infant Baptist, St. Anthony of Padua, and a Female Martyr*

Red chalk, red wash. 27.5 x 27.9 cm. Repaired tear at lower right; scattered losses; surface much abraded. Lined.

Inscribed in pencil at lower margin, just right of center, *Pontormo;* in pen and brown ink at lower margin of Pembroke mount, *Giacomo Pontormo. 1493-1556.*

PROVENANCE: Earls of Pembroke; Pembroke sale, London, Sotheby's, July 5-6, 9-10, 1917, no. 414, purchased by the Metropolitan Museum.

BIBLIOGRAPHY: Strong, 1900, part III, no. 26, repr.; Berenson, 1903, no. 2370; F. M. Clapp, *Les Dessins de Pontormo,* Paris, 1914, p. 352, perhaps by Lappoli and corrected by Pontormo; B. Burroughs, *Metropolitan Museum of Art Bulletin,* August 1919, p. 177, repr. p. 178; Berenson, 1938, no. 2256G; *Italian Drawings 1330-1780,* exhibition catalogue, Smith College Museum of Art, Northampton, Massachusetts, 1941, no. 31; *Metropolitan Museum, Italian Drawings,* 1942, no. 23, repr.; *Metropolitan Museum, European Drawings,* 1944, no. N.S.9,

repr.; C. Gamba, *Contributo alla conoscenza del Pontormo,* Florence, 1956, pp. 10-11, fig. 11 (the reproduction cropped at top and bottom); Berenson, 1961, no. 2256G; *Bacchiacca and His Friends,* exhibition catalogue, Baltimore Museum of Art, 1961, no. 64; J. Cox Rearick, *The Drawings of Pontormo,* Cambridge, Massachusetts, 1964, I, p. 398, no. A229, as a pastiche after Pontormo.

Hewitt Fund, 1917
19.76.11

The condition of the drawing is so poor – the surface is much abraded, the chalk has been ground into the paper, and inept restorations made, no doubt on the occasion of a remounting of the sheet – that it seems impossible to determine if this is a much-damaged original drawing by Pontormo himself or a pastiche by some follower. This state of affairs no doubt accounts for the divergence of critical opinion.

There is an old red chalk copy of the drawing in the Cabinet des Dessins of the Louvre (Inv. 1991, as Francesco Vanni).

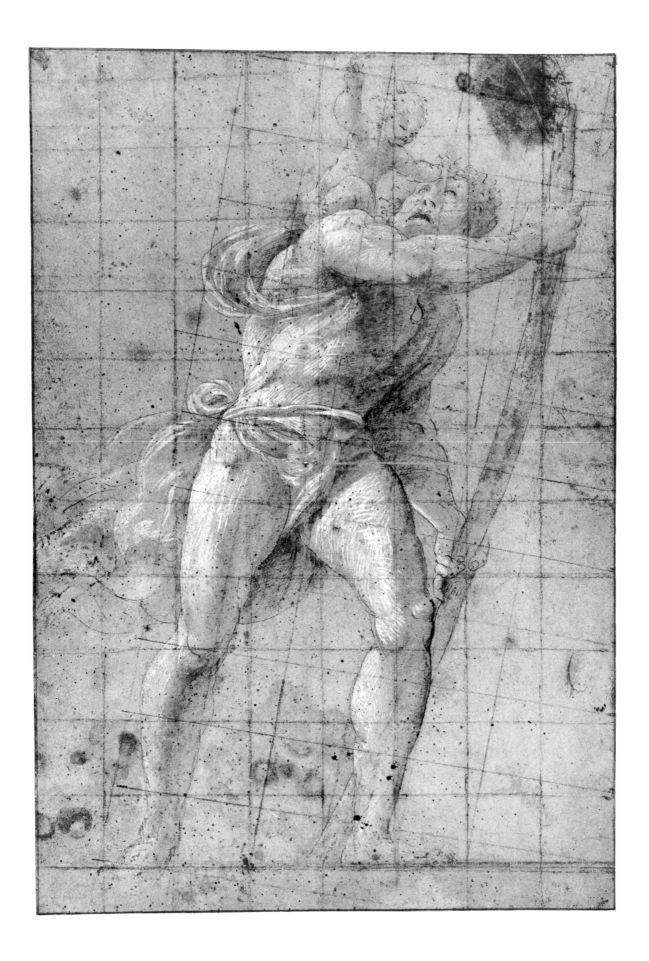

GIOVANNI ANTONIO DA PORDENONE

Pordenone 1484 – Ferrara 1539

192. *St. Christopher Bearing the Christ Child*

Pen and brown ink, brown wash, heightened with white, on blue paper. Squared vertically and horizontally in red chalk, diagonally in black chalk. 36.2 x 24.8 cm. A number of brown stains. Lined.

PROVENANCE: John Skippe; his descendants, the Martin family, including Mrs. A. D. Rayner-Wood; Edward Holland-Martin; Skippe sale, London, Christie's, November 20-21, 1958, no. 161, repr.; purchased in London in 1960.

BIBLIOGRAPHY: Tietze, 1944, no. 1334, pl. XCIV, 4; Bean, 1962, repr. p. 161, fig. 4; Bean, 1964, no. 13, repr.; Bean and Stampfle, 1965, no. 52, repr.; Cohen, 1973, p. 247, fig. 4, p. 248; Cohen, 1975, p. 24, fig. 11, p. 25; Cohen, 1980, pp. 17, 21, 34, 53, 101-102, fig. 43 (with additional bibliography).

The Elisha Whittelsey Collection
The Elisha Whittelsey Fund, 1960
60.135

This chiaroscuro study is Pordenone's *disegno finito* for the St. Christopher he painted on one of the two shutters of a cupboard for ecclesiastical silver in S. Rocco, Venice, about 1527 (Cohen, 1980, fig. 44). An old copy of this drawing is in the Crocker Art Gallery in Sacramento (*Master Drawings from Sacramento,* Sacramento, California, 1971, no. 11, repr., as Pordenone). The copy once figured in the collection of Baron Vivant Denon and was reproduced in reverse in Denon's *Monuments,* II, pl. 124.

At the Musée Condé in Chantilly there is a red chalk study for the figures of St. Martin and the beggar represented on the other shutter in S. Rocco (Cohen, 1980, figs. 41 and 42).

193. *Design for the Decoration of a Pilaster*

Red chalk. Faint red chalk studies for the decoration of another pilaster on verso: putti with trophies, and a seated figure with a child. 32.5 x 20.8 cm. Upper corners replaced; scattered stains; vertical and horizontal creases.

Inscribed in pen and brown ink at lower margin, *Correggio.*

PROVENANCE: Sir Peter Lely (Lugt 2092); Earls of Pembroke; Pembroke sale, London, Sotheby's, July 5-6, 9-10, 1917, no. 409, as Correggio, purchased by the Metropolitan Museum.

BIBLIOGRAPHY: Strong, 1900, part V, no. 47, repr., as Correggio; A. Venturi, *L'arte,* V, 1902, pp. 353-354, as Bernardino Gatti; Sturge Moore, 1906, p. 265, no. 29, as Correggio; Ricci, 1930, p. 185, not by Correggio; Tietze, 1944, no. 1360, as Pordenone; Heaton-Sessions, 1954, pp. 225-226, fig. 6, as Pomponio Allegri; Popham, 1957, pp. 62, 159, no. 47, pl. LIII, as Correggio; Bean and Stampfle, 1965, no. 69, repr., as Correggio; M. Laskin, Jr., *Burlington Magazine,* CIX, 1967, pp. 355-356, fig. 38 (recto), fig. 39 (verso); A. Ghidiglia Quintavalle, *L'opera completa del Correggio,* Milan, 1970, p. 114, repr., as Correggio; A. Ghidiglia Quintavalle in *Arte in Emilia 4, capolavori ritrovati e artisti inediti dal '300 al '700,* Parma, 1971, p. 55; D. A. Brown, *Master Drawings,* XIII, 2, 1975, p. 136; Cohen, 1980, pp. 11, 100-101, fig. 54 (recto), fig. 56 (verso).

Hewitt Fund, 1917
19.76.12

A. E. Popham endorsed the traditional attribution of this drawing to Correggio, suggesting that it was a design for one of the commissioned but never executed decorations of the pilasters in S. Giovanni Evangelista, Parma. Earlier, the Tietzes had emphatically rejected Correggio's authorship, and they proposed Pordenone's name. Their attribution, made on stylistic grounds, was vindicated when in 1967, Myron Laskin, Jr., established that the designs on recto and verso of the sheet are clearly Pordenone's studies for the pilaster decorations on the entrance arch of the Pallavicini Chapel in S. Francesco, Cortemaggiore.

All the ornamental elements of the design that appear on the recto of our sheet—the tortoise on a double volute, putti with a vase, a breastplate, caduceus, long-necked birds, cornucopia, and at right, the seated woman suckling a child—occur with slight variations on the left entrance pilaster (Cohen, 1980, fig. 55). The putti and the seated figure with a child that are faintly sketched on the verso (not reproduced here) appear on the pilaster at the right of the entrance (Cohen, 1980, fig. 57). Charles Cohen proposed a date ca. 1529 for the Cortemaggiore decorations.

Pordenone's debt to Correggio is apparent in this red chalk design, but as Laskin observed, "the compositional vigour, a sort of Solomonic column spiralling upward and not yet restrained to fit the limits of the pilaster, is not quite Correggesque [and] the emphasis upon contour, sculptural modelling, and bold movement are more characteristic of Pordenone" (M. Laskin, Jr., *op. cit.,* p. 356).

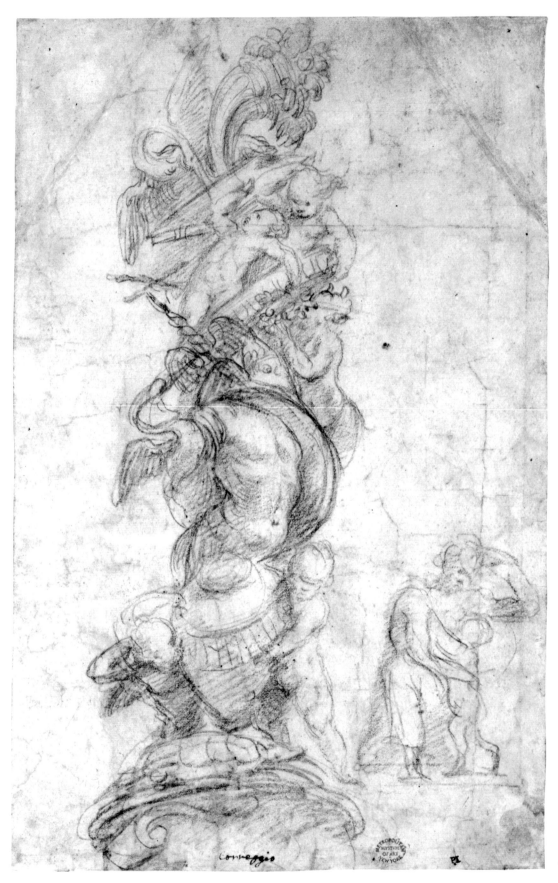

Correggio

193

194. *Standing Figure of Christ with Arms Upraised*

Point of brush, two shades of brown wash, on beige paper. Squared in black chalk. 40.2 x 23.1 cm. Water stain at upper margin. Lined.

Inscribed in pen and brown ink at center of right margin, partially reworked in a darker shade of ink to read, *da ma / del Co / regio.*

PROVENANCE: Adrien Prachoff, St. Petersburg; purchased in New York in 1961.

BIBLIOGRAPHY: *Collection Adrien Prachoff. I. Dessins origineaux* [sic] *des maîtres anciens,* St. Petersburg, 1906, no. 43, pl. 31, 1, as Correggio; Cohen, 1980, pp. 18-19, 41-42, 102, fig. 139.

The Elisha Whittelsey Collection
The Elisha Whittelsey Fund, 1961
61.167

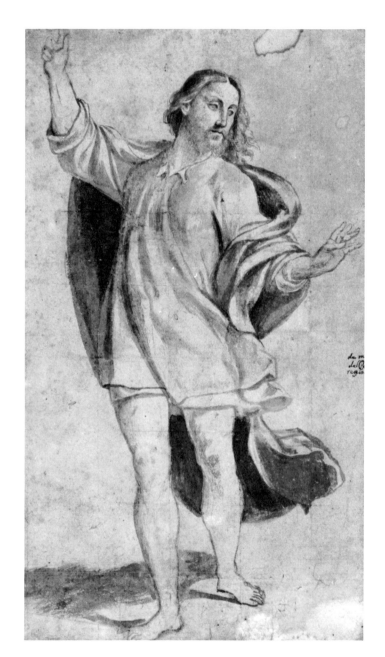

Finished study for the figure of Christ in the *Noli me tangere* in the Duomo at Cividale del Friúli; the painting is a late work by Pordenone datable about 1538 (Cohen, 1980, fig. 140). Unfortunately, the drawing has been clumsily reworked in many areas by a later restorer who tried to turn the drawing into a "Correggio"; the inscription at the right margin has been tampered with and *Pordenone* made to read *Coregio.* Pordenone's original drawing is executed with point of brush and pale brown wash, a technique unusual for him, but where his hand is nonetheless recognizable. The head of Christ is fine and characteristic, though even here there are awkward additions in a darker wash in the mouth, eyes, and at the parting of the hair. The interior of the mantle and the heel of Christ's left foot are areas where reinforcements in darker wash have much impaired the legibility of the original brush work. It has been suggested that the drawing might be a mere copy after the painting in Cividale, but the high quality of what survives of the original brush work here makes it more probable that this is Pordenone's *disegno finito* for the figure of Christ.

It is difficult to determine just when this drawing was reworked, but the harm was in any case done before the sheet was reproduced as the work of Correggio in the Prachoff catalogue of 1906.

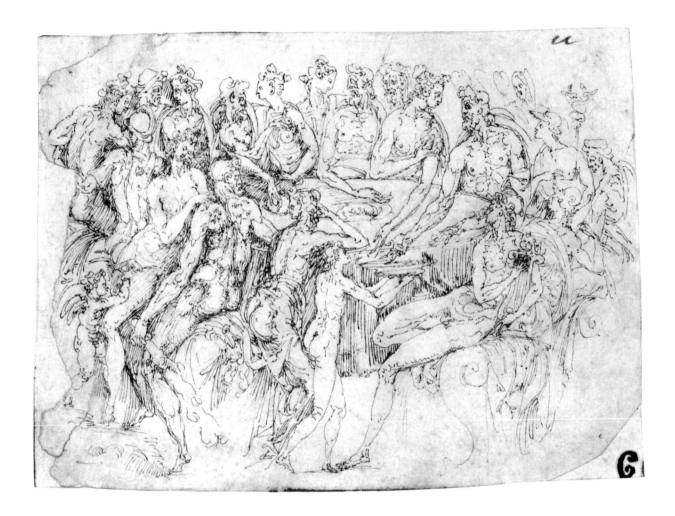

GUGLIELMO DELLA PORTA

Active in Genoa ca. 1530 – Rome 1577

195. *The Banquet of the Gods*

Pen and brown ink, over traces of black chalk. 12.3 x 16.6 cm. Left margin very irregular; lower right corner missing. Lined.

Inscribed in pencil at lower right corner of old mount, *Cellini;* in pen and brown ink, *guglielmo di marsiglia.*

PROVENANCE: Mark mistakenly associated with Pierre Crozat (Lugt 474); John F. Keane (according to Sotheby's); sale, London, Sotheby's, May 21, 1963, no. 55, purchased by the Metropolitan Museum.

BIBLIOGRAPHY: Bean and Stampfle, 1965, no. 111, repr.; W. Gramberg, *Jahrbuch der Hamburger Kunstsammlungen,* 13, 1968, pp. 69-94, fig. 5.

Rogers Fund, 1963
63.103.3

Study for one of a series of plaques representing scenes from Ovid's *Metamorphoses,* originally cast in bronze for

Della Porta by Jacob Cobaert. The complete series of sixteen plaques exists only in the Kunsthistorisches Museum in Vienna, but the Metropolitan Museum possesses a fine version of the *Banquet of the Gods* in repoussé gold backed with lapis lazuli. Guglielmo's spidery draughtsmanship, which owes much to Perino del Vaga with whom he collaborated in Genoa and Rome, is well documented in sketchbooks at Düsseldorf, published in facsimile by Werner Gramberg (*Die Düsseldorfer Skizzenbücher des Guglielmo della Porta,* Berlin, 1964). A drawing for the representation of the *Fall of the Giants* in this series is in the Pierpont Morgan Library, New York; one for the *Flaying of Marsyas* in the Kunsthalle, Hamburg; and one for the *Judgment of Paris* in a private collection in Copenhagen (repr. W. Gramberg, *op. cit.,* 1968, figs. 1, 8, and 13).

TEODORO DELLA PORTA

Rome 1567 – Rome 1638

196. *Design for an Ornamental Initial Letter* B

Pen and brown ink, brown wash, over black chalk, on blue paper. 18.5 x 18.4 cm. Lined.

Inscribed in pen and gray ink at lower center, *C. Teodoro della / Porta;* numbered in pen and brown ink at upper right corner of old mount, 69.

PROVENANCE: Sale, London, Christie's, March 28, 1972, no. 39, pl. IX, purchased by the Metropolitan Museum.

Rogers Fund, 1972
1972.135

A design for the initial letters N and C, also signed by the Cavaliere Teodoro della Porta, is in the Witt Collection at the Courtauld Institute, London (Inv. 405; Courtauld photograph 18/38/21). In style, both our drawing and that in the Witt Collection reveal the strong influence of Guglielmo della Porta on his son Teodoro.

FRANCESCO PRIMATICCIO

Bologna 1504 – Paris 1570

197. *Vulcan Forging the Darts of Cupid*

Red chalk, heightened with white, on beige paper. 34.1 x 43.7 cm. Cut to the shape of a spandrel. Vertical crease at center. Lined.

Inscribed in pen and brown ink at lower margin of old mount, *Primaticcio.*

PROVENANCE: Prosper Henry Lankrink (Lugt 2090); Earls of Pembroke; Pembroke sale, London, Sotheby's, July 5-6, 9-10, 1917, part of no. 500, purchased by the Metropolitan Museum.

BIBLIOGRAPHY: Strong, 1900, part V, no. 52, repr.; *Metropolitan Museum, Italian Drawings,* 1942, no. 25, repr.; Bean, 1964, no. 22, repr.; Bean and Stampfle, 1965, no. 97, repr.; Béguin, 1972, p. 149, under no. 162.

Hewitt Fund, 1917
19.76.7

Like No. 198 below, this is an elaborate preparatory study for a spandrel in the Salle de Bal, Château de Fontainebleau. The frescoes in this room were executed between 1551 and 1556; Primaticcio supplied the designs for the frescoes, but the painting is said to have been the work of his talented assistant Niccolò dell'Abate. The drawing comes very close to the fresco as executed. However, there are a number of minor but significant variations between drawing and painting. This spandrel is reproduced in reverse in a print by Alexandre Bettou (Robert-Dumesnil, VIII, p. 231, no. 13).

The most conspicuous features in Primaticcio's decorative scheme were the eight broad spandrels above the windows of the ballroom. In addition to the Metropolitan's drawings, four other designs for the spandrels survive: a study for *Apollo and the Muses on Mount Parnassus* in the British Museum (1900-6-11-4); drawings for the *Bacchanal* and *Ceres Presiding over the Harvest* at Chantilly (repr. L. Dimier, *Le Primatice,* Paris, 1928, pls. X-XI); and a study for *Phäethon in Supplication before Apollo* in Budapest (I. Fenyő, *Bulletin du Musée Hongrois des Beaux-Arts,* 22, 1963, pp. 97-98, fig. 54).

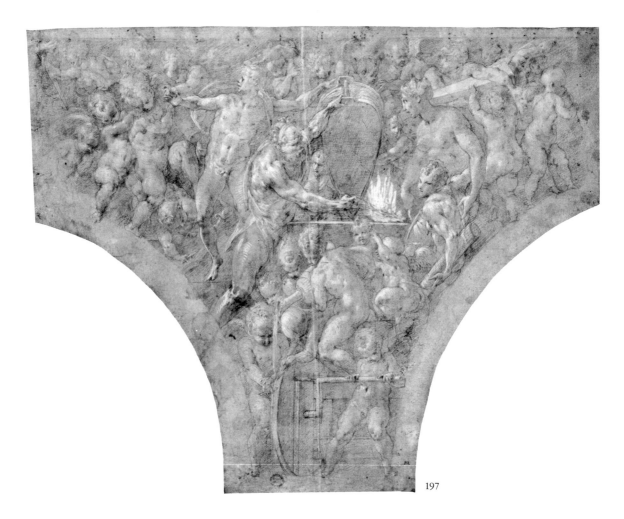

197

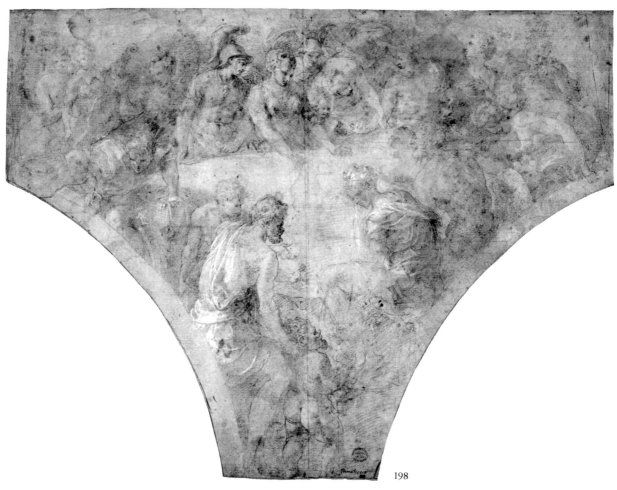

198

198. *Discord at the Marriage Feast of Peleus and Thetis*

Red chalk, heightened with white, on beige paper. 31.6 x 43.4 cm. Cut to the shape of a spandrel. Vertical crease and blue chalk line at center; repaired tears at left. Lined.

Inscribed in pen and brown ink at lower margin, *Primaticcio.*

PROVENANCE: Prosper Henry Lankrink (Lugt 2090); Earls of Pembroke; Pembroke sale, London, Sotheby's, July 5-6, 9-10, 1917, part of no. 500, purchased by the Metropolitan Museum.

BIBLIOGRAPHY: Strong, 1900, part V, no. 53, repr.; *Metropolitan Museum, Italian Drawings,* 1942, no. 24, repr.; Bean and Stampfle, 1965, no. 98, repr.; Béguin, 1972, p. 149, no. 162, repr. p. 150.

Hewitt Fund, 1917
19.76.6

Study for one of the spandrels in the Salle de Bal at Fontainebleau — see No. 197 above. The fresco modeled on this design is reproduced in reverse in a print by Alexandre Bettou (Robert-Dumesnil, VIII, p. 229, no. 6).

199. *Ulysses and His Companions Defeat the Cicones before the City of Ismarus*

Red chalk, heightened with white, on red-washed paper. 24.1 x 31.9 cm. Vertical red chalk line at left; several repaired losses; surface abraded. Lined.

Inscribed in pen and brown ink at lower margin of old mount, *Primaticcio;* on reverse of old mount, *Painted at Fountainebleau, and Engraved by / Theodore Van Tulden.*

PROVENANCE: Mrs. E. E. James (according to Sotheby's); sale, London, Sotheby's, May 16, 1962, part of no. 191; purchased in London in 1962.

BIBLIOGRAPHY: J. Bean, *Master Drawings,* VII, 2, 1969, p. 169, pl. 42.

Rogers Fund, 1962
62.204.2

Though the sheet is much damaged, it appears to be an original study by Primaticcio for one of the fifty-eight scenes of the adventures of Ulysses painted on the walls of the now-destroyed Galerie d'Ulysse of the Château de Fontainebleau. These paintings were engraved by

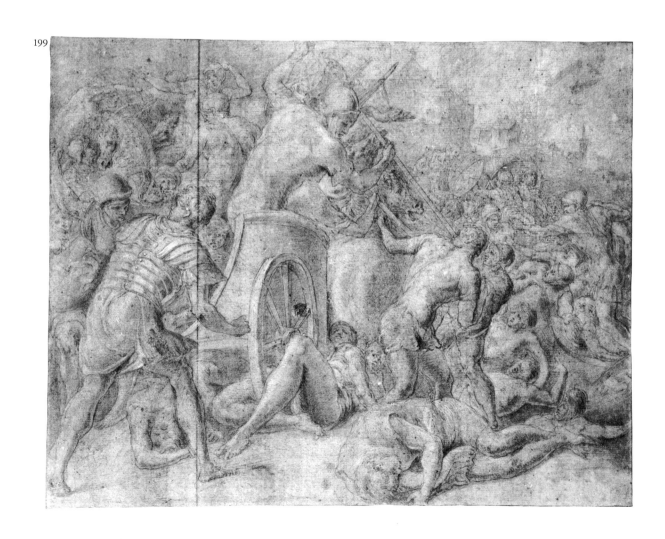

199

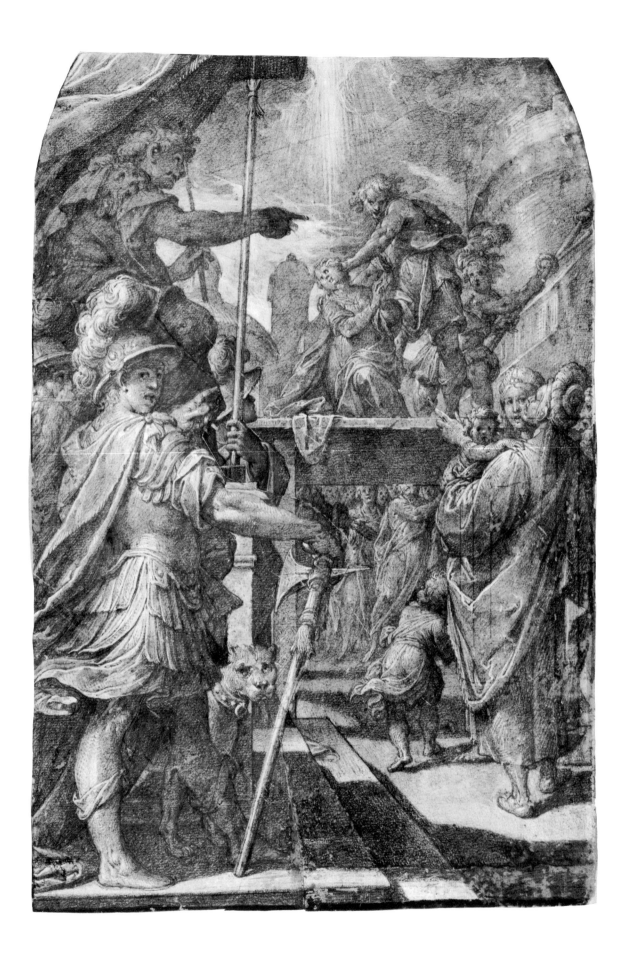

Theodor van Thulden; the scene for which our drawing is a study was reproduced in reverse as no. 4 in the series of prints. This damaged drawing is similar in style, technique, and dimensions to the twenty-six other surviving studies for the Ulysses series; nineteen of these are preserved in the Nationalmuseum at Stockholm, five in the Albertina, Vienna, one at the Musée Condé, Chantilly, and one in the Museum Boymans-van Beuningen, Rotterdam (L. Dimier, *Le Primatice, peintre, sculpteur et architecte des rois de France,* Paris, 1900, nos. 168-186, 152-155, 158, 131 respectively; for the Rotterdam drawing, see W. M. Johnson, *Master Drawings,* IV, 1, 1966, p. 25, pl. 16).

CAMILLO PROCACCINI

Bologna ca. 1555 – Milan 1629

200. *Martyrdom of a Female Saint*

Black chalk, gray wash, heightened with white, on brownish paper; some ruled lines in pen and brown ink. Pasted correction at left, including foreground figure of soldier. 46.0 x 31.1 cm. Drawing repaired and extended at right half of lower margin; upper right and left corners rounded off. Lined.

PROVENANCE: Michael Jaffé, Cambridge; sale, London, Sotheby's, November 11, 1965, no. 53, repr., purchased by the Metropolitan Museum.

BIBLIOGRAPHY: *Old Master Drawings Presented by W. R. Jeudwine,* exhibition catalogue, London, 1955, no. 47, repr.; *Old Master Drawings. P. and D. Colnaghi and Co.,* exhibition catalogue, 1956, no. 8; Stampfle and Bean, 1967, no. 2, repr.; Neilson, 1979, p. 156, fig. 143.

Rogers Fund, 1965
65.223

The drawing was recognized as the work of Camillo Procaccini by Philip Pouncey in 1953 when it was on the market in Paris; in 1968 Nancy Ward Neilson identified it as a study for a painting by Camillo in the Santuario dell'Addolorata at Rho near Milan, which she dates 1605-1609 (Neilson, 1979, p. 63, fig. 142). In both the painting and the drawing the Castel Sant'Angelo identifies the place of martyrdom as Rome; the victim could be St. Agnes.

201. *The Annunciation*

Red chalk. 9.9 x 7.2 cm. Lined.

PROVENANCE: James Jackson Jarves; Cornelius Vanderbilt.

BIBLIOGRAPHY: *Metropolitan Museum Hand-book,* 1895, no. 181, as Barocci; Neilson, 1979, pp. 155-156, fig. 253.

Gift of Cornelius Vanderbilt, 1880
80.3.181

Philip Pouncey made the attribution to Camillo Procaccini in 1965, and Nancy Ward Neilson has connected it with Camillo's painting of the same subject in the Ospedale Maggiore, Milan, which she dates around 1616-1618 (Neilson, 1979, p. 26, fig. 254).

202. *St. Francis of Assisi Resuscitating a Dead Youth*

Red chalk. 14.5 x 12.4 cm. Repaired losses at left. Lined.

PROVENANCE: James Jackson Jarves; Cornelius Vanderbilt.

BIBLIOGRAPHY: *Metropolitan Museum Hand-book,* 1895, no. 221, artist unknown; N. W. Neilson, *Arte lombarda,* 50, 1978, p. 99, fig. 11, p. 101; Neilson, 1979, p. 156, fig. 186.

Gift of Cornelius Vanderbilt, 1880
80.3.221

Like No. 201 above, this drawing was attributed to Camillo by Philip Pouncey in 1965. Since then Nancy Ward Neilson has suggested that it may be a preparatory study for one of the now-destroyed scenes from the life of St. Francis painted by or under the supervision of Camillo in the second cloister adjacent to the church of S. Angelo in Milan.

203. *The Birth of St. Francis of Assisi*

Pen and brown ink, pale brown wash, on beige paper. Faintly squared in black chalk. 15.6 x 13.1 cm. Surface abraded. Lined.

PROVENANCE: Harry G. Sperling, New York.

BIBLIOGRAPHY: Neilson, 1979, pp. 156-157, as "Birth of the Virgin ?", fig. 300.

Bequest of Harry G. Sperling, 1971
1975.131.242

Nancy Ward Neilson points out that there is a copy of this drawing in the Staatsgalerie at Stuttgart (repr. Thiem, Stuttgart, 1977, no. 184, as Lombard, ca. 1600). The subject has only recently been identified; Francis's mother, a lady of high station, wished to give birth to her first child in the stable of the family house in recollection of the humble birthplace of Jesus. In the background is visible the mysterious pilgrim visitor who, according to the Franciscan legend, announced the saintly vocation of the newborn son (see *Bibliotheca Sanctorum,* V, Rome, 1964, col. 1052). Another Lombard representation of this story is a painting by Giovanni Mauro della Rovere, now in the Prepositurale di S. Marco, Milan (repr. A. Ottina della Chiesa, *Dipinti della Pinacoteca di Brera in deposito nelle chiese della Lombardia, I,* Milan, 1969, p. 42, fig. 19).

204. *The Virgin and St. Joseph Find Jesus Disputing with the Doctors in the Temple*
(Luke 2:46-50)

Brush and gray wash, a little pen and black ink, heightened with white, over black chalk, on brownish paper. Squared in black chalk. 16.8 x 24.7 cm. Cut to an irregular oval shape. A few repaired losses.

Inscribed in pencil on reverse of old mount (now lost), *Camillo Procaccini.*

PROVENANCE: Eugene Victor Thaw, New York.

BIBLIOGRAPHY: Neilson, 1979, p. 156, fig. 323.

Gift of Eugene Victor Thaw, 1962
62.255

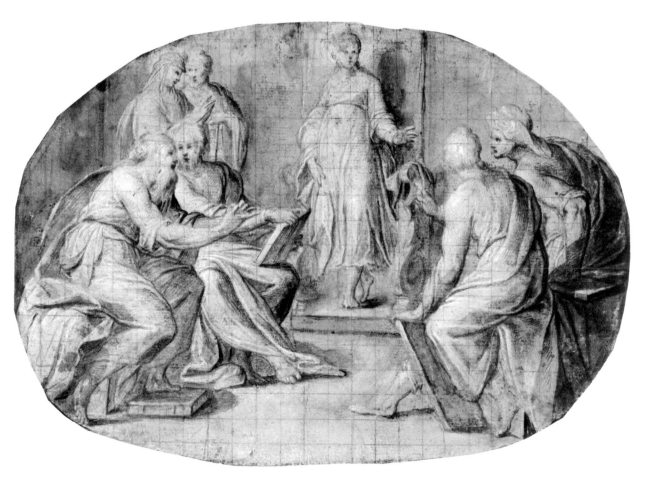

CAMILLO PROCACCINI

205. *Angel with a Banderole*

Red chalk, red wash, heightened with white, on beige paper. 24.0 x
10.7 cm. A few repaired tears and losses.

PROVENANCE: Giuseppe Vallardi (Lugt 1223); purchased in New
York in 1976.

BIBLIOGRAPHY: Neilson, 1979, p. 157, fig. 293.

Harry G. Sperling Fund, 1976
1976.186

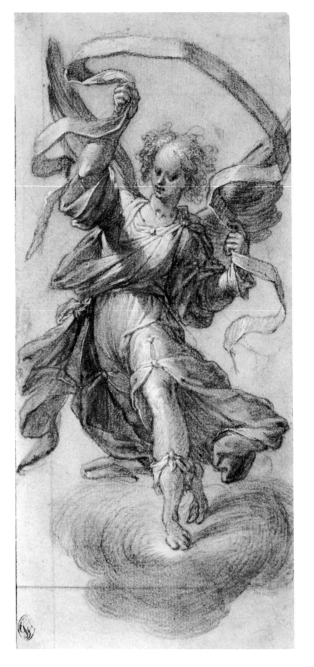

BIAGIO PUPINI
Bologna, notices 1511 – 1575

206. *Penitent Woman Anointing the Feet of Christ at the Table of Simon the Pharisee* (Luke 7:36-50)

Pen and brown ink, brown wash, heightened with white, on beige
paper. Ruled lines in pen and brown ink indicating the contours of
table and benches are drawn over the seated figures. Some contours
indented. On verso further ruled lines in pen and brown ink for the
table and stools, and studies of two of the figures at table. 23.3 x 38.3
cm. Verso of sheet rubbed with charcoal (for transfer ?).

Inscribed in pen and brown ink on Pembroke mount, *R:U: this shows
that to lay ye drapery the better Raphael first drew the naked – from vo!. 2ⁿᵈ
N. 24* (indicating the drawing's place in the Pembroke albums).

PROVENANCE: Nicholas Lanier (Lugt 2886); Earls of Pembroke;
Pembroke sale, London, Sotheby's, July 5-6, 9-10, 1917, no. 447, as
school of Raphael; purchased in New York in 1981.

BIBLIOGRAPHY: *Dessins originaux anciens et modernes . . . en vente chez
Paul Prouté, catalogue "Domenico" 1980*, Paris, 1980, no. 12, repr.

Harry G. Sperling Fund, 1981
1981.77

The position of Christ and the penitent woman at the
right end of the table, and that of the two standing
servers at the left of the composition, are probably in-
spired by Marcantonio's engraving after Raphael, *Christ
at the Table of Simon the Pharisee* (Bartsch, XIV, p. 29, no.
23). What is unusual in Pupini's representation of the
scene is the curious T-shaped table, the presence of
thirteen diners, a number usually associated with repre-
sentation of the Last Supper, and the fact that Christ, the
penitent woman, and several of the other guests are
represented nude.

In the Pembroke collection this drawing was given to
the school of Raphael; the convincing attribution to
Pupini seems to be modern.

207. *The Judgment of Solomon, after Raphael*

Black chalk, brush and gray wash, heightened with white, on blue
paper. 23.8 x 31.9 cm. Scattered brown stains. Lined.

PROVENANCE: Nicholas Lanier (Lugt 2886); Sir Peter Lely (Lugt
2092); Sir John Charles Robinson (Lugt 1433); Robinson sale, Lon-
don, Christie's, May 12-14, 1902, no. 32, as Biagio Pupini, mis-
takenly said to have come from the Lankrink collection; purchased in
London in 1909.

Rogers Fund, 1909
10.45.5

A free copy of the Judgment of Solomon composition in the Vatican Logge (repr. Dacos, 1977, pl. XLVIIa). This quite plausible attribution to Biagio Pupini goes back at least to the time of J. C. Robinson.

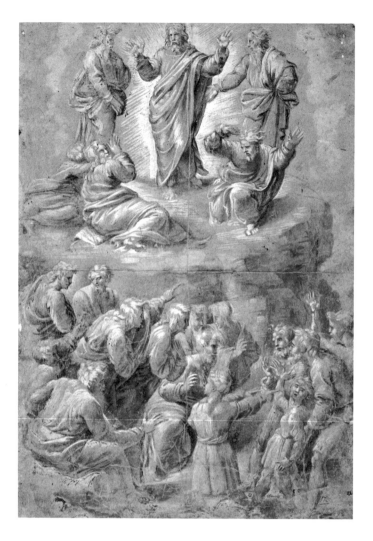

BIAGIO PUPINI

208. *The Transfiguration, after Raphael*

Brush and brown wash, heightened with white, over traces of black chalk, on blue paper. 40.0 x 27.6 cm. Vertical and horizontal creases at center; a number of irregular creases near lower margin; scattered losses. Lined.

Inscribed in pen and brown ink at lower margin of old mount, *Biaggio — outline . . .* ; in another hand, *by R:U:.*

PROVENANCE: Sir Peter Lely (Lugt 2092); Earls of Pembroke; Pembroke sale, London, Sotheby's, July 5-6, 9-10, 1917, no. 420, as Vicenzo di Biagio; sale, Munich, Karl and Faber, November 25-27, 1976, no. 362a; purchased in Zurich in 1977.

Harry G. Sperling Fund, 1977
1977.163

Pupini seems to have copied not the finished *Transfiguration* now in the Vatican Gallery, but an earlier stage of Raphael's planning that is recorded by a drawing in the

Louvre attributed by Konrad Oberhuber to Giovanni Francesco Penni (repr. *Berliner Museen,* IV, 1962, p. 121, fig. 4). The differences between the Louvre drawing and the finished painting are approximately those between the latter and the present copy. The attribution of this very routine production goes back to the time when it figured in the Pembroke collection.

JACOPO DELLA QUERCIA ?
Quercia Grossa ca. 1374 – Siena 1438

209. *Study for the Fonte Gaia, Siena*

Pen and brown ink, brown wash, on vellum. 19.9 x 21.4 cm. Lined.

PROVENANCE: Giorgio Vasari ? (according to Ragghianti Collobi); Erasmus Philipps; Richard Philipps, 1st Lord Milford (Lugt Supp. 2687); Sir John Philipps; purchased in London in 1949.

BIBLIOGRAPHY: R. Krautheimer, *Metropolitan Museum of Art Bulletin,* June 1952, pp. 265-274, repr. p. 266; J. Pope-Hennessy, *Burlington Magazine,* XCV, 1953, p. 278, doubts the attribution to Quercia; J. Pope-Hennessy, *Italian Gothic Sculpture,* London, 1955, p. 214, as a derivation from a design by Quercia; Bean, 1964, no. 1, repr.; A. C. Hanson, *Jacopo della Quercia's Fonte Gaia,* Oxford, 1965, pp. 11-13, 22-34, pl. 4; Degenhart and Schmitt, 1968, I-1, no. 112, I-3, pl. 161a; C. Seymour, Jr., in *Festschrift Ulrich Middeldorf,* Berlin, 1968, pp. 93-105, pls. XLVI, XLVIII, as Martino di Bartolommeo; C. del Bravo, *Scultura senese del Quattrocento,* Florence, 1970, pp. 24-25, 34, pl. 65, as a copy of Quercia; J. Pope-Hennessy, *Italian Gothic Sculpture,* London and New York, 1972, p. 213, as a derivation from a design by Quercia; C. Seymour, Jr., *Jacopo della Quercia, Sculptor,* New Haven, Connecticut, and London, 1973, p. 45, fig. 40, as Martino di Bartolommeo ?; Ragghianti Collobi, 1974, I, p. 43, II, fig. 52; *Jacopo della Quercia nell'arte del suo tempo,* exhibition catalogue, Palazzo Pubblico, Siena, 1975, p. 107, repr. p. 110 (not exhibited); F. Bisogni in *Jacopo della Quercia fra gotico e rinascimento. Atti del convegno di studi,* Florence, 1977, pp. 109-114, pls. XII.1, XII.2; Bellosi, 1978, p. xx; P. Ward-Jackson, *Victoria and Albert Museum Catalogues. Italian Drawings. Volume One. 14th-16th century,* London, 1979, pp. 21-24, under no. 17, as a copy after Quercia; F. Ames-Lewis, *Drawing in Early Renaissance Italy,* New Haven, Connecticut, and London, 1981, pp. 128, 130, repr.

Harris Brisbane Dick Fund, 1949
49.141

In 1408 Jacopo della Quercia was commissioned by the city of Siena to execute a fountain ornamented with "sculptures, figures, foliage, cornices, steps, pilasters, and coats of arms" in the Piazza del Campo, opposite the Palazzo Pubblico. Work on the fountain, which was completed in 1419, did not begin until 1415; the municipal records show that an original project supplied in

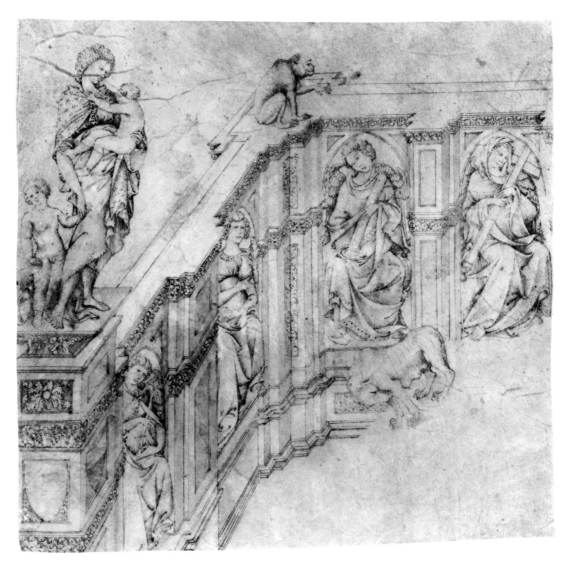

1408 had been modified and enriched in 1409 and changed again in 1415. This fountain, traditionally called the Fonte Gaia, has been replaced in the Piazza del Campo by a modern replica, but fragments of the original are preserved in the Palazzo Pubblico in Siena.

A pen design on parchment in the Victoria and Albert Museum was connected with the Fonte Gaia by Jenő Lányi (*Zeitschrift für bildende Kunst*, 61, 1927-1928, pp. 257-266), who suggested that the London drawing was part of the revised project supplied by Quercia in 1409. When the present drawing appeared in 1949, it was immediately apparent that the vellum sheet had been the left section of a design of which the Victoria and Albert drawing represented the right section. Krautheimer, who published the Metropolitan's drawing shortly after its acquisition, pointed out that the middle section of the project, probably containing a central niche with a sculptured figure, is missing. He reaffirmed Lányi's

suggestion that the design is related to the 1409 project. The fountain as executed differs in many respects from the drawings, though the freestanding figures on the projecting wings representing Acca Laurentia and Rhea Silvia, foster mother and mother of Romulus and Remus, legendary founders of Siena, appear both in the drawings and on the fountain. It is Acca Laurentia and the infant twins who are represented at the left in our drawing.

No other evidence of Quercia's style as a draughtsman has survived, and critical opinion is sharply divided on the issue of the originality of this and the Victoria and Albert drawings. Peter Ward-Jackson, in cataloguing the fragment in London, made a thorough survey of the problem; his conclusion is that the tentative, fragmentary character of both drawings, which lack essential features of the fountain design, suggest that they are copies or derivations of a lost original by Quercia.

RAPHAEL (Raffaello Santi)

Urbino 1483 – Rome 1520

210. *Madonna and Child with the Infant St. John*
VERSO. *Nude Male Figure*

Red chalk (recto). Pen and brown ink (verso). 22.4 x 15.9 cm. Paper stained at lower left and center of recto, abraded at lower right of recto. Horizontal fold at center.

Inscribed in pen and brown ink at lower left, *1509.* [?]; at lower right, *Raf: d'U.* Inscribed on verso in pen and brown ink in the artist's hand at lower right, *Carte de . . .* [the rest illegible]; in black chalk at lower left, *58 3/4 / 66 1/4 / H 31* [?].

PROVENANCE: Lambert ten Kate Hermansz., Amsterdam; Ten Kate sale, Amsterdam, June 16, 1732, portfolio H, no. 31; Antoine Rutgers, Amsterdam; Rutgers sale, Amsterdam, December 1, 1778, no. 268; Cornelis Ploos van Amstel (Lugt 2034); Ploos van Amstel sale, Amsterdam, March 3, 1800, portfolio EEE, no. 3; George Hibbert, London; Hibbert sale, London, Christie's, June 12, 1833, no. 169; Samuel Rogers, London; Rogers sale, London, Christie's, April 28 – May 16, 1856, no. 950; T. Birchall; Richard Rainshaw Rothwell; J. W. Rothwell; sale, London, Sotheby's, March 11, 1964, no. 150, purchased by the Metropolitan Museum.

BIBLIOGRAPHY: B. Picart, *Impostures innocentes, ou recueil d' estampes d'après divers peintres illustres, tels que Rafael, le Guide, Carlo Maratti, le Poussin, Rembrandt, etc.,* Amsterdam, 1734, pl. 5 (recto engraved in reverse); J.-D. Passavant, *Raphael d'Urbin et son père Giovanni Santi,* Paris, 1860, II, p. 496, no. 454; Weigel, 1865, p. 546, no. 6497; J. A. Crowe and G. B. Cavalcaselle, *Raphael. His Life and Works,* I, London, 1882, p. 264; Fischel, III, p. 140, note 2, under no. 116; Parker II, p. 267; J. Bean, *Metropolitan Museum of Art Bulletin,* Summer 1964, pp. 1-10, repr. frontispiece (recto), p. 8, cover (verso); Bean, 1964, nos. 11-12, repr. (recto and verso); Bean and Stampfle, 1965, no. 49, repr. (recto and verso); F. Coulanges-Rosenberg in *Le XVIe siècle européen. Dessins du Louvre,* exhibition catalogue, Musée du Louvre, Paris, 1965, pp. 20-21, under no. 39; J. G. van Gelder, *Nederlands Kunsthistorisch Jaarboek,* 1970, p. 153, fig. 8 (recto), p. 172; L. Dussler, *Raphael,* London and New York, 1971, p. 20; Macandrew, 1980, p. 275, under no. 518.

Rogers Fund, 1964
64.47

Composition study for the *Madonna im Grünen (Madonna in the Meadow)* in the Kunsthistorisches Museum in Vienna, which bears a date that can be read as 1505 or 1506. Painted for Raphael's friend and patron Taddeo Taddei, the picture remained in the Palazzo Taddei in Florence until 1662, when it was purchased by the Archduke Ferdinand Karl and taken to Austria. Several of Raphael's preparatory drawings for the picture have survived. A double-faced sheet in the Albertina (Fischel, III, nos. 115, 116) bears pen sketches of alternative poses for the three figures, and the figure of the Infant Baptist

is represented both standing and kneeling. In a pen drawing at Chatsworth (Fischel, III, no. 117), the Baptist is studied standing and also kneeling to embrace the Christ Child. A drawing at the Ashmolean Museum, Oxford (Fischel, III, no. 118), executed with the point of a brush and pale brown wash, comes close to the picture as executed, but the Metropolitan's drawing is the last in the sequence of preparatory drawings. There is, however, one significant difference between the drawing and the picture. The Madonna's right arm, free in the drawing, is covered in the painting with rather heavy drapery. In the present design Raphael is concerned with establishing the general construction of the composition, where the three figures form a monumental triangle animated by the Leonardesque turn of the Christ Child, who reaches forward to seize the cross held by the Infant Baptist. Only the staff of the cross, a prominent accent in the painting, is visible in the present design. At the top of the sheet appear studies of the Virgin's drapery and the Infant Baptist's right arm. The young Raphael has used red chalk with easy assurance to suggest the subtle contrasts of light and shade that model the figures; the drawing is one of the earliest examples of the artist's use of this drawing medium.

Raphael's pen study of a nude male figure on the verso of the sheet is strikingly different in intention and treatment from the red chalk drawing on the recto. The male figure has been drawn with a forceful pen line and sharp anatomical observation from a model in the studio, while the red chalk drawing, certainly not drawn from life, is a composition sketch where the artist is concerned with overall construction and lighting of a pictorial scheme and not with exact detail. The nude male figure, with head hanging limply forward and arms raised behind his back by cords that are hardly indicated, may well be a study for the figure of one of the thieves on a cross. Several drawings, datable on stylistic grounds to about the same time as the Metropolitan's sheet, testify that Raphael in his Florentine period had investigated solutions for a representation of the Descent from the Cross, and he may have intended to include the crucified thieves in the scene. On the verso of a sheet in the Albertina, bearing a study for one of the predella panels for the 1507 Borghese Gallery *Entombment of Christ,* is a pen design for a Descent from the Cross (Fischel, IV, no. 182). Stylistically related to this Vienna sheet is a pen drawing in the Louvre (Fischel, IV, no. 183) of a nude

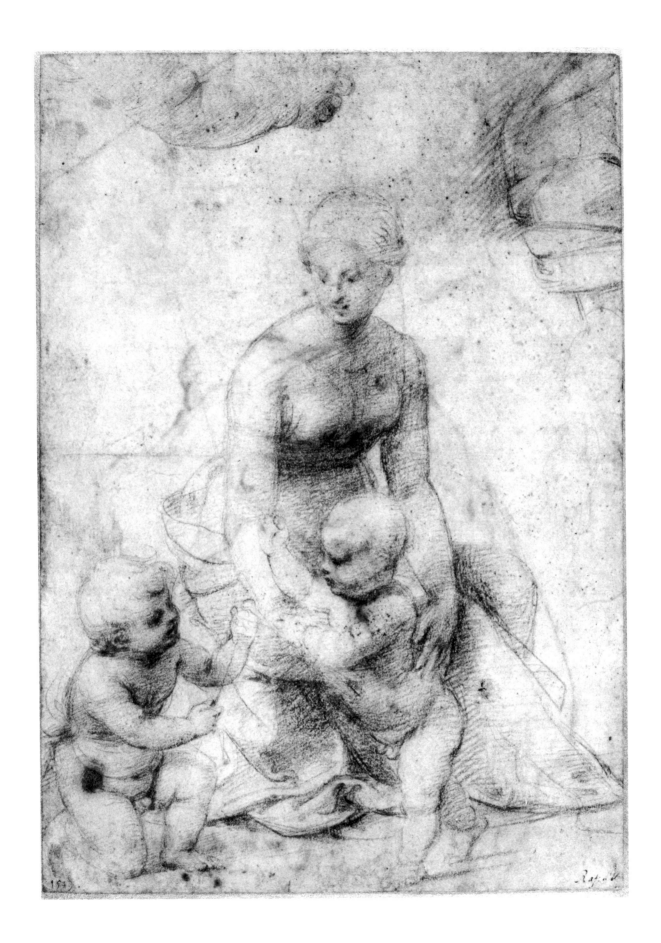

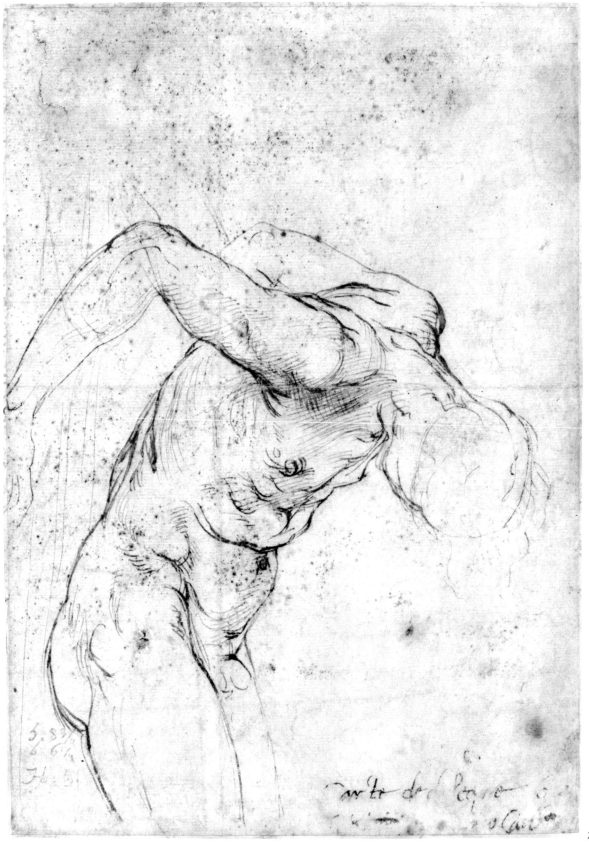

male figure hanging as from a cross; the figure is seen full length, but clearly derives from the male nude in the present drawing. The somewhat dry and schematic draughtsmanship of the Paris sketch suggests that it is not a study from life, but one worked up from the example of the Metropolitan's drawing or a similar study after a model.

RAPHAEL, copy after

211. *Back View of a Standing Male Nude*

Pen and brown ink on brownish paper. 27.9 x 11.3 cm. A number of stains and losses; lower right corner missing. Lined.

PROVENANCE: Cephas G. Thompson.

BIBLIOGRAPHY: *Metropolitan Museum Hand-book,* 1895, no. 739, as Raphael; B. Berenson, *Gazette des Beaux-Arts,* XV, 1896, p. 203, as Raphael; Fischel, II, p. 116, under no. 90, fig. 108, copy after Raphael; Burroughs, 1918, p. 214, as Raphael; K. Oberhuber, *Master Drawings,* II, 4, 1964, pp. 399-400, fig. 2, copy after Raphael.

Gift of Cephas G. Thompson, 1887
87.12.69

Old copy of a lost original drawing by Raphael.

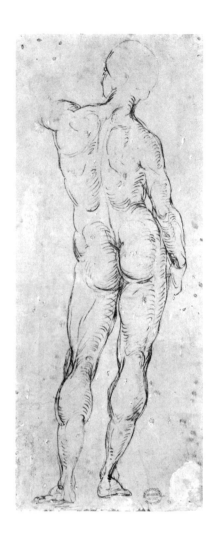

212. *The Creation of Eve*

Pen and brown ink. 22.5 x 18.5 cm. Lined.

Inscribed in pencil at lower right corner of old mount, *Raphael;* in pencil on reverse of old mount (in Reveley's hand ?), *Raphael's first Study for the formation of Eve / engraved in Raphael's Bible. & purchased at / Paris A.D. 1769. out of the Royal collection.*

PROVENANCE: Henry Reveley (Lugt 1356); purchased in London in 1911 from a descendant of Henry Reveley.

BIBLIOGRAPHY: Reveley, 1820, pp. viii, 9, as Raphael; *Metropolitan Museum of Art Bulletin,* June 1911, p. 139, as Raphael ?; A. Hayum, *Burlington Magazine,* CXIV, 1972, pp. 87, 89, fig. 39, as Vincenzo Tamagni after Raphael; K. Oberhuber, *Raphaels Zeichnungen,* IX, Berlin, 1972, pp. 161-162, no. 456, pl. 56, copy after Raphael; Dacos, 1977, pp. 155-156, pl. XIIb, as Vincenzo Tamagni after Raphael ?.

Rogers Fund, 1911
11.66.11

The drawing may be an old copy of a study by Raphael for the *Creation of Eve* in the Vatican Logge (repr. Dacos, 1977, pl. XIIa). There seems no particular reason to identify the copyist as Vincenzo Tamagni.

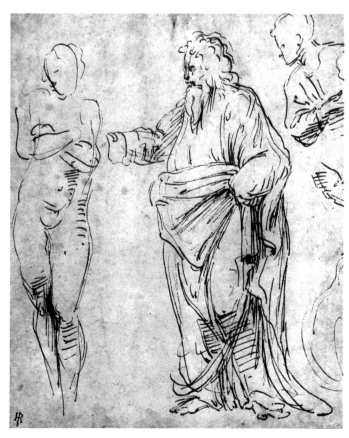

214

213

RAPHAEL, circle of

213. *Muzzle of a Horse: Fragment of a Cartoon for an Adoration of the Magi*

Brush, brown, red, green, yellow, and white gouache, over black chalk. 39.6 x 22.7 cm. Vertical and horizontal creases at center. Lined.

PROVENANCE: Jonathan Richardson, Sr. (Lugt 2184, 2984); Sir Joshua Reynolds (Lugt 2364); John W. Lisle.

BIBLIOGRAPHY: Adelson, 1980, p. 45, under no. 64; Dacos, 1980, p. 82, note 84; Macandrew, 1980, p. 280, under nos. 599-619.

Gift of John W. Lisle, in memory of his father, Joseph William Lisle, 1922
22.72.1

This and No. 214 below are fragments of the catroon for the *Adoration of the Magi* (repr. Müntz, 1897, p. 37), one of the *Scuola Nuova* tapestries now in the Vatican Museums. The series originally comprehended six scenes from the life of Christ. These tapestries are to be situated at the outermost periphery of what we call the circle of Raphael; they were probably commissioned after the artist's death, and the designs are no doubt the work of Raphael's assistants and followers. The tapestries themselves were woven in the Brussels workshop of Pieter van Aelst and sent to Rome to Pope Clement VII in 1531. The full-scale cartoon, of which these two drawings are

fragments, seems to have been executed in Brussels by Italian or Flemish specialists in thisstage of the preparation of a tapestry. Four further fragments are in the Ashmolean Museum, Oxford, and like ours they once belonged to Jonathan Richardson, Sr. (Parker II, nos. 605-608).

214. *Head of a Youth and a Horse's Mane: Fragment of a Cartoon for an Adoration of the Magi*

Brush, brown and red gouache, over a little black chalk. 24.0 x 33.2 cm. Vertical crease right of center; lower left corner missing; several brown and white stains. Lined.

PROVENANCE: Jonathan Richardson, Sr. (Lugt 2184, 2984); Sir Joshua Reynolds (Lugt 2364); John W. Lisle.

BIBLIOGRAPHY: Adelson, 1980, p. 45, under no. 64; Dacos, 1980, p. 82, note 84; Macandrew, 1980, p. 280, under nos. 599-619.

Gift of John W. Lisle, in memory of his father, Joseph William Lisle, 1922
22.72.2

See No. 213 above.

215. *A Woman's Headdress: Fragment of a Cartoon for a Presentation of the Infant Jesus in the Temple*

Brush, yellow, orange, brown, gray, and white gouache, over black chalk. 22.5 x 39.0 cm. Upper left corner missing; surface abraded. Lined.

PROVENANCE: Jonathan Richardson, Sr. (Lugt 2184, 2984); Sir Joshua Reynolds (Lugt 2364); John W. Lisle.

BIBLIOGRAPHY: Macandrew, 1980, p. 280 under nos. 599-619.

Gift of John W. Lisle, in memory of his father, Joseph William Lisle, 1922
22.72.3

Cartoon for the headdress worn by the Virgin in the *Presentation of the Infant Jesus in the Temple,* one of the *Scuola Nuova* tapestries (repr. Müntz, 1897, p. 38). Four cartoon fragments for this tapestry, also from the collection of Jonathan Richardson, Sr., are in the Ashmolean Museum, Oxford (Parker II, nos. 609-612; 609 repr. Dacos, 1980, fig. 30). Two additional fragments, not from Richardson's collection but from that of General Guise, are at Christ Church, Oxford (Byam Shaw, 1976, nos. 458-459; Dacos, 1980, figs. 29 and 24 respectively). See No. 213 above.

215

RAPHAEL, circle of

216. *Head Surmounted by a Tongue of Fire and a Nimbus: Fragment of a Cartoon for a Descent of the Holy Spirit*

Brush, yellow, orange, brown, cream, and white gouache. 26.0 x 27.7 cm. Roughly silhouetted, upper corners and lower right corner replaced; losses at lower center. Some contours pricked. Lined.

PROVENANCE: Jonathan Richardson, Sr. (Lugt 2184, 2984); Sir Joshua Reynolds (Lugt 2364); John W. Lisle.

BIBLIOGRAPHY: Macandrew, 1980, p. 280, under nos. 599-619.

Gift of John W. Lisle, in memory of his father, Joseph William Lisle, 1922
22.72.6

Cartoon for the head of the Apostle who appears on the extreme right (in reverse, of course) in the *Descent of the Holy Spirit at Pentecost,* one of the *Scuola Nuova* tapestries (repr. Müntz, 1897, p. 43). See No. 213 above. There are two further cartoon fragments related to this tapestry in the Ashmolean Museum, Oxford; one is said to have belonged to Jonathan Richardson, Sr., the other to Sir Joshua Reynolds (Parker II, nos. 615-616; Dacos, 1980, figs. 33, 32, respectively).

RAPHAEL, circle of

217. *Outstretched Hand, Body of a Seraph, and a Wing: Fragment of a Cartoon*

Brush, yellow, pink, green, gray, and white gouache, over black chalk. 36.5 x 20.1 cm. A number of creases and repaired tears; upper right corner replaced. Lined.

PROVENANCE: Jonathan Richardson, Sr. (Lugt 2184, 2984); Sir Joshua Reynolds (Lugt 2364); John W. Lisle.

Gift of John W. Lisle, in memory of his father, Joseph William Lisle, 1922
22.72.4

Though they share the same provenance and are technically compatible with the four cartoon fragments for the *Scuola Nuova* tapestries described above, Nos. 213-216, this fragment, and No. 218 below cannot be associated with any of the cartoons for that series. The present fragment, with outstretched hand seen against a background of winged spirits, could be part of a cartoon for a Transfiguration or an Ascension of Christ, but the fragment is clearly not related to the Ascension in the *Scuola Nuova* series (repr. Müntz, 1897, p. 43).

218. *Foot in a Buskin, Drapery, and a Plant: Fragment of a Cartoon*

Brush, yellow, blue, green, brown, black, and white gouache, over some black chalk. 27.5 x 30.9 cm. Lower corners replaced. Lined.

PROVENANCE: Jonathan Richardson, Sr. (Lugt 2184, 2984); Sir Joshua Reynolds (Lugt 2364); John W. Lisle.

Gift of John W. Lisle, in memory of his father, Joseph William Lisle, 1922
22.72.5

See No. 217 above.

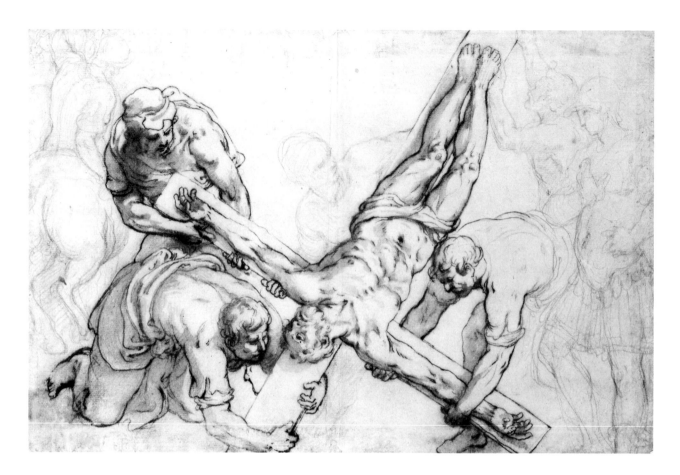

GIOVANNI BATTISTA RICCI

Novara 1537 – Rome 1627

219. *The Crucifixion of St. Peter*

Red chalk; pen, brown ink and wash added for the principal figures; architectural notations (?) in black chalk at upper margin. 23.2 x 36.0 cm. Vertical creases at center. Lined.

PROVENANCE: Mrs. W. M. de l'Hopital; sale, London, Christie's, March 26, 1968, no. 76, as Federico Zuccaro; purchased in London in 1971.

BIBLIOGRAPHY: *Old Master Drawings. Yvonne Tan Bunzl,* exhibition catalogue, London, 1971, no. 41, repr.; Bean, 1972, no. 44.

Rogers Fund, 1971
1971.222.2

The drawing is a study for a fresco on the left wall of the third chapel in the left nave of S. Maria in Traspontina, Rome. This chapel, dedicated to St. Peter and St. Paul, contains frescoes and an altarpiece by G. B. Ricci representing scenes from the lives of the two Apostles (Baglione, 1642, p. 148). The attribution of the drawing to G. B. Ricci was made by Philip Pouncey in 1968 when the drawing was on the London art market.

IL ROMANINO (Girolamo di Romano)

Brescia 1484/1487 – Brescia ? after 1559

220. *Nude Male Figure with Upraised Right Arm*

Brush and brown wash over traces of black chalk. 29.5 x 16.7 cm. Losses at upper, lower, and right margins. Lined.

Inscribed in pen and brown ink at upper right, *Gerolamo Romanino Prattico / Pittore Bresciano;* a long inscription in pen and black ink at upper right has been erased and is now illegible.

PROVENANCE: Purchased in London in 1961.

BIBLIOGRAPHY: *H. M. Calmann, Dealer in Old Master Drawings,* exhibition catalogue, London, 1958, no. 7, repr.; A. Morassi in *Festschrift Karl M. Swoboda,* Vienna, 1959, p. 190, fig. 39; Bean, 1962, p. 163, fig. 6; C. Gilbert, *Arte veneta,* XVI, 1962, p. 201, fig. 232; F. Kossoff, *Burlington Magazine,* CV, 1963, p. 77, fig. 52; Bean and Stampfle, 1965, no. 56, repr.

Rogers Fund, 1961
61.123.3

Florence Kossoff has suggested that this drawing might be a preparatory study for the figure of Adam climbing

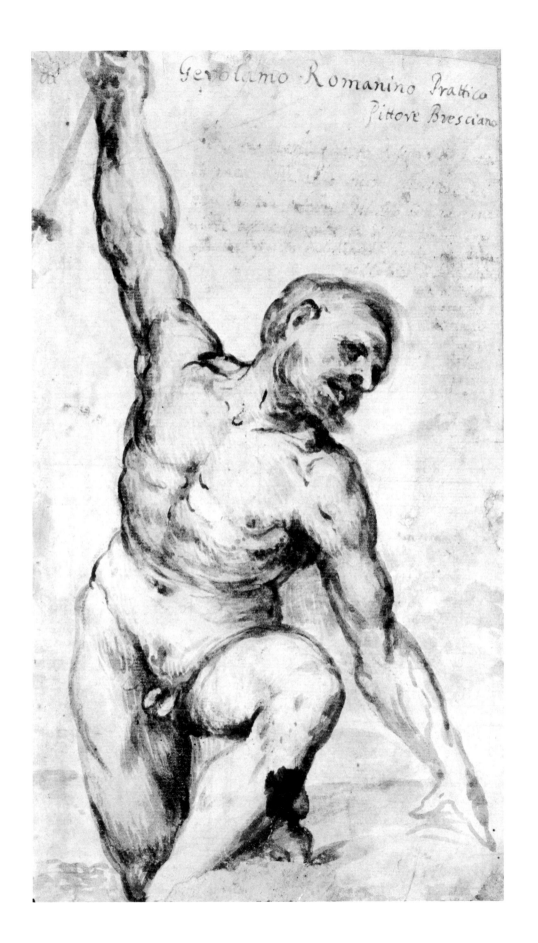

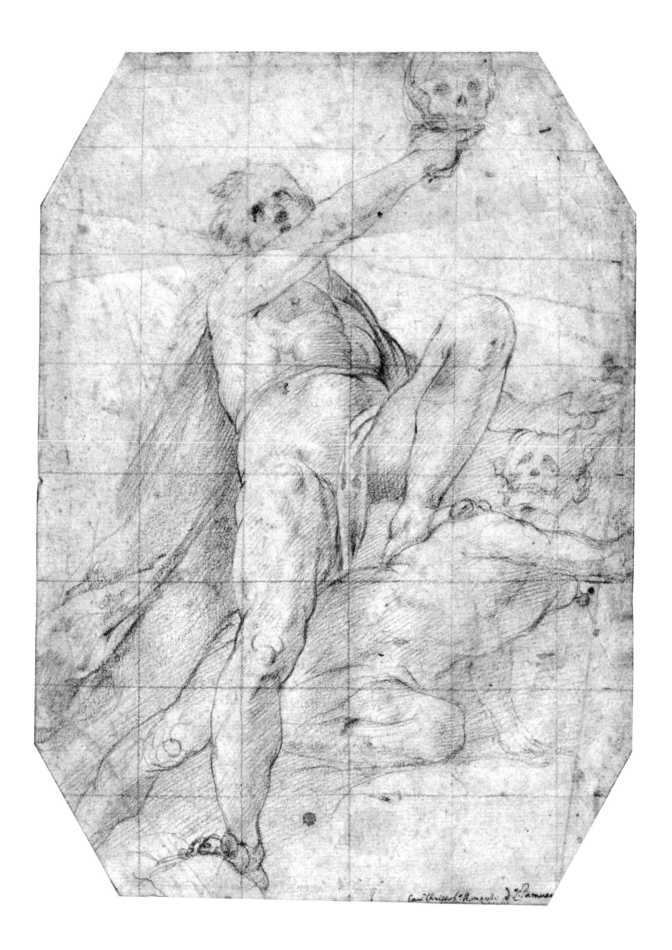

out of Limbo in the scene representing Christ Visiting the Underworld, part of Romanino's fresco cycle in S. Maria della Neve at Pisogne (repr. F. Kossoff, *op. cit.,* p. 75, fig. 54). If the drawing is not actually connected with the fresco, it may well date from the same time, about 1574.

CRISTOFANO RONCALLI

Pomerance 1551/1552 – Rome 1626

221. *Two Personifications of Winds* VERSO. *Half Figure of a Male Nude with Upraised Right Arm*

Red chalk. Recto faintly squared in red chalk. 29.8 x 21.3 cm. All four corners cut off; tear at lower left; diagonal creases in upper half of sheet; scattered brown stains.

Inscribed in pen and brown ink at lower right, *Cav Christof⁰. Roncalli d⁰. C. Pamaran. . . .*

PROVENANCE: William Young Ottley (the drawing on an Ottley mount, see Lugt Supp. 2662); Ottley sale, London, T. Philipe, June 6-23, 1814, part of no. 1139; Sir Thomas Lawrence (Lugt 2445); purchased in New York in 1962.

BIBLIOGRAPHY: L. Turčić, *Burlington Magazine,* CXXIII, 1981, pp. 614-617, the drawing fig. 41 (recto), the fresco fig. 40.

Rogers Fund, 1962
62.197

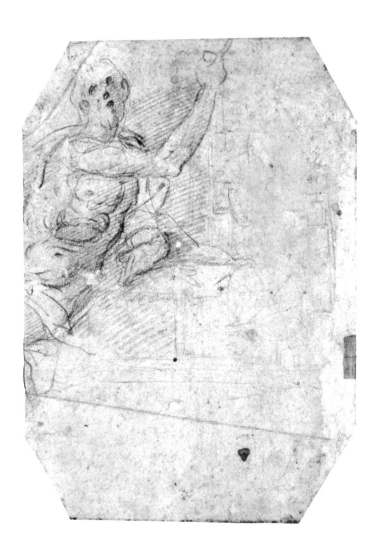

Lawrence Turčić recognized the figures on the recto of this sheet as studies for two of the personifications of winds that appear in a ceiling fresco surrounding the circular field of an anemoscope in the Sala della Meridiana, Torre dei Venti, Vatican Palace, Rome. There are a number of differences between fresco and drawing, the most obvious being the angle of the standing figure's head and the substitution of a deflated cloud for the skull in his right hand.

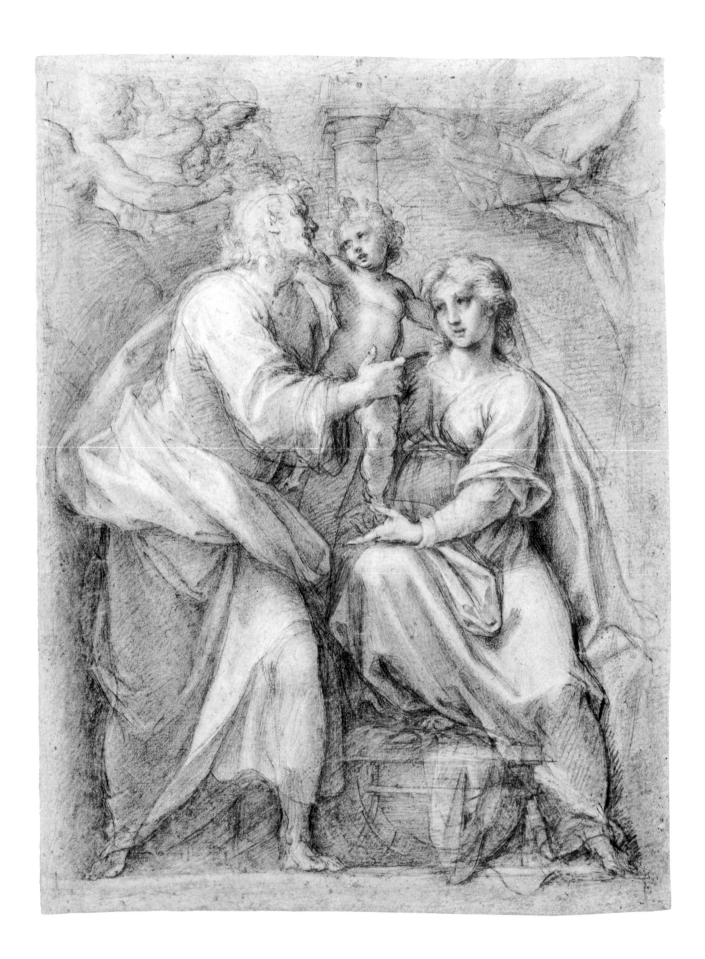

222. *The Holy Family with Angels*

Black chalk, heightened with white, on faded blue paper. 36.0 x 27.1 cm. Scattered brown stains; verso rubbed with black chalk.

Inscribed in pencil on verso, *Parmigiano.*

PROVENANCE: Hugh N. Squire, London; purchased in London in 1962.

BIBLIOGRAPHY: P. Pouncey, *Burlington Magazine,* XCIV, 1952, p. 356, fig. 70; P. Della Pergola, *Galleria Borghese, i dipinti,* II, Rome, 1959, p. 46, under no. 64, the painting repr. pl. 64; Stampfle and Bean, 1967, no. 3, repr.; Kirwin, 1972, p. 447, under no. XXIX.

Pfeiffer Fund, 1962
62.120.4

This drawing was first published in 1952 by Philip Pouncey, who recognized it as a study for Roncalli's painting of the *Holy Family* in the Borghese Gallery in Rome (Inv. 330). In 1964 Jacob Bean found a further study for the picture in the Uffizi, where it had been previously misattributed to Gabbiani. The drawing in Florence is in black, red, and white chalk on blue paper

(15428 F; repr. *Disegni dei toscani a Roma, 1580-1620,* exhibition catalogue, Gabinetto Disegni e Stampe degli Uffizi, Florence, 1979, no. 27, fig. 33). The preparatory drawings differ one from another in a number of details, just as they differ slightly from the painting, which W. C. Kirwin dates about 1603-1605.

223. *Design for a Lunette Decoration: Coat of Arms Flanked by Seated Allegorical Figures*

Pen and brown ink, brown wash, over black chalk. Squared in black chalk (recto). Another design for the coat of arms in red and black chalk, pen and brown ink, brown wash, on verso. 17.7 x 27.3 cm.

Inscribed in pen and brown ink at center of lower margin, *Pomaranci;* faintly in black chalk at lower right on verso, *Cristoforo Roncalli.*

PROVENANCE: Harry G. Sperling, New York.

Bequest of Harry G. Sperling, 1971
1975.131.20

The arms here are similar to those of the Mattei family, for whom Roncalli worked on occasion, but they lack the diagonal band running from top left to bottom right that figures in that family's escutcheon (see, for example, Gere, 1969, pl. 70). The allegorical figures have not yet been identified; the female at left holds up a small bird, while that on the right holds the model of a circular temple in both hands.

224. *God the Father*

Red chalk. Squared in red chalk. 13.3 x 14.4 cm. Brown stains at lower right.

PROVENANCE: Don Sebastien Gabriel de Borbón y Braganza (1811-1875); Don Pedro Alcántara de Borbón y Borbón, Duke of Dúrcal (1862-1892); Dúrcal sale, New York, American Art Galleries, April 10, 1889, part of no. 224, as José Caesare; Henry Walters; transferred from the Department of Prints, 1962

Gift of Henry Walters, 1917
17.236.50

The drawing entered the collection with an oldish attribution to Giuseppe Cesari, but in 1968 Herwarth Röttgen recognized it as a study by Cristofano Roncalli for the central figure of God the Father in Glory in a

fresco in the elliptical cupola of the nave of S. Silvestro in Capite, Rome (repr. J. S. Gaynor and I. Toesca, *S. Silvestro in Capite*, Rome, 1963, fig. 26). Philip Pouncey found a study for the whole cupola composition, with God the Father surrounded by a host of angels, in a red chalk drawing in the Uffizi (696 F, as N. Circignani). W. C. Kirwin dates the fresco about 1604-1605 (Kirwin, 1972, p. 452).

225. *Flying Angel*

Red and some black chalk. Squared in red chalk. 17.6 x 21.6 cm. Losses at upper corners and at lower right corner; repaired loss just below center.

Inscribed in pencil on verso, *Arpino-o*.

PROVENANCE: Don Sebastien Gabriel de Borbón y Braganza (1811-1875); Don Pedro Alcántara de Borbón y Borbón, Duke of Dúrcal (1862-1892); Dúrcal sale, New York, American Art Galleries, April 10, 1889, part of no. 222, as José Caesare; Richard Mansfield (according to Lichtenauer); Joseph M. Lichtenauer, New York.

Gift of Joseph M. Lichtenauer, 1890
90.20.2

The attribution to Roncalli was made by Philip Pouncey in 1958.

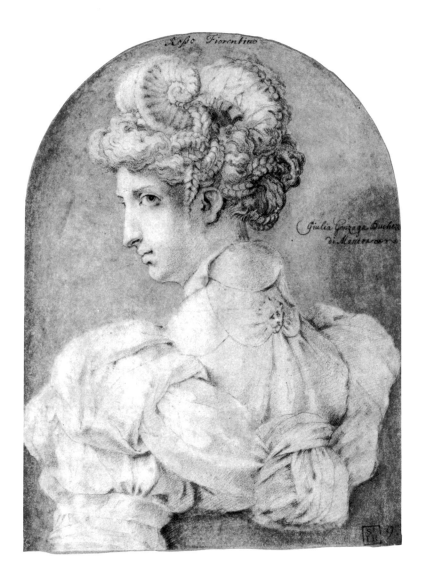

ROSSO FIORENTINO

Florence 1495 – Fontainebleau 1540

226. *Bust of a Woman with an Elaborate Coiffure*

Rogers Fund, 1952
52.124.2

Black chalk, certain contours reinforced in pen and brown ink, background tinted in brown wash. 23.6 x 17.7 cm. Arched top. Scattered stains.

Inscribed in pen and brown ink at upper margin, *Rosso Fiorentino;* at upper right, *Giulia Gonzaga Duchezz*[a] / *di Mantoa;* numbered at lower right corner, *93.* Inscribed in pen and brown ink on verso, *Rosso Fiorentino / e collectione J. Talman.*

PROVENANCE: John Talman (the drawing is on a Talman mount); Sir Joshua Reynolds (Lugt 2364); John Fitchett Marsh (Lugt 1455); purchased in London in 1952.

BIBLIOGRAPHY: Bean and Stampfle, 1965, no. 77, repr.; E. A. Carroll, *The Drawings of Rosso Fiorentino,* New York and London, 1976, I, 1, pp. 172-176, II, pp. 271-276, D.25, fig. 81, repr. with Talman mount.

Hugh Macandrew kindly informed us that the long and fanciful inscription on the mount is in the hand of the English collector John Talman (died 1726). It reads: "da Rosso Fiorentino / Julia Gonzaga / Barbarossa the famous Turkish Pirate attempted to surprize this famous Beauty in order to make a Present of Her / to Solyman y.ᵉ Emperour: and for that purpose landed by night 2000 Souldiers near Fundi where she then was; but at y.ᵉ / first alarm she mounting a Horse without any clothes but her smock made her Escape; at w.ᶜʰ y.ᵉ Barbarian was / so inraged that he burnt the Town; This Lady was the Widdow of Vespasian Colonna. Thuanus speaks much in her Praise. / Dictionaire de Moreri."

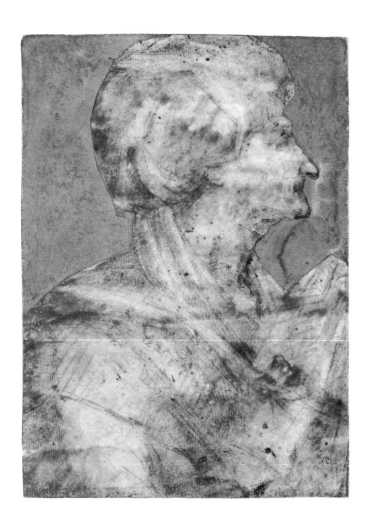

ROSSO FIORENTINO ?

227. *Bust of an Old Woman in Profile to Right*

Black chalk, heightened with white, on beige paper. Figure roughly silhouetted and background tinted in opaque gray wash. 20.0 x 14.3 cm. Surface abraded; a number of brown and gray stains. Lined.

Inscribed in pen and brown ink at lower margin of old mount in Richardson's hand, *Fra: Bartolomeo di S. Marco.*

PROVENANCE: Jonathan Richardson, Sr. (Lugt 2184, 2984, 2995); sale, London, Christie's, February 17, 1959, part of no. 71, as Fra Bartolomeo ?; purchased in New York in 1962.

BIBLIOGRAPHY: G. Smith, *Pantheon,* XXXIV, 1, 1976, pp. 26, 28, fig. 4, p. 29, note 11, the painting in S. Lorenzo repr. p. 25.

Rogers Fund, 1962
62.190

Jonathan Richardson attributed the drawing to Fra Bartolomeo. It was Philip Pouncey who in 1959 first noted the correspondence of this head with that of the old woman kneeling at the lower left in Rosso's *Marriage of the Virgin* in S. Lorenzo, Florence. Graham Smith published the drawing as a study by Rosso himself, but the sheet is so damaged and reworked as to make a definitive pronouncement difficult. It may be an old copy. Eugene A. Carroll, in a letter of August 30, 1981, rejected the possibility of Rosso's authorship.

GIOVANNI BATTISTA DELLA ROVERE

Milan ca. 1561 – Milan 1630 ?

228. *The Massacre of the Innocents*

Pen and brown ink, brown wash, over traces of black chalk. Sketch for the decoration of a spandrel in pen and brown ink over red chalk on verso. 39.9 x 55.4 cm. Vertical crease at center.

Inscribed in pen and brown ink in the artist's hand on verso, *J.B.R. mediolani / 1590 / Adi 10 Agosto / varalo;* a further but illegible inscription in the artist's hand (?) at upper right of verso.

PROVENANCE: Purchased in New York in 1963.

Rogers Fund, 1963
63.149

This is a design for the left wall and many of the figures in the left section of the *Massacre of the Innocents,* the religious tableau that occupies the eleventh chapel at the Sacro Monte above Varallo (repr. P. Galloni, *Sacro Monte di Varallo,* Varallo, 1914, p. 237). The central section of the scene, with the enthroned figure of Herod, is studied in a large drawing in the Louvre (Inv. 11280, identified as the work of G. B. della Rovere by Philip Pouncey), while the right section is planned in an equally large drawing in the British Museum (Sloane 5214-248, with the monogram *J.B.R.,* the date *1590,* and *varalo* inscribed on verso). These three drawings, with their crowds of agitated figures, make it clear that G. B. della Rovere designed both the pictorial and sculptural elements of this chapel, which contains more than ninety-five freestanding figures. These were executed by the sculptors Giacomo Paracca, Michele Prestinari, and Michelangelo Rossetti. Rossetti signed and dated one of his figures 1590, which is the date that appears on the reverse of both our drawing and that in the British Museum. Thus the attribution of the design of the chapel to G. B. della Rovere's younger brother, Giovanni Mauro, proposed by Paolo Arrigoni in Thieme-Becker (*Allgemeines Lexikon der bildenden Künstler,* XXIX, Leipzig, 1935, p. 125) is implausible, since Mauro was only in his fifteenth year in 1590.

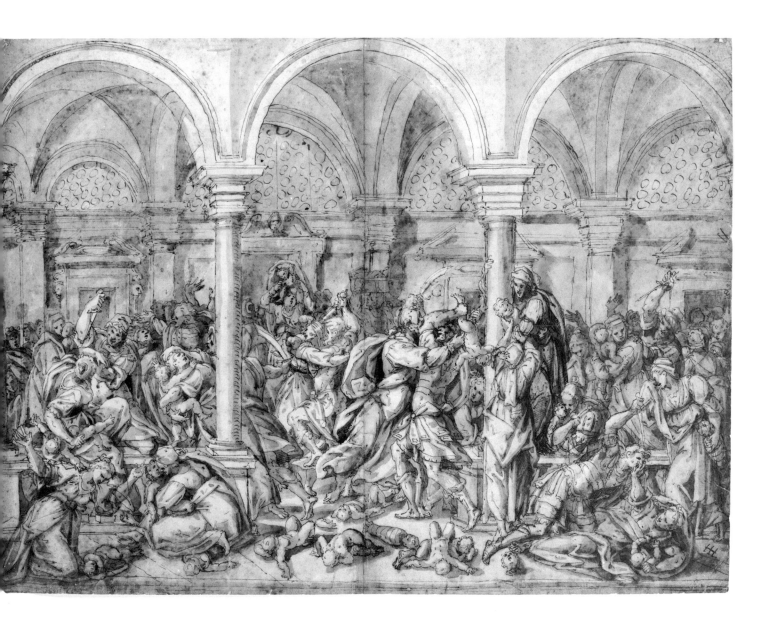

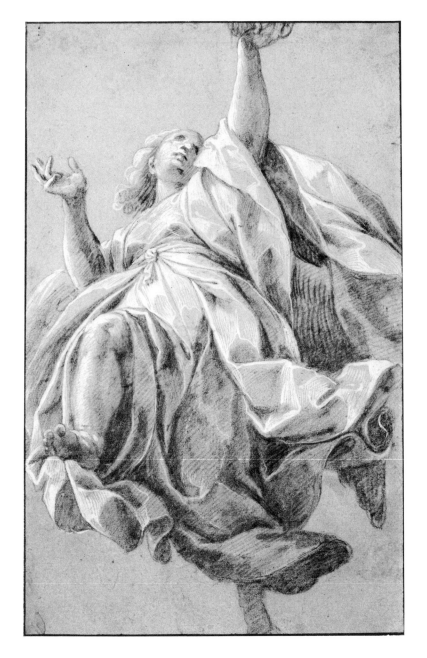

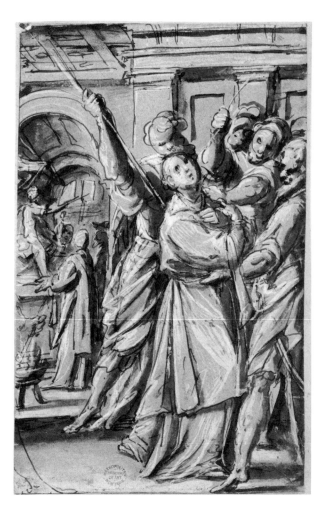

GIOVANNI MAURO DELLA ROVERE

Milan 1575 – Milan 1640

229. *Flying Angel with Arms Upraised*

Black chalk, gray wash, heightened with white, on blue paper. Framing lines in pen and dark brown ink. 35.4 x 22.3 cm. Scattered brown stains.

PROVENANCE: Sale, London, Christie's, December 11, 1979, no. 55, repr., purchased by the Metropolitan Museum.

Harry G. Sperling Fund, 1980
1980.20.2

In 1979 Nancy Ward Neilson identified this drawing as a study by Giovanni Mauro della Rovere for an angel that hovers to the right of the frame of the circular window which pierces the inner façade of the church of the Abbazia di Chiaravalle, Milan. The Della Rovere brothers (I Fiammenghini) painted on this inner wall in 1614 a frescoed representation of the foundation of the abbey. Painted angels flank and seem to support the window above this scene (repr. *Bollettino d'arte,* IV, 1910, p. 381). In our drawing the way in which the heavy drapery is modeled in gray wash with white highlights on blue paper is characteristic of Mauro as a draughtsman, as distinguished from his brother Giovanni Battista.

230. *A Deacon Led to Martyrdom*

Pen and brown ink, blue wash, heightened with white, on blue paper. 22.6 x 14.1 cm. Lined.

PROVENANCE: James Jackson Jarves; Cornelius Vanderbilt.

BIBLIOGRAPHY: *Metropolitan Museum Hand-book,* 1895, no. 470, artist unknown.

Gift of Cornelius Vanderbilt, 1880
80.3.470

Formerly classified as anonymous Italian, the drawing was recognized in 1958 by Philip Pouncey as a typical example of the work of Giovanni Mauro.

231. *The Virgin and Child, St. Dominic, and Angels Distributing Chaplets to the Faithful*

Pen and brown ink, pale brown wash, heightened with white, over traces of black chalk, on blue paper. 22.5 x 37.8 cm.

Inscribed in pen and brown ink in the artist's hand on verso, *adi 19 7tebre 1618.*; in another hand, *Venetian / Tiberio Tinelli;* in pencil, *From Mr. Roscoe's collection. 1815. / Hanwell 1835.*

PROVENANCE: Jan Pietersz. Zoomer (Lugt 1511); William Roscoe, Liverpool; Roscoe sale, Liverpool, Winstanley, September 23-28, 1816, no. 293, as Tiberio Tinelli; Hanwell (according to inscription on verso); purchased in London in 1962.

Rogers Fund, 1962
62.119.4

Chaplets are distributed to a crowd of votaries: on the left a group of men of distinction with a Pope and an emperor in front rank, at the right a group of kneeling gentlewomen with a lady wearing a crown in first place. The fact that the male spectator at lower right is seated on the lintel of a door or window suggests that the drawing may be a scheme for a wall decoration.

The nineteenth-century (?) attribution to the Venetian Tiberio Tinelli can be excluded. Stylistically, the drawing is typical of Giovanni Mauro, and the date on the verso is inscribed in what appears his own hand — see, for example, a monogrammed and dated drawing of 1613 by the artist in the Witt Collection, Courtauld Institute, London (Inv. 446; Courtauld photograph 108/45/6A).

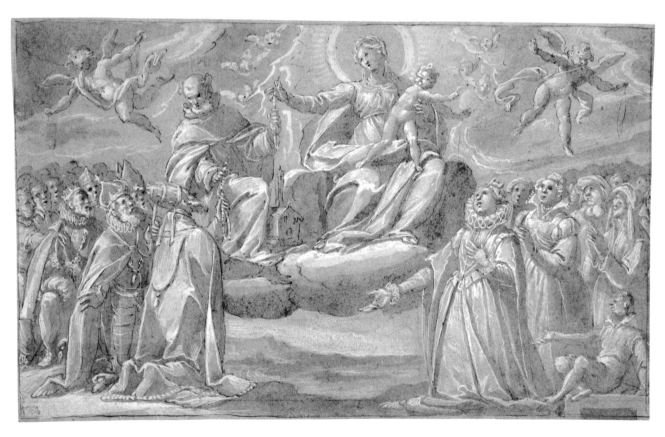

GIOVANNI MAURO DELLA ROVERE

232. *Design for a Decorative Panel: Five Winged Putti with a Church, a Torch, Lilies, a Star, and a Dog*

Pen and brown ink, brown wash, heightened with white, over traces of black chalk, on beige paper. 38.7 x 6.8 cm. Lined.

Inscribed in pen and brown ink on reverse of old mount, *Polidoro da Caravaggio.*

PROVENANCE: Janos Scholz, New York; purchased in New York in 1950; transferred from the Department of Prints, 1981.

The Elisha Whittelsey Collection
The Elisha Whittelsey Fund, 1950
50.605.22

The attribution of this drawing and No. 233 below to Giovanni Mauro della Rovere was made by Philip Pouncey in 1965.

233. *Design for a Decorative Panel: Four Winged Putti with a Cleaver, Books, a Platter, Palm Branches, and a Sword*

Pen and brown ink, brown wash, heightened with white, over traces of black chalk, on beige paper. 38.7 x 6.9 cm. Scattered losses. Lined.

Inscribed in pen and brown ink on reverse of old mount, *Polidoro da Caravaggio.*

PROVENANCE: Janos Scholz, New York; purchased in New York in 1950; transferred from the Department of Prints, 1981.

The Elisha Whittelsey Collection
The Elisha Whittelsey Fund, 1950
50.605.23

See No. 232 above.

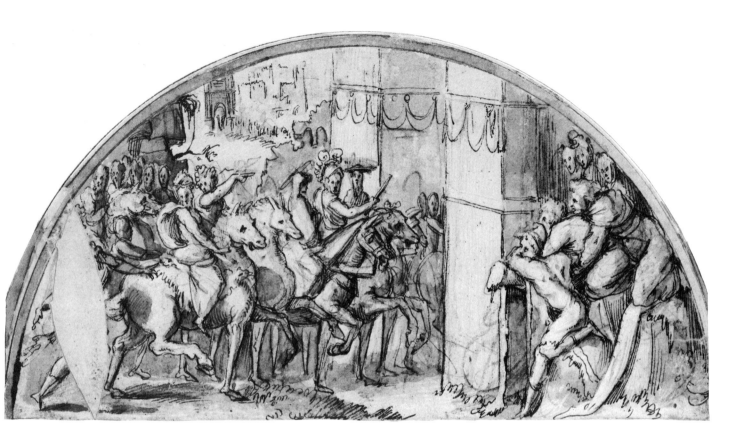

FRANCESCO SALVIATI
(Francesco de' Rossi)

Florence 1510 – Rome 1563

234. *Triumphal Entry into a City*

Pen and brown ink, brown wash, heightened with white, over black chalk, on beige paper. 10.6 x 20.2 cm. Cut to the shape of a lunette. Portion of original sheet missing at left. Lined.

Inscribed in pen and brown ink on reverse of old mount, *Salviati -;* and in Esdaile's hand, *1820. WE – B West's sale P93 – N100.*

PROVENANCE: John Thane (Lugt 1544); Benjamin West (according to Esdaile's inscription); West sale, London, Christie's, June 9-13, 1820, part of no. 62; William Esdaile (Lugt 2617); Esdaile sale, London, Christie's, June 18-23, 1840, probably part of no. 125; sale, London, Sotheby's, July 6, 1967, no. 19; purchased in London in 1968.

Rogers Fund, 1968
68.54.2

The attribution is traditional and correct. A companion drawing in the same lunette shape, representing a procession passing before what appears to be the Castel Sant'Angelo, was sold at Sotheby's in London (no. 18, repr.) on the same day as the present drawing; this latter drawing is now in the P. and N. de Boer Collection, Amsterdam.

ORAZIO SAMACCHINI

Bologna 1532 – Bologna 1577

235. *Study for the Decoration of a Vault*

Pen and brown ink, brown wash, heightened with white, over black chalk, on blue-green paper. 39.1 x 25.5 cm. Losses at upper right; a number of brown stains. Lined.

Inscribed in pen and brown ink at lower left, *Cherubino Alberti.*

PROVENANCE: Thomas Hudson (Lugt 2432); Sir Thomas Lawrence (Lugt 2445); sale, London, Sotheby's, March 23, 1971, no. 56, purchased by the Metropolitan Museum.

BIBLIOGRAPHY: Bean, 1972, no. 50; C. Johnston in Ottawa, 1982, no. 14, repr.

Rogers Fund, 1971
1971.66.6

In 1970 Philip Pouncey identified this drawing as Samacchini's study for part of the decoration of the vault of the north transept of the Cathedral in Parma, commissioned from the artist in 1570 (see L. Testi, *La cattedrale di Parma,* Bergamo, 1934, pp. 109-110, repr.). The seated prophet and sibyl, inspired by figures in Michelangelo's Sistine ceiling, also occur in a pair of rather dry drawings attributed to Samacchini at Windsor

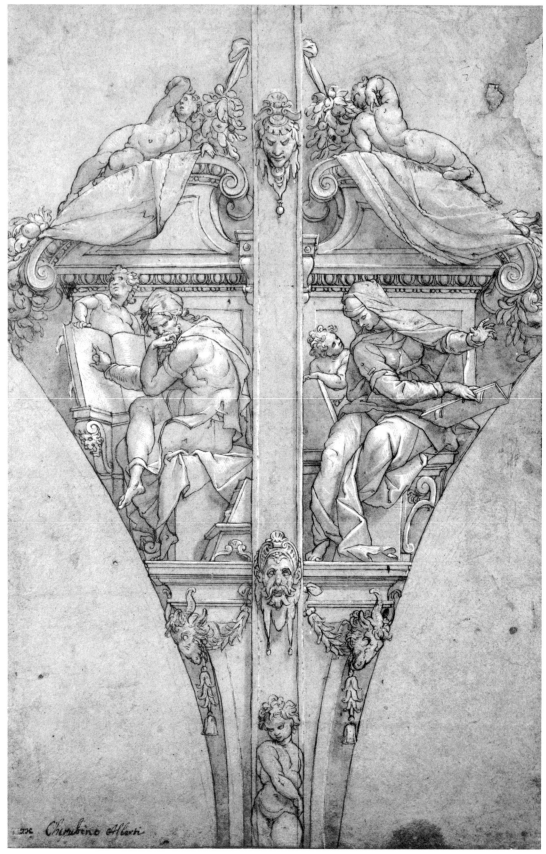

Cherubino Alberti

Castle. Some years ago A. E. Popham associated the drawings at Windsor with the Parma vault decorations (Popham and Wilde, 1949, nos. 907-908, as Samacchini).

ANDREA SCHIAVONE

Zara before 1501 ? – Venice 1563

236. *Cupid Presenting Psyche to the Gods*

Pen and brown ink, brown wash, heightened with white, over traces of black chalk, on brown-washed paper. 37.4 x 60.3 cm. Vertical crease at center; a number of repaired tears. Lined.

Inscribed in pencil on reverse of old mount, *Venus and Mercury summoned before Jupiter and Juno / (Assembly of the Gods) / Parmeggiano.*

PROVENANCE: C. R. Rudolf (Lugt Supp. 2811b); Rudolf sale, London, Sotheby's, May 21, 1963, no. 11, repr., purchased by the Metropolitan Museum.

BIBLIOGRAPHY: Rudolf Collection, 1962, no. 62, pl. 3; Bean and Stampfle, 1965, no. 116, repr.; A. Ballarin, *Arte veneta,* XXI, 1967, p. 89, fig. 103, p. 90; F. L. Richardson, *Master Drawings,* XIV, 1, 1976, pp. 35-36, fig. 5; F. L. Richardson, *Andrea Schiavone,* Oxford, 1980, pp. 39, 129, no. 185, fig. 116; Rearick, 1980, no. 5, repr.

Rogers Fund, 1963
63.93

The composition of this large pictorial drawing derives from and reverses Raphael's fresco of the same subject in the Farnesina, while the graceful, elongated physical types show the influence of Parmigianino. However, Schiavone's originality is apparent in the masterful play of broad accents of light and shade over the surface of the friezelike group.

Francis L. Richardson has suggested that the drawing is a *modello* for one of the now-lost scenes of the story of Psyche painted, according to Carlo Ridolfi, for the ceiling of a room in the Castello di S. Salvatore near Susegana (Conegliano). The format, a rectangle with rounded ends, would be appropriate for a ceiling panel.

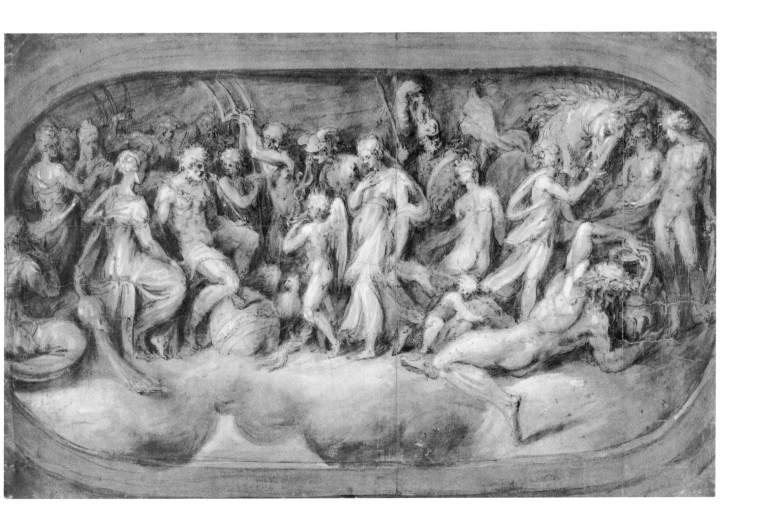

SEBASTIANO DEL PIOMBO
(Sebastiano Luciani)

Venice 1485 – Rome 1547

237. *The Christ Child and St. John the Baptist*

Black and some white chalk, on blue paper. 8.6 x 11.5 cm. Creases in the face of the Baptist and to the left of the orb where the chalk has not registered. Lined.

Inscribed in pencil on reverse of old mount, *Baldassar Peruzzi.* and *Peruzzi 93a / #57.*

PROVENANCE: Jonathan Richardson, Sr. (Lugt 2184); purchased in London in 1975.

BIBLIOGRAPHY: Bean, 1975, no. 30, repr.; M. Hirst, *Sebastiano del Piombo,* Oxford, 1981, p. 138, pl. 177.

Harry G. Sperling Fund, 1975
1975.89

The infant Savior resting on the sphere of the world is engaged in mystic dialogue with the Baptist holding a small cross, who stands behind at a lower level. Two solutions are supplied for the placement of the Christ Child's left hand resting on the globe. A similar group, with the infant Christ seated by a sphere and watched over by an old man is studied twice in a much larger sheet of black chalk studies by Sebastiano at Windsor

Castle (Popham and Wilde, 1949, no. 923, recto pl. 80; M. Hirst, *op. cit.,* p. 138, pl. 175).

Michael Hirst, who dates this drawing in Sebastiano's last years, suggests that the theme of the naked Christ Child with the globe may well have been inspired by the example of Parmigianino's *Madonna della rosa,* now in Dresden (Freedberg, 1950, pl. 73; Rossi, 1980, no. 43, repr.).

ERCOLE SETTI

Modena 1530 – Modena 1617

238. *Vendor of Horoscopes*

Pen and brown ink, over a little black chalk. 27.9 x 42.2 cm.

Numbered in pen and brown ink at upper left, *3;* inscribed in pen and brown ink at upper center, *labek* [?].

PROVENANCE: Private collection, Turin; sale, London, Sotheby's, March 26, 1976, no. 53, repr.; purchased in New York in 1977.

BIBLIOGRAPHY: F. Zava Boccazzi, *Master Drawings,* VI, 4, 1968, pp. 355-363, pl. 4.

Purchase, David L. Klein, Jr., Memorial Foundation Inc. Gift, 1977
1977.3

237

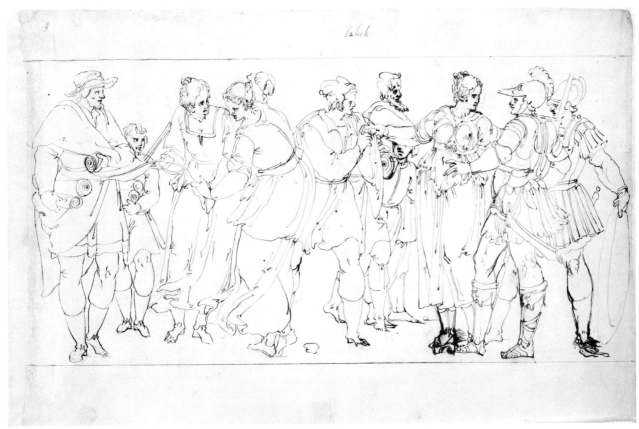

238

The drawing comes from an album of scenes of popular life and of the marketplace, said to have originally contained 125 pages. The sheets have been widely dispersed since the album was broken up after its partial publication (only nine of the sheets, including the present drawing, were reproduced) by Franca Zava Boccazzi in 1968.

239. *Jesus Disputing with the Doctors in the Temple* (Luke 2:46-47)

Pen and brown ink, over a little black chalk. 19.1 x 14.2 cm. Upper corners and lower left corner missing.

Inscribed in pencil on verso, *F. Zucoro,* and *F. Zucarri 15R;* numbered in pen and brown ink on verso, *14.*

PROVENANCE: Harry G. Friedman, New York.

Gift of Harry G. Friedman, 1960
60.66.17

The drawing entered the collection in 1960 as the work of an anonymous Italian artist of the sixteenth century; it

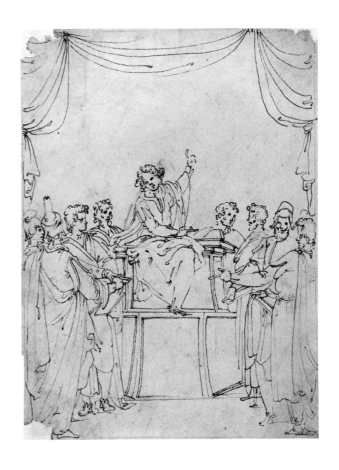

was in 1981 that Calvin Brown recognized here the very idiosyncratic hand of Ercole Setti. The abbreviated fashion in which heads, hands, feet, and drapery are indicated, even the liberty cap worn by the figure on the extreme left, are typical of this minor Emilian master. Setti's style was neatly characterized by Walter Vitzthum in a 1955 contribution to the *Burlington Magazine* (XCVII, 1955, pp. 252-254).

ULISSE SEVERINO DA CINGOLI

Cingoli 1536/1542 ? – Cingoli 1597/1600

240. *Coastal Landscape*

Pen and brown ink. 20.7 x 24.7 cm. Lined.

PROVENANCE: James Jackson Jarves; Cornelius Vanderbilt.

BIBLIOGRAPHY: *Metropolitan Museum Hand-book,* 1895, no. 385, as Domenico Campagnola; J. Bolten, *Master Drawings,* VII, 2, 1969, p. 142, no. 109.

Gift of Cornelius Vanderbilt, 1880
80.3.385

The attribution is due to J. Bolten, who attributes 154 drawings to this curious amateur artist in his study "Messer Ulisse Severino da Cingoli, a Bypath in the History of Art," which appeared in *Master Drawings* in 1969.

GIROLAMO SICIOLANTE DA SERMONETA ?

Sermoneta 1521 – Rome ca. 1580

241. *The Holy Family with the Infant Baptist*

Pen and brown ink, brown wash, heightened with white, on blue paper. 14.4 x 10.6 cm. Lined.

Inscribed in pencil on reverse of mount, *Angeli.*

PROVENANCE: Count Lanfranco di Campello, Rome; A. Branson, London (according to vendor); purchased in London in 1965.

Rogers Fund, 1965
65.66.1

A tentative attribution to Siciolante has been suggested by Bernice Davidson, who points out that it resembles certain of the master's drawings of the 1540s.

LAZZARO TAVARONE

Genoa 1556 – Genoa 1641

242. *Christ Crucified, Attended by the Virgin, St. Mary Magdalene, and St. John the Evangelist*

Pen and brown ink, pale brown wash, over black chalk, on gray-green paper. Squared in black chalk. 21.0 x 15.9 cm.

240

2-

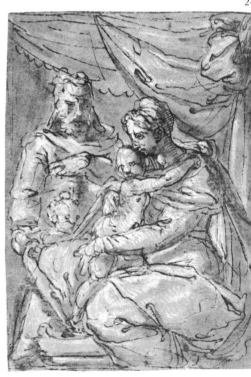

LAZZARO TAVARONE

Inscribed in pen and brown ink at lower right, *Soldij f.;* and in another hand, *Roma.*

PROVENANCE: Purchased in London in 1973.

Purchase, David L. Klein, Jr., Memorial Foundation Inc. Gift, 1973
1973.345

This drawing appeared on the London art market with the perfectly plausible attribution to Tavarone. Similar inscriptions occur on other drawings by Tavarone – for example, a scene of ancient history reproduced by Mary Newcome in *Antologia di belle arti* (8, 1978, fig. 14).

243. *Allegorical Female Figure Holding a Branch and a Dish*

Pen and brown ink, pale brown wash, heightened with white, over black chalk, on blue paper. Faintly squared in black chalk. 12.2 x 9.1 cm.

Inscribed in pen and brown ink at lower left, [P]*omerance;* and on verso, *Pomerance.*

PROVENANCE: Unidentified collector's mark at upper right corner of recto; Mrs. John H. Wright.

Gift of Mrs. John H. Wright, 1949
49.150.4

Though the sheet bears an old attribution to Pomarancio, Lawrence Turčić pointed out in 1977 that the drawing is almost *en suite* in subject, style, technique, and dimensions with a drawing of a seated allegorical female figure holding a bird in the Art Institute of Chicago (Leonora Hall Gurley Memorial Collection, 1922.1001; see H. Joachim, *The Art Institute of Chicago. Italian Drawings of the 15th, 16th, and 17th Centuries,* compiled by S. Folds McCullagh and S. Haller Olsen, Chicago and London, 1979, no. 5E7, repr. on microfiche). The Chicago drawing bears an old and convincing attribution to Tavarone.

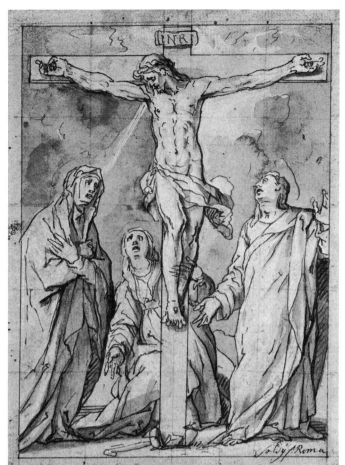

242

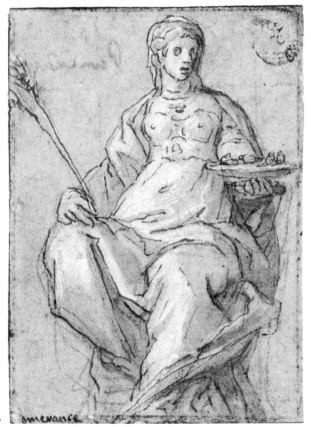

243

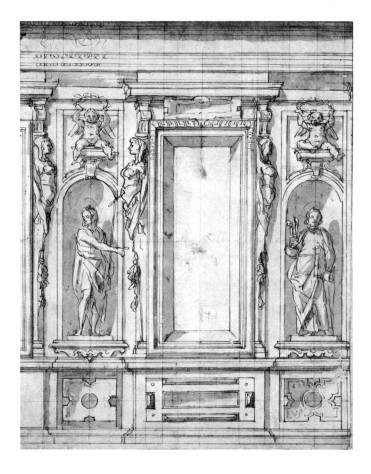

LAZZARO TAVARONE

244. *Window Frame Flanked by Niches with Figures of St. John the Baptist and St. Peter*

Pen and brown ink, brown wash, over black chalk. Squared in black chalk. 26.9 x 21.4 cm. Brown stains at center. Lined.

PROVENANCE: Janos Scholz, New York; purchased in New York in 1952; transferred from the Department of Prints, 1982.

BIBLIOGRAPHY: M. Newcome, *Paragone,* 375, 1981, p. 51, note 20.

The Elisha Whittelsey Collection
The Elisha Whittelsey Fund, 1952
52.570.124

The attribution to Tavarone is due to Mary Newcome.

ANTONIO TEMPESTA

Florence 1555 – Rome 1630

245. *The Virgin Immaculate Crowned by Two Angels, with Angel Musicians in the Foreground*

Pen and brown ink, brown wash, over black chalk. 22.6 x 17.3 cm. Repaired loss at center of lower margin; lower left corner missing. Lined.

Numbered in pen and brown ink at upper right, *127;* inscribed in pen and brown ink at center of lower margin, *A*[the rest missing] *Tempest.*

PROVENANCE: Prof. John Isaacs (according to vendor); purchased in London in 1961.

Rogers Fund, 1961
61.130.4

In style, this drawing may be compared with a sheet in the National Gallery of Scotland, Edinburgh, that represents the Virgin Immaculate, already crowned, with the child Jesus in her arms (Andrews, 1968, II, fig. 789). The Edinburgh drawing also bears an attribution to *Antonio Tempest* in what appears to be the same hand as that on the present study.

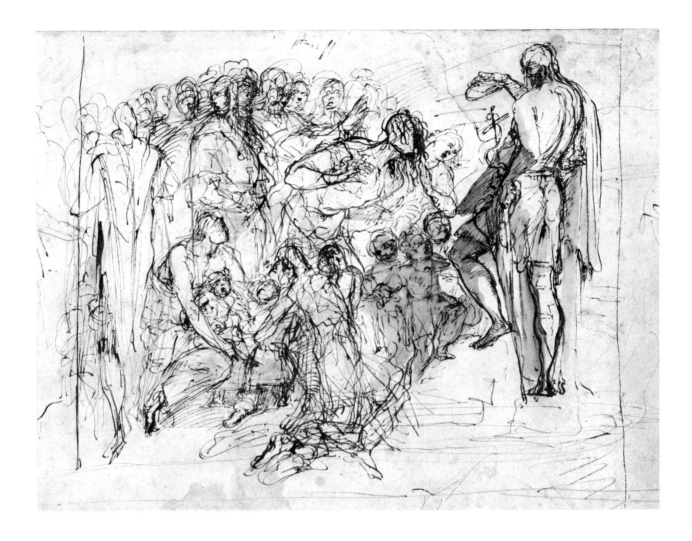

PELLEGRINO TIBALDI

Puria di Valsolda 1527 – Milan 1596

246. *St. John the Baptist Baptizing the Multitude*

Pen and brown ink, brown wash. 23.7 x 32.3 cm. Lined.

PROVENANCE: Sir Robert Witt, London; C. R. Rudolf (Lugt Supp. 2811b); Rudolf sale, London, Sotheby's, May 21, 1963, no. 12, repr.; Walter C. Baker, New York.

BIBLIOGRAPHY: Rudolf Collection, 1962, no. 65, pl. 8; J. A. Gere, *Burlington Magazine,* CIV, 1962, p. 88, fig. 40; Bean and Stampfle, 1965, no. 122, repr.; S. Zamboni in *Il tempio di S. Giacomo in Bologna,* Bologna, 1967, p. 153, the drawing fig. XLIV, the fresco figs. 185-187; C. Johnston in Ottawa, 1982, no. 9, repr.

Bequest of Walter C. Baker, 1971
1972.118.272

Study for the lower half of a fresco on the left wall of the Poggi Chapel in S. Giacomo Maggiore, Bologna, that probably dates from the early 1550s. Tibaldi's fresco on the opposite wall represents the Conception of the Baptist; there is a composition study for this scene at Windsor Castle (Popham and Wilde, 1949, no. 947, pl. 109).

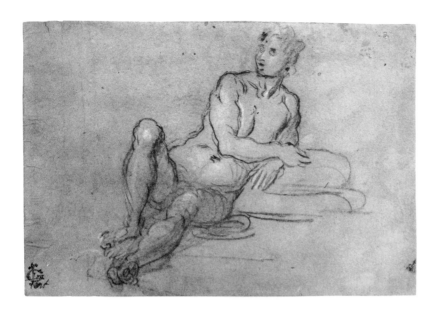

DOMENICO TINTORETTO
(Domenico Robusti)

Venice 1560 – Venice 1635

247. *Reclining Female Nude Figure*

Black chalk, heightened with white, on blue paper. 18.8 x 28.0 cm.
Scattered stains.

Inscribed in pen and brown ink at lower left, *Tint* (the inscription
partly hidden by the Grassi stamp).

PROVENANCE: Luigi Grassi (Lugt Supp. 1171b); Frits Lugt (see
Byam Shaw, 1981, p. 44, under no. 50); sale, London, Sotheby's,
May 13, 1924, part of no. 134; Robert Lehman, New York.

BIBLIOGRAPHY: Tietze, 1944, p. 267, no. 1534.

Gift of Robert Lehman, 1941
41.187.2

This drawing is one of a group of thirteen black chalk
studies on blue paper from a nude female model. This
series has been plausibly attributed to Domenico Tin-
toretto by the Tietzes.

Other drawings from this group are in the Frits Lugt
Collection, Institut Néerlandais, Paris (one); Robert
Lehman Collection, Metropolitan Museum of Art, New
York (eight; Szabo, 1979, nos. 54-61); Albertina,
Vienna (one); the present whereabouts of two of the
group is unknown (see Tietze, 1944, nos. 1510, 1535,
1553, respectively). The Tietzes described our drawing
as after a male model, but the figure is surely the same
nude female represented in the twelve other drawings.

JACOPO TINTORETTO (Jacopo Robusti)

Venice 1518 – Venice 1594

248. *Reclining Figure of Day, after Michelangelo*
VERSO. *Another Study of the Same Figure*

Black chalk, heightened with white, on blue paper. 35.0 x 50.5 cm.
Margins irregular; vertical crease at center.

PROVENANCE: Purchased in London in 1954.

BIBLIOGRAPHY: C. Virch, *Metropolitan Museum of Art Bulletin*,
December 1956, pp. 111-116, recto repr.; *Emporium*, CXXV, 3, 1957,
pp. 121-122, recto repr.; A. Forlani, *Arte veneta*, XI, 1957, p. 90, note
6, as workshop of Jacopo Tintoretto; [A. Seilern], *Italian Paintings
and Drawings at 56 Princes Gate London SW7*, London, 1959, men-
tioned pp. 48-49; P. Rossi, *I disegni di Jacopo Tintoretto*, Florence,
1975, p. 43, under no. 100, pp. 63-64 (mistakenly described as a
workshop copy of Jacopo's drawing after Michelangelo's *Evening* in
the Seilern collection); Byam Shaw, 1976, I, p. 205 under no. 762, as
Jacopo Tintoretto or studio.

Rogers Fund, 1954
54.125

Working from a small replica of Michelangelo's statue
of *Day* on the tomb of Giuliano de' Medici in the New
Sacristy, S. Lorenzo, Florence, Jacopo Tintoretto has
copied on both recto and verso the back view of the
figure. Another double-sided study of the back of the
statue, though seen from a quite different angle, is in the
Cabinet des Dessins of the Louvre (Tietze, 1944, no.
1739; C. Virch, *op. cit.*, recto repr. p. 114). At Christ
Church, Oxford, there is a double-faced study of the
figure seen from above (Byam Shaw, 1976, I, no. 762,
pls. 442, 443, as Jacopo Tintoretto or studio).

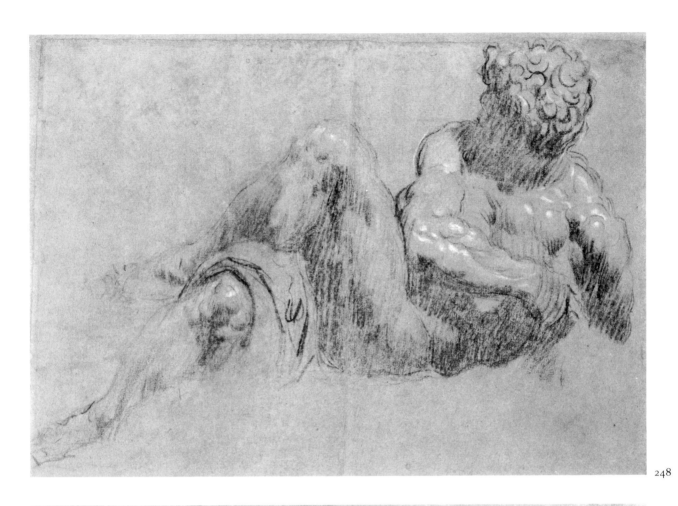

248

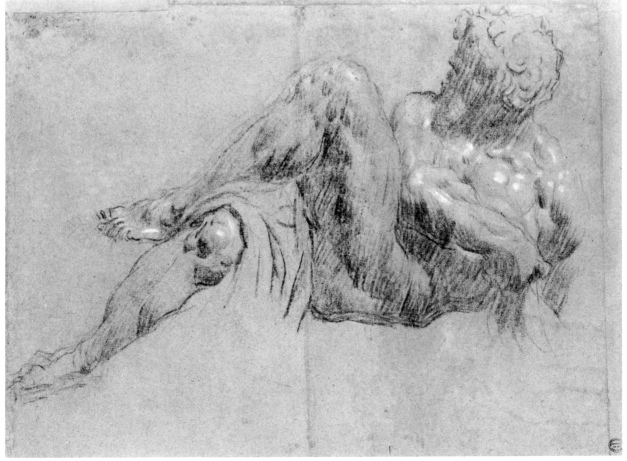

248 v.

TITIAN (Tiziano Vecellio)?

Pieve di Cadore ca. 1488/1490 – Venice 1576

249. Group of Trees

Pen and brown ink, traces of gray printer's ink at lower right, on beige paper. 21.8 x 31.9 cm.

Inscribed in pen and brown ink at lower margin, *Giorgione.*

PROVENANCE: Charles Sackville Bale (Lugt 640); Bale sale, London, Christie's, June 9, 1881, no. 2298, as Giorgione; Sir James Knowles, London; Knowles sale, London, Christie's, May 27-29, 1908, no. 181, as Titian, purchased by the Metropolitan Museum.

BIBLIOGRAPHY: Fry, 1908, p. 224, as Titian; S. Colvin, *Vasari Society,* first series, V, 1909-1910, no. 9, repr., as Titian or Domenico Campagnola (?); J. Meder, *Die Handzeichnung, ihre Technik und Entwicklung,* Vienna, 1919, p. 503, fig. 233 (detail), as Titian; D. von Hadeln, *Zeichnungen des Tizian,* Berlin, 1924, p. 39, pl. 39, by some pupil of Titian; H. Tietze and E. Tietze-Conrat, *Jahrbuch der kunsthistorischen Sammlungen in Wien,* X, 1936, pp. 167, 191, note 7, fig. 145 (related woodcut fig. 143); *Metropolitan Museum, Italian Drawings,* 1942, no. 14, repr. as Titian; Tietze, 1944, no. 1943, pl. LXIII, 2; *Metropolitan Museum, European Drawings,* 1944, no. N.S.4, repr., as Titian; H. Tietze, *Titian, the Paintings and Drawings,* London, 1950, p. 404, pl. 47, as Titian; Bean, 1964, no. 15, repr., as Titian; Bean and Stampfle, 1965, no. 58, repr., as Titian; K. Oberhuber, *Disegni di Tiziano e della sua cerchia,* exhibition catalogue, Fondazione Giorgio Cini, Venice, 1976, no. 23, repr., as Titian; Meijer, Florence, 1976, p. 4, fig. 1b, as Titian (not exhibited); Meijer, Paris, 1976, p. 4, pl.

29, as Titian (not exhibited); D. Rosand and M. Muraro, *Titian and the Venetian Woodcut,* Washington, D.C., 1976, p. 58, fig. I-8, p. 59, as Titian; W. R. Rearick, *Maestri veneti del Cinquecento,* Florence, 1977, no. 8, repr., as Titian; Pignatti, 1979, no. XV, repr., as Titian; P. Dreyer, *Pantheon,* XXXVII, 4, 1979, pp. 365-375, figs. 7, 9 (recto), 10 (verso), as the work of a forger; J. Byam Shaw, *Apollo,* CXII, 1980, pp. 388-389, as Domenico Campagnola ?; D. Rosand, *Master Drawings,* XIX, 3, 1981, pp. 300-308, fig. 2.

Rogers Fund, 1908
08.227.38

The old inscription on the sheet testifies to a traditional attribution to Giorgione, and the drawing figured as such in the C. S. Bale sale of 1881. By the time of the Knowles sale in 1908, it had acquired the ascription to Titian that up until the last few years has met with almost unanimous critical approval. In 1919 Joseph Meder suggested a connection with Titian's woodcuts, and the Tietzes in 1936 pointed out that each half of the drawing is utilized in a different part of the landscape background in the early woodcut the *Sacrifice of Abraham.* The trees in the left half of our drawing appear in reverse at the upper center of the print, while the trees and the stump in the right half of the drawing appear in reverse

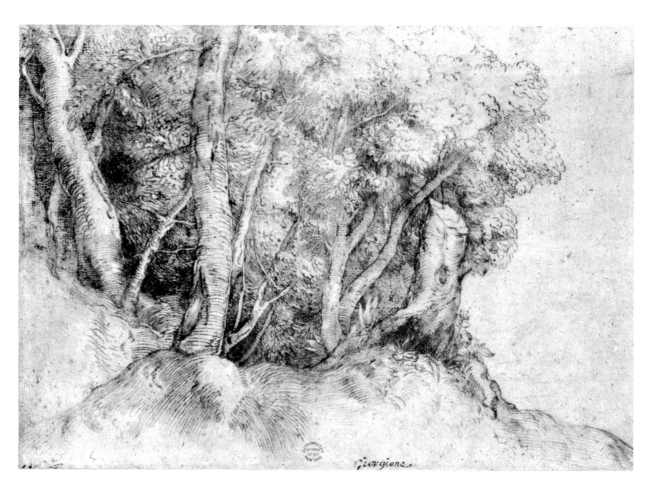

near the lower right margin of the woodcut. The pen lines of the drawing are somewhat blurred, which suggests that two ink counterproofs were pulled from the sheet in order to transfer and thus reverse the design. The vertical division at center of the sheet would indicate the margins of the two counterproof pulls.

A few years ago Peter Dreyer set up something of a stir by contending that our drawing is a forgery deriving from and not preparatory for the woodcut. According to him, the forger was a contemporary of the young Titian who drew over pale counterproof impressions in printer's ink deriving from the original blocks, and his intention was to produce a "fake." Dreyer also singled out drawings in Edinburgh, Frankfurt, and the Louvre in Paris as the work of this "forger." However, these latter drawings appear to us to be by a much inferior hand, and not connectible with the Metropolitan's *Group of Trees.*

There are indeed faint lines in printer's ink at the lower right, just visible to the naked eye. Furthermore, careful microscopic examination reveals traces of gray-black printer's ink under the lines in water soluble brown ink (bistre ?) that constitute this design. Though the presence of traces of printer's ink on the sheet is difficult to account for, it does not seem sufficient to justify a charge of intentional forgery.

As James Byam Shaw has recently suggested, the underlying counterproof from the blocks may have been made with some "perfectly innocent purpose, connected with the production of the prints, which now escapes our understanding." Byam Shaw tentatively suggested Domenico Campagnola as an alternative author, a possibility that had not been excluded by Sidney Colvin in the 1909-1910 Vasari Society publication. Colvin's comments on the Metropolitan drawing made then still seem valid: "Great obscurity surrounds the whole question of Titian's drawings but this seems as likely as any example extant to be a genuine work of his earlier years." In any case the drawing was executed by a draughtsman of consummate energy and authority.

250. *Winged Putto Holding the Base of a Cross*

Red chalk on blue paper. 14.8 x 17.8 cm. Spot of yellow pigment on the putto's forehead.

Inscribed in pen and brown ink on verso, *Tiziano.*

PROVENANCE: Sir Peter Lely (Lugt 2092); Sir Joshua Reynolds (Lugt 2364); William Mayor (Lugt 2799); Miss Lucy and Miss Louisa Cohen, London; purchased in London in 1911.

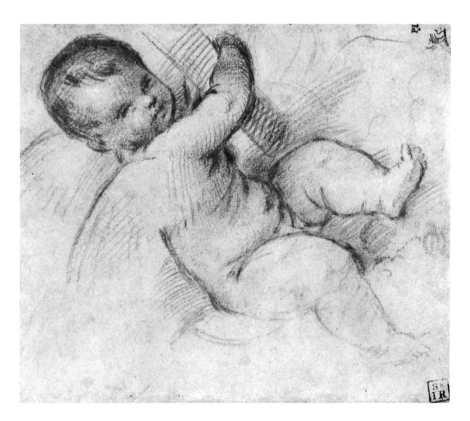

BIBLIOGRAPHY: *Exhibition of Venetian Art. The New Gallery*, London, 1894-1895, no. 334, as Giorgione; D. von Hadeln, *Art in America*, XV, 3, 1927, pp. 127-128, repr. p. 129, as Titian; Venturi, IX, 3, pp. 245-246, fig. 121, as Titian; H. Tietze and E. Tietze-Conrat, *Jahrbuch der kunsthistorischen Sammlungen in Wien*, X, 1936, pp. 185-186, fig. 162, not by Titian, closer to Romanino; A. L. Mayer, *Gazette des Beaux-Arts*, LXXIX, 1937, p. 311, as Titian ?; *Metropolitan Museum, Italian Drawings*, 1942, no. 15, repr., as Titian ?; *Metropolitan Museum, European Drawings*, 1944, no. N.S.5, repr., as Titian ?; Tietze, 1944, no. A 1944, not Titian; *Metropolitan Museum of Art Bulletin*, November 1946, repr. p. 94, as Titian; Meijer, Florence, 1976, p. 10, under no. 4, fig. 4b, as Titian (not exhibited); Meijer, Paris, 1976, p. 10, under no. 4, pl. 27, as Titian (not exhibited); Pignatti, 1979, p. 6, as a copy.

Rogers Fund, 1911
11.66.13

Though the drawing had been exhibited in London in 1894-1895 with an attribution to Giorgione, it seems to have entered the Metropolitan Museum under the name of Pordenone. Detlev Baron von Hadeln was the first to publish the drawing as the work of Titian, an opinion rejected by the Tietzes though accepted with reservation by August L. Mayer. More recently, Bert W. Meijer has reaffirmed the attribution to Titian, pointing out that the putto corresponds very closely, but not exactly, with an angel reclining on a cloud and bearing a cross who appears at the upper left of a painting in the Musée du Louvre, Paris, representing the Holy Family with the Infant Baptist in a Landscape (H. E. Wethey, *The Paintings of Titian*, I, *The Religious Paintings*, London, 1969, p. 172, no. X-14, pl. 208). Both Berenson and Wethey attributed this painting to Polidoro Lanzani, possibly after a composition by Titian, but Meijer pleads that the picture may well be the work of Titian himself.

Bert W. Meijer astutely observed that the presence of the collectors' marks of Lely and Mayor in one corner of the sheet had led earlier authors to reproduce the drawing as though the sheet were vertical in format with the putto seated. The presence, however, of the Reynolds mark in another corner of the sheet indicates that at a fairly early date it was thought that the drawing should be "read" horizontally, with the putto reclining and clutching the base of a cross. It is in just this position that the putto occurs in the Louvre painting.

In the Rijksprentenkabinet in Amsterdam there is a drawing in red chalk on blue paper representing a putto holding a shield. Meijer points out the close stylistic similarity between our study and the Amsterdam drawing, which he attributes as well to Titian himself (Meijer, Florence, 1976, no. 4, fig. 4a; Meijer, Paris, 1976, no. 4, pl. 7). The drawing in Amsterdam is there tentatively attributed to Pordenone (Frerichs, 1981, no. 125, pl. 153).

IL TROMETTA (Niccolò Martinelli)
Pesaro 1540/1545 ? – Rome 1610/1615 ?

251. *The Adoration of the Shepherds*

Pen and brown ink, pale brown wash, heightened with white, on beige paper. Many contours indented. 43.1 x 28.5 cm. Lower corners replaced; water damage at upper margin.

Inscribed in pen and brown ink on banderole at upper center, GLORIA IN . . . ELSIS DEO ET.

PROVENANCE: Purchased in London in 1970.

BIBLIOGRAPHY: *Old Master Drawings and Paintings Presented by Yvonne Tan Bunzl*, exhibition catalogue, London, 1970, no. 49; Bean, 1972, no. 53; Macandrew, 1980, p. 271, under no. 459.

Rogers Fund, 1970
1970.113.7

The attribution to Trometta was made by J. A. Gere when the drawing appeared on the art market nearly seven years after the publication of his fundamental study of the drawings of Trometta, which appeared in the fourth issue of *Master Drawings* (I, 4, 1963, pp. 3-18, pls. 1-15b). Another version of this composition, with many variations and without the angels and banderole at the top, is in the Ashmolean Museum, Oxford (Parker II, no. 459, as Passignano; J. A. Gere, *op. cit.*, p. 17, no. 33, pl. 15a, identified as the work of Trometta; Macandrew, 1980, p. 271, no. 459, as Trometta).

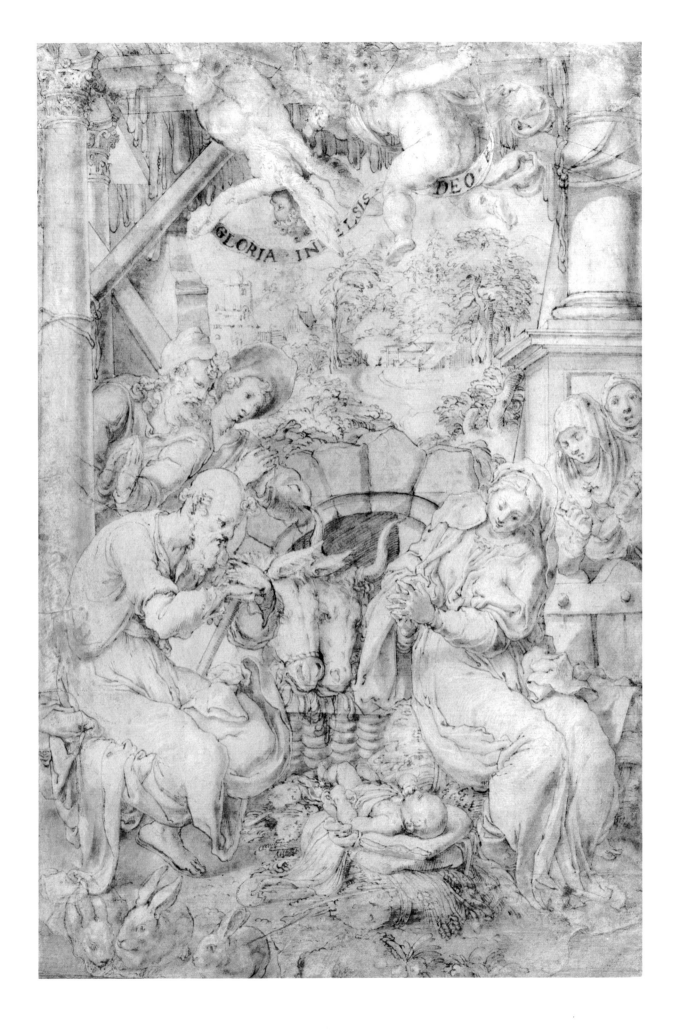

GIOVANNI BATTISTA TROTTI
(Il Malosso)

Cremona 1555 – Parma 1619

252. *The Circumcision of Jesus* (Luke 2:21)

Pen and brown ink, brown wash, heightened with white. Squared in black chalk. 23.0 x 37.7 cm. Rectangular patch (4.2 x 6.9 cm.) at upper margin, left of center. Vertical creases at center; several repaired losses; scattered stains.

Inscribed in pencil on verso, *Lor. Sabbattini;* in pen and brown ink in Esdaile's hand, *1835 WE.*

PROVENANCE: Charles I, King of England (according to Esdaile sale catalogue); John Thane (Lugt 1544); Thomas Dimsdale (Lugt 2426); William Esdaile (Lugt 2617); Esdaile sale, London, Christie's, June 18-23, 1840, part of no. 203, as L. Sabbatini, "The Presentation in the Temple; and the companion, in bistre; from Charles the First's Collection;" purchased in New York in 1968.

BIBLIOGRAPHY: *Disegni antichi. G. and A. Neerman,* exhibition catalogue, Florence, 1967, no. 15, repr.

Rogers Fund, 1968
68.2

Study for a painting in the Oratory of the Risen Christ, S. Luca, Cremona. The interior of the oratory is decorated with scenes of the life of Christ; all are the work of Malosso according to a late eighteenth-century guidebook to Cremona (Aglio, 1794, pp. 88-90). Three of the paintings, including the *Circumcision,* are treated as horizontal overdoors. The drawing differs from the finished painting in many details, most notably that in the latter the Christ Child is held by an attendant standing behind the altar while the priest, with knife in hand, circumcises the Infant.

Professor Giulio Bora, who very kindly supplied photographs of the paintings in the oratory, doubts that these scenes are the work of Malosso himself. According to Bora, they should be attributed to one or more pupils or imitators of the master, and he considers our preparatory drawing for one of the scenes to be the work of such an imitator. In addition, he calls attention to a drawing in the Uffizi (102867 F) that is a study for another horizontal composition in the oratory, *Christ Nailed to the Cross;* for Bora, the Uffizi drawing is not by Malosso, nor by the same pupil who executed our drawing.

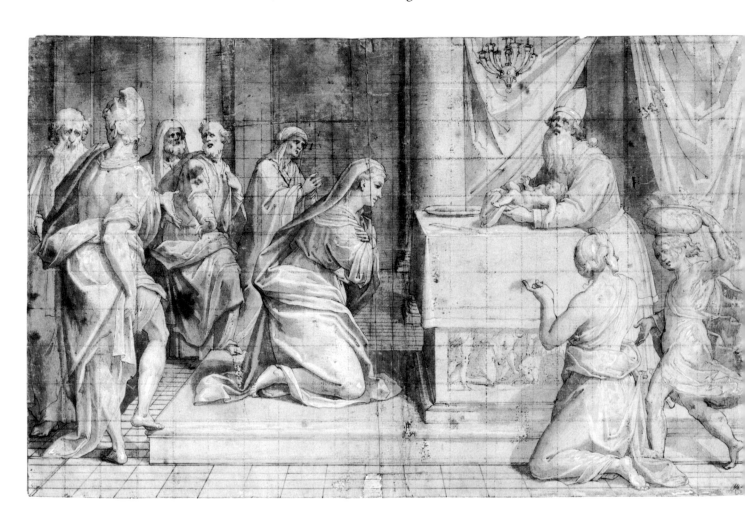

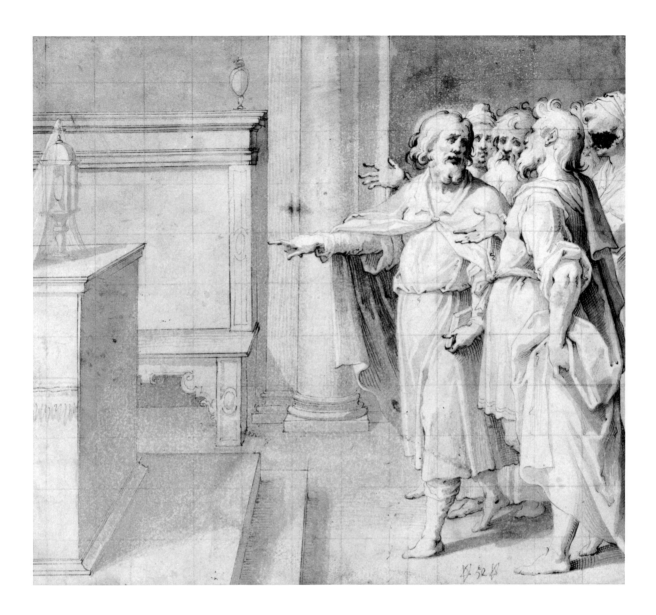

253. *A Male Saint Followed by a Group of Men, Pointing to a Monstrance on an Altar*

Pen and brown ink, gray wash. Squared in red chalk. 24.8 x 28.0 cm. Several brown stains.

Inscribed in pen and brown ink on verso, *Malosso*.

PROVENANCE: Comte de Caylus ? (two Caylus stars, Lugt 2919, flanking the number, *52*, in pen and brown ink at lower right); C. R. Rudolf (Lugt Supp. 2811b); Eric M. Wunsch, New York.

BIBLIOGRAPHY: Rudolf collection, 1962, no. 35; Bean, 1972, no. 54.

Gift of Eric M. Wunsch, 1970
1970.244.2

The old attribution is certainly correct. On the occasion of the 1962 exhibition of this drawing, then in the collection of C. R. Rudolf, it was suggested in the catalogue that the saint, evidently a layman, is possibly Homobonus, who was a Cremonese merchant and one of the patron saints of Cremona. The cataloguer further pointed out that a picture by Trotti, now lost, represented St. Homobonus "kneeling in front of the Holy Sacrament . . . with his arms outstretched, speaking to several people who gaze at him in wonder" (Aglio, 1794, p. 69).

254. *St. Cecilia, St. Mary Magdalene, St. Catherine of Alexandria, and Another Female Saint, Angels with Palm Branches and Crowns Above*

Pen and brown ink, over black chalk. Partially squared in black chalk. Slight figure sketches and sums in pen and brown ink on verso. 38.3 x.26.7 cm. Lower right corner replaced; several repaired tears and losses; scattered stains.

Inscribed in black chalk at lower right, *Taddeo,* and in pen and brown ink, *Zuccaro.*

PROVENANCE: Cephas G. Thompson.

BIBLIOGRAPHY: *Metropolitan Museum Hand-book,* 1895, no. 770, as Taddeo Zuccaro.

Gift of Cephas G. Thompson, 1887
87.12.100

The drawing was attributed to Malosso by Philip Pouncey in 1958.

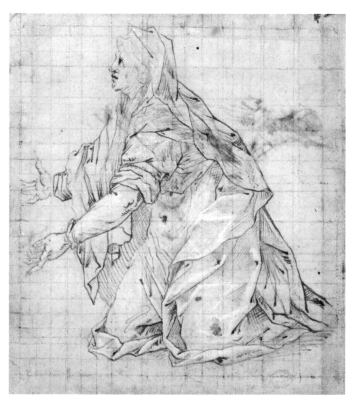

255. *Kneeling Woman Facing Left*

Pen and brown ink, heightened with white, over traces of black chalk. Squared in black chalk. Sketch of a seated market vendor in pen and brown ink on verso. 19.9 x 17.9 cm. Several brown stains.

PROVENANCE: James Jackson Jarves; Cornelius Vanderbilt.

BIBLIOGRAPHY: *Metropolitan Museum Hand-book,* 1895, no. 38, artist unknown.

Gift of Cornelius Vanderbilt, 1880
80.3.38

It was in 1958 that Philip Pouncey attributed the drawing to Malosso. Though it corresponds very closely to a drawing in the Uffizi, Florence (2033 F), they both appear to be original. The Uffizi drawing was engraved by Stefano Mulinari (*Disegni originali d'eccellenti pittori esistenti nella R. Galleria di Firenze,* Florence, 1766-1774, no. 117; Weigel, 1865, p. 376, no. 4545).

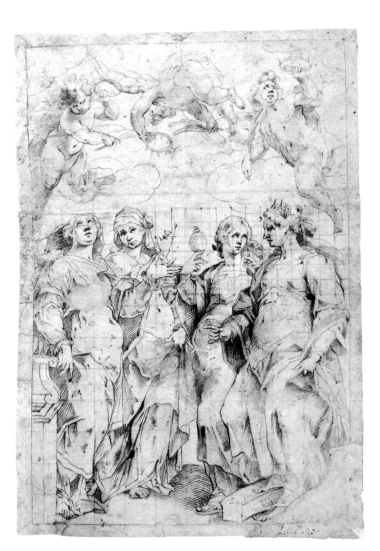

CARLO URBINO

Crema and Milan, notices 1553–1585

256. *The Visitation of the Virgin to St. Elizabeth; King Solomon in a Niche at Left*

Pen and brown ink, over black chalk. Framing lines in black chalk and pen and brown ink. 15.4 x 21.4 cm. Scattered stains; loss at right margin. Lined.

Inscribed in pen and brown ink, *Risuona la Voce sua nele m.. orechie* (on the banderole held by Solomon) and *Salamone* (at Solomon's feet); faint pencil inscriptions at lower right, *Visitation* [?].

PROVENANCE: F. Abott (Lugt 970); purchased in London in 1966.

Rogers Fund, 1966
66.56.1

Philip Pouncey attributed the drawing to Carlo Urbino in 1966. For Urbino's style as a figure draughtsman, see James Byam Shaw's discussion and reproduction of the preparatory drawings at Oxford and elsewhere for the artist's painting *Christ Taking Leave of His Mother* in S. Maria presso S. Celso, Milan (Byam Shaw, 1976, I, p. 286, no. 1124, figs. 91-94, II, pl. 684).

A drawing by Urbino with a representation of the Nativity in a square field at the center, and flanked by figures of prophets in niches, was on the London market in 1966. Like our drawing it bore the mark of the Edinburgh collector F. Abott (Lugt 970). The drawings are very close stylistically, and no doubt are projects for the same decorative scheme.

Boniface Ramsey, O.P., kindly points out that the Italian text on Solomon's banderole is a translation of a line from the Vulgate version of the Song of Songs: "Sonet vox tua in auribus meis" (Canticum Canticorum 2:14).

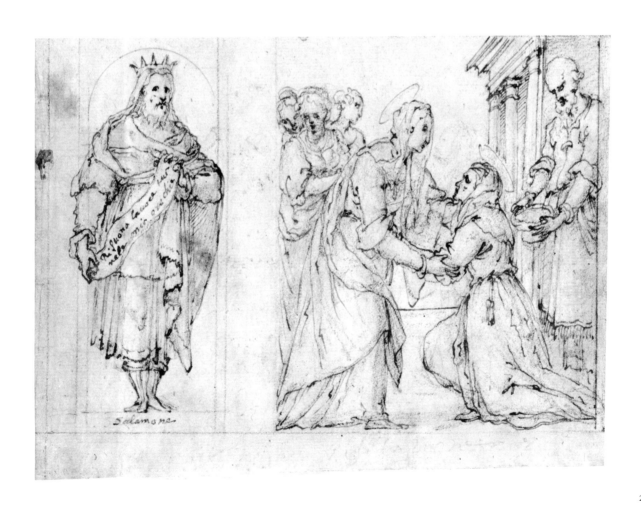

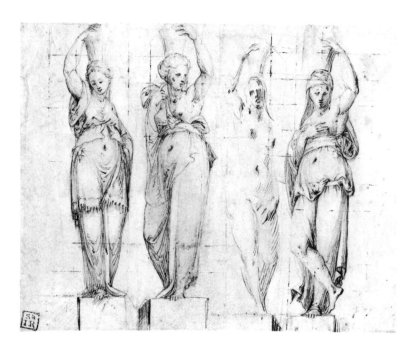

CARLO URBINO

257. *Four Canephori*

Pen and brown ink, over black chalk. Squared in pen and brown ink.
15.7 x 19.7 cm.

Inscribed twice in pen and brown ink on verso, *Pierino del Vaga*.

PROVENANCE: Sir Joshua Reynolds (Lugt 2364); Harry G. Sperling, New York.

Bequest of Harry G. Sperling, 1971
1975.131.14

The drawing was traditionally attributed to Perino del Vaga; while in the Sperling collection it figured under the name Bernardino Campi. It was Philip Pouncey who recently proposed the name of Carlo Urbino.

FRANCESCO VANNI

Siena 1563 – Siena 1610

258. *Standing Woman Looking to Left Background*

Red chalk and red wash. 24.8 x 16.7 cm. Repaired hole at lower left.
Lined.

PROVENANCE: Purchased in London in 1965.

BIBLIOGRAPHY: *Exhibition of Old Master Drawings. P. and D. Colnaghi and Co.,* London, 1965, no. 14; B. N[icolson], *Burlington Magazine,* CVII, 1965, p. 384, fig. 53; *Pantheon,* XXIV, 4, 1966, repr. p. 264; Riedl, 1976, p. 37, under no. 21; Bacou, 1981, under no. 44.

Rogers Fund, 1965
65.131.3

Study for a female spectator standing in the right foreground of Vanni's painting *St. Hyacinth Resuscitating a Drowned Boy,* S. Spirito, Siena. This altarpiece was in place in the Bargagli chapel of S. Spirito by 1596 (for the date see A. Bagnoli, *Prospettiva,* 9, 1977, p. 84; the painting repr. Venturi, IX, 7, fig. 592). In the painting the woman looks directly down at the miracle, which occurs in the immediate foreground. A *bozzetto* in oil paint on paper in the Cabinet des Dessins of the Louvre (Inv. 2015; Bacou, 1981, pl. 44), which differs in many ways from the finished painting, accounts for the backward glance of the figure in our drawing. In the Louvre composition sketch, the miracle takes place on a second plane of the pictorial space, thus the spectator in the foreground looks inward. A number of preparatory drawings for this painting have survived (see Riedl, 1976, pp. 36-37).

St. Hyacinth, a thirteenth-century Polish Dominican missionary, was canonized in 1594, and shortly thereafter Francesco Vanni received two important commissions for paintings representing miracles of this saint for Dominican churches in Siena (see also No. 259 below).

FRANCESCO VANNI

259. *St. Hyacinth Walking on the Waters*

Pen and brown ink, brown wash. 23.2 x 14.7 cm. Arched top.

Inscribed in pen and brown ink at lower right, *di mano del vanni;* numbered in faint black chalk at upper left, *n° 73.*

PROVENANCE: Dr. and Mrs. Victor Bloch; Bloch sale, London, Sotheby's, November 12, 1964, no. 94; Harry G. Sperling, New York.

Bequest of Harry G. Sperling, 1971
1975.131.55

St. Hyacinth is represented carrying the Blessed Sacrament and a statue of the Virgin out of the burning city of Kiev and across the waters of the Dnieper River. At the center of the composition five Dominican friars cross the river on Hyacinth's cloak.

The drawing is a composition study for a painting dated 1599 in S. Domenico, Siena (repr. Voss, 1920, II, fig. 201; Venturi, IX, 7, fig. 591). Larissa Salmina-Haskell identified a drawing in the Fitzwilliam Museum, Cambridge, as a composition sketch for the painting (*Burlington Magazine,* CIX, 1967, pp. 580-583, fig. 49). In the Fitzwilliam drawing and in the painting, the composition differs from the present sketch in that St. Hyacinth appears at the center and the friars have been moved from center to the left, where they appear behind the saint. Peter Anselm Riedl has published a number of studies for individual figures in this painting (*Connoisseur,* CXLVI, December 1960, pp. 163-169; and Riedl, 1976, no. 22). For another scene from the life of St. Hyacinth by Francesco Vanni, see No. 258 above.

260. *Figure Studies: Standing and Kneeling Clerics and Religious, Adam and Eve, and a Reclining Skeleton*

Pen and brown ink, a little brown wash, black chalk. 20.8 x 28.8 cm.

Inscribed in pen and dark brown ink at upper margin, *del* [?] *Vanni.*

PROVENANCE: Mrs. van der Gucht (according to vendor); purchased in London in 1966.

BIBLIOGRAPHY: *Exhibition of Old Master Drawings. P. and D. Colnaghi and Co.,* London, 1966, no. 13; Riedl, 1976, p. 45, under no. 33.

Rogers Fund, 1966
66.93.4

Studies for the figures of St. Francis, St. Dominic, St. Louis of Toulouse, and St. Margaret of Cortona who stand or kneel before the Tree of Life in an allegorical representation of the Immaculate Conception, a painting by Vanni in S. Margherita, Cortona, which is datable 1602 or shortly thereafter (repr. *Arte in Valdichiana dal XIII al XVIII secolo,* exhibition catalogue, Cortona, 1970, no. 78). The nude figures of Adam and Eve and the skeleton representing Death, studied at the upper right margin of the sheet, appear in the painting at the foot of the Tree. It was Peter Anselm Riedl who was the first to point out the connection between our drawing and the painting in Cortona. He has also identified drawings for the same picture in the Kupferstichkabinett, Berlin-Dahlem, and in the E. Schapiro collection in Paris (the latter repr. *Münchner Jahrbuch der bildenden Kunst,* XXX, 1979, p. 87, fig. 8). However, the composition studies in the Uffizi and the Louvre (10808 F and Inv. 2038, respectively), which Riedl considers to be original works by Vanni, appear to us weak copies of a lost original drawing.

261. *The Virgin, Protectress of the City of Siena*

Pen and pale brown ink, brown wash, over black chalk, on beige paper. 20.8 x 27.3 cm. Lined.

Inscribed in pen and brown ink at lower right, *Vanni;* numbered in pen and brown ink at lower left, *2.* Inscribed in pen and brown ink in Richardson's hand at lower margin of old mount, *Cav: Francesco Vanni,* and on reverse of old mount, *Va in Stampo nei Santi di Siena./ P. Resta.*

PROVENANCE: Padre Sebastiano Resta; John, Lord Somers (Lugt 2981; *l.201* as Vanni — Lansdowne Ms., *Cav: Fr°: Vanni. Va in Stampo nei Santi di Siena);* Richard Houlditch (Lugt 2214); Jonathan Richardson, Sr. (Lugt 2183, 2984, 2992, 2995); Sir Joshua Reynolds (Lugt 2364); Hugh N. Squire, London; purchased in London in 1962.

BIBLIOGRAPHY: Bean, 1964, no. 29, repr.; Bean and Stampfle, 1965, no. 151, repr.

Pfeiffer Fund, 1962
62.120.8

The Virgin appears in glory, her right hand raised in benediction, while St. Bernardino and St. Catherine of

260

261

256

FRANCESCO VANNI

Siena intercede for their fellow citizens. At the lower margin is indicated the skyline of Siena, easily identified by the silhouettes of the Torre del Mangia and of the cupola and campanile of the Duomo. The right limit of the nearly square composition is indicated by a vertical framing line, at the right of which are sketches for heraldic devices.

A squared pen and wash study by Vanni for the same composition is in the collection of Sir John Pope-Hennessy, New York (Courtauld photograph B66/229). Sir John makes the very plausible suggestion that both drawings are studies for a Sienese *Biccherna* panel. Such panels – originally used as covers for the financial records of the Republic of Siena, but later conceived as independent works of art – commemorated in pious and patriotic imagery the terms of office of municipal comptrollers. The subject and even the format of the composition would be eminently suitable for such a purpose, and the heraldic emblems studied at the right in the Metropolitan's drawing could easily have figured in the arms of an incumbent officer on a *Biccherna* panel. Vanni did in fact paint at least one *Biccherna* panel; it commemorates an administration of the *Biccherna* that ran from July 1601 to June 1604 and includes a representation of the Madonna of Provenzano venerated by St. Bernardino and St. Catherine of Siena (repr. E. Carli, *Le tavolette di Biccherna*, Florence, 1950, no. 99, pl. LX).

GIORGIO VASARI

Arezzo 1511 – Florence 1574

262. *The First Fruits of the Earth Offered to Saturn*

Pen and brown ink, brown wash, over traces of red chalk. 17.1 x 39.2 cm. Scattered stains and repaired tears.

PROVENANCE: E. Calando (Lugt 837); J. A. Gere, London; purchased in New York in 1971.

BIBLIOGRAPHY: W. Vitzthum, *Master Drawings,* III, 1, 1965, p. 56, fig. 2; Edinburgh, 1969, no. 89, repr.; Bean, 1975, no. 31; E. Allegri and A. Cecchi, *Palazzo Vecchio e i Medici, guida storica,* Florence, 1980, p. 71, fig. 17(II), mistakenly described as belonging to the "City Art Gallery, Londra."

Rogers Fund, 1971
1971.273

The drawing, surely from the hand of Vasari himself, is a study for an *Allegory of Earth* painted by his assistant Cristofano Gherardi in the Sala degli Elementi, Palazzo Vecchio, Florence (repr. Venturi, IX, 6, fig. 183; E. Allegri and A. Cecchi, *op. cit.,* p. 67). There are a number of differences between the preparatory drawing and the finished fresco. Vasari supplied a full description of the complex symbolism of this allegorical composition that is dominated by the figure of Saturn holding up a serpent that bites its own tail. This circular symbol is said to be an Egyptian hieroglyph, symbolic of the rotundity of the heavens among other things (Vasari, VIII, pp. 30-32).

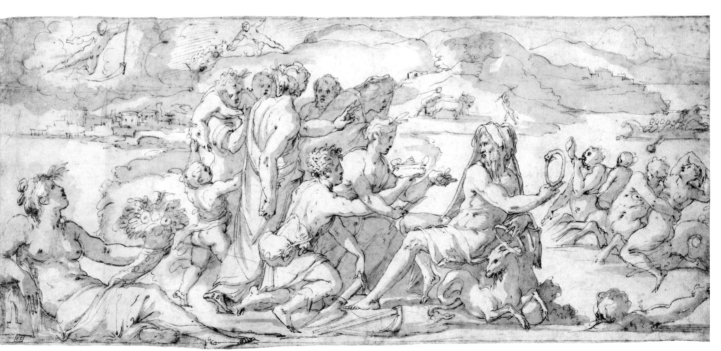

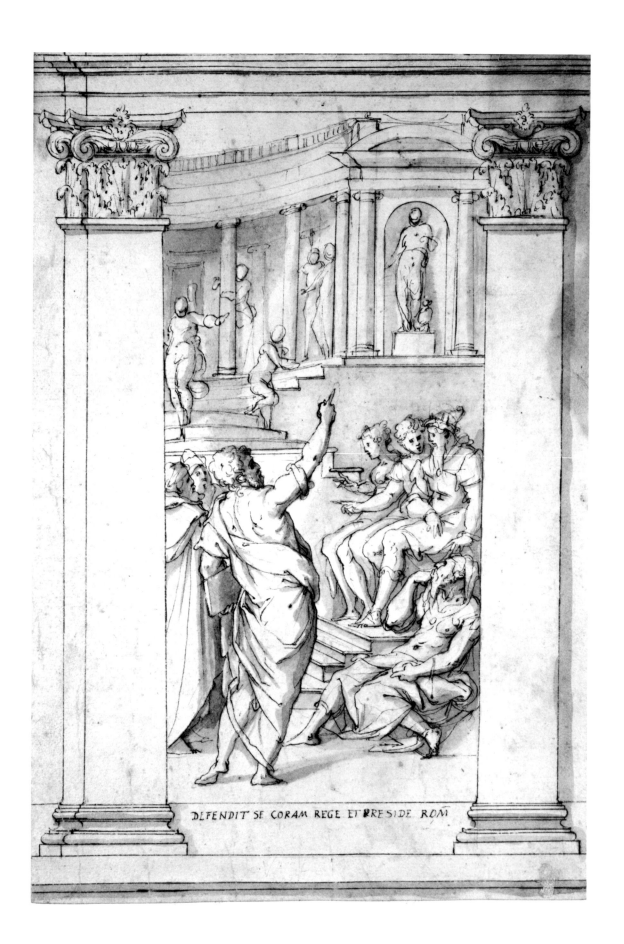

DEFENDIT SE CORAM REGE ET PRESIDE ROM

263. *St. Paul Speaking before King Agrippa*
(Acts 26)

Pen and brown ink, brown wash, over a little black chalk. 32.1 x 21.4 cm.

Inscribed in pen and brown ink in the artist's hand at lower center, DEFENDIT SE CORAM REGE ET PRESIDE ROM̄.

PROVENANCE: Prof. John Isaacs; sale, London, Sotheby's, March 12, 1963, no. 103, purchased by the Metropolitan Museum.

BIBLIOGRAPHY: *Age of Vasari*, 1970, p. 84, no. D38, repr. p. 128.

Rogers Fund, 1963
63.75.3

Vasari's Latin inscription identifies the subject, and the principals in the audience, Bernice, Festus, and Agrippa are easily recognizable at the right.

The Cappella del Monte in S. Pietro in Montorio, Rome, was dedicated to St. Paul, and there Vasari painted four scenes from the life of the Apostle: *Ananias Restoring Paul's Sight* as the altarpiece, and *Paul Preaching at Athens, Paul Carried up to Heaven,* and *Paul before the Proconsul in Corinth* in trapezoidal fields in the apse. A number of preparatory drawings by Vasari for this important enterprise commissioned in 1550 have survived; in none of them is the subject of the present drawing included, though the composition has certain points in common with *Paul at Athens,* where the preaching Apostle is a conspicuous figure in the left foreground. There are drawings in the Louvre and the Albertina for the *Paul at Athens* scene in the apse (Monbeig-Goguel, 1972, nos. 200-202; for the Albertina drawing, see E. Pillsbury, *Master Drawings,* XI, 2, 1973, p. 173, pl. 34).

The framing of the present spacious composition in Corinthian pilasters clearly makes it unsuitable for inclusion in a small trapezoidal field surrounded by stucco ornament in the vault of the apse. A drawing by Vasari in a private collection in Paris representing *Christ Giving the Keys to St. Peter* with the identifying inscription, QVOD CVNQVE [*sic*] SOLVERIS *etc.* (Matthew 16:19), is framed with the same Corinthian pilasters (pen and wash, 29.5 x 21.0 cm.; repr. *Dessins du XVI^e et du XVII^e siècle dans les collections privées françaises,* exhibition catalogue, Galerie Claude Aubry, Paris, 1971, no. 112). The Paris drawing seems to be pendant to ours, and the doubling of the pilasters on the right in the former is echoed in the latter by a doubling of pilasters on the left. Thus the Met-ropolitan drawing could be a project for the decoration of the left wall of a chapel, while the Paris drawing could be a scheme for the decoration of the right wall. It is difficult to associate these projects with any stage of the planning for the Cappella del Monte, where the left and right side walls are taken up by sculptured figures in niches by Ammanati. Furthermore, the specifically Petrine subject matter of the drawing in Paris would not have been particularly appropriate in a chapel dedicated to St. Paul.

264. *Allegory of Forgetfulness*

Pen and brown ink, pale gray wash, over traces of black chalk, on beige paper. Diameter 9.4 cm. Circular framing line in pen and brown ink and gold-colored paint; compass pinhole at center; scattered stains. Lined.

Inscribed in pen and brown ink at lower border of old mount, *Georgio. Vasari.*; in pen and brown ink on reverse of old mount, *Georgio. Vasari.*

PROVENANCE: Purchased in London in 1967.

BIBLIOGRAPHY: *Age of Vasari*, 1970, p. 89, no. D50, repr. p. 146; Kliemann, 1981, p. 161, no. 55b, fig. 173.

Rogers Fund, 1967
67.95.3

In 1981 Julian Kliemann pointed out that this drawing and No. 265 below appear to correspond with two sections of a ceiling decoration of a bedroom (possibly for

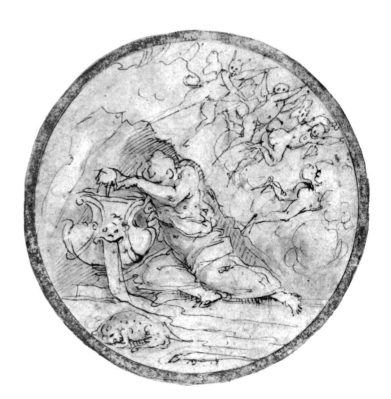

Francesco I de' Medici) planned by Vincenzo Borghini in a text datable ca. 1569/1570. Forgetfulness is represented as a river god resting on an urn from which flow the dark waters of Lethe. The sleeping leopard and lizard in the foreground play emblematic roles, while "certi spiritelli come diavolini," representing cares, fly away at upper right.

265. *Allegory of Sleep*

Pen and brown ink, pale gray wash, over traces of black chalk, on beige paper. Diameter 9.4 cm. Circular framing line in pen and brown ink and gold-colored paint; compass pinhole at center; scattered stains. Lined.

Inscribed in pen and brown ink on old mount, *Georgio. Vasari.*; in pen and brown ink on reverse of old mount, *Georgio. Vasari.*

PROVENANCE: Purchased in London in 1967.

BIBLIOGRAPHY: *Age of Vasari*, 1970, p. 89, no. D49, repr. p. 145; Kliemann, 1981, p. 161, no. 55c, fig. 174.

Rogers Fund, 1967
67.95.4

The drawing differs in a number of ways from Vincenzo Borghini's description of the *Allegory of Sleep* for the bedroom project discussed in No. 264 above. The essential elements of Borghini's scheme are nonetheless present; *Sleep* is attended by a young woman, and butterfly-winged putti holding mirrors appear above.

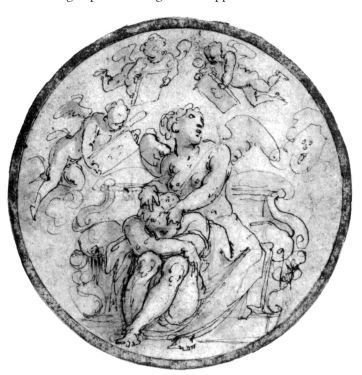

GIOVANNI DE' VECCHI
Sansepolcro 1536? – Rome 1615

266. *St. John the Evangelist*

Pen and dark brown ink, extensively heightened with white, over black chalk, on beige paper. Squared in black chalk. Irregular circle, 26.4 x 25.3 cm. Scattered stains. Lined.

Inscribed in pencil at lower margin of old mount, *G. da Borgo St. Sepolcro;* in pen and brown ink on reverse of old mount, *in San Pietro in Vaticano.;* and in another hand, *Giovanni de' Vecchi da Borgo S. Sepolcro. / . . . disegno ideato per uno de quatro Evangelisti che sono nella Tribuna.*

PROVENANCE: Thomas Hudson (Lugt 2432); Sir Joshua Reynolds (Lugt 2364); Samuel Rogers, London; Rogers sale, London, Christie's, April 28 – May 16, 1856, part of no. 941; sale, London, Sotheby's, December 1, 1964, no. 212, repr., purchased by the Metropolitan Museum.

BIBLIOGRAPHY: Bean and Stampfle, 1965, no. 138, repr.; Gere, 1971, fig. 40; A. Pinelli in *Ricerche di storia dell'arte*, 6, 1977, p. 60, no. 13, fig. 36.

Purchase, Joseph Pulitzer Bequest, 1964
64.295.3

An eighteenth-century English inscription on the back of the old mount correctly identifies this drawing as a study for one of Giovanni de' Vecchi's most important commissions, the cartoons for two of the mosaic pendentives under Michelangelo's dome in St. Peter's. Cartoons for the figures of St. John the Evangelist and St. Luke in colossal medallions were supplied by de' Vecchi; those for the figures of St. Matthew and St. Mark were designed by Cesare Nebbia (Baglione, 1642, pp. 117, 128). Nebbia and de' Vecchi prepared the cartoons between June 12, 1598, and September 24, 1599; actual work on the mosaics began in late 1599 and continued through early 1601 (M. L. Chappell and C. W. Kirwin, *Storia dell'arte,* 21, 1974, p. 126, note 56).

Giovanni de' Vecchi's drawing corresponds fairly closely to the mosaic, though in the latter the Evangelist looks down rather than gazing to upper right (the mosaic repr. in C. Galassi Paluzzi, *La Basilica di S. Pietro,* Bologna, 1975, pl. VIII, and fig. 234).

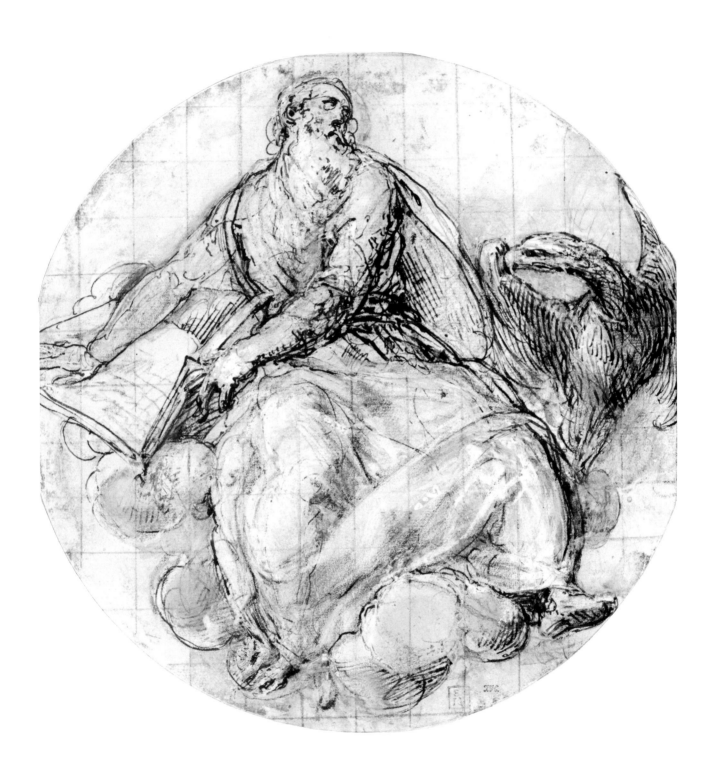

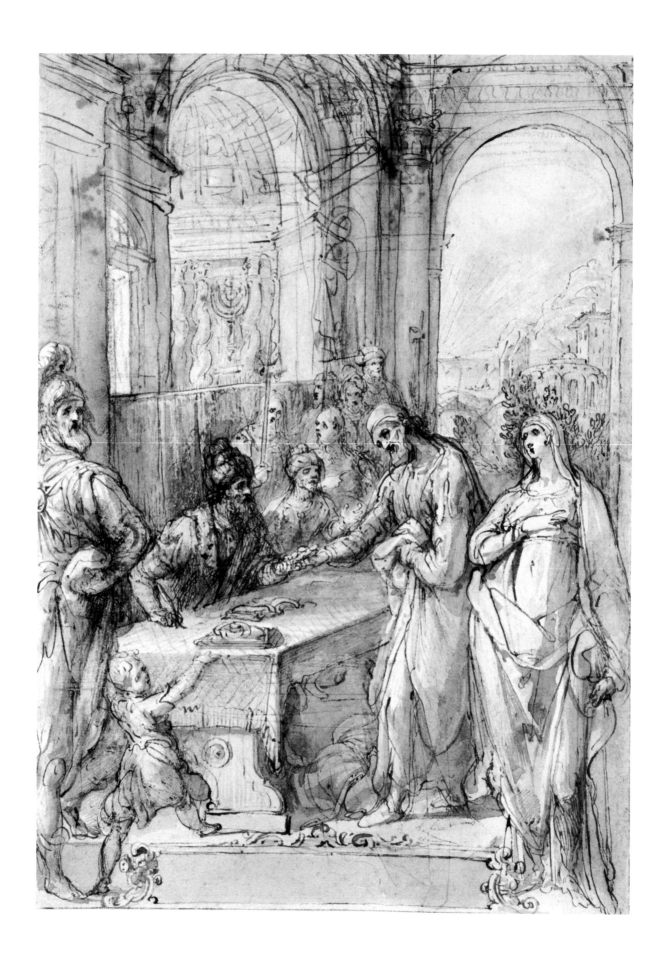

267. *Esther and Mordecai before King Ahasuerus* (Esther 8:1-12)

Pen and brown ink, brown wash, over black chalk. 31.6 x 22.4 cm. Scattered stains; some foxing.

Inscribed in pen and brown ink on verso, *Gio . . . de Vechi;* in pencil, *v. Rumohr Sam̄lung n. 3497: / Aus der Geschichte der Esther / Vechi, Johann de geb. zu Bologna 1544 / st. zu Rom 1614.*

PROVENANCE: Von Rumohr (according to inscription on verso); H. W. Campe (Lugt 1391); Anton Schmid, Vienna; purchased in Zurich in 1969.

BIBLIOGRAPHY: Bean, 1972, no. 56.

Rogers Fund, 1969
69.126.3

The identification of the subject as an incident from the book of Esther, suggested in a German inscription on the verso, seems correct. However, the signet ring that Ahasuerus presents to Mordecai becomes here a large, and thus more visible seal.

268. *Design for a Wall Decoration: Representations of the Ascension and of the Conversion of the Ethiopian Eunuch*

Pen and brown ink, over black chalk (architectural elements); red chalk, pen and brown ink, traces of black chalk (narrative scenes). 31.3 x 54.4 cm. Scattered stains.

Inscribed in pen and brown ink below the figure in niche at left of center, S. PHILIPPVS; below the figure in niche at right, L'EVNVEO [*sic*].

PROVENANCE: James Jackson Jarves; Cornelius Vanderbilt.

BIBLIOGRAPHY: *Metropolitan Museum Hand-book,* 1895, no. 651, as school of Palladio.

Gift of Cornelius Vanderbilt, 1880
80.3.651

In the scene at the left Christ ascends into a bank of clouds, having left his footprints on the summit of the Mount of Olives. At right of center St. Philip has joined the Eunuch in his chariot and explains the passage of Isaiah the Ethiopian is reading, while in the background

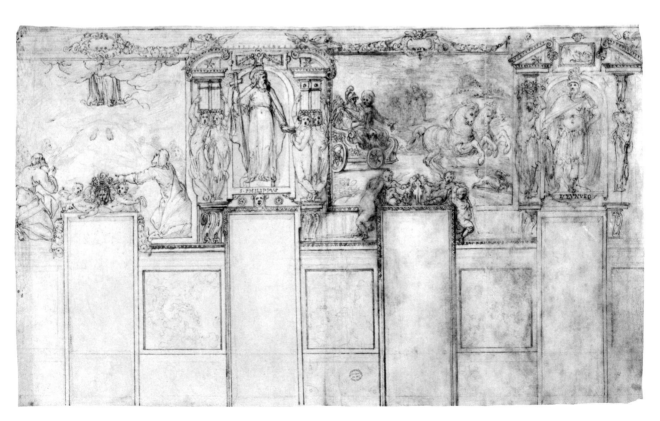

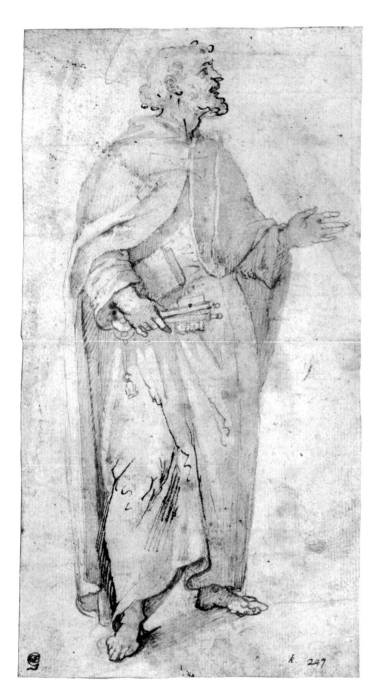

St. Philip is seen baptizing his convert (Acts 8:26-40). The "bretessed bend" and the stars of the Aldobrandini arms that appear above the figure of St. Philip could identify this project as a never-executed scheme commissioned by or proposed to Pope Clement VIII Aldobrandini, who reigned from 1592 to 1605.

The convincing attribution to Giovanni de' Vecchi was first proposed by Philip Pouncey in 1965.

269. *Standing Figure of St. Peter Holding Book and Keys*

Pen and two shades of brown ink, pale brown wash, over traces of black chalk. 24.2 x 12.9 cm. Lined.

Inscribed in pen and brown ink at lower margin of old mount in Richardson's hand, *Innocentio da Imola.*

PROVENANCE: Padre Sebastiano Resta; John, Lord Somers (Lugt 2981; *k*.247 as Innocentio da Imola—Lansdowne Ms., *secondo anzi terzo stile*); Jonathan Richardson, Sr. (Lugt 2984, 2995); Dr. C. D. Ginsburg (Lugt 1145); sale, London, Sotheby's, April 20, 1967, no. 4, purchased by the Metropolitan Museum.

Rogers Fund, 1967
67.96

For Padre Resta the drawing was the work of Innocenzo da Imola; in 1967 Philip Pouncey proposed the alternative attribution to Giovanni de' Vecchi.

ANDREA DEL VERROCCHIO ?

Florence 1435 – Venice 1488

270. *Measured Drawing of a Horse Facing Left*

Pen and brown ink, over a little black chalk. 24.9 x 29.8 cm. Vertical crease at center; lower right corner cut off.

Inscribed in pen and brown ink at lower left, *And: Verrocchio;* inscribed in pen and brown ink in the artist's hand from ear to chest, *u*[na] *t* 5/16 *1/2* / *dal osso del orecchio infino al petto una testa e cinque sedecimi e mezo;* from ear to withers, *u*[na] *T* 3 *1/6 1/2* / *dal orecchio al guidalescho una testa e tre sedecimi 1/2;* from chest to withers, *una T e 1/2 sedecimo* / *dal petto al guidalescho una testa e mezo sedecimo;* from beginning of front leg to withers, *una T e dua 1/6* / *dal chomincio dela gamba enfino al guidalescho una testa e dua sedecimi;* from chest to back side of upper leg, *10 sedecimi e mezo* / *dal petto al chomincio de la ghamba dieci sedecimi;* from chest to front side of upper leg, *sei 1/6 1/2* / *dal petto al chomincio dela ghamba se sedecimi;* at front left hoof, *tre sedecimi 1/2* / *3 1/6 1/2;*

Anl: Verrocchio

from front fetlock to knee, *nove sedecimi / da questo nodello al ginochio 9 16;* from front left knee to belly, *undici 16 1/2 / dal ginochio al chominciamento / undici sedecimi e mezo;* across thickness of belly, *una T 5 1/6 1/2 / grosso una testa e cinque 1/6;* from front knee to beginning of flank, *una T e 4 1/6 / dal ginochio al chomenzo dela choscia una testa e quadttro 1 6;* from chest to rump, *dua T e 10 1/6 / dal petto alla groppa dua teste e dieci sedecimi;* from withers to top of the rump, *una T e 11 1/6 / dal guidalesch a p[r]incipia dela groppa una testa e undici sede / cimi;* from bone in front part of upper leg to the rump, *undici 1/6 / da qu al osso de la groppa undici 1/6;* from rump (or crupper) to tail, *nove 16 / dal groppa alla choda nove 16;* from lower rump to top of tail, *14 16 1/2 / da qui alla choda di sopra 14 1/6 1/2;* from top of upper rear leg bone to knee, *u[na] T e 10 1/6 / da questo o dala groppa infino al ginochio una testa e dieci sedecimi;* from sex to rear knee, *da questo o enfino al ginochio 13 1/6 1/2;* from rear knee to lower rump, *otto sedecimi / dal ginochio a questo 8;* from rear fetlock to above the knee, *dodici 16 / da questa guntion al disopra del ginochio dodici 1/6.*

BIBLIOGRAPHY: Strong, 1900, part VI, no. 58, as attributed to Verrocchio; Berenson, 1903, no. 1951A, as school of Antonio Pollaiuolo; Burroughs, 1919, p. 137, repr., as Antonio Pollaiuolo; Sirén, 1928, II, pl. 81B, as Leonardo da Vinci; W. R. Valentiner, *Burlington Magazine,* LXII, 1933, p. 232, repr., as Verrocchio; O. Kurz, *Old Master Drawings,* XII, 1937-1938, p. 14; Berenson, 1938, no. 1947B, as school of Antonio Pollaiuolo; B. Degenhart, *Zeitschrift für Kunstgeschichte,* VIII, 1939, p. 140, fig. 57, p. 141, as Antonio Federighi; Berenson, 1961, no. 1947B, as school of Antonio Pollaiuolo; Ragghianti Collobi, 1974, I, p. 82, II, fig. 230; Beltrame Quattrocchi, 1979, repr. p. 25, p. 26, under no. 7, as Verrocchio; *The Horses of San Marco,* supplementary exhibition catalogue, Metropolitan Museum of Art, New York, 1980, no. 82, as follower of Verrocchio; *I cavalli di San Marco,* exhibition catalogue, Palazzo Reale, Milan, 1981, no. 47, repr., as follower of Verrocchio; G. Scaglia, *Art Bulletin,* LXIV, 1, 1982, pp. 32-44, figs. 7, 8, as Verrocchio.

PROVENANCE: Earls of Pembroke; Pembroke sale, London, Sotheby's, July 5-6, 9-10, 1917, no. 358, repr., as Verrocchio, purchased by the Metropolitan Museum.

Hewitt Fund, 1917
19.76.5

James Draper, who kindly transcribed the notations on this sheet, points out that the unit of measurement appears to be the length of the horse's head. Thus the short diagonal line at top right, from the crupper to the tail, equals nine-sixteenths of the head.

The attribution to Verrocchio is traditional, and Valentiner even suggested that this sheet might be one of the two measured drawings of horses by Verrocchio that figured in the collection of Giorgio Vasari (mentioned Vasari, III, p. 364). There is, however, no trace of a Vasari mount on our drawing. The impersonal and schematic character of line in this diagram makes it difficult to recognize a specific artistic personality. Nonetheless the handwriting is very close to that of Verrocchio as it is recorded in a Florentine *catasto* (register of landed property) of 1481 (C. Pini and G. Milanesi, *La scrittura di artisti italiani riprodotta con la fotografia,* I, Florence, 1869, n. pag.).

Enrichetta Beltrame Quattrocchi attributes to Verrocchio a double-faced sheet of studies of a horse, seen from different points of view, in the Farnesina, Rome. The notations on the sheet in Rome appear to be in the same hand as those on our drawing (Beltrame Quattrocchi, 1979, no. 7, recto and verso repr.).

TIMOTEO VITI

Urbino 1469 – Urbino 1523

271. *Bust of a Youth with Right Arm Upraised*

Black chalk, on beige paper. 19.5 x 13.8 cm. Margins very irregular. Scattered brown stains. Lined.

Inscribed in pencil at lower margin of old mount, *from the Davarinn Collection / Girolamo Genga. / Born 1476 / Died 1551.*

PROVENANCE: Davarinn (according to inscription on old mount); purchased in London in 1966.

BIBLIOGRAPHY: S. Ferino in *Maestri umbri del Quattro e Cinquecento,* Florence, 1977, p. 24, under no. 20; Beltrame Quattrocchi, 1979, pp. 45-46, under no. 30.

Rogers Fund, 1966
66.53.5

When this drawing appeared on the London art market in 1966 Philip Pouncey identified it as the work of Timoteo Viti and connected it with Viti's painting of the *Virgin Annunciate with St. John the Baptist and St. Sebastian* now in the Brera, Milan (Venturi, VII, 3, fig. 739). The drawing is a study for St. Sebastian, whose raised right arm is tied to the branch of a tree and who looks upward at the standing figure of the Virgin. In the Gabinetto Nazionale delle Stampe in Rome there is a chalk and wash study for the whole composition (Beltrame Quattrocchi, 1979, no. 30, repr.); the drawing in Rome differs from the painting and from our drawing of St. Sebastian in that the saint looks downward rather than up at the Virgin.

ANTONIO VIVARINI ?

Murano ca. 1415 – Venice 1476/1484

272. *Standing Youth with Sword and Palm Branch*

Brush, brown wash, heightened with white, on brown-washed paper. 30.1 x 16.7 cm. The drawing was once covered with a coat of varnish, but this has been removed and many surface losses repaired. Lined.

PROVENANCE: Purchased in London in 1908.

BIBLIOGRAPHY: Fry, 1908, pp. 223-224, as Ferrarese, circle of Cossa; Hellman, 1916, pp. 160-162, repr., as anonymous Ferrarese, circle of Ercole Grandi; D. von Hadeln, *Old Master Drawings,* II, 1927-1928, pp. 34-35, pl. 36, as Antonio Vivarini; *Metropolitan Museum, Italian Drawings,* 1942, no. 2, repr., as unknown Ferrarese artist, XV century; Tietze, 1944, no. 2251, pl. I, 3, as Antonio Vivarini.

Rogers Fund, 1908
08.227.26

Roger Fry thought the drawing Ferrarese when he acquired it for the Museum in 1908. Nineteen years later, Detlev von Hadeln proposed an attribution to Antonio Vivarini; this was accepted by the Tietzes "with all the reservations inevitable on such an uncertain ground as Venetian painting in the early 15th century." In any case, the sheet has been so much restored that it is hard to categorize.

271

272

FEDERICO ZUCCARO

Sant'Angelo in Vado 1540/1541 – Ancona 1609

273. The Vision of St. Eustace

Point of brush, brown, gray, green, yellow, and red wash, heightened with white, over traces of red and black chalk. Lightly squared in black chalk. 34.0 x 20.2 cm. Lined.

Inscribed in pen and brown ink at lower margin of old mount in Richardson's hand, *Fed. Zuccaro;* and on reverse of old mount, *Fece dunq. di colori in una facciata, La storia di Sant'Eustachio, che, caccian: | :do, vede frà le corna d'un cervio Giesù Christo crocifisso. Vasari vit. di Taddeo p. 114 | This is the First Picture that Federico did on his Own account, (He was now | 28 y!. Old, having before allways work'd for, & with his Bro. Taddeo) at which | He was so Delighted, that, when Taddeo, considering that it was to be so much in the | Publick View, as being on the Front of a Palace in a great Square, not only Over: | : Look'd it, but alterd or Corrected several Parts; He was so far Transported with | Jealousy; & perhaps with some reason, because (as L.y. Mary Wortley Mountague S.d. | to M. Pope (as Himself told us) who was for altering some Verses of Hers that She | ask'd his Opinion of) He knew Whatever was Lik'd, would be said to be of Taddeo | when poor Federico's heart was sett on acquiring Credit for his Own Performance, | that, as soon as his Brother was gone, He defac'd All that He had done, & repaint: | :ed it with his Own Hand. However This was soon made up, as Taddeo was a | Reasonable Man, & Lov'd Him. See Vasari, Life of Taddeo, p. 114 Ed. Bot. | At this Early time of his Life He frequently us'd to Colour his Finish'd Drawings. ib.*

PROVENANCE: Jonathan Richardson, Sr. (Lugt 2184); Jonathan Richardson, Jr. (Lugt 2170); Sir Joshua Reynolds (Lugt 2364); purchased in London in 1962.

BIBLIOGRAPHY: Bean, 1963, p. 232, fig. 5; J. A. Gere, *Burlington Magazine,* CV, 1963, p. 394, note 12; Bean and Stampfle, 1965, no. 140; Gere, 1966, p. 27, under no. 29; Gere, 1971, pl. XVIII; G. Smith, *The Casino of Pius IV,* Princeton, 1977, pp. 29-30, fig. 37.

Rogers Fund, 1962
62.76

Finished squared study for a fresco between the two second-story windows on the narrow façade of a small palace on the Piazza Sant'Eustachio in Rome executed by Federico Zuccaro at the age of eighteen. The fresco survives in a very damaged state, but is recorded in an engraving by Cherubino Alberti (Bartsch, XVII, pp. 68-69, no. 52; repr. W. Körte, *Mitteilungen des Kunsthistorischen Institutes in Florenz,* III, 1919-1932, p. 521). A drawing in the Uffizi documents an earlier stage in the planning of the composition (11173 F; repr. W. Körte, *op. cit.,* p. 519). Federico's fresco differed from the monochrome Roman façade frescoes of the early sixteenth century in that it was executed in a variety of colors, already present in this drawing.

274. The Virgin and Child with St. Joseph, Attendant Angels, and a Group of Supplicants

Pen and brown ink, brown wash, over a little red chalk. Black chalk sketch of a nude male torso on verso. 29.3 x 23.0 cm. Upper left corner replaced; brown stain at lower right.

Inscribed in pen and brown ink at lower left, *F.co Zuccaro,* and on verso, *Battista Naldini.*

PROVENANCE: Purchased in London in 1968.

BIBLIOGRAPHY: *Exhibition of Old Master Drawings. P. and D. Colnaghi and Co.,* London, 1968, no. 10; Gere, Paris, 1969, p. 67, under no. 92; Byam Shaw, 1976, I, pp. 156-157, under no. 547, fig. 36.

Rogers Fund, 1968
68.106.2

J. A. Gere has pointed out that there are studies by Federico for the central group of the Virgin holding the standing Christ Child, who raises His right hand in benediction, in the Cabinet des Dessins, Musée du Louvre (Inv. 12281; Gere, Paris, 1969, no. 92) and at Christ Church, Oxford (Byam Shaw, 1976, I, no. 547 verso, II, pl. 304).

275. The Virgin and Child Appearing to St. Peter, St. Damasus, St. Lawrence, and St. Paul; the Martyrdom of St. Lawrence in the Background

Pen and brown ink, pale brown wash, over traces of red and black chalk, on beige paper. 36.7 x 24.4 cm. Arched top. Horizontal crease at center; surface abraded.

Inscribed in pen and brown ink on a strip affixed to the sheet at lower right, *Federicus Zuccarus 1585* [?].

PROVENANCE: Pierre Crozat ? (63 with the paraph: Lugt 2951); Sir Charles Greville (Lugt 549); Earl of Warwick (Lugt 2600); Warwick sale, London, Christie's, May 20-21, 1896, part of no. 453; Mrs. D. Appleton, London; sale, London, Sotheby's, July 9, 1973, no. 68; John Steiner, Larchmont, New York.

BIBLIOGRAPHY: J. A. Gere, *Burlington Magazine,* CVIII, 1966, pp. 341-343, fig. 10; Gere, 1969, p. 127.

Gift of John Steiner, 1977
1977.76

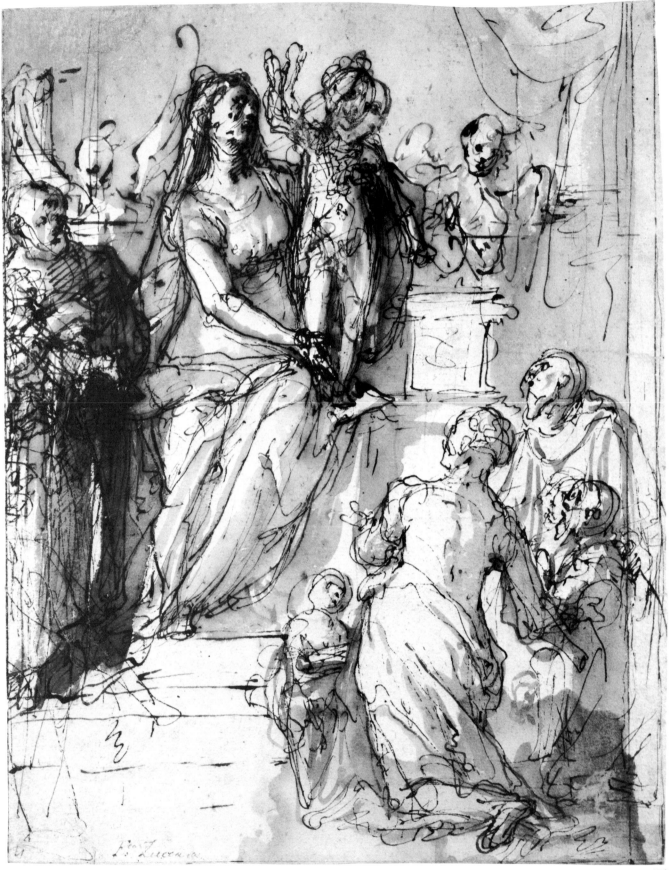

FEDERICO ZUCCARO (NO. 275)

A preparatory study by Federico Zuccaro for the high altarpiece in S. Lorenzo in Damaso, Rome, a work commissioned from Taddeo Zuccaro but actually executed by Federico and completed in 1568, nearly two years after Taddeo's death. The finished altarpiece differs from this project in that the upper half of the composition is occupied by a representation of the Coronation of the Virgin (see J. A. Gere, *op. cit.,* 1966, fig. 11). J. A. Gere has pointed out that Federico has combined in the present drawing two motifs studied separately by Taddeo in surviving drawings that relate to this project: the appearance of the Virgin to four saints (inspired by Raphael's *Madonna di Foligno*), and the martyrdom of St. Lawrence. Finished *modelli* by Federico, corresponding in every detail with the painting, are in the Louvre, at Chatsworth, and in the Kunsthalle, Bremen (see J. A. Gere, *op. cit.,* 1966, p. 341; and Gere, Paris, 1969, no. 61).

FEDERICO ZUCCARO

276. *Paradise*

Pen and brown ink, brown, gray, gray-green, and a little red wash, heightened with white. Left and central sections squared in red chalk. 39.8 x 113.6 cm. The support consists of three sheets joined vertically. A *pentimento* with figures of Christ, the Virgin, and St. John the Baptist, measuring 14.0 x 24.0 cm., has been affixed at the center of the drawing. The surface is much abraded, and many losses have been repaired. Lined.

Inscribed in pencil at lower left, *Taddeo Zucchero* (almost illegible); in pencil and again in pen and brown ink on reverse of old mount, *Taddeo Zucchero / Design of a Cieling [sic] for the Cathedral at Urbino.*

PROVENANCE: Pierre Crozat ?; Crozat sale, Paris, April 10–May 13, 1741, possibly part of no. 216, "Huit grands Desseins de Tadée et de Frederic Zuccaro, dont le Paradis"; Baron von Stumm (according to Voss); purchased in Munich in 1961.

BIBLIOGRAPHY: H. Voss, *Burlington Magazine,* XCVI, 1954, pp. 172-175, fig. 17; W. Vitzthum, *Burlington Magazine,* XCVI, 1954, p. 291; D. Heikamp, *Rivista d'arte,* XXXIII, 1958, p. 47, note 8; Gere, Paris, 1969, pp. 46-47, under no. 49; S. Sinding-Larsen, *Christ in the*

Council Hall. Studies in the Religious Iconography of the Venetian Republic (*Acta ad Archaeologiam et Artium Historiam Pertinentia,* V), Rome, 1974, p. 61, pl. XLIV; J. Schulz, *Arte veneta,* XXXIV, 1980, pp. 112-126, fig. 7.

Rogers Fund, 1961
61.201

In this representation of Paradise, Christ is seated in Judgment at the center and flanked by the Virgin and St. John the Baptist who intercede for mankind. At the right appear a throng of Old Testament figures dominated by Adam, Eve, and Moses with the tablets of the law. At the left are ranged a host of saints of the New Dispensation: St. Peter and St. Paul with the other Apostles, St. Catherine of Alexandria, St. Lawrence, St. Sebastian, St. Francis, St. Dominic, and many others.

God the Father appears in glory at upper center, while the central foreground is occupied by angel musicians.

Hermann Voss, who first published this drawing, suggested that it is Federico Zuccaro's project for the redecoration of the end wall of the Sala del Maggior Consiglio in the Palazzo Ducale after the fire of 1577. However, Walter Vitzthum pointed out the the testimony of Vasari in the 1568 edition of the *Lives* and the stylistic evidence of the drawing itself indicate that this project is earlier; it must date from Federico's first visit to Venice in the mid 1560s. This *Paradise* may have been intended to replace Guariento's probably damaged *Coronation of the Virgin* on the end wall, more than a decade before the 1577 fire.

In our scheme, the reserves in the paper indicate the placement of the two doors that pierce the wall and of the top of the back of the central bench. The six pendentives indicated at the top margin suggest that Federico proposed a vaulted ceiling for the great room, instead of the flat wooden ceiling that at this narrow end was orginally supported by eleven corbels.

In the Cabinet des Dessins at the Louvre, there is another large design for the same scheme (Inv. 4546; Gere, Paris, 1969, no. 49, pl. XII). It differs from our drawing most notably in that the central subject is the *Coronation of the Virgin*.

Though later in his career Federico Zuccaro executed a painting for the Sala del Maggior Consiglio (*Frederick Barbarossa Submitting to Pope Alexander III*; see No. 124 above), the *Paradise* that eventually replaced Guariento's *Coronation* is a late work of Jacopo Tintoretto. New information concerning the *Paradise* in the Sala del Maggior Consiglio has recently been supplied by Juergen Schulz.

277. *Scene from the Last Judgment*

Pen and brown ink, brown wash, over red chalk. 44.8 x 24.3 cm. Cut to the shape of a segment of an octagonal cupola.

Inscribed in pencil on reverse of old mount, *Le Jugemant* [sic] *Dernier / Federico Zuccari / né en 1530-1609.*

PROVENANCE: Purchased in New York in 1961.

BIBLIOGRAPHY: Frerichs, 1981, p. 93, under no. 382.

Roger Fund, 1961
61.53

Study for the third segment to the right of the central figure of Christ in Judgment in the frescoed decoration of the interior of the octagonal cupola of the Duomo in Florence (repr. Monbeig-Goguel, 1972, p. 20, left). Work on this enterprise was begun in 1571 by Giorgio Vasari on an iconographical program planned by Vincenzo Borghini and based on Dante. At Vasari's death in 1574 only the frescoes around the lantern of the cupola had been completed, and in 1575 Federico Zuccaro arrived in Florence to finish the task, using as his general guide Vasari's drawings for the project, a great many of which are now preserved in the Cabinet des Dessins of the Louvre. However, many areas of the fresco, particularly the Last Judgment scenes in the lower register, seem to be of Federico's own invention. The fresco was finished and unveiled in September 1579.

This preparatory drawing corresponds fairly closely to the finished fresco in which are represented, reading from top to bottom, one of the elders of the Apocalypse, angels with the Crown of Thorns, representatives of secular power, allegorical figures of Good Council, Mercy, and Justice, and in the lowest register the punishment in hell of those guilty of avarice (Vasari, VIII, p. 225, *Angolo terzo*). The most significant difference between drawing and fresco is that in the former the secular powers are flanked on the left by representatives of ecclesiastical authority.

This is one of a great many surviving drawings by Federico for the vast project. Many seem to be the work of studio assistants, but here the hand of Federico himself is evident. A drawing in the Rijksprentenkabinet, Amsterdam (Inv. A 2189), is related to the same segment as our drawing. It differs in detail from both the fresco and the present study, but it seems to be the work of an assistant, rather than of Federico himself.

278. *Ecce Homo* (John 19:5)

Pen and brown ink, brown wash, heightened with white, on beige paper. 23.9 x 14.9 cm. All four corners rounded. Lined.

Inscribed in pen and brown ink on verso, where old mount has been peeled away, *di fedrico . . . ero.*

PROVENANCE: James Jackson Jarves; Cornelius Vanderbilt.

BIBLIOGRAPHY: *Metropolitan Museum Hand-book,* 1895, no. 485, as Lucas Cranach.

Gift of Cornelius Vanderbilt, 1880
80.3.485

TADDEO ZUCCARO

Sant'Angelo in Vado 1529 – Rome 1566

279. *Standing Nude Man*
VERSO. *Three Studies of Soldiers*

Red chalk, heightened with a little white (recto); red chalk (verso). 42.0 x 28.7 cm.

Inscribed in pen and brown ink on verso, *Maturino.*

PROVENANCE: Unidentified collector's mark, Z (similar to but somewhat larger than Lugt 2680); Carl König (Lugt 583); sale, London, Sotheby's, March 11, 1964, no. 141, as Maturino; Philip Pouncey, London; purchased in New York in 1968.

BIBLIOGRAPHY: Gere, 1969, p. 179, no. 143, pl. 12 (recto), pl. 14 (verso); J. Bean, *Metropolitan Museum of Art Bulletin,* February 1969, recto repr. p. 312; Gere, 1971, fig. 14 (recto); *Notable Acquisitions,* 1975, p. 57, recto repr.

Rogers Fund, 1968
68.113

The attribution to Taddeo Zuccaro is due to J. A. Gere. These studies are early, and possibly made with a façade decoration in mind. Gere points out that the male figure on the recto of the sheet is a study for the soldier holding the bridle of a horse in the center of a Polidoresque compositon study in the collection of David Rust, Washington, D.C. (Gere, 1969, no. 250, pl. 9; Gere, 1971, pl. XVI).

280. *St. Paul Restoring Eutychus to Life*

(Acts 20:7-12)

Pen and brown ink, brown wash, heightened with white, over a little black chalk, on gray paper. 33.7 x 46.1 cm. A number of repaired losses. Lined.

PROVENANCE: Prof. Einar Perman, Stockholm; purchased in Stockholm in 1967.

BIBLIOGRAPHY: Gere, 1966, pp. 25-26, under no. 27; J. Bean, *Metropolitan Museum of Art Bulletin,* October 1968, repr. p. 86; Gere, 1969, no. 142, pl. 84; Byam Shaw, 1976, I, p. 152, under no. 534.

Rogers Fund, 1967
67.188

This drawing is a study — with notable differences, especially in the pose of St. Paul — for a fresco in the vault of the Frangipani chapel in S. Marcello al Corso (Gere, 1969, pl. 85). The identification was made by J. A. Gere when the drawing was in Stockholm. At Christ Church, Oxford, there is a much-damaged drawing by Taddeo for what seems to be an earlier stage in the planning of this composition (Byam Shaw, 1976, I, no. 534, II, pl. 291). A copy of the Metropolitan drawing is in the Fitzwilliam Museum in Cambridge (Inv. 3115).

There is an impressive study for the *Martyrdom of St. Paul,* the fresco in the center of the vault of the Frangipani chapel, in the Robert Lehman Collection at The Metropolitan Museum of Art (Gere, 1969, no. 147, pl. 82; Szabo, 1979, no. 38, repr.). Taddeo seems to have begun work in the Frangipani chapel by the end of 1558, at the latest, but the decorations were not quite complete at his death in 1566. No. 281 below is also associated with the frescoes in this chapel.

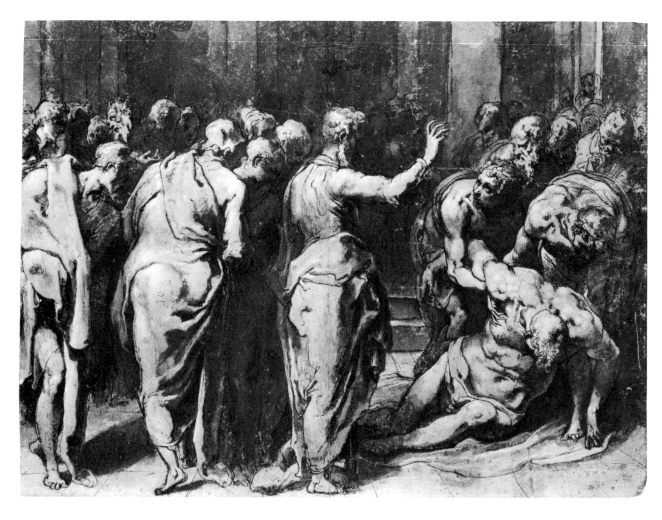

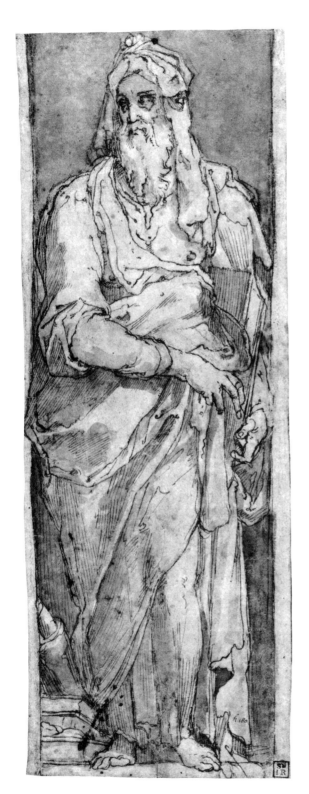

281. *Standing Prophet in a Niche, Holding a Book*

Pen and brown ink, brown wash, over black chalk, on brownish paper. 40.4 x 14.4 cm. Lined.

Inscribed in pen and brown ink at lower margin of old mount in Richardson's hand, *Mecarino da Siena.*

PROVENANCE: Padre Sebastiano Resta; John, Lord Somers (Lugt 2981; k. 180 as Beccafumi—Lansdowne Ms., *Domenico Beccafumi d°. Mecarino da Siena. nacque del 1484, fu scolaro di Pietro Perugino poi stato col Sodoma da Vercelli tornando in Patria*); Jonathan Richardson, Sr. (Lugt 2995); Sir Joshua Reynolds (Lugt 2364); William Roscoe, Liverpool; Roscoe sale, Liverpool, Winstanley, September 23-28, 1816, no. 92, as Beccafumi; Walter Lowry, New York.

BIBLIOGRAPHY: Gere, 1969, p. 176, under no. 134, as a copy after Taddeo Zuccaro; Harprath, 1977, pp. 174-175, under no. 124, as a copy.

Gift of Walter Lowry, 1957
57.32.2

The drawing had been traditionally attributed to Beccafumi, and it was J. A. Gere who pointed out the connection with Taddeo Zuccaro. He considered it a copy of a drawing in Munich that he recognized as a study for the figure of a prophet on the left-hand entrance pilaster of the Frangipani chapel in S. Marcello at Corso (the Munich drawing, Inv. 37815; Harprath, 1977, pl. 45; the fresco repr. Gere, 1969, pl. 107a). Our drawing in fact differs in a number of significant details from the sheet in Munich, of which it is certainly not a slavish copy. It seems to us to merit the status of an original drawing by Taddeo, and Richard Harprath who only recently saw the drawing now concurs with this view.

A drawing in the Kupferstichkabinett in Berlin-Dahlem, formerly attributed to Goltzius, was identified by Gere as a further study for the prophet on the left-hand entrance pilaster (KdZ 2677; Gere, 1969, no. 4, pl. 106b).

282. *Studies for a Circular Composition of Diana and Her Nymphs Bathing* VERSO. *Studies for the Same Composition*

Pen and brown ink, brown wash. 27.3 x 20.7 cm.

Inscribed in pencil at upper center, *Ecole Italienne 16ᵉ siècle.*

PROVENANCE: Walter Lowry, New York.

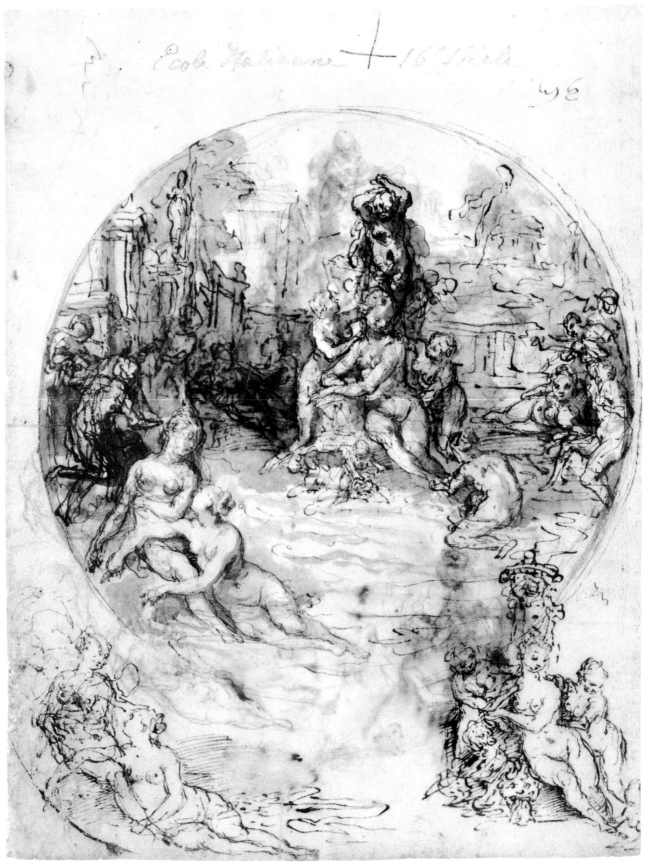

TADDEO ZUCCARO

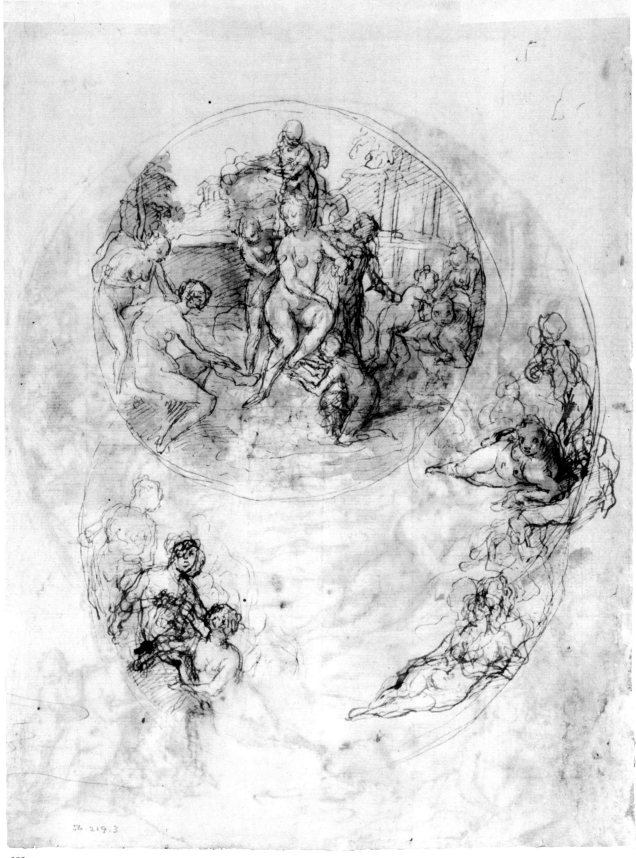

282 v.

BIBLIOGRAPHY: Bean and Stampfle, 1965, no. 134, recto and verso repr.; Gere, 1969, no. 141, pl. 121 (recto); Gere, Paris, 1969, p. 41, under no. 41; J. A. Gere, *Master Drawings*, VIII, 2, 1970, p. 125.

Gift of Walter Lowry, 1956
56.219.3

The drawing entered the collection in 1956 as an anonymous Italian work of the sixteenth century, and it was in 1964 that Jacob Bean recognized it as the work of Taddeo Zuccaro. J. A. Gere remarked that though the purpose of this compositon is unknown, the shape might suggest a design for maiolica. Gere also pointed out that the following drawing, No. 283, is a study for part of the same composition, and that Taddeo's final composition is recorded in a drawing in the Louvre that may well be the work of Orazio Samacchini, to whom it is traditionally attributed (Cabinet des Dessins, Inv. 9030; Gere, 1969, no. 187).

283. *Nymphs Bathing*

Pen and brown ink, brown wash. Red chalk sketch of a leg on verso. 12.3 x 12.3 cm.

Inscribed in pen and brown ink at lower right, *Tadeo Zucchari.*; on verso, *Tadeo Zucharo.*

PROVENANCE: Unidentified collector's mark at lower left corner of recto; Prof. Einar Perman, Stockholm; purchased in Stockholm in 1970.

BIBLIOGRAPHY: Bean and Stampfle, 1965, p. 75, under no. 134; Gere, 1969, no. 232; Bean, 1972, no. 59.

Rogers Fund, 1970
1970.101.20

See No. 282 above.

ANONYMOUS TUSCAN ARTIST

early 15th century

284. *Two Monks Looking up at a Dragon in a Tower*

Pen and brown ink, brown wash, on vellum. 18.7 x 13.9 cm.

PROVENANCE: L. Böhler, Lucerne; Walter C. Baker, New York.

BIBLIOGRAPHY: Berenson, 1961, no. 1391F-3**, fig. 18, as school of Lorenzo Monaco; Virch, 1962, no. 2, as the Master of 1417; Degenhart and Schmitt, 1968, I-2, no. 179, I-4, pl. 200b, as Tuscan, 1417.

Bequest of Walter C. Baker, 1971
1972.118.260

In both calligraphy and subject matter this pen sketch appears to belong to a group of drawings on vellum produced in some monastery workshop in Tuscany in the early fifteenth century (Degenhart and Schmitt, 1968, I-2, nos. 173-178, I-4, pls. 198-200). All of them represent scenes of pilgrimage; one of the drawings in the group (Fogg Art Museum, Cambridge, Massachusetts) bears a text dated 1417. Berenson assigned the drawings to the school of Lorenzo Monaco, while Degenhart and Schmitt prefer to classify them as anonymous Tuscan.

ANONYMOUS ARTIST

mid-15th century ?

285. *"Uomini famosi": Minos, Jephthah Sacrificing His Daughter, Agamemnon, Menelaus, Priam, Helen of Troy, Paris, Jason with the Golden Fleece, and Hector*

Pen and brown ink, watercolor of various hues, traces of gold paint, on vellum. Letters of the alphabet repeated in a childish hand in pen and brown ink on verso; and a faint counterproof of the sheet beginning with Pirus, no. 21 of the 1958 sale. 31.0 x 20.0 cm.

Inscribed in pen and brown ink in the first register, *Minos condidit leges.* / *fuit anno .iiai.dccxxxxvi.; iepte filiā immolavit ex voto* / *fuit anno iiai.dccxxxxviii.;* *Agamenon* / *fuit tp̄ore iepte;* in the second register, *Menalaus.* / *fuit tp̄ore iepte;* *Plamus plmus* / *Rex troyāg* / *fuit eodem tp̄ore;* *Elena* (and in another hand) *de grece; paris elenā rapuit* / *fuit ho tp̄ore;* in the third register, *iason acquisivit* / *vellus aureum* (and in another hand) *qui quon* / *quit la* / *toison* / *fuit anno .iiai.dcclxvi.;* *hector* (and in another hand) *de troie* / *fuit anno .iiai.dcclxxiiii.* Numbered at upper right corner, 4 [?].

PROVENANCE: William Morris; Charles Fairfax Murray; Fairfax Murray sale, London, Sotheby's, July 18, 1919, part of no. 50; Sir Sydney Cockerell; sale, London, July 2, 1958, no. 15, repr.; Walter C. Baker, New York.

BIBLIOGRAPHY: Berenson, 1938, no. 164C, fig. 27 (here No. 285), as school of Fra Angelico; I. Toesca, *Paragone,* 25, 1952, pp. 16-20, pls. 9 (here No. 285), 12 (here No. 286), as French; R. Longhi, *Paragone,* 27, 1952, pp. 56-57; F. Saxl and H. Meier, *Verzeichnis astrologischer und mythologischer illustrierter Handschriften des lateinischen Mittelalters,* III, *Handschriften in englischen Bibliotheken,* London, 1953, 1, pp. 279-281, pl. XX, fig. 51 (here No. 286, detail of first two registers), as Italian, ca. 1450; J. Q. van Regteren Altena, *Bulletin van het Rijksmuseum,* VII, 1959, p. 83; Berenson, 1961, no. 164 C*, as school of Fra Angelico; R. W. Scheller, *Bulletin van het Rijksmuseum,* X, 1962, pp. 56-67, fig. 5 (here No. 285); Virch, 1962, no. 1 (here No. 285), as Florentine, first half of the 15th century; R. W. Scheller, *A Survey of Medieval Model Books,* Haarlem, 1963, p. 206, note 7; A. E. Popham and K. M. Fenwick, *European Drawings in the Collection of the National Gallery of Canada,* Toronto, 1965, p. 3, under no. 1, as Florentine school, ca. 1450; W. A. Simpson, *Journal of the Warburg and Courtauld Institutes,* XXIX, 1966, pp. 135-159; M. Laclotte, *Acta Historiae Artium, Academiae Scientiarum Hungaricae,* XIII, 1967, pp. 33-41; Degenhart and Schmitt, 1968, I-2, pp. 592, 619, note 14; M. Laskin, Jr., in *European Drawings from the National Gallery of Canada, Ottawa,* exhibition catalogue, P. and D. Colnaghi and Co., London, 1969, pp. 12-13, under no. 1, as Florentine school, ca. 1450; R. L. Mode, "The Monte Giordano Famous Men Cycle of Cardinal Giordano Orsini and the *Uomini Famosi* Tradition of Fifteenth-Century Italian Art," doctoral dissertation, University of Michigan, Ann Arbor, Michigan, 1970, pp. 43-86, pls. XXIXb (here No. 285), XXXb (here No. 286); I. Toesca, *Paragone,* 239, 1970, pp. 62-66; R. L. Mode, *Burlington Magazine,* CXIV, 1972, p. 370; F. Anzelewsky in *Vom späten Mittelalter bis zu Jacques Louis David,* exhibition catalogue, Staatliche Museen Preussischer Kulturbesitz, Berlin, 1973, pp. 21-25, under no. 27, as North Italian artist, ca. 1450; Bean, 1975, no. 33 (here No. 285), as North Italian artist, about 1450; B. Degenhart and A. Schmitt, *Corpus der italienischen Zeichnungen 1300-* *1450, part II, Venedig,* Berlin, 1980, 2, pp. 380-382, under no. 714, as French, mid-15th century ?; Frerichs, 1981, pp. 9-10, under no. 10, as Lombard, mid-15th century.

Bequest of Walter C. Baker, 1971
1972.118.10

This and the following vellum sheet (No. 286 below) bear delicately colored miniature paintings representing famous men (and women) of classical and biblical antiquity. They were part of a group of eight sheets that belonged in turn to William Morris, C. Fairfax Murray, and Sir Sydney Cockerell. The eight pages were dispersed at auction in London in 1958. In addition to the two sheets now in the Metropolitan Museum, one is in the National Gallery of Canada, Ottawa (no. 18 of the sale), one in the Rijksprentenkabinet, Amsterdam (no. 20), one in the National Gallery of Victoria, Melbourne (no. 21), one in the Ian Woodner Family Collection, New York (no. 22), while the present whereabouts of the remaining two is uncertain (nos. 16, 19). A ninth sheet, certainly belonging to the group, but without the Morris, Fairfax Murray, and Cockerell provenance, was acquired in 1960 by the Kupferstichkabinett, Berlin-Dahlem.

In 1962 R. W. Scheller suggested that these miniatures reflected a fresco series painted by Masolino in the early 1430s for Cardinal Giordano Orsini in his palace on Monte Giordano in Rome. Furthermore, he proposed that the copies were based not on the original frescoes, but on a complete record of Masolino's cycle preserved in a codex signed by the Lombard artist Leonardo da Besozzo, now in the Crespi collection, Milan. Scheller's conjectures were confirmed when in 1966 W. A. Simpson published early documents describing the frescoes at Monte Giordano. These texts made it clear that the Crespi codex reproduced Masolino's cycle in its entirety.

The Crespi codex contains thirty-eight pages recording a sequence of "uomini famosi" beginning with Adam and Eve and ending with Tamerlane (who died in 1405). Heinrich Brockhaus, who was the first to discuss the

Crespi codex at any length, dated it between 1436 and 1442 (in *Gesammelte Studien zur Kunstgeschichte . . . für Anton Springer,* Leipzig, 1885, pp. 42-63). More recently, Robert L. Mode has proposed a slightly earlier dating, suggesting that the copies were made by Leonardo da Besozzo in Rome on his way to or from Naples where he decorated the choir of S. Giovanni a Carbonara shortly after 1433 (R. L. Mode, *op. cit.,* 1972, p. 370). In Masolino's fresco decorations the Famous were probably represented in a continuous procession around the walls of the *sala theatri* of the palace, while Leonardo da Besozzo and the author of our sheets were obliged, because of the format of their pages, to represent the figures in short superimposed registers that read from left to right and from top to bottom. Thus the long bench, on which Agamemnon and Menelaus were seated facing each other in Masolino's fresco, was rendered by Leonardo da Besozzo in the Crespi codex as a single piece of furniture, even though it was necessary to cut the bench in half and relegate Menelaus to the left of the second register. That the present drawing derives from the model of the Crespi codex is clear, as Scheller pointed out, from the fact that our copyist has misunderstood this ingenious if somewhat awkward division and interpreted the long bench as two quite separate pieces of furniture. The nine drawings under discussion here are free copies of pages in the Crespi codex that cover a period ranging from 2509 to 3498 in the history of the created world (our No. 285 reproduces fol. 4 verso; and No. 286 below copies fol. 7 recto). Thus they are all pages that deal with pre-Christian history, since the birth of Christ is recorded in the Crespi codex as having occurred in the year 3963.

It should be emphasized that the quality of the figure draughtsmanship in the nine "copies" is distinctly superior to that found in the Crespi codex "originals." Our draughtsman must have been a specialist in manuscript illumination. He had a very refined sense of light and color, and gave his figures a solidity lacking in Leonardo da Besozzo's copies. The identity of the talented artist is a matter of speculation, as is the approximate date of the execution of the drawings. Berenson, who did not note the connection of the drawings to the Crespi codex, attributed them to the school of Fra Angelico. Fedja Anzelewsky proposed that the author

was a Lombard artist working 1440-1450. However, the artist was not necessarily Italian. The figure types show knowledge of the art of the Van Eycks, and Ilaria Toesca has pointed out subtle affinities with the manuscript illumination of Jean Fouquet. Prof. Toesca's suggestion, that the nine sheets may be the work of an artist in the milieu of King René of Anjou, has much to recommend it.

286. *"Uomini famosi": Romulus and Remus Suckled by the Wolf outside the Walls of Rome, the Erythraean Sibyl, Numa Pompilius, the Prophet Isaiah, the Cumaean Sibyl, the Prophet Jeremiah, and Midas*

Pen and brown ink, watercolor of various hues, on vellum. Faint counterproof of the sheet beginning with Elisha, no. 18 of the 1958 sale. 31.4 x 19.9 cm.

Inscribed in pen and brown ink in the first register, *.Roma. / .S.P.Q.R. / .Roma condituri fuerunt anno. iii*ai*.ccxxxiii.;* in the second register, *Sibilla. eritea. / Iudicii signum sudore / madescet.* [The sign of judgment becomes moist with sweat] / *fuit hoc t*p̄ore; *Numa pompilius / hic dedit leges / Romanis.* [He gave laws to the Romans] / *fuit anno iii*ai*cclii.; ysayas ppha* (and in another hand) *isaïe prophète / Ecce virgo concipiet / et pariet filium* [Isaiah 7:14, Behold a virgin shall conceive, and bring forth a son.] / *fuit h*° *t*p̄ore; in the third register, *Erofila Si billa. / Ecce veniet dives et nas . . . / . . . d paupcula et bestie terrarg / adorabūt eum clamabūt et / dicēt laudate eum in aster / celorg* [Behold, one who is rich will come and (will be born) of a poor maiden and the beasts of the earth will adore him (and) they will cry out and say: Praise him in the stars of the heavens] / *fuit h*° *t*p̄ore; *iremi as ppha. /* (and in another hand) *jeremie proph. / patrem invocabitis qui / terra fecit et condidit / terras* (this word crossed out) *celos.* [You will call upon the Father, who made the earth and established the heavens.] / *fuit anno iii*ai*.ccxviiii*°*.; mida Rex. / fuit h*° *tempore.* Numbered at upper right corner, 6.

PROVENANCE: William Morris; Charles Fairfax Murray; Fairfax Murray sale, London, Sotheby's, July 18, 1919, part of no. 50; Sir Sydney Cockerell; sale, London, July 2, 1958, no. 17, purchased by the Metropolitan Museum.

BIBLIOGRAPHY: See No. 285 above.

Harris Brisbane Dick Fund, 1958
58.105

See No. 285 above.

Roma·

S·p·q·r·

Roma condita fuerunt anno m̄ cxxxvij·

Sibilla critea Numa pompilius Ysayas p̄pha isaie p̄pḥete

fuit hoc t̄pore fuit anno m̄ cccc j· fuit t̄o t̄pore

Erofila Si billa ierem as p̄pha mca Rex
 ieremie
 p̄opḥt·

fuit b̄o t̄pore fuit anno m̄ cccc xxviij· fuit t̄o tempore

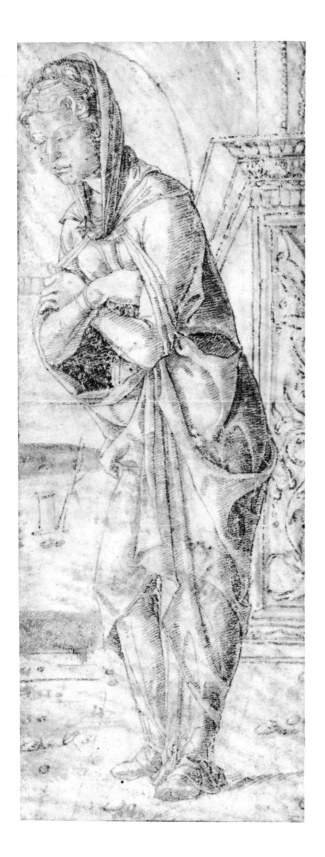

ANONYMOUS FERRARESE (?) ARTIST

end of the 15th century

287. *The Virgin Annunciate*

Pen and brown ink, brown wash, on parchment. 20.8 x 7.9 cm. Surface slightly abraded. Lined.

PROVENANCE: Henry Oppenheimer, London; Oppenheimer sale, London, Christie's, July 10, 13-14, 1936, no. 40, pl. 8, as Butinone; Elie de Talleyrand, Rome (according to vendor); purchased in New York in 1964.

BIBLIOGRAPHY: *Vasari Society,* second series, II, 1921, no. 1, repr., attributed to Francesco Cossa; *Exhibition of Italian Art 1200-1900,* Royal Academy, London, 1930, no. 619, attributed to Francesco Cossa; Lord Balniel and K. Clark, *A Commemorative Catalogue of the Exhibition of Italian Art Held in the Galleries of the Royal Academy, Burlington House, London, January-March, 1930,* Oxford and London, 1931, I, p. 238, no. 750, as Bernardino Butinone ?; Popham, 1931, no. 148, pl. CXXVI B, as Bernardino Butinone ?; Bean and Stampfle, 1965, no. 80, repr.

Pfeiffer Fund, 1964
64.137

The drawing was first published in 1921 with an attribution to Francesco del Cossa proposed by Tancred Borenius, and it was exhibited as such at the Royal Academy in 1930. On that occasion, A. G. B. Russell suggested the rather unlikely name of the Lombard Bernardino Butinone, and the drawing figured in the Oppenheimer collection under this designation. Cossa, however, seems nearer the mark, for the flat, broad, metallic folds of the drapery have a distinctly Ferrarese character, as do the square face and broad hands of the figure. Ferrarese drawings of the late fifteenth century are rare, and often of problematic attribution. At the present state of our knowledge of this material it seems impossible to say anything more specific of this fine design on parchment than that it is probably by a Ferrarese, or more generally Emilian, artist not far from Cosimo Tura or Marco Zoppo.

head entered the Metropolitan Museum in 1911. The drawing is by neither one nor the other of these two artists; and in fact, is very difficult to "situate." It could even be a pastiche of a Renaissance drawing executed in the seventeenth or eighteenth century.

ANONYMOUS NORTH ITALIAN (?) ARTIST

mid-16th century

289. *St. John the Baptist*

Pen and brown ink, brown wash. Framing lines in pen and brown ink. 18.5 x 11.5 cm. (overall). A horizontal strip .5 cm. in height has been added at lower margin. The design traced in black chalk on verso.

Inscribed in pen and brown ink on verso, *giorgione.*

PROVENANCE: Jan Pietersz. Zoomer (Lugt 1511); Valerius Röver ($\frac{32}{36}$ in pen and brown ink on verso, Lugt Supp. 2984a); J. Goll van Franckenstein (*N3260.* in red ink on verso, Lugt 2987); purchased in London in 1906.

Rogers Fund, 1906
06.1051.10

ANONYMOUS ARTIST

about 1500 ?

288. *Bust of a Man, His Gaze Directed Toward the Spectator*

Black chalk, some stumping. 32.6 x 23.6 cm. Scattered losses. Lined.

Inscribed in pen and brown ink at lower margin, *raffaello.*

PROVENANCE: Henry Reveley (Lugt 1356); Reveley sale, London, Christie's, May 11-12, 1852, as a self-portrait by Raphael (bought in); purchased in London in 1911 from a descendant of Henry Reveley.

BIBLIOGRAPHY: Reveley, 1820, p. 9, as a self-portrait by Raphael; *Metropolitan Museum of Art Bulletin,* June 1911, p. 140, as Timoteo Viti.

Rogers Fund, 1911
11.66.10

Henry Reveley, an eighteenth-century owner of this drawing, thought it was a self-portrait by Raphael. Langton Douglas seems to have been responsible for the attribution to Timoteo Viti with which this portrait

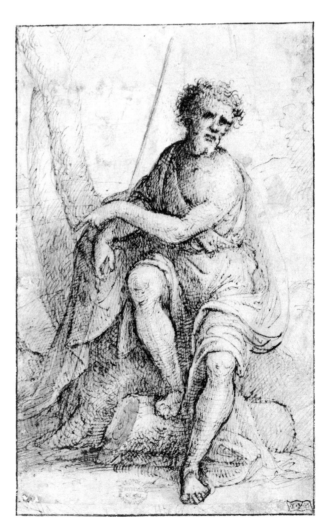

This drawing figured in portfolio No. 32 of Valerius Röver's collection under the name of Giorgione, but it seems to have been acquired by the Museum in 1906 as the work of Amico Aspertini. Both these attributions are to be rejected and the artist, possibly mid-sixteenth-century and North Italian, has yet to be identified.

Pen and brown ink, brown wash. Squared in black chalk. 18.0 x 20.4 cm.

Numbered in pencil at upper right, *n?* 2.

PROVENANCE: Purchased in New York in 1961.

Rogers Fund, 1961
61.20.5

ANONYMOUS EMILIAN (?) ARTIST
third quarter of the 16th century

290. *Mythological Scene: Venus before Apollo ?*

A similar composition, with notable variations, is found in a drawing in the Louvre which Philip Pouncey has suggested is close in style to Orazio Samacchini (Inv. 10494, anonymous Italian). Both drawings may derive from a lost original by Niccolò dell'Abate.

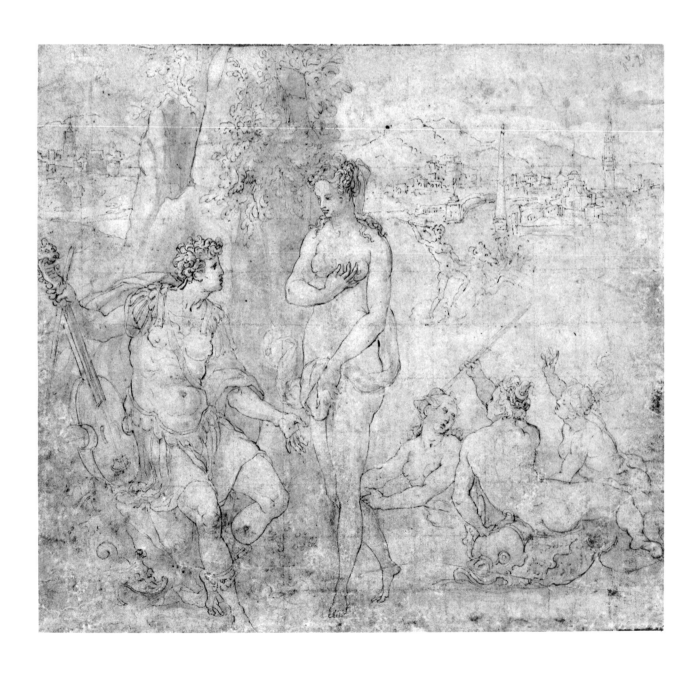

ANONYMOUS SIENESE ARTIST

late 16th century

291. *Family Group Kneeling before a Street Shrine*

Red and black chalk. Framing lines in pen and brown ink. 15.5 x 20.6 cm. Lined.

PROVENANCE: Purchased in London in 1908.

BIBLIOGRAPHY: Hellman, 1916, pp. 174-175, repr., as Federico Zuccaro.

Rogers Fund, 1908
08.227.11

The shrine is clearly dedicated to the Sienese Madonna di Provenzano. In style the drawing recalls the work of Francesco Vanni and Ventura Salimbeni, but it cannot be attributed to either of them.

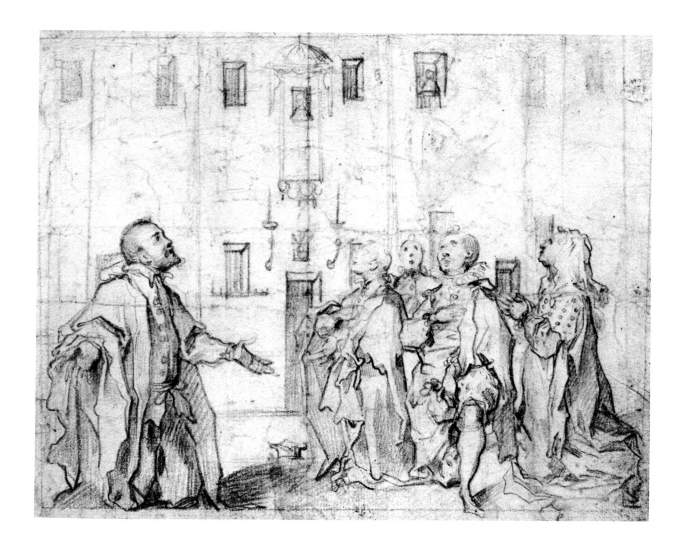

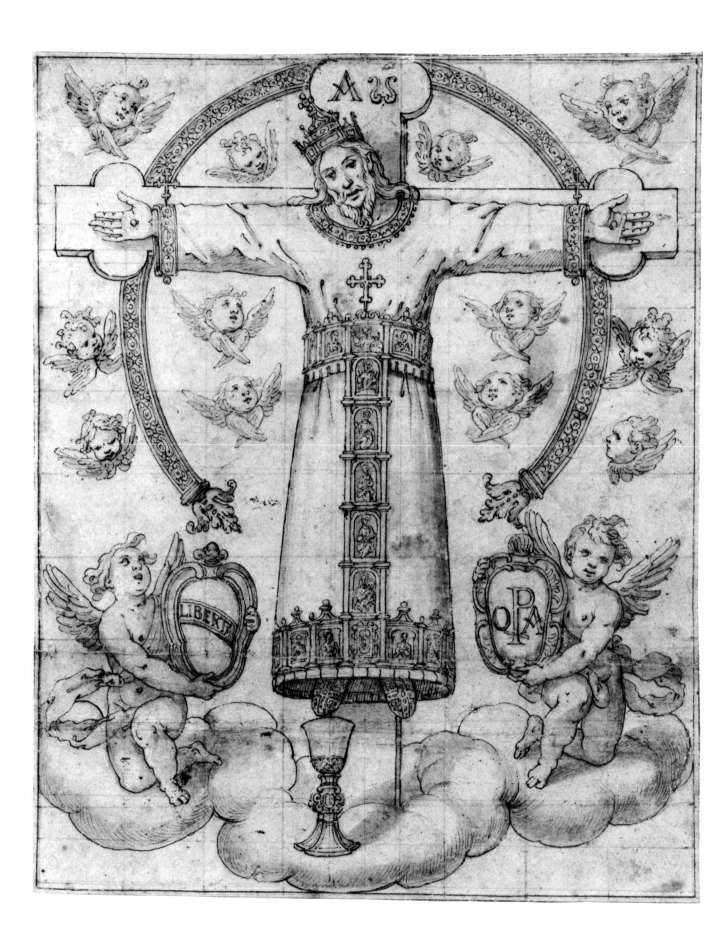

ANONYMOUS TUSCAN ARTIST

late 16th century

292. *The Volto Santo of Lucca*

Pen and brown ink, pale brown wash, over black chalk, on beige paper. Squared in black chalk. 37.9 x 30.2 cm. Horizontal crease below center.

PROVENANCE: Stefan Ehrenzweig, New York.

Gift of Stefan Ehrenzweig, 1961
61.211

The drawing may be a design for a processional banner. The *Volto Santo,* an ancient wooden figure of the crucified Christ preserved in the Duomo at Lucca, wears the same ornamented tunic as in a fresco by Amico Aspertini in S. Frediano, Lucca, the *Miraculous Arrival of the Volto Santo* (repr. F. Baroni, *Il Volto Santo di Lucca,* Lucca, 1932, opposite p. 64). At lower left a putto holds a shield bearing the motto of the city of Lucca, *Libertas;* the putto at lower right holds a shield with the monogrammatic emblem of an unidentified confraternity. The draughtsman must have been a Tuscan artist influenced by Jacopo da Empoli.

ANONYMOUS VENETIAN (?) ARTIST

late 16th century

293. *The Queen of Sheba before Solomon, with a Study of a Boy's Head Above*

Black and red chalk (the boy's head in black chalk alone), heightened with a little white, on blue paper. 29.8 x 20.0 cm. Lined.

Inscribed in pen and brown ink at left of center, *la Reginasabea Ascholta la sapientia De Salamō[e]*; in another hand at lower margin, *Basan.*

PROVENANCE: Sir James Knowles; Knowles sale, London, Christie's, May 27, 1908, part of no. 126, as "Bassano"; purchased in London in 1908.

BIBLIOGRAPHY: Fry, 1909, p. 7, as Leandro Bassano; *Metropolitan Museum, Italian Drawings,* 1942, no. 26, repr., as Leandro Bassano; Tietze, 1944, A229, pl. CXCVIII, 4, the attribution to Leandro Bassano rejected; Ames, 1962, no. 236, as Giovanni Contarini.

Rogers Fund, 1908
08.227.33

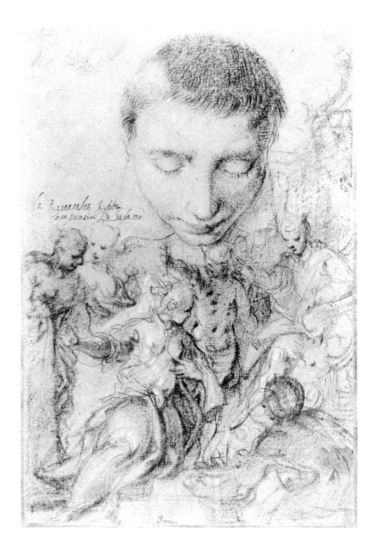

An old inscription assigns the drawing to an artist of the Bassano family, and Roger Fry, who purchased the sheet for the Museum in 1908, tentatively proposed the name of Leandro Bassano. The Tietzes — with reason, it seems to us — rejected the ascription to Leandro. They suggested a possible stylistic connection between the narrative scene at the bottom of the sheet and a drawing in the *Codice Resta* at the Ambrosiana, Milan, that Padre Resta attributed to the late sixteenth-century Venetian artist Giovanni Contarini (repr. Bora, 1976, no. 113). On the other hand, the head of a youth at the top of the sheet recalled for the Tietzes the portraiture of Tiberio Tinelli. Both these attributions are highly speculative. All that can be said with any certainty about this fine drawing is that it appears to be the work of a late sixteenth-century artist active in Venice or the Veneto.

Appendix: 17TH CENTURY
ITALIAN DRAWINGS
Acquired since 1978

ALESSANDRO ALGARDI

Bologna 1598 – Rome 1654

App. 1. *Design for a Finial with the Arms of the Aldobrandini and Pamphilj Families*

Pen and brown ink, brown wash, over black chalk. 31.3 x 20.2 cm. Lower and left margins somewhat irregular.

PROVENANCE: Purchased in Switzerland in 1979.

BIBLIOGRAPHY: *Dessins anciens. Pietro Scarpa, Venise,* exhibition catalogue, Grand Palais, Paris, 1978, no. 37, repr.; *Notable Acquisitions,* 1980, p. 50, repr.; C. Johnston in Ottawa, 1982, no. 62, repr.

Harry G. Sperling Fund, 1979
1979.131

The stars and the "bretessed bends" figure in the arms of the Aldobrandini family, while the lily and the dove with an olive branch in its beak are features of the arms of the Pamphilj. This design is no doubt associable with temporary decorations executed on the occasion of the marriage of Camillo Pamphilj, nephew of Pope Innocent X, to the heiress Olimpia Aldobrandini in 1647.

GIULIO BENSO ?

Pieve di Teco ca. 1601 – Pieve di Teco 1668

App. 2. *Jacob Wrestling with the Angel*

Pen and brown ink, brown wash, over traces of black chalk. 27.3 x 19.2 cm. Lined.

Inscribed in pen and brown ink at lower left, *guin;* in pencil on reverse of old mount, *J. Gheyn.*

PROVENANCE: Harry G. Friedman, New York.

Gift of Harry G. Friedman, 1964
64.245

The drawing entered the collection in 1964 with an old and implausible ascription to J. de Gheyn II. Both J. Q. van Regteren Altena and Keith Andrews suggested that the drawing was Genoese. Lawrence Turčić proposes an attribution to Giulio Benso based on the close stylistic connection with a print representing the same subject by Camillo Cungi after Giulio Benso (C. Le Blanc, *Manuel de l'amateur d'estampes,* Paris, 1854-1888, II, p. 76, no. 2; repr. M. Newcome, *Paragone,* 355, 1979, fig. 36a).

App. 2

GIOVANNI ANGELO CANINI

Rome 1617 – Rome 1666

App. 3. *Allegorical Composition with a Young Man Kneeling before a Tree*

Pen and brown ink, brown wash, heightened with white, over black chalk, on brown-washed paper. 24.0 x 16.9 cm.

Inscribed in pen and brown ink on plaque near upper margin, ACADEMIA; on verso, *di Franceschini da Bologna;* at lower margin of old mount, *del Franceschini.*

PROVENANCE: Janos Scholz, New York; purchased in New York in 1952; transferred from the Department of Prints, 1980.

BIBLIOGRAPHY: N. Turner, *Master Drawings,* XVI, 4, 1978, p. 393, pl. II.

The Elisha Whittelsey Collection
The Elisha Whittelsey Fund, 1952
1980.119

App. 3

Nicholas Turner, who was responsible for the attribution of the drawing to Canini, suggested that the arms held up by a putto on the right are those of the Chigi: a "*stemma* of three *monti* surmounted by a star (rendered as if in soft sculpture)." Turner described the scene as a representation of a young man contemplating the Chigi arms, which inspire him to set out with the soldier in the background to scale the mountain on the summit of which stands Fame holding a laurel crown.

GIOVANNI ANDREA CARLONE
Genoa 1639 – Genoa 1697

App. 4. *Adam and Eve after Their Expulsion, with the Infants Cain and Abel*

Pen and brown ink, pale brown wash, heightened with white, over black chalk, on blue paper. Squared in black chalk. 21.0 x 29.2 cm.

Inscribed in pen and brown ink on verso, *Gio Anda. Carlone.*

PROVENANCE: Sale, London, Sotheby's, December 10, 1979, no. 294, purchased by the Metropolitan Museum.

Harry G. Sperling Fund, 1980
1980.20.1

GIACOMO CAVEDONE

Sassuolo (Modena) 1577 – Bologna 1660

App. 5. *Kneeling Youth Facing Left*

Charcoal, heightened with white, on blue paper. 33.2 x 25.1 cm. Upper right corner replaced. Lined.

Inscribed in pen and brown ink at lower margin, *Cavedone;* numbered in pen and brown ink at lower right corner, *66 3.*

PROVENANCE: Mark mistakenly associated with Pierre Crozat (Lugt 474); purchased in Paris in 1979.

BIBLIOGRAPHY: *Exposition de dessins de maîtres anciens et modernes. Galerie de Bayser,* exhibition catalogue, Paris, 1978, no. 9, repr.

Harry G. Sperling Fund, 1979
1979.10.5

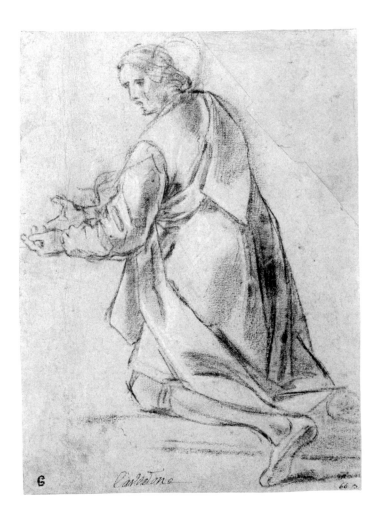
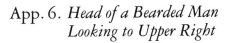

App. 6. *Head of a Bearded Man Looking to Upper Right*

Charcoal. Charcoal sketch of the head of an old man on verso. 15.8 x 16.4 cm.

Faint inscriptions in pen and brown ink at lower right, *Guido,* corrected in another ink to, *Cavedon;* numbered in pen and brown ink at upper right, *n. 510.*

PROVENANCE: John Steiner, Larchmont, New York.

Gift of John Steiner, 1979
1979.24

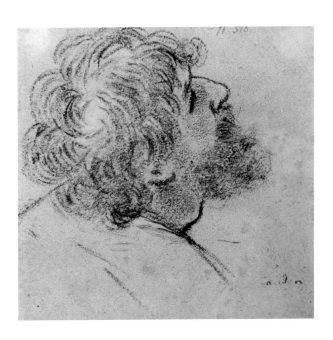

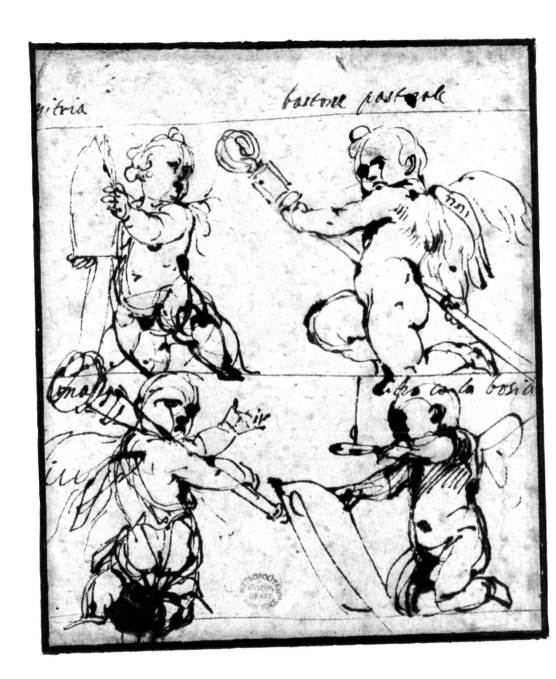

DANIELE CRESPI

Busto Arsizio ca. 1598 – Milan 1630

App. 7. *Putti with a Mitre, Crosier, Mace, Book, and Candle*

Pen and brown ink, on faded blue paper. 15.9 x 13.6 cm. Lined.

Inscribed in pen and brown ink in the artist's hand at upper left, *mitria;* at upper right, *bastone pastorale;* at left center, *mazza;* at right center, *libro con la bogia.* Inscribed in blue pencil on reverse of old mount, *Correggio ?.*

PROVENANCE: James Jackson Jarves; Cornelius Vanderbilt.

BIBLIOGRAPHY: *Metropolitan Museum Hand-book,* 1895, no. 217, as Correggio ?; C. Ricci, *Rassegna d'arte,* I, 1901, p. 10, repr. p. 9, possibly by Correggio; A. Venturi, *L'arte,* V, 1902, p. 354, not by Correggio; Ricci, 1930, p. 184, not by Correggio; *Metropolitan Museum, Italian Drawings,* 1942, no. 22, repr., as Correggio ?; Heaton-Sessions, 1954, p. 227, fig. 19, as Orazio Samacchini; Popham, 1957, pp. 187-188, possibly by Pietro Testa; L. Turčić, *Master Drawings,* XIX, 1, 1981, pp. 23-25, pl. 20.

Gift of Cornelius Vanderbilt, 1880
80.3.217

Study for two pair of putti holding ecclesiastical paraphernalia that appear in the lower frieze of the choir in the church of the Certosa di Pavia. Lawrence Turčić, who attributed this drawing to Daniele Crespi, pointed out that a pen sketch at the Musée des Beaux-Arts in Besançon, formerly attributed to Pietro Testa, is a study for additional putti with episcopal emblems in the frieze (D 1656; repr. L. Turcić, *op. cit.,* pl. 21).

See also App. No. 8 below.

App. 8. *Putti with a Small Keyboard Instrument and Music Books*

Pen and brown ink. 5.2 x 18.8 cm. The support consists of two sheets of paper joined vertically at right of center; upper margin irregular; scattered losses. The drawing has been mounted on a sheet measuring 6.0 x 18.8 cm., and the drawing continued at upper right (the putto's head) by another hand.

Inscribed in pen and brown ink at lower right margin, *R.V.*

PROVENANCE: Sale, London, Sotheby's, December 10, 1979, no. 246, as P. del Vaga; Kurt Einhorn, Düsseldorf; purchased in New York in 1981.

Purchase, Howard J. and Saretta Barnet Gift, and David L. Klein, Jr., Memorial Foundation Inc. Gift, 1981
1981.400

Shortly after the publication of App. No. 7 above as the work of Daniele Crespi, Kurt Einhorn proposed that the present drawing, then in his collection, might be by Daniele, and for the decorations in the Certosa di Pavia. Indeed, these music-making putti appear with variations in a frieze in the choir immediately below the fresco representing St. Bruno Praying before a Crucifix (repr. A. Morassi, *La Certosa di Pavia,* Rome, 1938, p. 69).

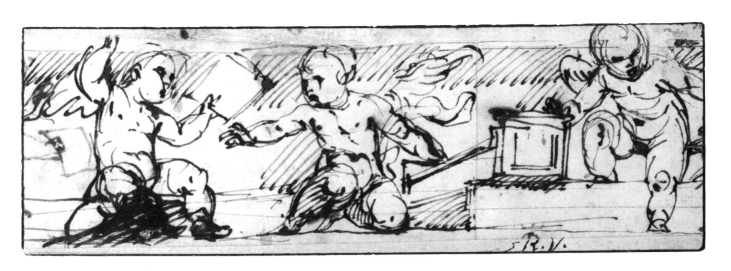

DOMENICO FETTI

Rome ca. 1588/1589 – Venice 1623

App. 9. *Head of a Bearded Man*

Black chalk, red, yellow, and pink pastel, heightened with white, on gray-green paper. 34.9 x 24.6 cm. Lined.

Numbered in pen and brown ink at upper right, *6;* inscribed on the Mariette mount within a cartouche, DOMINICUS / FETI ROMAN., and in another hand, *sc. del Cigoli.*

PROVENANCE: Pierre-Jean Mariette (Lugt 2097); Mariette sale, Paris, 1775-1776, no. 403, "Une belle Tête de Vieillard à barbe, dessinée aux trois crayons."; Marquis de Lagoy (Lugt 1710); M. Villenave; Villenave sale, Paris, Alliance des Arts, December 1-3, 5-8, 1842, no. 77 (Lugt 61); sale, Amsterdam, Frederick Muller and Co., November 20, 1882 (according to inscription on reverse of old mount); A. Freiherr von Lanna (Lugt 2773); Lanna sale, Stuttgart, H. G. Gutekunst, May 6-11, 1910, no. 135; purchased in Lausanne in 1981.

BIBLIOGRAPHY: *Dessins du XVI^e et du XVII^e siècle dans les collections privées françaises,* exhibition catalogue, Galerie Claude Aubry, Paris, 1971, no. 49, repr.

Harry G. Sperling Fund, 1981
1981.394

The attribution to Domenico Fetti goes back at least to the time of P.-J. Mariette, and the intensity of the gaze of the astutely observed sitter recalls Fetti's celebrated painting, the *Portrait of an Actor,* in the Hermitage, Leningrad (repr. P. Askew, *Burlington Magazine,* CXX, 1978, p. 61, fig. 2). Pastels are used here in a fashion that Fetti would have learned from his master Cigoli, who in turn was strongly influenced by the pastel head studies of Federico Barocci.

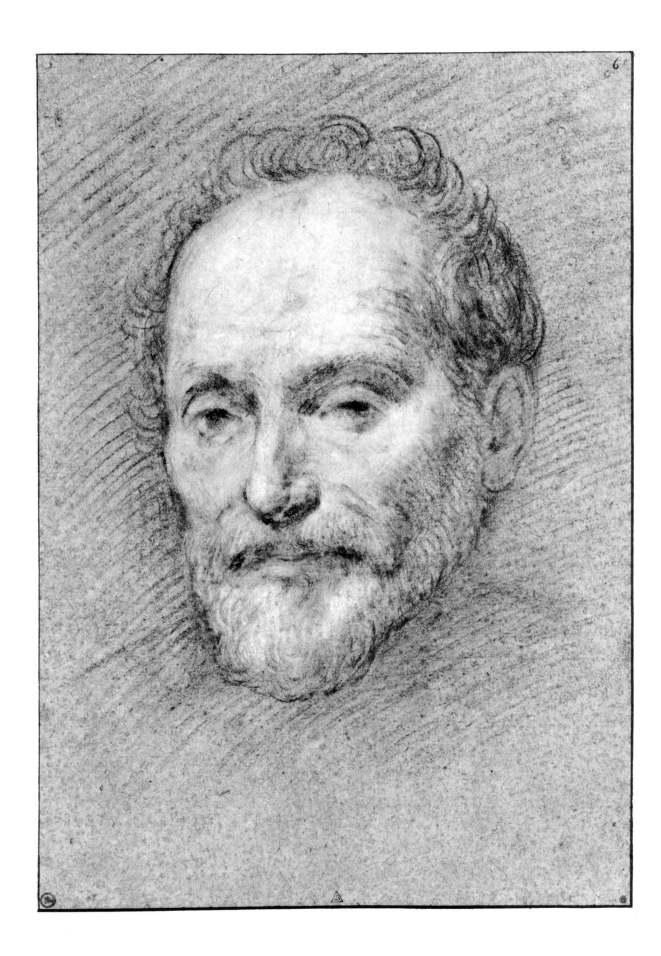

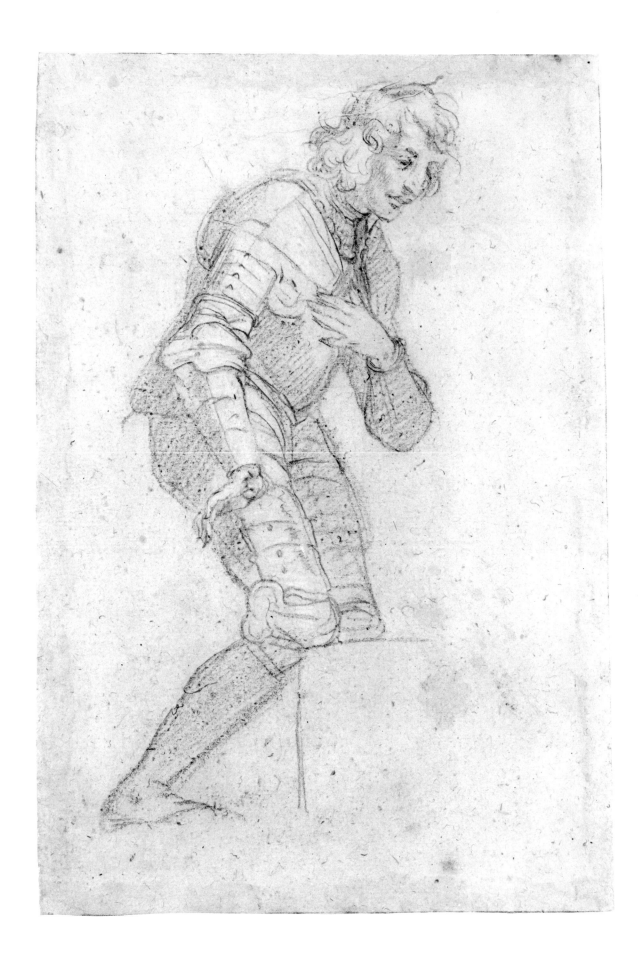

BALDASSARE FRANCESCHINI,
called Il Volterrano

Volterra 1611 – Florence 1689

App. 10. *Kneeling Youth in Armor*

Red chalk on beige paper. 41.8 x 28.0 cm.

PROVENANCE: Purchased in London in 1980.

Harry G. Sperling Fund, 1980
1980.9

Study for the kneeling figure of Charles V in a fresco by
Volterrano at the Villa della Petraia near Florence, repre-
senting Pope Clement VII de' Medici crowning the
emperor at Bologna (M. Winner, *Mitteilungen des
Kunsthistorischen Institutes in Florenz,* x, 4, 1963, p. 227,
fig. 8). The fresco is an early work by Volterrano, and it is
part of a cycle depicting high points in the history of the
Medici family. A black chalk composition study for the
Coronation scene is preserved in the Albertina in Vienna
(*Beschreibender Katalog,* III, 1932, no. 650). At the Uffizi
there are a number of red chalk studies for individual
figures in the fresco (A. M. Petrioli Tofani in *La quadreria
di Don Lorenzo de' Medici,* exhibition catalogue, Villa
Medicea, Poggia a Caiano, 1977, pp. 91-93, nos. 31-38,
repr.).

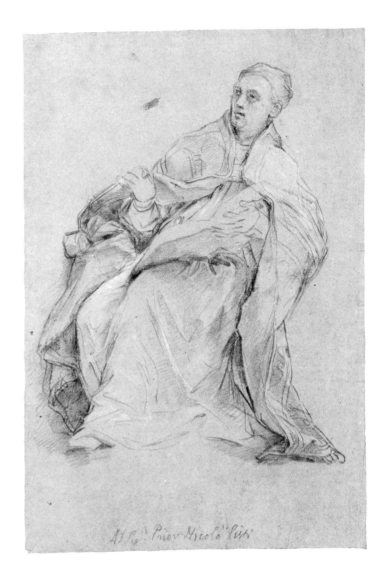

CARLO MARATTI

Camerano 1625 – Rome 1713

App. 11. *Seated Prelate*

Black chalk, heightened with white, on blue-gray paper. 39.1 x 26.0
cm. Spot of gray wash at upper left. Lined.

Inscribed in black chalk at lower margin, *Al Sig. Prior Nicolò Sisti* [?];
in pen and brown ink at lower margin of old mount, *di Carlo Maratti.*

PROVENANCE: F. A. Drey, London; Sir John Pope-Hennessy.

BIBLIOGRAPHY: Blunt and Cooke, 1960, p. 56, under no. 286; E.
Schaar in *Kataloge des Kunstmuseums Düsseldorf. Handzeichnungen, I.
Die Handzeichnungen von Andrea Sacchi und Carlo Maratta,* Düsseldorf,
1967, p. 127, under no. 343; J. Bean, *17th Century Italian Drawings in
The Metropolitan Museum of Art,* New York, 1979, p. 211, under no.
277.

Gift of Sir John Pope-Hennessy, 1981
1981.364

Study, with slight variations, for the seated figure of St.
Gregory the Great in the *Discourse on the Immaculate
Conception,* the altarpiece in the Cybo chapel, S. Maria del
Popolo, Rome. Maratti made a great many studies for
this painting, which was finished in 1686; the Met-
ropolitan Museum already possesses two designs for the
whole composition (J. Bean, *op. cit.,* nos. 277, 278,
repr.). Two chalk drawings for the head of St. Gregory
the Great have survived: one is in the British Museum
(1927-5-18-6; repr. A. Mezzetti, *Rivista dell'Istituto
Nazionale d'Archeologia e Storia dell'Arte,* IV, 1955, p.
279, fig. 24), the other in the Biblioteca Nacional,
Madrid (no. 7970, repr. M. B. Mena Marqués, *Mit-
teilungen des Kunsthistorischen Institutes in Florenz,* xx,
1976, p. 247, fig. 28). At the Kunstmuseum in Düssel-
dorf there is a free pen sketch for the whole figure of St.
Gregory (FP 540; E. Schaar, *op. cit.,* no. 343; Gernsheim
photograph 87,535).

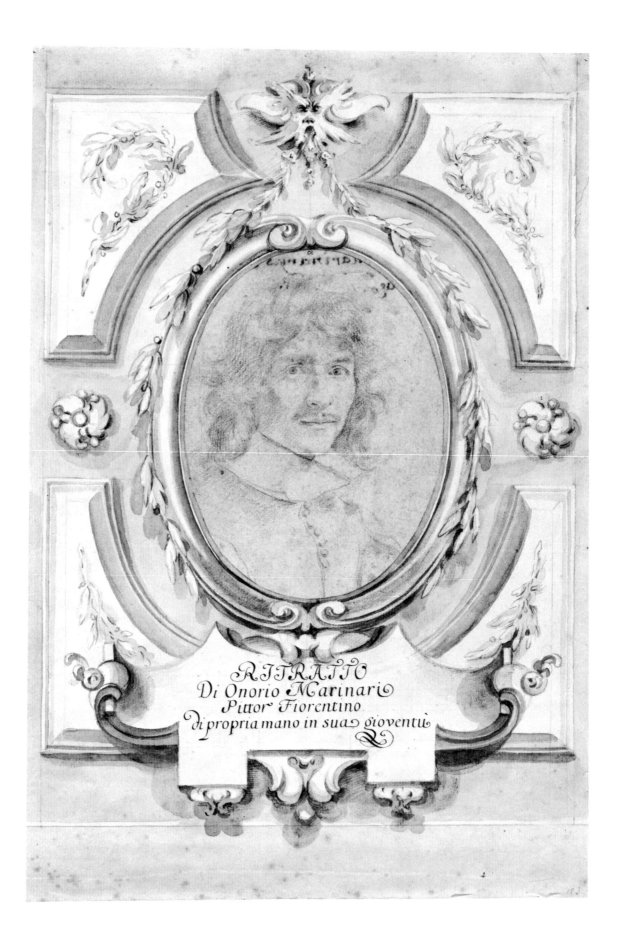

RITRATTO
Di Onorio Marinari
Pittor Fiorentino
di propria mano in sua gioventù

ONORIO MARINARI

Florence 1627 – Florence 1715

App. 12. *Self-Portrait*

Black and red chalk on beige paper (the oval portrait); brush and gray wash over black chalk (the drawn frame). Oval, 15.0 x 11.4 cm. Frame, 36.5 x 24.6 cm.

Inscribed in pen and brown ink on cartouche, RITRATTO / *Di Onorio Marinari / Pittor Fiorentino / di propria mano in sua gioventù;* in pen and brown ink on verso (partly visible through old backing), [M]*arinarys,* and in another hand, *Ritrato di Onorio / Marinari . . . / Fiorentino . . . / di sua. . . .*

PROVENANCE: Charles Rogers (Lugt 625); Rogers sale, London, T. Philipe, April 15-23, 1799, no. 412 (according to Christie's); sale, London, Christie's, March 26, 1974, no. 10, repr.; purchased in Rome in 1980.

Purchase, David L. Klein, Jr., Memorial Foundation Inc. Gift, 1980
1980.281

Marinari's painted self-portrait in the Uffizi, dated 1709 when he was in his early 80s, shows the same physiognomy (repr. *Gli Uffizi, catalogo generale,* Florence, 1979, p. 927, no. A573).

The drawing figured in the collection of Charles Rogers with a great many more portraits or self-portraits of Italian artists mounted on similarly elaborate drawn frames with identifying titles in Italian. These portraits are now widely dispersed, though mention should be made of six in the Ashmolean Museum (portraits of G. L. Bernini, Donato Creti, Pontormo, Elisabetta Sirani, Francesco Solimena, see Parker II, nos. 792, 986, 489, 953, 956, respectively; also Pietro da Cortona, see Macandrew, 1980, p. 103, no. 835A).

GIOVANNI BATTISTA MOLA

Coldrerio 1585 – Rome 1665

and

PIER FRANCESCO MOLA

Coldrerio 1612 – Rome 1666

App. 13. *Album Containing Architectural, Ornament, and Figure Drawings*

PROVENANCE: Probably Queen Christina of Sweden; Decio Cardinal Azzolini; Marchese Pompeo Azzolini; Prince Livio Odescalchi (the album may be the book of architectural drawings by P. F. Mola that is said to figure in the 1713 inventory of the Odescalchi collection; see J. Q. van Regteren Altena, *Les Dessins italiens de la reine Christine de Suède,* Stockholm, 1966, p. 29, note 46); purchased in Switzerland in 1978.

BIBLIOGRAPHY: E. Schleier, *Antichità viva,* XVI, 6, 1977, p. 20, one drawing (here App. No. 13l) repr.

Harry G. Sperling Fund, 1978
1979.62.1

Of the sixty-six drawings mounted in this album, fifty-four are architectural or ornamental designs by Giovanni Battista Mola (almost all of them signed, many of them dated 1631). Pier Francesco Mola has added figural elements to fourteen of his father's architectural schemes, and the album also contains two drawings by the hand of Pier Francesco alone. The remaining drawings in the album are architectural and ornament schemes that appear to be the work of a later hand. The designs by the architect Giovanni Battista Mola in the album include projects for altars, doors, wall tombs, palace and church façades, towers, fortifications, cannons, and an escutcheon with the arms of Pope Urban VIII Barberini. These architectural designs will be published in the *Metropolitan Museum Journal.* Here we reproduce only those sheets in which there are figural elements drawn by Giovanni Battista's son, the painter Pier Francesco Mola.

a. (fol. 2) *Design for a Doorway Surmounted by a Niche*

Pen and brown ink, brown wash, over a little black chalk. 20.1 x 13.7 cm.

Signed in pen and brown ink at lower center, *GBa Mola f.*

The Virgin and Child in the niche and the figures reclining on the pediment are by Pier Francesco Mola.

b. (fol. 7) *Design for a Doorway*

Pen and brown ink, over a little black chalk. 20.3 x 12.5 cm.

Signed in pen and brown ink at lower center, *GBa Mola f.*

The shield and the two figures on the pediment are by Pier Francesco Mola.

c. (fol. 9) *Design for a Doorway*

Pen and brown ink, over a little black chalk. 19.2 x 13.0 cm.

Signed and dated in pen and brown ink at lower center, *GBa Mola f 1631.*

The urn and the two figures on the pediment are by Pier Francesco Mola.

d. (fol. 14) *Design for a Rusticated Doorway*

Pen and brown ink, pale brown wash, over a little black chalk (the doorway); black chalk (the figures on the pediment). 19.7 x 14.4 cm.

Signed in pen and brown ink at lower center, *GBa Mola f.*

The figures on the pediment are by Pier Francesco Mola.

e. (fol. 16) *Design for a Doorway Surmounted by Papal Arms*

Pen and brown ink, over a little black chalk (the doorway); black chalk (the figures on the pediment). 17.8 x 12.3 cm.

Signed and dated in pen and brown ink at lower center, *GBa Mola f 1631.*

The figures on the pediment are by Pier Francesco Mola.

a

b

c

d

e

f

f. (fol. 22 verso) *An Empty Coat of Arms Supported by a Standing Youth*

Red chalk. 19.3 x 13.8 cm. Several brown stains. Fol. 22 recto bears a signed pen design for a doorway by G. B. Mola; these pen lines show through on fol. 22 verso.

This red chalk design is by Pier Francesco Mola.

g. (fol. 27) *Design for the Gate to a Garden or Vineyard*

Pen and brown ink, brown wash, over a little black chalk. 18.2 x 14.0 cm.

Signed and dated in pen and brown ink at lower center, *GBa Mola f 1631;* inscribed at upper margin, *porta di Giardino o Vig*[n]a.

The figures on the pediment are by Pier Francesco Mola.

h

g

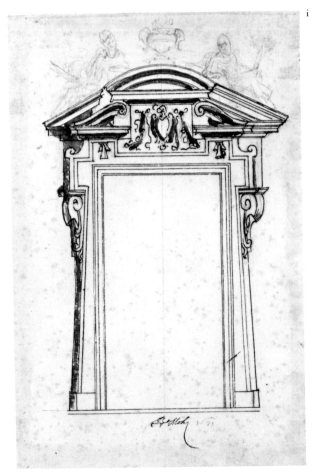

i

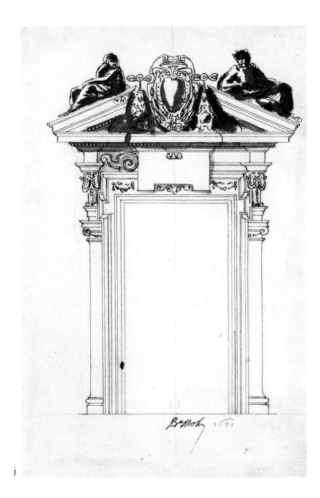

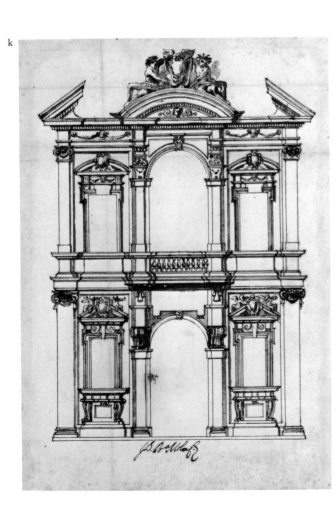

h. (fol. 31) *Design for a Doorway*

Pen and brown ink, over a little black chalk (the doorway), faint black chalk (the figure on the pediment to the left). 19.0 x 13.4 cm.

Signed in pen and brown ink at lower center, *GBᵃ Mola f*.

The scarcely visible reclining figure sketched in pale black chalk on the pediment to the left is by Pier Francesco Mola.

i. (fol. 32) *Design for a Doorway*

Pen and brown ink, brown wash, over a little black chalk (the doorway), faint black chalk (the urn and the figures on the pediment). 18.6 x 12.5 cm.

Signed and dated in pen and brown ink at lower center, *GBᵃ Mola f 1631*.

The urn and the figures reclining on the pediment are by Pier Francesco Mola.

j. (fol. 36) *Design for a Doorway Surmounted by the Arms of a Cardinal*

Pen and brown ink, brown wash, over a little black chalk. 18.5 x 12.3 cm.

Signed and dated in pen and brown ink at lower center, *GBᵃ Mola f 1631*.

The figures on the pediment are by Pier Francesco Mola.

k. (fol. 42) *Design for a Façade*

Pen and brown ink, brown wash, over a little black chalk. 27.1 x 18.5 cm.

Signed in pen and brown ink at lower margin, *G.Bᵃ Mola f*.

The coat of arms and the figures that support it on the central pediment are by Pier Francesco Mola.

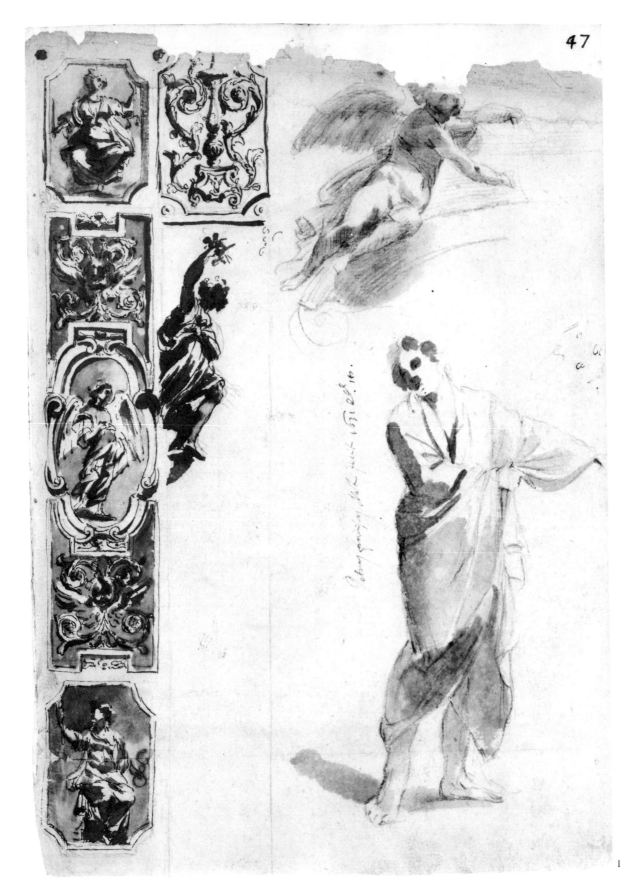

l. (fol. 45) *Sheet of Studies: Standing Man, Flying Angels, and a Design for a Decorative Panel*

Pen and brown ink, brown wash, over black chalk. 28.3 x 20.4 cm. Upper margin irregular; horizontal crease near lower margin.

Inscribed in pen and brown ink at center, *Petrus franciscus Mola fecit 1631 aᵉ 18.*

All the sketches on this sheet are by Pier Francesco Mola; they are dated 1631, when the artist was eighteen.

m. (fol. 46) *Design for a Wall Niche*

Pen and brown ink, brown wash, over a little black chalk. 19.7 x 11.9 cm.

Signed and dated in pen and brown ink at lower center, *GBᵃ Mola f 1631.*

The standing prophet or saint in the niche, and the winged putti on the pediment, are by Pier Francesco Mola.

n. (fol. 47) *Design for an Altar*

Pen and brown ink, brown wash, over a little black chalk. 21.4 x 14.0 cm.

Signed in pen and brown ink at lower center, *GBᵃ Mola f.*

The sketch of the penitent Magdalene in the altarpiece is by Pier Francesco Mola.

o. (fol. 49) *Two Designs for Wall Niches*

Pen and brown ink, brown wash, over a little black chalk. 17.1 x 19.0 cm. Two sheets joined vertically at center.

Signed in pen and brown ink at lower left, *GBᵃ Mola f;* and signed and dated at lower right, *GBᵃ Mola f 1631.*

The bacchic figure in the niche at the left and the vestal virgin in that to the right are by Pier Francesco Mola.

p. (fol. 50) *Two Designs for Wall Tombs*

Pen and brown ink, over a little black chalk. 20.1 x 19.5 cm. Two sheets joined vertically at center.

Signed in pen and brown ink at lower left and right, *GBᵃ Mola f;* inscribed in pen and brown ink at upper left corner, *Quest' ornamᵗᵒ é per / un' deposito, da meter / in uno posto stretta.*

Only the bust in the niche at the top of the left wall tomb is by Pier Francesco Mola.

m

n

o

p

Quest' ornamto è per
un deposito, da meter
in una parte streta

DOM

DOM

ASTOLFO PETRAZZI

Siena 1579 – Siena 1665

App. 14. *Unidentified Subject: Standing Man Bestowing a Scapular (?) on a Kneeling Figure*

Pen and brown ink, brown wash. 31.3 x 22.2 cm. All four corners replaced; a number of gray stains at left.

Inscribed in pen and dark brown ink at lower right, *palmi. . . .*

PROVENANCE: Old, unidentified paraph on verso (Lugt 2956); Francis G. Hickman, Memphis, Tennessee (according to Christie's); sale, London, Christie's, March 25-26, 1963, part of no. 219, as Francesco Vanni; sale, London, Sotheby's, December 10, 1979, no. 226, repr., purchased by the Metropolitan Museum.

BIBLIOGRAPHY: *Exhibition of Old Master Drawings. Yvonne ffrench,* London, 1963, no. 10, repr., as Francesco Vanni; P. Pouncey, *Revue de l'Art,* 14, 1971, p. 70, note 17, fig. 12, attributed to Astolfo Petrazzi.

Harry G. Sperling Fund, 1980
1980.20.4

The attribution to the little-known Astolfo Petrazzi is due to Philip Pouncey.

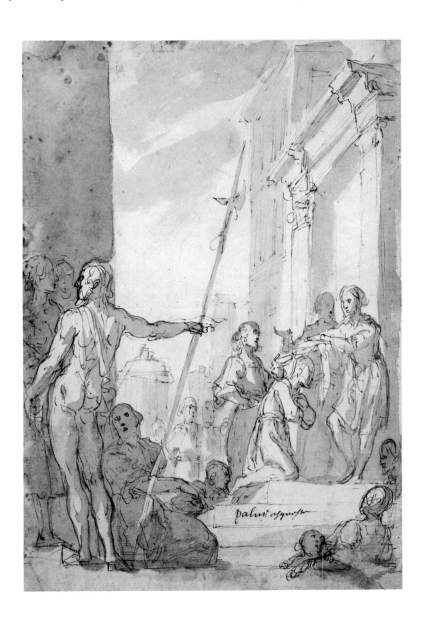

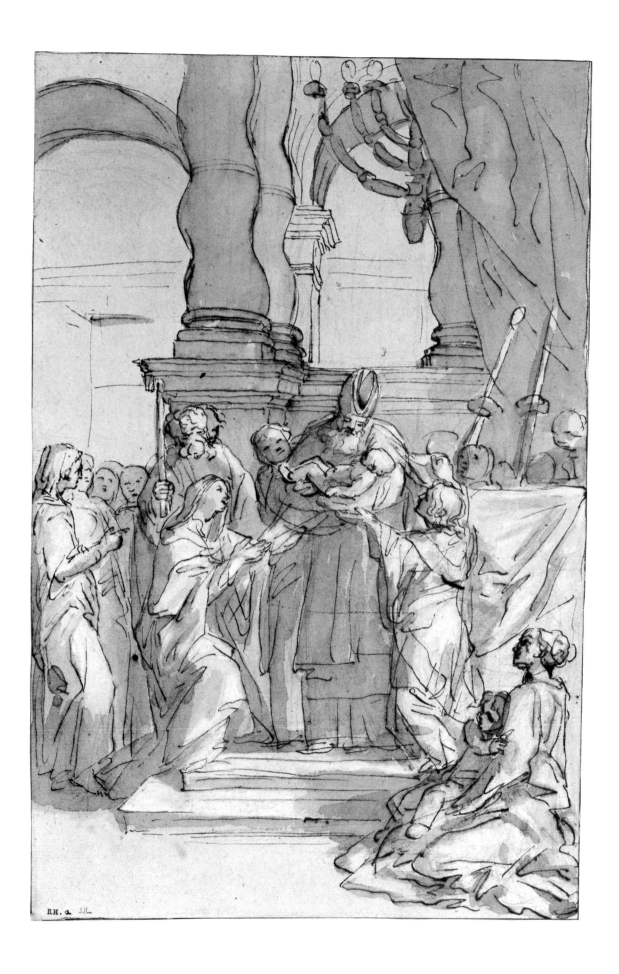

PIETRO ANTONIO DE PIETRI

Premia 1663 (or 1665) – Rome 1716

App. 15. *The Presentation of the Infant Jesus in the Temple* (Luke 2:22-38)

Pen and brown ink, brown wash, heightened with a little white, over black chalk, on beige paper. 38.1 x 24.8 cm. Lined.

Numbered in pen and brown ink at lower left, *2;* inscribed in pen and brown ink at lower margin of old mount, *Pietro de Petri.*

PROVENANCE: Richard Houlditch (Lugt 2214); John Jacob Lindman (Lugt Supp. 1479a); private collection, Cleveland, Ohio (according to vendor); purchased in New York in 1980.

BIBLIOGRAPHY: A. Percy in *A Scholar Collects, Selections from the Anthony Morris Clark Bequest,* exhibition catalogue, Philadelphia Museum of Art, 1980, p. 18, under no. 7.

Harry G. Sperling Fund, 1980
1980.122

Pietro de Pietri made a number of drawings for a vertical representation of the Presentation of the Infant Jesus in the Temple, with full-length figures in a spacious architectural setting. A large pen and wash study in Chicago includes the twisted columns that figure so conspicuously in the upper part of our composition, but the kneeling Virgin appears at the right (1972.323; repr. H. Joachim and S. Folds McCullagh, *Italian Drawings in the Art Institute of Chicago,* Chicago, 1979, no. 93, pl. 100). A red chalk drawing in the Kupferstichkabinett, Berlin-Dahlem, with a different architectural setting, has been connected by Peter Dreyer with a painting formerly in the collection of Tomás Harris, London (KDZ 18232 verso; P. Dreyer, *Zeitschrift für Kunstgeschichte,* XXXIV, 3, 1971, pp. 188-191, figs. 2, 6). In the Berlin drawing the Virgin appears at the right as she does in a red chalk sketch of the same subject in the Philadelphia Museum of Art (1978-70-386; A. Percy, *op. cit.,* p. 155, no. 148), and in a pen and wash study that was sold in London at Christie's on March 28, 1979 (no. 207, recto repr.).

Except in subject matter this group of drawings has no connection with the *Presentation of the Infant Jesus* in S. Maria in Via Lata, Rome, one of the four oval compositions that Pietro de Pietri executed at the end of his life for the side walls of the nave of that church. The figures in these ovals are three-quarter length, and they occupy almost all of the pictorial space, leaving room for only a slight indication of architectural setting. A drawing for the oval representation of the *Presentation of Christ* is at Windsor Castle (Blunt and Cooke, 1960, no. 671, fig. 66).

App. 16. *Young Cleric Kneeling before a Pope*

Pen and brown ink, brown wash, over black chalk. 18.5 x 11.6 cm.

PROVENANCE: Earl Spencer (Lugt 1531); Spencer sale, London, T. Philipe, June 10-17, 1811, no. 573; William Bateson (Lugt Supp. 2604a); Bateson sale, London, Sotheby's, April 23-24, 1929, no. 8, as Andrea Boscoli; Robert Isaacson, New York.

Gift of Robert Isaacson, 1981
1981.23

The drawing was correctly given to Pietro de Pietri in the Spencer sale in 1811, but by the time it appeared — more than a hundred years later — in the Bateson sale at Sotheby's in 1929, it had acquired a mistaken attribution to Andrea Boscoli. The 1929 catalogue states: "A copy of this drawing by Pietro di Pietri is in the British Museum." Indeed, in the British Museum there is a rather feeble copy of the composition, presumably made after our drawing (1874-8-8-2271).

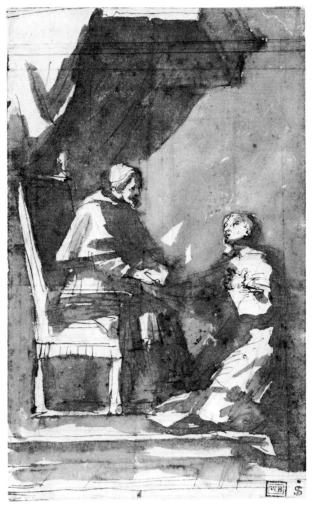

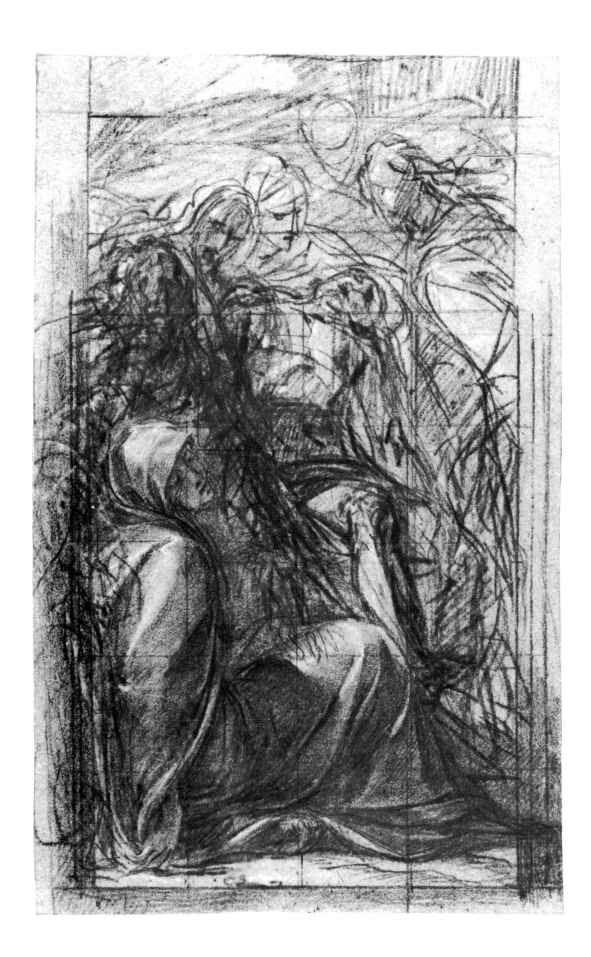

GIULIO CESARE PROCACCINI

Bologna 1574 – Milan 1625

App. 17. *Pietà*

Black chalk, heightened with white, on blue paper. Squared in black chalk. 23.6 x 15.0 cm. Horizontal crease near upper margin. Lined.

Inscribed in pen and brown ink twice on reverse of old mount, *di Camillo Procaccini*.

PROVENANCE: Worsley collection (according to inscription on mount); private collection, Denmark (according to Sotheby's); sale, London, Sotheby's, March 25, 1982, no. 7, repr., purchased by the Metropolitan Museum.

Harry G. Sperling Fund, 1982
1982.92

Nancy Ward Neilson recently identified this drawing as a study for the *Pietà* in S. Maria presso S. Celso, Milan, Giulio Cesare Procaccini's earliest known oil painting, delivered to the church in 1604 (for the painting see H. Brigstocke, *Jahrbuch der Berliner Museen,* XVIII, 1976, pp. 85, 87, fig. 1). There are only minor differences between this composition study and the painting.

A sheet of pen figure studies by Giulio Cesare in the Ambrosiana, Milan, has been convincingly connected with the *Pietà* by Emma Spina Barelli (*Disegni di maestri lombardi del primo Seicento,* Milan, 1959, no. 31, repr.; also M. Valsecchi, *I grandi disegni italiani del '600 lombardo all'Ambrosiana,* Milan, 1975, p. 43, fig. XXVII). Spina Barelli associated another drawing in the Ambrosiana — studies of mourning women, in black chalk on blue paper — with the painting in S. Maria presso S. Celso, but the connection is rather tenuous (E. Spina Barelli, *op. cit.,* no. 32, repr.; also M. Valsecchi, *op. cit.,* pl. 46).

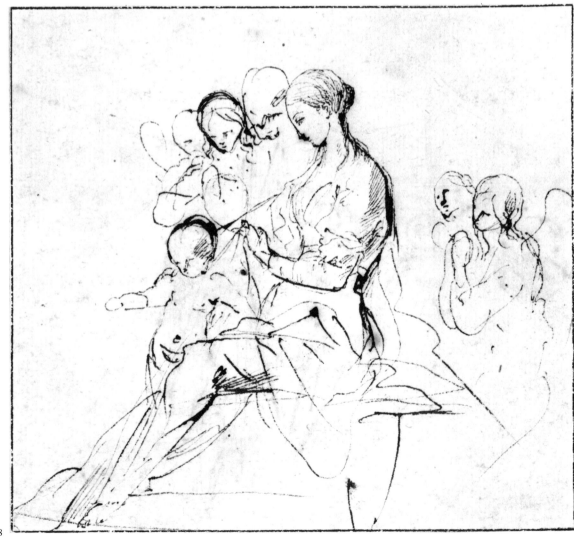

App. 18

PIETRO TESTA

Lucca 1612 – Rome 1650

App. 18. *The Holy Family with Attendant Angels*

Pen and brown ink. On verso, fragmentary copy in pen and brown ink of figures in Mantegna's engraving, the *Senators* (Bartsch, XIII, pp. 234-235, no. 11). 13.7 x 15.4 cm. Framing lines in pen and brown ink. Lined.

Inscribed in pen and brown ink on old mount, *Pietro Testa;* in pencil, *P. Testa;* in pen and brown ink, *N934. | Coll du prince Ysenburg-Birstein;* in pen and brown ink on reverse of old mount, *.N:51. Pietro Testa.*

PROVENANCE: Isembourg-Birstein (according to inscription on old mount); Städelsches Kunstinstitut, Frankfurt am Main (Lugt 2356 on verso, in part inked out); Städel sale, Munich, Montmorillon'sche Kunsthandlung, September 24, 1860, part of no. 460; purchased in New York in 1980.

Purchase, Mr. and Mrs. David T. Schiff Gift, 1980
1980.309

Study for the Holy Family in Testa's etching, the *Adoration of the Magi* (Bartsch, XX, pp. 215-216, no. 3). In the print the Virgin, St. Joseph and the Infant Jesus appear in reverse without attendant angels.

App. 19. *A River God, the Nine Muses, a Group of Male Poets, and Pegasus Striking the Rock to Bring Forth the Hippocrene Spring*

Pen and brown ink, over black chalk. The sketch of Pegasus in black chalk only. 33.7 x 24.0 cm. Framing lines in pen and brown ink. Lower right corner replaced by the artist himself; this fragment bears a study of a nude man's leg in black chalk and brown wash on the reverse. Lined.

Inscribed in pen and brown ink at lower right, *p. testa;* at lower right of old mount, *Pietro Testa 1611-1650 | a vigorous sketch of numerous figures | Pen and Ink from Sir Anthony Westcombe's Collection | Thos Bateman.;* numbered in pen and black ink at lower right corner of old mount, *169.*

PROVENANCE: Sir Anthony Westcombe, Bt.; Thomas Bateman (according to inscription on old mount); purchased in Paris in 1980.

Harry G. Sperling Fund, 1980
1980.12

This design was utilized in reverse and at the right—with variations, especially in the group of poets above—in Testa's etching, *The Triumph of Painting* (Bartsch, XX, pp. 226-227, no. 35). A pen design for the whole composition is in the Städelsches Kunstinstitut, Frankfurt am Main (Inv. Nr. 4405; *Burlington Magazine,* CXII, 1970, p. 18, fig. 19).

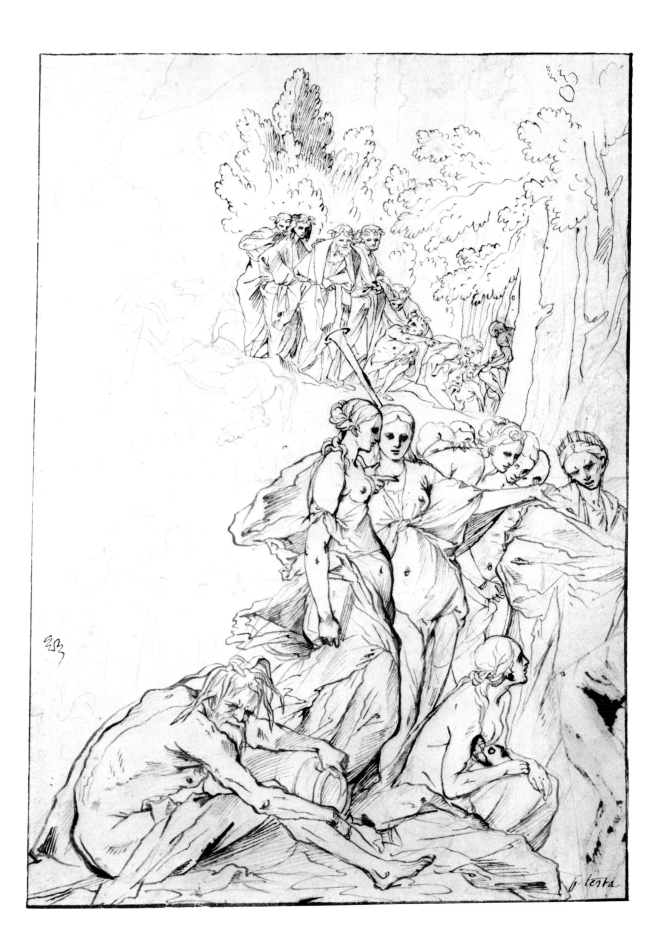

Index of Former Owners

Concordance METROPOLITAN MUSEUM OF ART ACCESSION NUMBERS

ACC.NO.	THIS VOLUME	ACC. NO.	THIS VOLUME	ACC.NO.	THIS VOLUME	ACC.NO.	THIS VOLUME
80.3.38	255	11.66.11	212	52.570.124	244	62.255	204
80.3.58	89	11.66.13	250	54.119	43	63.75.1	166
80.3.114	72	12.56.5a	94	54.125	248	63.75.3	263
80.3.115	71	12.56.6	17	56.219.3	282	63.76.1	163
80.3.147	142	17.142.1	107	57.32.2	281	63.76.2	56
80.3.154	123	17.142.2	108	57.165	25	63.76.3	90
80.3.181	201	17.142.3	111	58.105	286	63.93	236
80.3.195	118	17.236.2	58	60.66.17	239	63.96	4
80.3.217	App. 7	17.236.3	57	60.135	192	63.103.3	195
80.3.221	202	17.236.37	70	61.20.5	290	63.106	113
80.3.227	15	17.236.50	224	61.21.1	128	63.125	18
80.3.301	138	19.76.1	106	61.53	277	63.149	228
80.3.320	181	19.76.2	164	61.123.2	11	64.40	185
80.3.364	124	19.76.3	112	61.123.3	220	64.47	210
80.3.385	240	19.76.4	156	61.130.4	245	64.48.1	183
80.3.413	61	19.76.5	270	61.136.1	101	64.136.3	19
80.3.470	230	19.76.6	198	61.158.1	42	64.137	287
80.3.485	278	19.76.7	197	61.159	134	64.179	168
80.3.487	34	19.76.9	60	61.161.2	155	64.197.1	165
80.3.585	143	19.76.10	59	61.167	194	64.197.2	5
80.3.632	144	19.76.11	191	61.178.2	182	64.245	App. 2
80.3.651	268	19.76.12	193	61.179.2	80	64.295.3	266
87.12.23	187	19.76.15	83	61.180	169	65.66.1	241
87.12.26	146	19.76.17	97	61.201	276	65.66.8	186
87.12.34	46	19.76.18	33	61 203	151	65.112.1	176
87.12.69	211	19.151.6	14	61.211	292	65.112.2	154
87.12.100	254	22.72.1	213	61.212.1	77	65.112.3	115
90.20.2	225	22.72.2	214	62.54	141	65.125.3	102
06.1042.12	92	22.72.3	215	62.76	273	65.131.3	258
06.1051.6	127	22.72.4	217	62.93.1	132	65.136.1	81
06.1051.9	122	22.72.5	218	62.119.4	231	65.138	148
06.1051.10	289	22.72.6	216	62.119.9	75	65.208	136
07.283.15	41	23.280.7	24	62.119.10	84	65.223	200
08.227.11	291	24.197.2	131	62.120.3	157	66.32	32
08.227.26	272	34.114.1,2	99	62.120.4	222	66.53.5	271
08.227.27	13	36.101.1	117	62.120.7	114	66.56.1	256
08.227.28	28	40.91.4	45	62.120.8	261	66.93.2	6
08.227.32	170	41.187.2	247	62.123.2	135	66.93.4	260
08.227.33	293	46.80.3	152	62.129.5	120	66.127	54
08.227.34	171	49.141	209	62.130.1	73	66.618.1	126
08.227.38	249	49.150.4	243	62.132.1	74	67.95.3	264
10.45.1	109	50.143	22	62.135	153	67.95.4	265
10.45.3	159	50.605.22	232	62.168	38	67.95.11	147
10.45.4	158	50.605.23	233	62.190	227	67.96	269
10.45.5	207	50.605.30	173	62.197	221	67.152	133
11.66.5	98	51.90	110	62.204.2	199	67.188	280
11.66.10	288	52.124.2	226	62.247	172	68.2	252

ACC. NO.	THIS VOLUME	ACC. NO.	THIS VOLUME	ACC. NO.	THIS VOLUME	ACC. NO.	THIS VOLUME
68.54.2	234	1971.273	262	1975.89	237	1978.376	104
68.78	12	1972.118.7	86	1975.96	129	1979.10.5	App. 5
68.106.2	274	1972.118.8	85	1975.97	30	1979.24	App.6
68.113	279	1972.118.10	285	1975.126	140	1979.61	16
68.123.1	35	1972.118.11	96	1975.131.1	179	1979.62.1	App. 13a-p
68.203	55	1972.118.239	26	1975.131.4	36	1979.62.2,3	91
68.204	93	1972.118.240	27	1975.131.12	39	1979.131	App. 1
69.126.3	267	1972.118.241	23	1975.131.13	37	1979.286.2	49
1970.101.1	51	1972.118.243	40	1975.131.14	257	1980.9	App. 10
1970.101.2	52	1972.118.247	47	1975.131.20	223	1980.12	App. 19
1970.101.3	53	1972.118.251	79	1975.131.28	88	1980.17.1	3
1970.101.4	62	1972.118.252	82	1975.131.29	87	1980.17.2	2
1970.101.5	63	1972.118.253	95	1975.131.30	103	1980.20.1	App. 4
1970.101.6	64	1972.118.259	125	1975.131.35	121	1980.20.2	229
1970.101.7	65	1972.118.260	284	1975.131.44	167	1980.20.3	76
1970.101.8	66	1972.118.261	137	1975.131.45	1	1980.20.4	App. 14
1970.101.9	67	1972.118.263	149	1975.131.55	259	1980.119	App. 3
1970.101.10	68	1972.118.264	162	1975.131.242	203	1980.122	App. 15
1970.101.11	69	1972.118.265	175	1975.150	150	1980.281	App. 12
1970.101.20	283	1972.118.268	177	1976.87.1	20	1980.309	App. 18
1970.113.4	116	1972.118.270	188	1976.87.2	21	1981.23	App. 16
1970.113.7	251	1972.118.271	10	1976.186	205	1981.77	206
1970.176	100	1972.118.272	246	1976.187.1	48	1981.128	50
1970.238	161	1972.135	196	1977.3	238	1981.281	130
1970.244.2	253	1973.87	31	1977.12	178	1981.364	App. 11
1971.63.2	184	1973.321	160	1977.76	275	1981.394	App. 9
1971.64.1	78	1973.322	189	1977.163	208	1981.400	App. 8
1971.66.6	235	1973.345	242	1977.249a	7	1982.92	App. 17
1971.85	174	1974.16	119	1977.249b	8		
1971.142	44	1974.216	29	1977.249c	9		
1971.221.2	145	1974.367	180	1978.94	139		
1971.222.2	219	1974.389	105	1978.375	190		

Index of Artists

Published by The Metropolitan Museum of Art, New York
Bradford D. Kelleher, Publisher
John P. O'Neill, Editor in Chief
Anne M. Preuss, Editor
Peter Oldenburg, Designer

Composed by Finn Typographic Service
Printed by The Meriden Gravure Company
Bound by American Book-Stratford Press